Signs of Grace

Signs of Grace

Religion and American Art in the Gilded Age

KRISTIN SCHWAIN

CORNELL UNIVERSITY PRESS

Ithaca and London

Publication of this book was made possible, in part, by a grant from the University of Missouri.

First published 2008 by Cornell University Press

Printed in the United States of America

Library of Congress Cataloging-in-Publication Data

Schwain, Kristin, 1971–
 Signs of grace : religion and American art in the Gilded Age /
 Kristin Schwain.
 p. cm.
 Includes bibliographical references and index.
 ISBN 978-0-8014-4577-4 (cloth : alk. paper)
 1. Eakins, Thomas, 1844–1916. 2. Tanner, Henry Ossawa, 1859–1937.
3. Day, F. Holland (Fred Holland), 1864–1933. 4. Thayer, Abbott
Handerson, 1849–1921. 5. Art and religion—United States. 6. Art,
American—19th century. 7. Art, American—20th century. I. Title.

N6510.S39 2008
704.9'480973—dc22 2007022113

Cornell University Press strives to use environmentally responsible suppliers and materials to the fullest extent possible in the publishing of its books. Such materials include vegetable-based, low-VOC inks and acid-free papers that are recycled, totally chlorine-free, or partly composed of nonwood fibers. For further information, visit our website at www.cornellpress.cornell.edu.

Cloth printing 10 9 8 7 6 5 4 3 2 1

Contents

List of Illustrations vii
Acknowledgments ix

Introduction 1
CHAPTER 1: *Thomas Eakins's Clerical Portraits and the Art of Translation* 13

CHAPTER 2: *"A school-master to lead men to Christ":*
Henry Ossawa Tanner's Biblical Paintings and Religious Practice 42

CHAPTER 3: *Art for Religion's Sake:*
F. Holland Day and The Seven Last Words of Christ 71

CHAPTER 4: *The Protestant Icons of Abbott Handerson Thayer* 104

Notes 133
Bibliography 155
Index 169

Illustrations

FIGURE 1. Thomas Eakins, *Cathedral of Seville*, 1869–70 16

FIGURE 2. Robert Walter Weir, *Taking the Veil*, 1863 17

FIGURE 3. Diego Rodríguez Velázquez, *The Crucifixion*, 1632 22

FIGURE 4. Thomas Eakins, *Drawing I [The Law of Perspective]*, ca. 1884 25

FIGURE 5. Thomas Eakins, *Portrait of Archbishop William Henry Elder*, 1903 31

FIGURE 6. Diego Rodríguez Velázquez, *Portrait of Pope Innocent X*, 1650 31

FIGURE 7. Young and Carl, *William Henry Elder*, 1904 32

FIGURE 8. Thomas Eakins, *Portrait of Very Rev. John J. Fedigan*, 1902 37

FIGURE 9. Thomas Eakins, *Monsignor James P. Turner*, ca. 1906 40

FIGURE 10. Henry Ossawa Tanner, *Two Disciples at the Tomb*, ca. 1905–6 47

FIGURE 11. Henry Ossawa Tanner, *The Wise and Foolish Virgins (Behold! The Bridegroom Cometh)*, ca. 1906–7 48

FIGURE 12. J. James Tissot, *Eloi, Eloi, Lama Sabachthani*, ca. 1895 53

FIGURE 13. Frank Vincent DuMond, *Christ and the Woman Taken in Adultery*, 1906 54

FIGURE 14. Henry Ossawa Tanner, *The Mothers of the Bible—Hagar*, 1902 57

FIGURE 15. Henry Ossawa Tanner, *The Thankful Poor*, 1894 61

FIGURE 16. Watson Heston, "Prototype of Methodist Revivals," 1890 61

FIGURE 17. F. Holland Day, *Beauty Is Truth, Truth Beauty*, ca. 1896 74

FIGURE 18. F. Holland Day, *The Entombment*, ca. 1896 74

FIGURE 19. National Arts Club exhibit, 1902 75

FIGURE 20. F. Holland Day, [Christ with crown of thorns, looking up], 1898 77

FIGURE 21. Guido Reni, *Ecce Homo*, 1639–42 77

FIGURE 22. *The Crucifixion*, n.d. 78

FIGURE 23. Carl Stockmann, *On Calvary*, 1890 79

FIGURE 24. Richard G. Hollaman, *Passion Play of Oberammergau*, 1898 79

FIGURE 25. *Twelve Boston Physicians and Their Composite Portrait*, ca. 1894 81

FIGURE 26. F. Holland Day, *Touch Me Not . . .*, ca. 1898 84

FIGURE 27. American Mutoscope Co., *Pope Leo XIII*, ca. 1898 88

FIGURE 28. Secondo Pia, *The Shroud of Turin*, 1898 89

FIGURE 29. F. Holland Day, *Beauty Is Truth* and *The Entombment* 92

FIGURE 30. Masaccio, *Trinita*, 1427 92

FIGURE 31. F. Holland Day, *Vita Mystica*, ca. 1900 100

FIGURE 32. F. Holland Day, *Frederick H. Evans Viewing One of* 101
 the Seven Last Words, 1900

FIGURE 33. Raphael, *Sistine Madonna*, 1512–13 110

FIGURE 34. Gertrude Käsebier, *Blessed Art Thou among Women*, 1899 112

FIGURE 35. Charles Sprague Pearce, *The Annunciation*, ca. 1893 113

FIGURE 36. Abbott Handerson Thayer, *Mother and Child*, 1886 114

FIGURE 37. Abbott Handerson Thayer, *Angel*, ca. 1889 116

FIGURE 38. Abbott Handerson Thayer, *A Virgin*, 1892–93 117

FIGURE 39. Abbott Handerson Thayer, *Stevenson Memorial*, 1903 119

FIGURE 40. Joseph Gray Kitchell, *Composite Madonna*, ca. 1899 122

FIGURE 41. Abbott Handerson Thayer, *Caritas*, 1894–95 124

Color plates follow page 96

PLATE 1. Thomas Eakins, *The Crucifixion,* 1880

PLATE 2. Thomas Eakins, *The Translator* (Rt. Reverend Hugh T. Henry), 1902

PLATE 3. Henry Ossawa Tanner, *The Annunciation,* 1898

PLATE 4. Henry Ossawa Tanner, *The Resurrection of Lazarus,* 1896

PLATE 5. F. Holland Day, *Crucifixion with Mary, Mary Magdalen,*
 Joseph, and St. John, 1898

PLATE 6. F. Holland Day, *The Seven Last Words of Christ,* 1898

PLATE 7. Abbott Handerson Thayer, *Virgin Enthroned,* 1891

Acknowledgments

The completion of this book has been possible because of the encouragement and support of many people and institutions. It is a pleasure to thank publicly those who have generously shared their expertise, insights, and resources with me over the years.

My greatest scholarly debt belongs to David Morgan, whose intellectual discipline and interdisciplinary approach first stimulated my interest in the study of visual culture and religion. His counsel and friendship continue to influence my work and sense of vocation. I am also deeply grateful to Alexander Nemerov, Wanda Corn, and Michael Marrinan, whose mentorship played no small role in molding this book. I hope it reflects a small percentage of the creativity, historical rigor, and theoretical sophistication they model in their scholarship and teaching. My gratitude extends as well to "DAD," the "Deeply Anonymous Donor" who funded a yearlong residency for senior Americanists at Stanford University. During their tenures, Bryan Wolf, Sally Stein, and Roger Stein encouraged my initial forays into the paintings of Henry Ossawa Tanner, the photographs of F. Holland Day, and the relationship between American art and religion, respectively. Other colleagues provided sage advice and personal encouragement as well. Sally Promey's guidance was invaluable in the conceptualization and realization of this book. John Davis, Erika Doss, Heather Hole, Elizabeth Hutchinson, Elizabeth Johns, Michael Leja, Barbara Buhler Lynes, and Kathleen Pyne read portions of the manuscript, and their perceptive comments markedly improved the final product.

My participation in a number of interdisciplinary programs advanced my thinking in beneficial and productive ways. The Young Scholars of American Religion Program, sponsored by the Center for the Study of Religion and American Culture at

Indiana University–Purdue University, Indianapolis, provided a dynamic environment for the discussion of American religions from a variety of perspectives. I am particularly grateful to my class's mentors, Steven Prothero and Ann Taves, for their intellectual generosity, and to Clarence Hardy, Danielle Brune Sigler, and Doug Winiarski, for their bibliographic suggestions and incisive comments. Winiarski deserves special mention for his thoughtful reading of several chapters; the manuscript is far better for his attention. My colleagues in a two-week Summer Seminar in Art History, sponsored by the Erasmus Institute of the University of Notre Dame, complicated and enriched my understanding of Thomas Eakins, while members of the Americanist Reading Group at the University of Missouri–Columbia provided constructive feedback at critical moments. Wendy Bellion and Jennifer Roberts have been part of this book since I first put pen to paper, or, more precisely, fingers to keyboard, so many years ago.

The following individuals also offered guidance and encouragement at various points in the process: at Boston College, Steven Schloesser; at Boston University, Maurice Lee; at Colgate University, Michael Peletz; at the Museum of Fine Arts, Houston, Emily Ballew Neff; at Rutgers University, William Collins Donahue; at the Smithsonian American Art Museum, Richard Murray and William Truettner; at Stanford University, Scott Bukatman and Paul Robinson; at the University of Georgia, Isabelle Wallace; at the University of Miami–Ohio, Peter Williams; at the University of Missouri–Columbia, Patricia Beckman, Richard Callahan, Andrew Hoberek, Daffany Hood, Keith Eggener, John Evelev, John Klein, Elaine Lawless, Anne Stanton, and Jeffrey Williams; and at the University of Notre Dame, Brad Gregory, Paul Kollman, Bob Sullivan, and James Turner. Their contributions to the project are innumerable.

A scholarship from the Georgia O'Keeffe Museum Research Center in 2004–05 provided a year's release from teaching and an ideal environment for research and writing. In addition to Lynes and Hole, I want to thank Eumie Imm-Stroukoff and Judy Chiba Smith for making my time in Santa Fe so productive and enjoyable. The Department of Art History and Archaeology and the College of Arts and Science at the University of Missouri–Columbia advanced this project as well. The institution's leave policy made it possible for me to accept the Center's generous offer, while the University of Missouri Research Board and the University of Missouri–Columbia Research Council provided financial support and generous publication subventions. I was fortunate to receive funding in the nascent stages as well, and want to extend my gratitude to the Terra Foundation for the Arts; the Erasmus Institute at the University of Notre Dame; the Pew Program in Religion and American History at Yale University; the American Council of Learned Societies, with funding from the Henry Luce Foundation; the Smithsonian American Art Museum; the Stanford Humanities Center; and the Department of Art and Art History, Stanford University.

In addition, many institutions shared their holdings with me, and I am grateful to their professional staffs for their kind assistance: the Archives and Historical Collections, Archdiocese of Philadelphia; the Archives of American Art; the Department of

Archives, Manuscripts, and Museum Collections, Catholic University of America; the Cleveland Museum of Art; Falvey Memorial Library, Villanova University; the Library of Congress; the Hirshhorn Museum and Sculpture Garden; the National Museum of American Art; the Philadelphia Museum of Art; the Pennsylvania Academy of the Fine Arts; the Presbyterian Historical Society; Ryan Memorial Library, St. Charles Borromeo Seminary; the Smithsonian Institution Libraries; the Stanford University Libraries; and the University of Missouri Libraries. I want to thank, too, the rights and reproductions departments at various institutions in the United States and abroad.

I am deeply grateful to Alison Kalett of Cornell University Press for her enthusiastic support of this book as well as her advice and insight. I am also thankful to Cameron Cooper, Katy Meigs, and Ange Romeo-Hall, for their time and attention. In addition, I could not have asked for more attentive, constructive, and thorough reviews from the anonymous readers of the manuscript. An earlier draft of the Day chapter appeared in *American Art*, and I am grateful to the editor, Cynthia Mills, for her initial support and the University of Chicago Press for permission to publish the revised version.

I could not have completed this book without the encouragement, humor, and patience of so many friends and family members, especially my brothers, Kevin and Kerry. Finally, I dedicate this book to my parents, Barbara and David Schwain. Whether attending gymnastics meets with the same floor music playing over and over and over again; responding to my youthful questions about religion by inquiring, "What do you think?"; discussing focus group responses to marketing campaigns over dinner; or predictably calling every Sunday evening, their unconditional love and support made this book possible.

Signs of Grace

Introduction

In 1887, a columnist for the *Art Age*, an eclectic fine arts journal that covered painting, sculpture, architecture, decoration, and printing, heralded the "revival of religious art" in the United States: "The exhibition of the great Munkacsy, of the immense head of 'Jesus of Nazareth' by Marshall, the influence which is turning two, three or four of the most notable of the younger painters towards religious subjects and the manifestations of the same influence in the text and the illustrations of the monthly and weekly periodicals— all these are incidents in the history of a certain growing popular interest in religious art."[1] The writer was prescient; the visual culture of the American northeast became more and more inundated with religious art in exhibitions, traveling shows, popular periodicals, education materials, domestic amusements, and commercial entertainment in the following decades. However, artists, critics, philosophers, and tastemakers characterized the relationship between the two in a variety of ways. The American painter John Singer Sargent, for example, associated forms of religious belief with modes of artistic expression in his description of his Boston Public Library mural series, *The Triumph of Religion*: "It will be noticed that, parallel with the progress of belief towards a more spiritual ideal, the material and formulated character of symbolic treatment gives place to a less conventional artistic expression."[2] While Sargent emphasized the interdependence of art and religion, another critic asserted the two were one and the same: "It is the lack of [true belief] that makes art lifeless and mediocre; or perhaps I should say the practice of arts, for art in itself is religion, vital and vigorous, debarred only by being misnamed."[3]

In this book I explore the dynamic exchange between art and religion that helped shape modern visual practices in late nineteenth and early twentieth-century America.

I do so by examining how four artists—Thomas Eakins, Henry Ossawa Tanner, F. Holland Day, and Abbott Handerson Thayer—drew on religious beliefs and practices to explore new relationships between viewers and objects, and how beholders looked to art to experience transcendence and save their souls. At the turn of the century, religious leaders, publishers, tastemakers, and commercial magnates promoted a modern conception of faith that characterized religion as an individual relationship with the divine more than a formal set of theological precepts. This stress on the interior and subjective experience of religion coincided with artists' efforts to engage beholders personally with works of art. Although these new ways of seeing emphasized the viewer's ability to transcend the material world, they nevertheless contributed to evolving debates over class, ethnicity, sexuality, and gender. Indeed, cultural producers conceptualized fine art as a means to inculcate Anglo-American Protestant values and prompt middle-class codes of conduct at the same time as they universalized these norms. Focusing on the individual more than the community, personal experience more than social ritual, and interiority more than shared moral standards, modern American art and religion invited disciplined transcendence.

America's Christian Visual Culture

Christian art adorned modern America. In addition to the art of Eakins, Tanner, Day, and Thayer, academic works by Kenyon Cox, Frank Vincent DuMond, Mary L. Macomber, and Elizabeth Norse; mystical paintings by Robert Loftin Newman, Albert Pinkham Ryder, and Elihu Vedder; and photographs by Gertrude Käsebier, Jacob Riis, and Lewis Hine depicted biblical scenes, religious customs, holy figures, and contemporary church leaders. John Singer Sargent and Violet Oakley decorated public spaces with histories of religion, while a series of traveling exhibitions highlighting Mihály Munkácsy's *Christ before Pilate* (1881) and James Joseph Jacques Tissot's illustrations of the New Testament (1886–94) drew great crowds and critical attention.[4] Collector Charles Lang Freer purchased "therapeutic" works such as Thayer's *The Virgin* (1893) for his private home, while Isabella Stewart Gardner displayed medieval relics in sacralized spaces. Art critics treated images and objects with religious subject matter as part and parcel of the fine arts scene, and publishers dedicated pages and pages to religious art in the United States and abroad in popular periodicals.[5]

The pervasiveness of Christian imagery in America's visual culture was by no means accidental. Tastemakers assumed that fine art—as well as mass-produced reproductions of it—would instill virtue, secure cultural tradition, and educate the national citizenry generally. The frontispiece of one of the many illustrated "Life of Christ" books published at the end of the nineteenth century encapsulated the importance of imagery to public edification: "This is the age of illustrations. The eye and mind are quicker educated by a single glance at a fine picture than by hours devoted to reading pages of printed material."[6] As middle-class Americans turned increasingly to visual imagery, rather than

printed text, for instruction and socialization, civic leaders ensured they had access to it by establishing three of the most important institutional contributors to America's modernization: museums, department stores, and world's fairs.[7]

Concerned with the rise of industrialization, the influx of immigrants, and the growing threat of urban and working-class unrest, cultural capitalists founded museums (along with libraries, universities, and zoos) to socialize lay audiences into middle-class values and standards of deportment and to promote social stability. Art collectors focused their attention on European masterpieces and nineteenth-century academic paintings because they were seen to exemplify taste and present eternal truths. For example, Gardner and J. Pierpont Morgan schemed to purchase a Raphael Madonna; John D. Rockefeller, Jr. purchased several of Heinrich Hoffman's paintings of Christ, one of which he displayed in his ecumenical Riverside Church a few years later; and John Wanamaker, W. H. Vanderbilt, William Astor, and W. T. Walters owned works by the Hungarian painter Mihály Munkácsy.[8] The urban elite sanctified art and established museums as "cathedrals" and "temples" of culture to homogenize the manners and morals of the rapidly expanding urban population.[9]

Museums relied on the same civic aims and presentation strategies as the department store. The intimate relationships among art, commerce, and Christianity in the final decades of the nineteenth century is clearly exemplified by Wanamaker, the Philadelphia merchant whose department stores grew alongside philanthropic efforts that centered on the practice and progress of Christianity around the world. By 1898, he lectured to almost two thousand people every week at his Sunday Bible classes. He served as president of the Philadelphia Sabbath Association for forty years, expanded the Salvation Army and the YMCA (the latter into Madras, Calcutta, Seoul, and Peking), and was president of the World Sunday School Association in 1919.[10] Believing that art and commerce were two sides of the same coin, Wanamaker included art galleries in his department stores to display his extensive art collection and advertised exhibitions alongside sales of shoes, clothing, and home furnishings. He sanctified works that appeared in his New York City establishment by calling it the Tissot Gallery, presumably after the French painter whose biblical illustrations were seen by thousands of Americans during a multicity tour.[11] Wanamaker deemed his evangelical Presbyterian beliefs central to his civic responsibility and art collecting. All three promoted economic development, established social order, and impelled the progress of American civilization.

The golden age of collecting and the emergence of the department store coincided with the growth of world's fairs, displays of extraordinary assortments of cultures, manufactures, and technological innovations organized to position Western culture at the apex of civilization. Over 35 percent of the U.S. population witnessed American ingenuity and evolutionary progress at the 1893 World Columbian Exposition in Chicago and considered the Palace of Fine Arts a principal destination. Walking through the classical revival building, fairgoers viewed George de Forest Brush's *Mother and Child*, Frank

Vincent DuMond's *Holy Family*, Thomas Eakins's *The Crucifixion*, Carl Gutherz's *Light of the Incarnation*, Ella Condie Lamb's *The Advent Angel*, John LaFarge's *Visit of Nicodemus to Christ*, Mary Macomber's *The Annunciation*, Abbott Handerson Thayer's *Virgin Enthroned*, and Elihu Vedder's *Delilah and Sampson* (among others). These works joined hundreds of others in celebrating American art's ascension in the international scene and crowning the nation as one of the most technologically—and culturally—advanced civilizations in the world.[12]

Middle-class Americans were well prepared to experience works of art in museums, department stores, and world's fairs because publishers ensured they had the analytical tools to do so. As historian JoAnne Mancini admirably demonstrates, the turn-of-the-century art world was shaped in no small way by the "boom in art publishing" that followed the Civil War, which "included new mass visual media like magazines, chromolithography, and art education materials for the public schools."[13] The line separating the old master copy and its original, the plaster cast and its classical antecedent, and the mass-produced print and its fine art precursor was fluid, and painting, mass media, photography, illustration, and commercial art overlapped in complicated and significant ways. Publishers moved in the same social circles as museum trustees and art dealers; artists decorated their homes with prints, worked on commission, and produced art with distribution and large audiences in mind; and art critics and tastemakers celebrated the democratization of art. Although the ideological distinctions between "fine" and "popular" art, "high" and "consumer" culture, began solidifying in this period, they remained, nonetheless, in flux and reliant on one another.[14]

Publishers and entrepreneurs included art in a variety of publication genres and types of popular entertainment that shaped how turn-of-the-century Americans approached works of art. Middle-class audiences learned about the old masters and contemporary European and American artists in newspapers and magazines. Art was discussed in general periodicals such as *Harper's Weekly*, *Century Magazine*, *McClure's Magazine*, and *Outlook*, as well as in more specialized publications such as *Brush and Pencil*, *Camera Notes*, *Craftsman*, and *Modern Art*. Women's magazines in particular educated their publics about art history, highlighted the work of contemporary artists, and even served as patrons. For example, Edward Bok, the longtime editor of *Ladies' Home Journal*, commissioned Tanner to produce four illustrations for a "Women of the Bible" series published in 1902–03.[15] Gift books, too, brought the fine arts into the middle-class home. Illustrated "Life of Christ" and "The Madonna in Art" books told the Gospel story through the history of art, and home decorating manuals encouraged women to hang high-quality reproductions in every room of their homes. Stereo photographs brought art from around the world into the parlor; *tableaux vivants* (or "living pictures") staged well-known old master paintings in homes, schools, churches, and civic pageants; and travel lecturers and early cinema showmen included lantern slides of well-known works in their performances. Additional commodities, including postcards, bookmarks, holy cards, schoolbooks, and illustrated Bibles, reveal how processes of modernization extended the

visual culture of American Christianity to all areas of the country and to the homes, schools, work spaces, and entertainment venues of a growing middle-class population.[16]

Religious and Aesthetic Experience

The ubiquity of religious visual culture in the United States was predicated, in part, on Christianity's centrality to America's modernization. Scholars of modernity often claim that urbanization, industrialization, and bureaucratization displaced religion from public life, or, put differently, secularized life and experience.[17] Certain currents in American history appear to confirm that narrative. The growth of historical criticism threatened biblical authority and religious "truth" by stressing the book's human creation. Studies of anthropology and comparative religions disputed Christianity's claim to divine origin and sanction, just as they underscored historical relativism. And scientific reliance on empirical observation questioned the unseen and intangible, and more generally, emphasized a concept of knowledge that "put stricter limits on what was 'real' by casting suspicion on impalpable realities."[18]

However, challenges to Christianity did not undermine religion's influence on public and private life; they inspired religious leaders and individuals to create new interpretations, belief systems, and forms of religious experience that made sense of contemporary conditions. As the historian of religion Martin Marty puts it, "Instead of assuming a single nonreligious style of rationality and life, as some predicted they would, [turn-of-the-century] citizens kept inventing protean ways to pursue their spiritual questions."[19] The number of Protestant denominations increased in the nineteenth century with schisms among the Baptists, Disciples of Christ, Methodists, and others. New religious movements, such as Christian Science, the Emmanuel Movement, New Thought, Mormonism, Pentecostalism, Seventh-day Adventism, Spiritualism, and Theosophy further populated the religious landscape, along with the eastern religions of Buddhism, Hinduism, and Islam. Public awareness of this pluralism flourished as well, exemplified by the enthusiasm garnered by the World Parliament of Religions at the 1893 Columbian Exposition.[20]

Although denominational differences still mattered to turn-of-the-century Americans, religion was defined more in relation to personal subjectivity than to institutions and doctrines. In his book *The Varieties of Religious Experience* (1902), William James articulated the feelings of many when he defined religion as "the feelings, acts, and experiences of individual men in their solitude, so far as they apprehend themselves to stand in relation (moral, physical, ritual) to whatever they consider the divine." James severed religion from institutional settings and moral behavior and advocated a private religious faith premised on firsthand encounters with the divine. This faith, characterized generally as "a primal reality . . . the individual feels impelled to respond to solemnly and gravely," was the "more" of life: it was trust in an unseen order that gives significance to the visible world; belief in a supreme power outside the conscious self with which believers

seek communion and harmony; and sense of zest, joy, and security that stems from the spiritual energy that flows between the believer and "God" (or "spirit" or "law").[21] Part of the philosopher's lifelong quest to reconcile modern science and liberal Protestantism, the *Varieties* validated human subjectivity and grounded religion in the facts of lived experience.[22]

Certainly, religion has always included an experiential dimension. Religious studies scholar Catherine Albanese writes that religions encompass four elements: creedal statements; prescriptive behaviors and everyday codes of conduct; shared social institutions; and multisensory, communal rituals that engage the bodies of believers.[23] Understanding what "lived" or "popular" religion looks like in a particular time and place demands an investigation of how believers translated official theology into daily life and refashioned it to fit local circumstances.[24] Insight into turn-of-the-century religious experience emerges in the myriad ways Christianity inundated the public sphere. As I have already shown, radical changes in print technology, educational practices, reading tastes, and transportation networks resulted in an all-pervasive Christian visual culture. Essays by leading clergymen and theologians appeared in newspapers and popular periodicals, and contemporary trends in biblical scholarship—particularly concern with the "historical Christ"—materialized in essays, books, landscape paintings, travel lectures, and early films. Although a liberal Protestant believer's "checklist" never emerges from this cultural jumble, it becomes clear that middle-class Americans, influenced by Horace Bushnell's theories of "Christian nurture," Ralph Waldo Emerson's transcendentalism, and new religious movements (among others), conceived of "true religion" as a subjective and interior relationship with God, fostered through intuition, spiritual encounters, and emotional responses.

Protestant leaders relied on images to encourage religious feeling. Art historian David Morgan shows that two general forms of popular religious art appeared throughout the nineteenth century: didactic imagery, which instructed and taught, and was employed to facilitate conversion; and devotional imagery, which was contemplated by the viewer and intended to nurture and aid in character formation. Although both modes remained active throughout the century, and many images encouraged both forms of engagement, a general shift in emphasis occurred throughout the nineteenth century from the didactic to the devotional. According to Morgan, "By promoting the appreciation of fine art and by investing artists with the power to interpret scripture rather than merely to illustrate it, liberal Protestant clergy, pedagogues, and the authors of illustrated lives of Christ joined with the new wealth of American commerce to imbue art with a devotional and liturgical purpose that overcame traditional Protestant anxieties about imagery."[25] As Protestant attitudes toward the visual began to parallel those of Roman Catholics, many turn-of-the-century Americans turned to art to encounter the divine.

At the same time as experience became an increasingly critical component of American Christianity, it assumed added importance in the fine art world. Although

art with religious subject matter was prevalent throughout the nation's history, its appearance at the end of the nineteenth century was considerably different from that of its predecessors. Early American gravestones and portraits, for example, relied heavily on the emblematic tradition to communicate with viewers, while religious history paintings by Washington Allston, Daniel Huntington, and William Page (among others) demanded a knowledge of allegorical, scriptural, and typological interpretation to convey meaning. Apocalyptic and Romantic landscape paintings, too, relied on allegory and typology—as well as iconography and metaphor—to conflate America and the "New Israel," contemporary events and the biblical text, in order to purvey moral lessons and cultural instruction.[26] Turn-of-the-century artists employed some of these representational tools, producing a likeness of the visible world and calling on communally shared signs and symbols to communicate directly with beholders. At the same time, however, they encouraged viewers to engage the work of art, to view it as a permanent presence rather than as a historical record or instructional object.

In a period that championed "object lessons" in all spheres of intellectual endeavor, art critics placed considerable emphasis on evaluating individual artworks and stressing their uniqueness.[27] In doing so, they drew on a host of philosophical systems that professed an intimate relationship between art and religion, some relying on the English critic John Ruskin's association of art, nature, and morality and others on the German idealists' spiritualization of art. Ruskin's American apologist, William James Stillman, argued that art needed religion to avoid becoming "*merely* aesthetic":

> Reverence of Nature and consequent humility is, then, we assert, the first requisite of religious Art—and, in proportion as the artist grows in the perception of the spiritual meaning of Nature, and reads in her forms only Divine truth, he becomes more highly religious, so that without possessing the full knowledge of truth which constitutes Christianity, his Art will still be religious in the degree of his light.[28]

Although Ruskin's influence declined in the 1890s, his disciple, William Morris, adapted his mentor's aesthetic and social thought for a more industrial and urban age. Morris's cultural idealism was embraced by American aesthetes, arts and crafts enthusiasts, and Progressive Era reformers, who believed that art had the power to cultivate taste and socialize children and immigrants into modern life.

Other critics called on eighteenth-century German philosophers and aestheticians such as Friedrich Schleiermacher, who sought to liberate religious doctrine from metaphysical beliefs and ecclesiastical institutions, and Karl Philipp Moritz, who developed the concept of disinterested contemplation of the art object. By treating religious and aesthetic experience as autonomous moments complete in and of themselves and as moments of complete dependence on, or communion with, the infinite, they set the stage for the "spiritualization of art" that gained in strength throughout

the nineteenth century. Drawing on this rich intellectual tradition, such art critics as Bernard Berenson, Clive Bell, and Roger Fry championed forms of aesthetic experience that paralleled religious engagement. Beholders communed with works of art, transcended the everyday, and attained "rapture," "ecstasy," and "mystic" visions.[29]

Late nineteenth-century tastemakers found support for their moral or spiritual conceptions of aesthetic engagement in American pragmatism, which provided an epistemological framework that validated experience as a legitimate way of knowing. Maintaining that a strictly positivist worldview was inadequate to understand human existence, figures such as Charles Sanders Peirce, William James, and John Dewey promoted experience as a bridge between interior and exterior realities. Although these figures did not agree on the nature of experience—James promoted a priori, "pure experience," while his student, John Dewey, characterized it as an integration of "act and material, subject and object" in an "unanalyzed totality"[30]—the intensity of the debate surrounding its characterization stemmed from a tension between the Enlightenment project of isolating, studying, and disciplining the senses and the contemporaneous need to merge self and other, exterior and interior.[31] To counter the isolation, crisis of authority, and increasing sense of moral unease that stemmed from the processes of modernization and the expansion of industrial capitalism, Americans turned to art and religion (along with the "simple life" and the "Strenuous Life," among others) to integrate the self, commune with nature, and recover authentic experience.[32]

Signs of Grace

In her 1895 discussion of contemporary religious painting in America, art critic Clara Erskine Clement announced: "Those works which most deeply appeal to me and most vividly place before my imagination, as well as before my eyes, the scenes represented, have been the 'outward and visible sign' of the 'inward and spiritual grace' with which the artist had been endowed by a power higher than himself."[33] By using the phrases "outward sign" and "inward grace," Clement employed the commonly known and often repeated Christian definition of sacrament in her description of successful religious paintings. In addition to asserting a belief in art as a material manifestation of the unseen, she intimated that the viewer's personal engagement with the work of art was sacramental in nature, that aesthetic experience bestowed the beholder with grace.

In the chapters that follow, I look closely at the paintings and photographs of Eakins, Tanner, Day, and Thayer to examine the myriad ways religious and aesthetic experience became intertwined and interdependent during America's modernization. All four men were well-known members of the art world, which was located in the urban areas of the American northeast: they looked to Europe for training (Eakins, Tanner, and Thayer all studied in Paris) as well as artistic precedents and professional legitimacy; they submitted their work to local, national, and international exhibitions; and they received extensive press coverage and recognition. Their significance to contemporary

artists, collectors, critics, and viewers makes their work—both its production and reception—a useful lens through which to examine the development of modernist aesthetics and viewing practices. Moreover, the varying degrees and divergence of their religious convictions typify the varieties of Christianity at the end of the century. Through these four case studies, then, I explore the specific ways Eakins, Tanner, Day, and Thayer relied on religious beliefs and practices to impel personal encounters with works of art. At the same time, I delineate the broader themes that shaped the era, particularly the artists' insistence on communicating abstract ideals through the depiction of the human figure and the more general desire to root vision in personal experience, and, at the time, discipline perception and detach it from historical conditions.

The Philadelphia painter Thomas Eakins was by all accounts agnostic. He was raised in a culturally Protestant, but nonobservant, home, with traces of Quakerism from his mother's side. He eschewed membership in any church, teased those who regularly attended services and Sunday school, and smiled "superciliously when anyone spoke about future life."[34] Although Eakins dispensed with the supernatural, the evidence indicates that he engaged religious doctrines and adhered to many of the cultural values and social structures that undergirded Protestant America. He considered *The Crucifixion* (1880) his most representative piece, worked with his student and closest friend, Samuel Murray, on a series of sculptures that represented the biblical prophets (1896), and painted fourteen portraits of the Roman Catholic hierarchy. In chapter 1, I show how Eakins's theoretical conception of art was shaped by more than his serious study of anatomy, perspective, and movement; it was formed, too, by his understanding of linguistics and translation, reverence for authority and tradition, and faith in the generational transmission of knowledge. He conceived of fine art as Logos, or "Word made Flesh," articulated in the opening verses of John's Gospel: "In the beginning was the Word, and the Word was with God, and the Word was God." For Eakins, art was a form of incarnation that integrated the immanent and transcendent in a historical figure. It included the sitter in the annals of history and translated him into the present for generations of viewers.

The work of Henry Ossawa Tanner, a student and later portrait subject of Eakins, shows how a theology of experience, popular among a variety of Protestant denominations, helped sponsor a middle-class culture of consumption. Unlike Eakins, Tanner was raised in a religiously devout home. His father, Benjamin Tucker (B. T.) Tanner, was a minister, and later a bishop, in the African Methodist Episcopal (AME) Church. The church, described as "the greatest Negro organization in the world" by W. E. B. DuBois in *The Souls of Black Folk* (1903), focused on religious conversion, evangelism, and African American uplift.[35] B. T. Tanner's position as editor of the *Christian Recorder* and later the *A.M.E. Church Review* acquainted the aspiring artist with the theological and social debates that occupied the church leadership. In chapter 2, I examine how Tanner's upbringing in the AME Church influenced his "visual exegesis," or the way he visualized his interpretation of the biblical text. I demonstrate that Methodism's emphasis on

religious experience led Tanner to create paintings that engaged the viewer's emotions, while his elite status in the African-American community and promotion of middle-class values ensured those emotions were disciplined and restrained.

F. Holland Day's eclectic spiritual search mirrored that of other Americans who looked beyond their denominational affiliation to experience transcendence. The photographer's New England Unitarianism was supplemented by his attendance at high Anglican services and Roman Catholic mass as well as at séances and lectures by noted mediums. His broad reading list included works on Mormonism, mysticism, the occult, Theosophy, and a variety of Eastern religions. Chapter 3 analyzes Day's series of sacred photographs within the context of Christianity's massive visual culture. They relied on a shared visual vocabulary of mass-produced religious imagery, *tableaux vivants,* Passion plays, travel lectures, and early films to translate Christian beliefs and devotional practices into artworks that impelled new relationships between the viewer and the object. Importantly, these established customs and innovative technologies overlapped with new spiritual traditions that found broad support among the cultural elite and reinforced the increasing attention to personal religious and aesthetic encounters. Day compared these two practices, raising the photograph to the status of sacred art and providing the occasion for communion with the divine.

Day's fellow Bostonian, Abbott Handerson Thayer, was the most well-known painter of ideal womanhood at the end of the nineteenth century. Born into a family of educators in 1849, Thayer was raised as a Unitarian, heavily influenced by transcendentalism. His liberal Protestantism, combined with his reading of nature writing, classical philosophy, German idealism, and American pragmatism, set the stage for a humanist conception of religion that stressed spiritual experience more than church doctrine. The final chapter examines how Thayer's more than life-sized paintings of contemporary women relied on woman's sacred role in turn-of-the-century American life to elevate the sitter into a universal type, worthy of veneration and contemplation. Viewers, calling on the same cultural assumptions, considered his paintings devotional objects that inspired imagination, attention, and spiritual experience. The piety with which viewers engaged Thayer's paintings illustrates how models of individual religious devotion structured aesthetic experience in turn-of-the-century America.

Attempting to characterize the meaning of "experience" for turn-of-the-century audiences presents a host of theoretical and practical problems. As intellectual historian Martin Jay writes, experience is "at the nodal point of the intersection between public language and private subjectivity, between expressible commonalities and the ineffability of the individual interior."[36] However, as recent studies of the subject show, while moments of experience happen to individuals, people filter their explanations of these moments through aesthetic and religious discourses, historical processes, and traditions of interpretation. Consequently, I rely on a variety of primary source materials to uncover the analytical practices viewers employed to describe and interpret their aesthetic and religious experiences. To put it differently, I explore early modernism's "period eye" by

paying attention to the interpretive models turn-of-the-century Americans employed, especially as defined by their artistic, educational, and theological training, as well as the codes of viewing, social experiences, and visual cultures on which they drew.[37]

This study of vision's modernization has been shaped by recent studies in the inter-disciplinary field of visual culture.[38] I share the art historian David Morgan's contention that "seeing is an operation that relies on an apparatus of assumptions and inclinations, habits and routines, historical associations, and cultural practices."[39] It is an action that encompasses the object, the beholder, the process of viewing, and the setting in which it takes place. At the end of the nineteenth century, improved optical devices and repro-ductive technologies as well new forms of commercial amusements produced a panoply of new visual practices. Although different spaces, including art museums, department stores, world's fairs, and domestic interiors, prompted particular ways of seeing, these processes overlapped and influenced one another. And, although artists and critics would work to isolate the realm of fine art from other spheres of perception in the following decades, early-twentieth-century viewers processed the multisensory experiences in America's increasingly spectacular mass culture in ways more alike than different.[40]

Modernist culture—its ideas, beliefs, values and modes of perception—was a re-sponse to and mediation of the socioeconomic effects of modernization. It sought to "restore a sense of order to human experience under the often chaotic conditions of twentieth-century existence."[41] Although formalist aesthetics and the avant-garde have been its most discussed and celebrated products, modernism encompassed vernacular culture—advertising, cinema, and photography, among others—as well as a host of aesthetic styles.[42] The figurative art of Eakins, Tanner, Day, and Thayer registered this cultural milieu and constituted it, creating a contemporary set of symbols and viewing practices that mediated between the natural and supernatural realms, defined the role of the individual within them, and did so while remaining consistent with contempo-rary artistic, religious, and modern concerns.

Thomas Eakins's Clerical Portraits
and the Art of Translation

Throughout the nineteenth century American Protestants polarized the theological and social distinctions they perceived between Protestantism and Roman Catholicism: Protestant Enlightenment and Popish duplicity; Protestant word and Catholic image; Protestant spirit and Catholic matter; Protestant authenticity and Catholic theatricality; Protestant autonomy and Catholic authority. Protestant apologists argued that while they encouraged immediate access to God, Catholics employed corrupt interlopers who used ornate surfaces and religious performances to mask deviant interiors. One popular metaphor illuminating Protestant and Catholic oppositions centered on the stained glass window. Rather than allowing the Word's pure light to shine directly through a transparent window, the Catholic Church's use of stained glass distorted perception, refracted light, and muffled the Gospel message.[1]

The rift American Protestants perceived between themselves and Roman Catholics illuminates two issues that roused the cultural elite generally: the appropriate relationship between the material and spiritual realms and the authority of the translator who bridged them.[2] Seeing and believing never enjoyed an unadulterated union; however, the correlation between the two faced significant challenges in the final decades of the nineteenth century. Although observation and personal experience still served as determinants of scientific and religious truth for some, the limitations of the human eye exposed by technological developments and forms of modern entertainment, including photography and P. T. Barnum's "humbugs," made others increasingly skeptical.[3] The growing fissure between perception and reality led culture brokers to ask two fundamental questions: Who has the knowledge

to determine the truth of appearances? What criteria should be used to establish whether that expert can be trusted? For Thomas Eakins, America's preeminent realist painter, Roman Catholicism provided a model for conceptualizing the uneasy union between seeing and believing and for asserting control over it, both through the maintenance of tradition and through hierarchical modes of social organization.[4]

Many scholars have perceived religious subject matter as being at odds with the artist's biography and interest in science and modern life more generally.[5] Raised in a culturally Protestant home inflected with Quakerism on his mother's side, Eakins eschewed membership in any church and was by all accounts agnostic.[6] His serious study of anatomy, perspective, and instantaneous photography, as well as his close associations with scientists of all kinds, appears to confirm the artist's contribution to America's "secularization," a theory of modernity popularized in the early twentieth century that maintained that the rise of modernization necessitated the decline of religious belief.[7] However, the visual evidence shows that Eakins's critiques of Christianity and dedication to scientific inquiry existed alongside a lifelong engagement with theological questions and a high regard for Roman Catholic prelates. He admired the work of Spanish artists; considered *The Crucifixion* (1880) his most characteristic painting; worked with his favorite student and closest friend, Samuel Murray, on a sculptural program for the Presbyterian Board of Publication and Sabbath School Work in 1896; and painted fourteen portraits of the Roman Catholic hierarchy in the first decade of the twentieth century. Far from idiosyncratic to his oeuvre, Eakins's religious works are part of his larger investigation into the capacities of human vision and art's function in the modern world.

In this chapter, I argue that Roman Catholicism played a critical role in determining Eakins's aesthetic style and theoretical conception of art. It helped the artist formulate a notion of art as Logos, or "Word made flesh," a union of the immanent and transcendent in a material object. In doing so, he placed himself in an intellectual community that believed the meaning of visual signs was not inherent in the objects themselves, but rather was contingent on the beholder's relationship to them as well as the community in which he or she lived. Fearful of such a fluid interpretative field, Eakins worked to fix the truth of signs through his extensive studies of anatomy, linear perspective, movement, mathematics, and painting. He turned, too, to a model of social organization that demanded respect for authority and tradition and emphasized the generational transmission of knowledge in homosocial communities. For Eakins, art kept the historical subject—and the universal traits he embodied—present for generations of viewers.

Eakins's Religious Sensibilities

Many of Eakins's written comments on religion appear in the letters he wrote to his family as an art student in Paris. His religious critiques, which included a distrust of clergymen, disbelief in religious dogmas that ignored material realities, and contempt

for the sentimentalized piety of the lower classes, were far from unique; they were consistent with those of liberal Protestants and agnostics alike who sought to create a coherent view of the world in the face of scientific challenges to faith in the final quarter of the nineteenth century.

Eakins associated clergymen with affectation. He wrote to his sister that "a minister would use the word attenuated . . . instead of thin because it is longer."[8] Their use of long words when short ones would communicate just as effectively conferred on them a public authority unsupported by actual proficiency. He decried also the clergy's tendency to evade controversial passages by impersonating a hypothetical clergyman's description of the Old Testament: "How would you like to hear a minister reading the bible and omitting everything improper or coughing in its place, thus Abraham had one (hundred and ninety nine) (prolonged cough) wife and seven hundred and ninety three (concubines) (more coughs)."[9]

The young artist further critiqued religion because of its reliance on "mystery" and its denial of physical realities. He wrote that church leaders rarely provided adequate grounding from the physical world to prove their theses. In one of the few religious statements that centered on church doctrine, he stated: "Think of the contemptible catholic religion the three in one and one in '3' $3=1$ $1=3$ $3 \times 1=1$ which they call mystery and if you dont believe it be damned to you and the virgin mother that afterwards married a man look at it isnt it ridiculous and the virgin grandmother for his grandmother was made so recently by Pope Pius IX. . . . Its beyond all belief."[10] Eakins expressed his contempt for the Trinity by testing mystery against mathematical reason, which highlighted the absurdity of the equations and stressed religion's logical inconsistencies. He condemned, too, the dogma of the Immaculate Conception, issued in 1854 by Pope Pius IX. This decree declared that Mary, like Christ, was born free of original sin. He did not understand how the Immaculate Conception (itself a biological impossibility) could be projected onto a human centuries after her death, how dogma could be "made so recently."

Much of Eakins's disgust for religion stemmed from his desire to distance himself from the lower classes and align himself with the intellectual elite. For example, the young Eakins portrayed a church service he attended while in Spain with an ethnographic sensibility:

> The music on the organ is the queerest I ever heard. It is the quickest
> nigger jig kind of music then its echo in the distance. Then another jig
> and it comes so sudden each time or you can't get accustomed to it.
> The whole cathedral floors are covered with thick matting and there
> are no seats. The people all keep on their knees men and women and
> from time to time fell their face on the ground like a Hindoo sticking
> the backside up in the air and then back on their knees again (sic).[11]

Eakins described the mass and disassociated himself from it. He could not "get accustomed to" what he perceived as an irregular musical format. The music, he declared, was

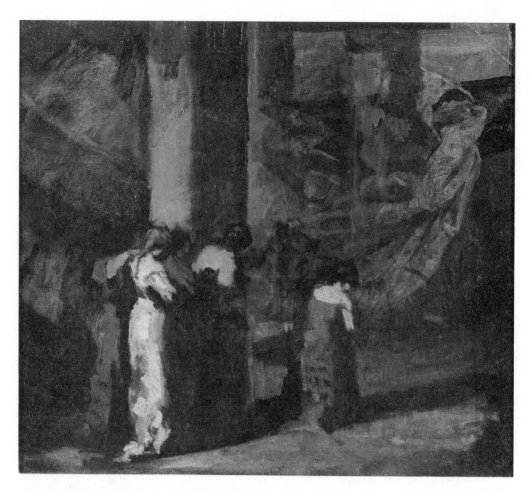

Figure 1. Thomas Eakins, *Cathedral of Seville*, 1869–70. Hirshhorn Museum and Sculpture Garden, Smithsonian Institution, Gift of Joseph H. Hirshhorn Foundation, 1966.

more associated with African-American culture than his own Protestant heritage and the parishioners prayed on their knees like "Hindoos" instead of seated in ordered pews.

Eakins visualized his ambivalence to Catholic ritual in his *Scene in a Cathedral*, painted in 1869–70 (fig. 1). The image depicts a group of women praying in a non-descript religious space, their heads bowed and their hands clasped in front of them. A single woman kneels in supplication in front of the group, isolated physically and emotionally. Importantly, Eakins does not include the altar, crucifix, or statue the women are facing in the work. His focus remains on the act of prayer, as seen from a distant and elevated viewing position. In this way, the picture bears a structural resemblance to Robert W. Weir's *Taking the Veil* (1863), a commercially successful canvas that depicts a young novice taking her convent vows (fig. 2).[12] Weir excluded signs denoting a particularly Catholic space. He ensured that the crucifix, an immediate marker of Catholicism in nineteenth-century America, remained hidden by a curtain to avoid potential controversy.[13]

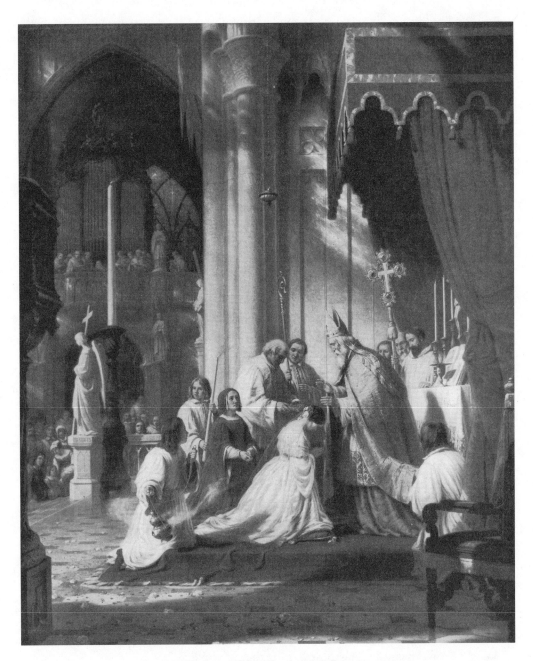

Figure 2. Robert Walter Weir, *Taking the Veil*, 1863. Yale University Art Gallery.

Eakins's *Scene in a Cathedral* and Weir's *Taking the Veil* enable the beholder to witness Catholic ritual without participating in it. By establishing detached spaces of observation, Eakins and Weir expressed their fascination with and detachment from Catholic devotion and liturgy. They were not alone. Throughout the nineteenth century, there was a "distinctive Protestant gaze on Rome, a gaze that acknowledged its spiritual desire, celebrated Catholicism as a spectacle, and fantasized the consumption of this foreign substance rather than conversion to it."[14] "Romanism" served an imaginative discourse that permeated Old World travel narratives, the histories of W. H. Prescott and Francis Parkman, Native American and convent captivity narratives, conversion stories, and the writings of Edgar Allen Poe, Herman Melville, Nathaniel Hawthorne, and Henry Wadsworth Longfellow. In the visual arts, the Protestant gaze opened a space of active, embodied viewing that was considered central to the Catholic experience of ritual but potentially dangerous and disruptive to Protestant, disembodied worship.[15] Eakins's youthful comments and artworks underscore his participation in this cultural community.

Eakins's critiques of Christianity did not negate a generalized religious sensibility, however. The young artist described a "Turk" as the opposite of Swiss and Spanish peasants and the embodiment of a "healthy religious": "[His] religion is a silent prayer to the unknown immense God. The sun is going down. The man of the desert stops his horse, takes off his shoes, everything is silent there, he forgets he is of the world and prays to his Allah. How simple and grand. How Christ like."[16] For Eakins, a true religious life was not giving money to build a new church, listening to uneducated, lazy priests, or praying to statuettes; it took place away from the trappings of the material world.

Eakins's dismissive appraisals of popular religious practice accompanied, too, a deep intellectual engagement with Christian scholarship and art. He often read the New Testament in Latin and was fully aware of contemporary criticism regarding biblical interpretation.[17] In addition, Eakins expressed profound respect for well-traveled and educated priests. He wrote to his mother about the hours he spent in conversation with a Jesuit priest:

> He is the most learned man I ever saw and talks French with me by the hour. He had read all the books with which I am acquainted and knows them. He chats about authors, painters, musicians, colleges, the animals of the south, those of France. He knows anatomy, medicine and the languages of Europe. He has never tried to convert me although he knows I belong to no church, and the only moral advice he ever gave me was to abstain from gaming in Paris which he says ruins many Americans. The most striking thing about him is his modesty.[18]

Eakins's tone indicates he was surprised the priest did not evangelize or display the affectation he usually associated with clergymen. The Jesuit priest earned the young

artist's admiration because of his solid intellectual training in anatomy, art, linguistics, literature, medicine, and science, as well his complete lack of pretense.

Finally, Eakins found his aesthetic identity in Spanish painting, particularly that of Diego Velázquez and Jusepe de Ribera. He wrote to his father from Madrid, praising their work: "O what satisfaction it gave me to see the good Spanish work so strong so reasonable so free from every affectation. It stands out like nature itself."[19] Eakins's admiration for Spanish painting, while increasingly common among American artists studying in Paris, was relatively unusual among American Protestants. Although partly due to the relative obscurity of Spanish art in the United States during this period, an equally important factor was its association with Catholic "sensuality" and materiality. For example, in John LaFarge's version of the very popular illustrated "Life of Christ" books that inundated the nineteenth-century book market, the artist noted that denominational affiliation influenced aesthetic taste:

> Perhaps it may be well again to remember that race has much to do with the appreciation of works which, in the art of painting or writing, are meant to carry a religious sentiment. For instance, the Spaniards have painted wonderful religious paintings . . . [that] carry an extraordinary amount of religious feeling. Tradition tells us that these artists were deeply religious in their lives and thought, and yet, to some types, such as certain English people, or some accurate and cauistic Frenchmen, their love of humanity, their splendor of sympathy, would not be sufficiently proper and prudish for men and women brought up in narrower ways, and also (it is worth noting) in a more worldly manner, for the mark of the Spaniard is unworldliness.[20]

LaFarge's theory that "race" and religious affiliation shaped aesthetic taste was not unfounded or unusual. One of America's premier academic artists, Kenyon Cox, praised Velázquez's "abundant vitality" but described his work as "coarse" and "unchastened . . . to our more refined sensibilities."[21] He deemed the Spaniard's realism incongruent with contemporary propriety. Not surprisingly, Eakins's admiration for Spanish painting was premised on many of characteristics LaFarge praised and Cox condemned: its close attention to humanity and what the former described as "emotion of a physical kind."[22]

Inconsistencies suffused Eakins's early commentaries on religion. He distrusted religious authority, yet sought a mode of control for the peasant population. He decried mystery as an interpretive strategy, yet described a healthy religious belief with a sense of sublime awe. And he critiqued religion's materialist devotional practices, yet claimed it had no engagement with physical realities. Eakins's religious comments resonated with those of liberal Protestants and the burgeoning agnostic community in the second half of the nineteenth century. Many well-educated Anglo-American men such as Lyman Abbott, Washington Gladden, and Josiah Strong endeavored to expedite the processes of modernism from within Protestantism by embracing a universal outlook, adapting to

evolutionary theory, and accepting biblical criticism in history.[23] In a different, though related vein, agnostics shared a coherent notion of reality that excluded God. Although their unbelief was relatively radical for the time period, they were often culturally conservative, demanding strict adherence to conventional moral codes predicated on the dominant Protestant culture. They linked morality to natural law and human progress, effacing its foundation in religious beliefs and values.[24] Eakins's comments on Christianity joined a critical discourse that encompassed a myriad of viewpoints voiced from within religious institutions as well as from outside them.

The Word Made Flesh

Eakins returned to Philadelphia in 1870 and ten years later attempted a theme popular among the old masters and contemporary French academic painters—Christ's crucifixion (1880) (plate 1). His rendition of the biblical event appeared seven years after he completed the bulk of his rowing pictures, five years after *The Gross Clinic*, and three years after *William Rush*—all works that helped establish Eakins's approach to art making and self-definition as an artist.[25] The artist exhibited the painting until his death in 1916; hung it in the front hall of his home after loaning it to St. Charles Borromeo Seminary at Overbrook for a number of years; and offered it to the Metropolitan Museum of Art as his "representative" work in 1910. One explanation for *The Crucifixion's* continuing significance to Eakins rests in the way of seeing it prompted. The work encouraged the viewer's embodied and conceptual engagement with it, a visual practice shared and encouraged by Philadelphia's Roman Catholic hierarchy.

Stripped of beautifying effects, devotional aids, moral sentiment, and traditional iconography pointing to Christ's resurrection, Eakins's life-size Christ dramatically confronts the viewer. His head falls forward, darkened by shadows; his hands are clenched in rigor mortis, punctured by nails; and the blood from his body collects in his legs, which have turned purple. Christ is dying, isolated in a forsaken, nondescript landscape, and abandoned by friends and followers. Eakins's clinical representation of the human body produced what he termed "an objective study of a human being in his last moments."[26]

In *The Crucifixion*, Eakins returned to what he considered the event's central themes: a human figure, suffering in isolation, nearing death. Mariana Griswold Van Rensselaer, one of the few critics to respond favorably to the image, pointed to Eakins's paring down of iconographic elements:

> But for the crown of thorns and the scroll above the cross one could not tell what martyr's death might be before us. These things, however, consecrated though they are by all tradition, are but accessories which an artist may omit at will provided he gives us the essential idea— which is that of *sacrifice*—and provided he uses this novel material to heighten the impression of terror or pathos at which he aims.[27]

Eakins's earlier praise for the Turk's religious practice as an individual encounter with God, removed from the noise and clutter of daily life, set the stage for his image of the historical Christ as a solitary, sacrificing figure.

Eakins's realist idiom and attention to anatomical detail accented Christ's historical reality. The artist's emphasis on the humanity of Christ, rather than his divinity, situated him within a larger American and international context that sought knowledge of the historical Christ: what he looked like, the places he lived, and the roads he walked. The French scholar Ernest Renan propagated a version of this historical search in his *Life of Christ*, which became one of the most widely read books of the late nineteenth century. First published in 1863, Renan's literary *Life of Christ* provided a scientific account of the biblical text, premised on archeological findings and clinical diagnoses. The iconography of *The Crucifixion* indicates that Eakins based his representation on Renan's text. The painting's brutally frank, anatomically accurate representation of Christ's dying body and the position of the sun in the sky visualizes Renan's medical diagnosis of Christ's death—Christ died at three in the afternoon of a "rupture of a blood-vessel" near the head.[28]

In addition to contemporary biblical criticism, Eakins relied on visual precedents for the painting throughout Catholic Europe, including Velázquez's *Christ on the Cross* (1632), which set the solitary Christ against a dark background and pulled the viewer into a confrontation with the sacred figure's crucified body (fig. 3).[29] He followed in the footsteps of his artistic mentors and teachers as well. One of Eakins's instructors in Paris, Léon Bonnat, was rumored to have nailed a cadaver to a cross in order to depict a body's physical response to crucifixion with anatomical precision in his *Christ on the Cross* (1874). Eakins, in turn, strapped one of his students, J. Laurie Wallace, to a cross in a New Jersey countryside, and later on the roof of his Philadelphia row house, while working on the canvas.[30]

Eakins may have had a more local source, as well: the recently completed Cathedral of Saints Peter and Paul in Philadelphia. In 1876, Dr. Samuel D. Gross introduced the artist to his close friend, the Roman Catholic archbishop James Frederick Wood. Eakins asked Wood to pose for a portrait a year after the prelate was installed as archbishop. Wood's tenure as leader of the church was distinguished: he restored the finances of the diocese; oversaw the completion of the cathedral; relocated St. Charles Borromeo Seminary to Overbrook in 1871; and built up the diocese to an archdiocese in 1875.[31] Eakins intended to depict Wood celebrating a pontifical High Mass at the newly completed cathedral. He attended religious ceremonies there and completed a number of sketches of the proceedings and, during another visit, the interior decorations: a group of clerics, a Mother and Child statue, a standing figure and a cross, a statue of a kneeling angel and a crucifix, and a crucifix that included its dimensions.[32] Although Wood's poor health forced Eakins to abandon the plan and paint a seated portrait, his preparation for the work reacquainted him with Catholic aesthetics, iconography, and liturgy.

Although critics praised the anatomical precision of the painting, most considered the realism inappropriate for such an ideal subject. One reviewer, recalling the uproar

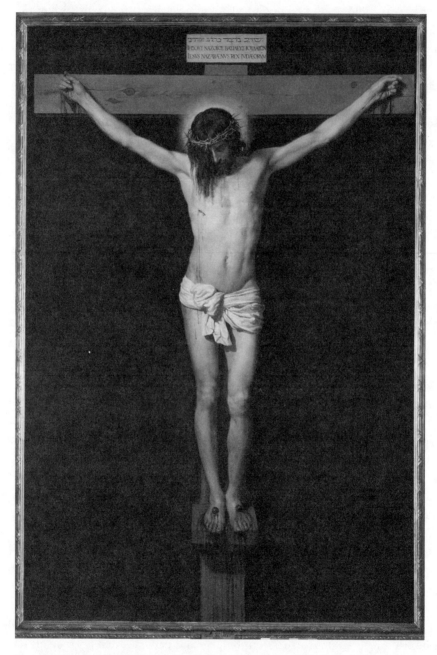

Figure 3. Diego Rodríguez Velázquez, *The Crucifixion*, 1632. Museo del Prado, Madrid.
Photo credit: Erich Lessing/Art Resource, New York.

over *The Gross Clinic*, wrote: "Mr. Eakins has approached the work with the same feelings that might agitate the breast of a surgeon, and has invaded, with cold-blooded realism, a field of pictorial illustration from which it's very difficult to dislodge the idealism that has long had full possession of this particular domain."[33] This critic's comparison of Dr. Gross and Eakins as cold-blooded butchers was exacerbated by another, whose headline included the phrase "Christ Crucified by Eakins." Although meant to stress the subject of the painting, the author's assertion that it was an "unnecessary picture" connotes a secondary meaning, that Eakins's painting recrucified Christ.[34] A personal friend of Eakins's encapsulated the problem when he noted that contemporary reception to *The Crucifixion* depended on "whether the spectator has ever conceived, or is willing to conceive, of the Crucifixion as an event which actually occurred under certain understood conditions."[35]

Protestant viewers were uncomfortable with the stark realism of the canvas because it did not serve what they deemed to be art's proper functions: to serve a good purpose, to stir noble emotion, and to elevate the mind. A reviewer for the *Chicago Tribune* wrote: "Thomas Eakins's *Crucifixion* is a large canvas representing a horrible form of death in a most ghastly and horrible manner, and it may well be doubted whether such a picture serves any good purpose outside of the classroom of an art school." Another critic agreed that the artist's presentation of Christ's body was accurate, but noted that "there is nothing artistic in this realism because it does not stir any noble emotion." A third summarized the feelings of many when he argued that "the mere presentation of a human body suspended from a cross and dying a slow death under an Eastern sun cannot do anyone any good, nor awaken thoughts that elevate the mind."[36] For these critics, realism must be tempered with idealism and reverence in religious representation.

Although Eakins's rendition in *The Crucifixion* did not meet the expectations of Protestant viewers, it did correspond to a Catholic emphasis on the educational and edifying role of aesthetic engagement. The crucifixion played a prominent role in Catholic devotional imagery. In an apology for the role of art in Catholic life, the Rev. D. I. McDermott wrote that Crucifixion imagery "brings before our minds the mystery of redemption and enable[s] us the more fully to appreciate it":

> When we look upon the suffering Son of God, when we see the most beautiful of the sons of men nailed to that unhewn tree, hanging on it for three hours; when we see that there is no soundness left in that miraculously formed body; that from the crown of the head to the sole of the foot it is covered with wounds. . . . Then we can, in a measure, realize that each wound inflicted on Jesus a pain so intensely excruciating as to be beyond the power of men to endure it. . . . While striving to form a conception of the greatness of Jesus' sufferings from consideration of their number, their intensity, their duration, if we look on this picture we can hear Jesus say to us: "There is no sorrow like unto My sorrow."[37]

The continual use of active verbs in the present tense—"we look," "we see," "we can," "we hear"—highlighted the beholder's dynamic role in looking at art objects. Far from simply seeing Christ hanging on the Cross, the viewer set the historical scene, entered it, and related it to the present. He brought his knowledge of scripture and secondary textual criticism, as well as his own experience, to the image, which enabled him to actually hear Christ speak and feel his pain. This conception of art was not about passive edification. Rather, it emphasized dynamic encounters that required intellectual and emotional engagement and resulted in historical and spiritual knowledge. Art brought the past into the present, translated the historical into the contemporary.

Eakins's realist style further coincided with the Catholic clergy's desire for the immediacy of experience. By presenting the human, suffering body of Christ and forcing the viewer to confront the physical reality of his death, Eakins joined the clergy in insisting on the role of embodied engagement in the acquisition of knowledge. Catholic apologists believed that Protestants' aversion to imagery "led to the belief that men could not be moved to worship God through the medium of the eye, but only through the medium of the ear." However, "this conception of worship is founded on the false notion that there is no language but that of the tongue. . . . We may learn as much through the eye as through the ear; we may be moved as much by what we see as by what we hear. . . . We can express as much by a sign as by a word."[38] The Catholic reliance on visual imagery acknowledged the power of the phenomenal world and refused to subsume or repress it in abstract principles and rational, written abstractions. To reduce knowledge to the word rather than the Word, and the aural rather than the visual and sensory, neglected the physical and material realities of human life.

Eakins's attention to the viewer's physical space in front of his paintings underscores his intention of activating the spectator before his images. In his lectures on perspective, he encouraged students to create works that acknowledged the beholder's position in front of the canvas. His extensive studies and extant preparatory drawings show that Eakins relied on a complicated perspectival system that created a fixed relationship between the artist, the picture, and the objects depicted. This system was conceived in relation to the beholder's place before the picture. Eakins noted that "a picture once drawn, can be correctly looked at from but one point, where the spectator should have a care to place himself."[39] An illustration Eakins drew for a drawing manual in the early 1880s pictured the *Law of Perspective* (fig. 4). The beholder's point of sight determined what the picture plane could reasonably contain to produce a convincing image. Eakins's cognizance of the beholder's bodily presence in front of his paintings stressed his interest in the ways in which embodied vision creates meaning in works of art.

Painting as Logos

Eakins's decision not to picture ominous skies and storm clouds in *The Crucifixion* indicates that Renan was not his only textual source. The French scholar drew on the

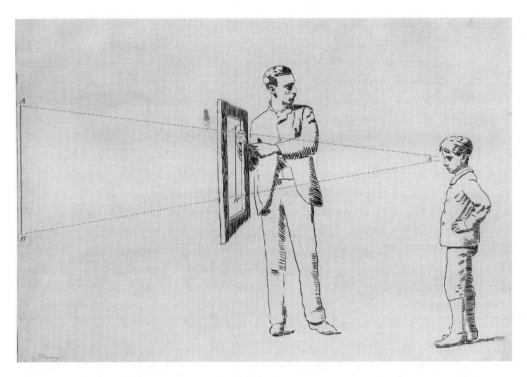

Figure 4. Thomas Eakins, *Drawing I [The Law of Perspective]*, ca. 1884. Pen and ink over graphite on cream wove paper, 39.5 × 56.5 cm. Courtesy of the Pennsylvania Academy of the Fine Arts, Philadelphia. Charles Bregler's Thomas Eakins Collection. Purchased with the partial support of the Pew Memorial Trust and the John S. Phillips Fund.

Gospels of Matthew, Mark, and Luke for meteorological information, writing that the skies darkened during Jesus's crucifixion and death. Eakins's painting, in contrast, presents Christ's body against a brilliant blue background (later reworked into an intense gray), indicating his reliance on John's Gospel.[40] John opened his account with a declaration of the Incarnation: "In the beginning was the Word, and the Word was with God, and the Word was God. . . . And the Word became flesh and lived among us, and we have seen his glory, the glory as of a father's only son." The "Word," or Logos in Greek, is more than text—it is speech, reason, discourse, creation. By calling on John's Gospel, Eakins represented Christ as Logos, the "Word made Flesh," and indicated his faith in art's capacity to fuse the historically specific and the universal.

Eakins may have used John's Gospel because his faith in direct observation as a means to truth corresponded with the common assumption that John was one of Christ's apostles. Many scholars stressed the Gospel writer's empirical reliability because he was in a position to observe, firsthand, the character and teachings of Jesus. Others questioned whether the apostle authored the book, but nonetheless cited the Incarnation as evidence for Christianity's rational foundation and considered it a metaphor for history.[41] Eakins may have been familiar with the Gospel, too, because of its central role in Quaker theology. His mother was raised in a strict Quaker family, his father taught

in a Quaker school, and many family friends were members of Quaker congregations in Philadelphia. The opening passages of John were particularly important to the faith community's doctrine of the Inner Light, which asserted that people attained salvation when they followed the divine light within themselves.[42]

Most likely, however, Eakins's turned to John's Gospel because the relationship between the Word and human speech, thought, and action developed by John the Evangelist permeated nineteenth-century linguistic theory. Ten years before Eakins painted *The Crucifixion*, he told his sister Fanny that men and scholars had corrupted the simple principles of grammar and Christianity: "All things spring from such a fact as simple as the religion of Jesus Christ and see what men and grammarians have done for them both."[43] Eakins's comparison of theologians and grammarians is not surprising given his interest in the work of Friedrich Max Müller, a German-born philologist who spent most of his career at Oxford studying the historical origins and growth of human languages and religions. Müller's study of religion grew directly out of his study of language. He stressed that Christian missionaries provided linguistics with its material evidence: "The pioneers of our science were those very apostles who were commanded 'to go into all the world, and preach the gospel to every creature' and their true successors, the missionaries of the whole Christian Church."[44] Müller was not alone in this assessment. In a book that translated a single Bible verse into 267 languages, the author asserted that "the study of language has been advanced to an extraordinary degree by the impetus given by Religion to the translation of one book."[45]

Correspondence with his sister, Frances, makes it clear that Eakins's sense of how words generate meaning was shaped by a lecture series delivered by Müller on the science of language in 1861. In it, Müller concluded that a "word is the thought incarnate."[46] His use of the term "incarnate" built the assertion that a word's meaning hinged on external realities, on the one hand, and human conceptions, on the other.[47] *The Crucifixion* visualized Müller's notion of a word as both materially and culturally determined. Eakins's clinical and "cold-blooded" depiction of Christ's body accented his physical being and involvement in the material world. At the same time, his reliance on traditional depictions of the crucifixion in Western art history situated Christ in a realm of human interpretation that transcended his historical specificity.

Like *The Gross Clinic* and *William Rush*, *The Crucifixion* represents Eakins's reflections on the capabilities of art and its social functions. More specifically, it presents the artist's understanding of art as Logos. *The Crucifixion* pictures a moment that evades simple dichotomies of flesh and spirit, word and image. It demands a mode of looking that relies on an embodied viewer who conceives of signs as related to an historical entity as well as varied textual and visual traditions. Eakins depicts Christ at the moment of his human death and cultural resurrection in the form of theological writing, artworks, and ritual enactments.

Art as Translation

Eakins integrated his conception of painting as incarnation and trust in homosocial communities in a series of clerical portraits produced in the first decade of the twentieth century. Beginning in the 1890s, Eakins and Murray biked from the painter's home in downtown Philadelphia to St. Charles Borromeo Seminary at Overbrook. The two artists spent Sundays there, staying for dinner and attending vespers (Eakins enjoyed listening to the Latin chants of the seminary choir).[48] As in his portraits of musicians, scientists, and surgeons, Eakins asked the prelates to sit for him, often to celebrate the sitter's recent promotion or honor. He traveled long distances to obtain the necessary sittings when needed (from Philadelphia to Washington, D.C., and Cincinnati), and presented the finished portraits to the subject, his family members, or the appropriate church communities.[49] Eakins's portrait of the Right Reverend Hugh T. Henry, *The Translator* (1902), highlights the manifold reasons the artist affiliated himself with Philadelphia's Roman Catholic community (plate 2). In addition to sharing a firm belief in art as incarnation, the artist and his priestly cohort acknowledged the power of signs to communicate and miscommunicate with readers and viewers and sought to control their circulation through hierarchical forms of social organization.

Far from simply parish priests, Eakins's portrait subjects were archbishops, provincials, delegates to the Vatican, eminent scholars, and founders of Catholic institutions such as convents, hospitals, parish schools, and publishing companies. Their intense intellectual activity in the areas of theology, history, and literature marked the years between 1875 and 1925 as the "Golden Age of Philadelphia Catholicism."[50] These same scholars pioneered the Catholic Church's growth in Philadelphia. Their strong leadership and professional acumen in financial, commercial, and educational affairs increased the number of priests from 200 to 400, churches, from 130 to 244,[51] and parish schools, from 58 to 103.[52] Eakins's clerical portraits honored members of Philadelphia's intellectual and cultural elite, who worked to integrate a primarily immigrant, working-class population into American life. They pointed to his inclusion, too, in a cosmopolitan, scholarly community that valued the fine art tradition and deemed art a crucial tool for education, socialization, and spiritual engagement.[53] In 1920, the Reverend Herman Heuser responded to a letter from Murray and commented: "I have your kind note and am glad to be remembered by you as it recalls pleasant associations of the days of Mr. Eakins and the [zeal] for art to which [we were] jointly rooted."[54]

Henry was a prominent member of the Philadelphia religious community. After his ordination in 1889, Henry was professor of Latin, English, and church music at Overbrook. While continuing his duties there, he served as rector of the Roman Catholic High School for Boys (1902–19), as president of the American Catholic Historical Society for two terms, and as editor of the journal *Church Music* (1905–09). He authored a number of books, wrote poetry and hymns, and contributed to Catholic periodicals, publishing over four hundred articles on historical, literary, and hymnological subjects.

Henry also was a spiritual advisor to solidarities, gave lectures at the Catholic summer school, performed vespers, and directed the seminary choir (among a host of other activities). Of all Henry's activities and accomplishments, however, Eakins chose to depict him as a translator of the pope's writing, dressing him in his doctor of literature robes to stress his linguistic work rather than his clerical functions.

In *The Translator*, Eakins represents Henry rendering the *Poems, Charades, Inscriptions* of Pope Leo XIII, published the year this portrait was painted. Henry sits behind a wooden desk, one hand resting on a sheet of paper, the other holding an ink pen. He looks up and to the side, caught in a moment of reflection, bracing his pen as if ready to write (despite the pen's distance from the paper). His desk is neatly organized, with the pope's original text lying open before him. He is surrounded by the tools of his trade: paper, pen, and ink sit on the wooden desk, the work of other scholars rests on the bookshelf behind him, and the spirit of the original writer fills the space. A well-known picture of Leo XIII appears above Henry, hovering over his shoulder and guiding Henry's translation of his work.

In his introduction to the pope's writings, Henry argued that the purpose of translation was to maintain, as closely as possible, the reflection of author and word: "Interesting as all these [writings] are because of the sublime dignity of the Author, they become, if possible, more valuable as mirroring the genial, cultured, affectionate, devout soul of the man and the priest"; they reveal "in his own words the inner heart of the great pontiff."[55] Erasing himself as mediator, Henry placed his notes on the pope's verses at the end of the text, in an appendix (although an explanatory note occasionally appears in the body of the work). Similarly, Eakins portrayed Henry as a "pane of glass"—one of many optical metaphors the priest employed in his own work—since the pope gazes directly at the beholder. The pontiff's dominant presence signifies Henry's successful translation of his words, transporting the author—the historic person—into the immediate present.

At the same time, however, Eakins acknowledged Henry's mediating role, since the cleric's left shoulder juts into the pope's space. Although the cleric attempted to remove himself as much as possible from the *Poems, Charades, Inscriptions*, Eakins emphasized his place between the pope and the viewer. In doing so, he stressed that translation is not a simple matter of transcription, the truth descending from the writer to the translator to the reader. Rather, the translator intercedes on the author's behalf, enabling a direct connection between author and reader.

The Meaning of Signs

The dominance of Leo XIII in *The Translator* indicates Henry's successful rendition of his poems; indeed, the pope's presence is nearly as prominent as that of the young priest. To emphasize the complexity of the process, Eakins etched a Latin inscription into Henry's desk: "Thomas Eakins painted in 1902 in person Hugh Thomas Henry, who accommodated to English ears the melodious voice of the Swan of the Vatican, Leo XIII." The artist drew attention to the trustworthiness of the portrayal by informing

the viewer that he painted the sitter from life, suggesting a direct relationship between the real and represented Henry. He implied, too, that a word has both an aural and visual referent since Henry translated the Pope's poetry into sound and text. By suggesting that signs have a physical relationship to what they represent and rely on an educated community to attain meaning, Eakins intimated that one of the translator's key tasks was to direct and delimit interpretation.

Eakins established a theory of signs during his student days in Paris that integrated Müller's history of language and his early training in writing and drawing. In the late 1860s, the young artist argued that the basis of language originated in motion, since it emerged when humankind bestowed an object with a name that corresponded to its form or habits. Sign language exemplified this, according to Eakins, because the deaf signified an object by moving their hands in a way that corresponded to its characteristic appearance or behaviors.[56] Eakins's belief in language as a sign system was highlighted in another letter to his sister in which he extended her "thin series" (a series of derivations from the word *thin*) to Armenian, Arabic, Chinese, Egyptian, Hebrew, and Roman.[57] He argued, further, that the life of a language was contingent on its daily usage. Eakins lamented that scholars still had not established the pronunciation of Old French, and as a result, it would not become the universal language despite its superiority to "modern" ones.[58] For the young artist, language was premised on shapes and diacritical marks whose meanings and utterances were predicated on the object's form and known and accepted by a community of readers and speakers.

Eakins's understanding of words and signs as equal manifestations of the same idea coincided with the underlying premises of father's occupation and his own early training. As a writing master, Benjamin Eakins taught penmanship and engrossed documents in an ornamental hand. The written word functioned as an artistic sign, resulting in the coexistence of two distinct fields of representation. Eakins's understanding of the interrelationship between writing and drawing was strengthened during his education at Central High School. He used Rembrandt Peale's *Graphics*, a manual of writing and drawing that asserted the two were interrelated notation systems.[59] Peale wrote that writing and drawing were one and the same; writing was "drawing the form of letters" while drawing was "writing the forms of objects."[60] By linking visual perception, motor skills, intellectual thought, and moral judgment, Peale laid the foundation for Eakins's understanding of motion as the basis for all kinds of human communication.

While the young artist linked a word to its form, positing an actual connection between the two, he stressed its power to integrate author and reader as well: "A poem may give you, by communicating a man's feelings, his judgments and experience of years and you become a part of him."[61] The standards for a portrait, or visual translation, were contingent also on disciplined observation of the sitter and knowledge of his character. Eakins greatly admired his French art mentor Jean-Léon Gérôme's representation of Dante because it embodied the poet's external appearance—his physiognomy "[told] his story"—and his written work—"I don't know anything [besides Gérôme's portrait]

that looked as if he might be the writer of the *Comedy*."[62] According to the young artist, a portrait captured the subject's external appearance, inner character, and scholarly production. Moreover, it incarnated the sitter. It captured the "living, thinking, active" person and restaged him in an eternal present.[63]

Eakins's understanding of the sign included a paradox; while he believed a sign referred to its material reality, he recognized, too, that it acquired and maintained meaning through its use by an interpretive group. In this way, he belonged to a larger intellectual community that included the nineteenth-century American philosopher Charles Sanders Peirce.[64] Although there is no indication the two men knew one another, there are important parallels in their biographies. Both shared a similar contempt for Victorian morality and social custom that resulted in a certain degree of notoriety among their peers. Both were interested in great men, Peirce teaching a course on the psychology of great thinkers and comparative biography and Eakins painting Philadelphia's artistic, athletic, and intellectual leaders. Finally, both men relied on Logos and its formulation by John the Evangelist to explain the power of signs to represent the real.[65] Peirce defines a sign as an object that stands for something else. It includes a material quality, a physical connection to what it represents, and an appeal to the mind of the interpreter. Moreover, it demands a "community of inquirers." Consequently, representation, interpretation, or meaning consists of the object, the subject's physical relationship to the object, and the subject's interpretation of the object, which is commonly shared by an interpretive group.[66]

Eakins's belief in the fixed and culturally contingent nature of signs appeared in his clerical portraits—and in his late portraits in general—through his dual attention to securing the sitter's likeness and communicating his cultural import through long-standing portrait conventions. For example, in *Archbishop William Henry Elder* (1903), the artist depicts the prelate in a simple armchair, set in a bare room decorated only with a hanging bookcase in the upper left corner (fig. 5).[67] Eakins used Velázquez's portrait of *Innocent X* as a precedent for *Archbishop Elder* (fig. 6). The two men's postures, arm placements, and hand gestures almost mirror one another.[68] However, in the Spaniard's papal portrait, Innocent's hard gaze penetrates the viewer while his brilliant costume and ornamental chair enhance his imposing and monumental presence. Eakins, in contrast, rotated Elder's body, represented him looking down and away from the beholder, and included a single light source that highlighted Elder's face and cast a long shadow behind him, presaging the prelate's death. Instead of presenting an image of divinely sanctioned power, Eakins represented the complex intermingling of human morality and vitality, physical frailty and personal tenacity, public presentation and self-reflection.

Contemporary reviewers praised the portrait for its realism. Although Eakins was denounced for the "brutality" of *The Gross Clinic* and *The Crucifixion* earlier in his career, turn-of-the-century writers celebrated what prominent art critic Charles H. Caffin described as a "cold, deliberate analysis of a human personality" in his representation of Archbishop Elder.[69] Caffin reiterated his sense of Eakins's almost clinical gaze in *The Story*

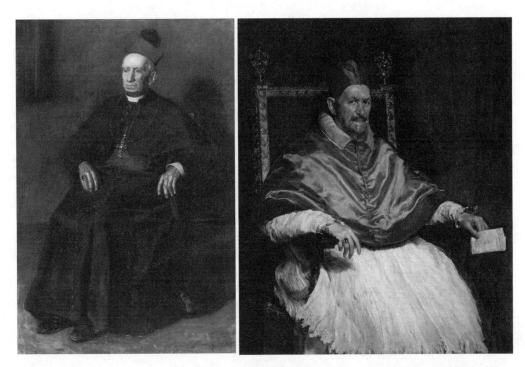

Figure 5 (left): Thomas Eakins, *Portrait of Archbishop William Henry Elder*, 1903. Cincinnati Art Museum. Louise Belmont Family in memory of William F. Halstrick, bequest of Farny R. Wurlitzer, Edward Foote Hinkle Collection and bequest of Frieda Hauck by exchange. Figure 6 (right): Diego Rodríguez Velázquez, *Portrait of Pope Innocent X*, 1650. ADP—licensed by Fratelli Alinari/Art Resource, New York. Galleria Doria Pamphili, Rome, Italy. Photo credit: Alinari/Art Resource, New York.

of American Painting (1907), when he emphasized the objectivity and "impersonal point of view" the artist displayed in his portraits of men.[70] Importantly, while *Archbishop William Henry Elder* is an accurate likeness of the prelate, a comparison of Eakins's painting with a photograph taken the following year shows that the artist exaggerated the prelate's frailty, as he did to so many other sitters (fig. 7). By emphasizing Elder's mortality, Eakins illustrated the physical and psychological toll modern life took on the body.[71]

Eakins portrayed Elder's mortality in a conventional portrait format that solidified the sitter's place within the social hierarchy.[72] To underscore the prelate's commitment to the Church in general and to his congregation in particular, the artist included two episcopal ornaments in the picture: Elder's ring and pectoral cross. The ring, worn on the fourth finger of the right hand, was conferred during the rite of consecration and represented the bishop's betrothal to the Catholic Church.[73] The pectoral cross, hung around his neck at Mass and solemn functions as well as part of everyday attire, served as a symbol of jurisdiction. When a bishop entered another diocese, he concealed it.[74] In addition to communicating Elder's status in the Roman Catholic hierarchy, Eakins employed Church symbols to emphasize particular elements of the cleric's personality. By picturing Elder in a simple, unadorned room, for example, he underscored the

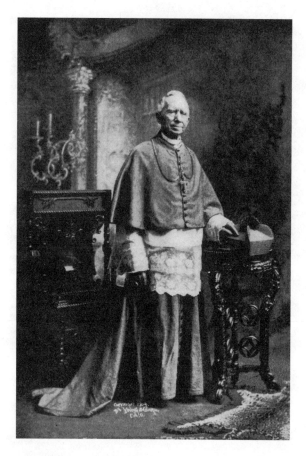

Figure 7. Young and Carl, *William Henry Elder*, 1904. Reprinted in *Character-Glimpses of Most Reverend William Henry Elder, D.D.* (Cincinnati: Frederick Pustet and Co., 1911), frontispiece.

archbishop's well-known poverty and distaste for formal ceremony. When Elder first arrived in Cincinnati, he rejected an expensive bedroom set made of marble. Later, he turned down an offer to assume the "palatial residence" of a wealthy citizen to serve as the archiepiscopal residence.[75] Moreover, by representing Elder donning a red biretta, Eakins pictures him performing an act of ecclesiastical jurisdiction and presiding over the affairs of his archdiocese.[76] When not traveling, Elder was known to spend his afternoons meeting with "all classes of callers, some on business, some seeking spiritual advice, the sick at heart and the weary" in a room "furnished without attempt at ornamentation."[77]

By creating a recognizable likeness of the aged prelate and filtering it through the fine art tradition, Eakins presented a man whose humility, business savvy, and sanctity made him a respected member of the Cincinnati community. An editorial in the secular *Kentucky Post* published after the archbishop's death read:

> It isn't every day a man dies of whom you can say: "Copy him." But they are laying away all that is mortal of such a man to-day, and no tomb can hide his virtues or make the world forget his kindly simplicity.

> Archbishop William Henry Elder had high ideals, and lived close to
> them. He was unaffected, kind, and true. He was admired for his fine
> character in his Church, and out of it, for *true manhood is wider than the
> boundaries of any creed.*[78]

To repeat the words of the editorial, Eakins's portrait portrayed an example of "true
manhood" that others should "copy." It did so by encouraging two forms of behold-
ing simultaneously. The viewer responded to the subject as a "living, thinking, active"
person due to Eakins's realist style and decoded the picture's iconographic program
to determine the sitter's status, activity, and character. The artist depicted Elder as a
historical figure and as a model to emulate.

Eakins's dual commitment to realism and tradition bore a close relationship to the
Catholic conception of symbol, the interpretation of which required the reader or
beholder to call on a host of sources to effect meaning, including the biblical text,
liturgical rituals, art objects, papal encyclicals, historical events, and devotional tradi-
tions. Henry summarized the Church's teaching on symbols in his 1925 book, *Catholic
Customs and Symbols: Varied Forms and Figures of Catholic Usage, Ceremony, and Prac-
tice Briefly Explained.* He rejected any "materialistic, wholly prosy, quasi-scientific or
pseudo-scientific" explanation for the origins of symbols, underscoring instead their poetic,
devotional, utilitarian, and instructive purposes. He believed that symbolism led hu-
mankind "far beyond the bourn of time and space" and provided a "visible parable to
increase Beauty."[79] Henry sponsored such interpretative freedom despite the Catholic
community's experience of persecution, which maintained its power in part because
assumptions and stereotypes blocked access to truth. In his presidential report to the
American Catholic Historical Society, for example, Henry asserted:

> Catholics have left the writing of their history to those who, even when
> they tried to be fair minded, saw us through the glass of their life-long
> prejudices, and therefore saw us darkly. We have given vent periodically
> to strictures, satire, retorts courteous and discourteous, and we have
> looked on the caricature gravely put forth by historians, and conscien-
> tiously regarded by our fellow-citizens, as our true portrait.[80]

Although scholars were supposed to look directly through a pane of glass to the his-
torical event, prejudice refracted the "light of truth" and caused misinterpretations of
the past. Henry employed the term "refraction" to describe this process in another es-
say, noting that "the ray of truth is apt to suffer refraction when it leaves one medium
and enters another."[81]

Henry and his Catholic counterparts valued the educational and devotional
function of the sign, which was raised to the status of symbol through the human
encounter. Recognizing that appearances, prejudices, and assumptions shaped cul-
tural norms, they worked to guide the viewer's interpretation of texts and images.

Although the Catholic community sought to delimit the sign's meaning in a number of ways—including writing its own history and defending itself against the public's misinterpretation of Catholicism—Eakins called attention to its reliance on a hierarchical model of organizations.[82]

True Brotherhood

The Translator testifies to the artist's reliance on intergenerational all-male communities to limit interpretive possibilities. Eakins included two significant objects in the background of the painting: a portrait of Pope Leo XIII and a bookcase. Following the medieval iconography of St. Jerome, whose biblical translations were inspired by God whispering in his ear, Eakins depicted the pope as Henry's primary inspiration. The Pontiff passed along knowledge and wisdom to the cleric. By emphasizing male mentors and the acquisition of knowledge in his interrogation of translation, Eakins emphasized the generational transmission of knowledge from "father" to "son."[83]

In 1867, the young Eakins told his sister that all knowledge could be traced through a male lineage, even that of a word's origin or meaning: "Languages are all the same in roots and always will be. . . . and the relation between any two words can be traced through its *father or brothers or uncles or cousins* indeed in a hundred ways."[84] Eakins's early faith in masculine succession intersected with his deep respect for his own father and his lifelong reliance on male mentors. He had close relationships with his father and his father's friends, many of whom continued to support him and serve as models in single paintings like *The Chess Players* (1876). In his portrait of George Morris (1901), a hunting and boating companion of Eakins and his father, the artist included a Latin inscription: "The son of Benjamin Eakins painted this effigy of paternal love for his dearest friend."[85] Created a year after Benjamin Eakins's death, Eakins names himself through his father and paints the picture with "paternal love."

Eakins not only benefited from male mentors but played that role for his students. Just as he admired the "big paintings" of "big men" like Gérôme while in Paris, his students referred to him as the "Boss" or "dear Master."[86] When forced to resign from the Pennsylvania Academy, many of his students followed and formed the Art Students' League. It was through the League that Eakins first met Murray, the eleventh of twelve children born to Irish-Catholic immigrant parents, in November 1886.[87] The two artists became fast friends. They shared a studio throughout the 1890s, exhibited together, and worked on common subject matter. In fact, at least thirty-six people sat for both Eakins and Murray.[88] The two men remained tied personally and professionally until Eakins died in 1916.[89] That same year, their friendship was celebrated by the *Philadelphia Press Magazine* in an article entitled "True Romance Revealed in Unique Bonds of Three Gifted Artists." Featuring the friendships of Eakins, Murray, and H. Humphrey Moore, a friend of Eakins from his student days in Paris, the article, in its relative inattention to the

men's artistic accomplishments, underlined the greater value it placed on their creation of a "shrine" to true "human brotherhood."[90]

Eakins worked with Murray on a sculptural series featuring the biblical prophets for the Presbyterian Board of Publication and Sabbath School Work (PCUSA) that enshrined the artists' own intergenerational community.[91] Located in Philadelphia and named for John Witherspoon—the sixth president of Princeton University and the only clergyman to sign the Declaration of Independence—the building was intended to celebrate the denomination's integral role in America's ideological and national development. Murray and Eakins created ten terra-cotta sculptures that decorated the three public sides of the building on the eighth floor. William Henry Green, chair of Biblical and Oriental Literature at Princeton Theological Seminary, selected the prophets and provided Eakins and Murray with written descriptions of the figures as well as with writings on them. The two artists turned to contemporary men and women who they believed exemplified the biblical type in appearance and character to model for them. More specifically, they selected people within their social circle they had painted or sculpted previously. For example, they selected Walt Whitman to represent Moses; Eakins's father-in-law, William H. Macdowell, to represent Jeremiah; and George W. Holmes, a teacher, landscape artist, and close friend of Eakins's father who later went blind, to stand in for Isaiah.[92] By selecting men who functioned as role models in their lives and work, Eakins and Murray followed Green's description of the biblical prophets as "a distinct order of men, universally recognized as such, the im- mediate messengers of God to the people to declare his will and purposes to them for their guidance, instruction, and admonition."[93] For Eakins and Murray, male mentors were "prophets," messengers, and translators of knowledge.

Eakins and Murray highlighted the prophetic role of male mentors in a poem entitled "Brotherhood," presumably written by them in the painter's later years after his eyesight failed. In the poem, a narrator describes his routine encounter with "two strong and stalwart men" who walk "arm in arm" on their daily stroll (the narrator likens this physi- cal linkage, incidentally, to their "kindred mind"). As Murray, "the favored one," guides Eakins down the street, he "shar[es] his gift of sight," "paint[ing]" the scene for Eakins, for "whom the world is dark." Although blindness is reiterated three times in the short poem, and ends two of the three stanzas, "brotherhood" eclipses blindness as the poem's emphasis:

> Their heads are gray, and they have walked
> This way for years and years,
> Linked arm and arm; and strangers oft
> Have gazed on them with tears;
> And they have shown throughout their lives,
> As sometimes mortals can,
> The meaning of true brotherhood,
> The angelic side of man.[94]

In the poem, Eakins and Murray suggested that men attain transcendence through friendship, particularly through their position as translators: Murray viewed the world, explicated what he saw, and Eakins used that verbal description to conjure a mental image of the scene in his mind. Their choice of the word "angelic" furthered this signification. Although "angel" denoted a spiritual being superior to humans in intellect and wisdom, it also referred to an attendant guardian or spirit, messenger, or harbinger. Brotherhood, in other words, involved mediation, guardianship, and protection.

The sentimental magazine article and poem reiterate the important role brotherhood played in the artist's life and work, particularly after 1880. In 1879, Eakins was appointed professor of drawing and painting at the Pennsylvania Academy of the Fine Arts and, in 1882, as director of schools. After he removed the loincloth from a male model while lecturing to a class of women in 1886, he was dismissed officially for pedagogical differences. The incident set off private feuds as well, and accusations of sexual impropriety and dishonorable professional practices spread rapidly.[95] Eakins responded to these allegations by retreating to intergenerational and principally same-sex communities that provided him with admiration and support. He worked with Eadweard Muybridge on his photographic studies of "animal locomotion" at the University of Pennsylvania; created an archive of photographic figure studies with his students, family, and friends; and embarked on public sculptures with Murray and New York-based artist William O'Donovan.[96] Eakins solidified his standing within these communities by painting portraits of his colleagues. The clerical series was part of the artist's reformulation of his personal and professional life in the 1880s and 1890s and modeled Eakins's belief in hierarchical social organization as being necessary for the transmission of knowledge.

Eakins's portrait of *Father John J. Fedigan* (1902), for example, stressed respect for one's superiors (fig. 8).[97] Almost seven feet high and four feet wide, Eakins's picture accentuates the figure's tall stature and esteemed position in the Augustinian order. Fedigan's diplomatic skills led the religious order—presided over by another of Eakins's sitters, the Apostolic Delegate and Prior General Sebastian Martinelli—to elect him provincial in 1898.[98] As provincial, he supervised the local superiors, called for and presided over chapter meetings, and oversaw the administrative and financial affairs of the province. Since Villanova College was affiliated with and run by the province, Fedigan was also responsible for its affairs.

Eakins pictured Fedigan with a hyperrealistic depiction of the Augustinian monastery on the Villanova College grounds, a building project that led some of Fedigan's subordinates to undermine his authority. Fedigan sought to construct a new monastery and college building that would cost over $250,000 to stabilize enrollment, improve academic programs, and make the college more competitive. He faced opposition from the board of trustees, which encouraged the provincial secretary (who supposedly worked under Fedigan) to appeal Fedigan's actions directly to the Augustinian prior-general in Rome

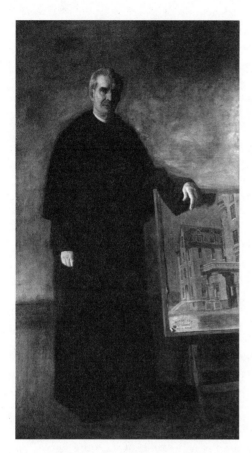

Figure 8. Thomas Eakins, *Portrait of Very Rev. John J. Fedigan,* O.S.A. 1902. Oil on canvas 89 × 50 in. On loan to Villanova University from the Province of St. Thomas of Villanova, Villanova, Penn.

and to send letters to the local priors informing them of his directive and demanding obedience. Despite his zealous efforts, the secretary lost his campaign against "Fedigan's Folly" and construction resumed. Yet, the undermining of his plan and authority by his subordinates took a huge toll on Fedigan personally and on the project financially. Although the building project is remembered as a vital reason for the college's survival and Fedigan is considered a "man of courage and vision who contributed greatly to the advancement of the university and the archdiocese of Philadelphia," the bitter opposition Fedigan faced during these years led him to reject another term as provincial.[99]

The biographical similarities of Eakins and Fedigan indicate there may have been a particular sympathy between them, with both perceiving themselves as having been unfairly subjected to injustice by institutions and family members while working to attain the highest standards. Fedigan's keen sense of persecution emerged when he wrote in the provincial records:

> Although, as we know the prophets are dead, still I am convinced that I was a true prophet . . . [when I told you . . . that the provincial was but a target for the shafts of criticism, humor, and wit of those opposed

> to the administration] since that prediction has been proved by facts since then; and while no pen, or tongue of mortal shall ever tell the full story of what I have suffered from that till this day there is one who shall never forget it. What can equal the pangs inflicted by the hands of friends—brethren, not merely, brethren by the higher, holier tie of solemn profession in Holy Religion![100]

Fedigan felt betrayed by his family—a family joined in full cognizance of the humility necessary for the smooth operation of monastic life. His angry tone echoed that of Eakins in the letters he wrote during his forced resignation from the Pennsylvania Academy of Fine Arts. When Eakins reflected on the event a few months later, he wrote: "I myself see many things clearer now than I did when in my first surprise I was stabbed from I knew not where and half remembered or perverted. It was a petty conspiracy in which there was more folly than malice, weak ambitions, and foolish hopes, and the actors in it are I think already coming to a sense of their shame. My conscience is clear, and my suffering is past."[101] Eakins's interpretation of the scandals can be summed up in his 1894 autobiographical statement: "My honors are misunderstanding, persecution, and neglect, enhanced because unsought."[102]

Eakins's portrait of Fedigan commemorated his strong adherence to the concept of brotherhood and respect for those in authority. Whereas the artist eventually retreated from public life, Fedigan triumphed over adversity and oversaw the completion of the monastery and college in 1902. Eakins highlighted the cleric's role in the building of the Augustinian monastery in particular by including its image in the portrait, rather than the contemporaneous addition to the college. By picturing Fedigan with the sign of his accomplishment, and positioning his hand in a way that allows him to literally "point" to it, Eakins signaled Fedigan's triumph over intraprovincial opposition. Indeed, Eakins painted his portrait in 1902, after Fedigan's resignation. His decision to etch his name into the drawing board inscribed this association between Fedigan's Folly and Eakins's art.

Art as Presence

While Eakins venerated brotherhood and respect for authority in *Father John J. Fedigan*, he pointed to their transcendence in *The Translator*. The portrait of Henry reformulates the Trinity: Pope Leo XIII stands in for God the Father, Henry for Christ, his Son, and the bookshelf for the Holy Spirit.[103] By representing the translator as the "Word made Flesh," Eakins reiterated the link he made between art and Logos in *The Crucifixion*. Just as Henry incarnated the pope in his rendition of *Poems, Charades, Inscriptions*, Eakins incarnated the translator in the portrait. Importantly, Eakins avoided any reliance on the supernatural by replacing the Holy Spirit with scholarly production, the result of human intellect and accomplishment, in the form of books. In this way, Eakins insisted that translation did not require divine intervention, but rather the transmission of

skills and knowledge through personal interaction and paternal devotion. Resurrection occurred through emulation and learning and was secured through history and tradition. Portraiture translated the sitter into a continuous present that maintained his real presence in the eyes, minds, and lives of generations of viewers.

Eakins visualized art's ability to maintain the presence of the past in the portrait of *Monsignor James P. Turner* of 1906 (fig. 9). Eakins pictured Turner in the Cathedral of Saints Peter and Paul in Philadelphia, the official church of the archdiocese. Turner stands in front of a gate leading to the Lady Chapel, a secondary altar dedicated to Mary at the right or Gospel side of the main altar. The gate's ornate decoration framed a cartouche enclosing the letter *M*, figuratively linking Mary and the monsignor. Both served as intermediaries between Christ and the faithful, and were dedicated to the poor and oppressed.[104] Even more to the point, by including a picture of Mary within a picture of Turner and establishing a frame with a frame, Eakins displayed an infinite regression of human influence. Despite the gulf of time that divided the two figures, Mary maintained a constant presence in Turner's life and served as a model for engaging the world around him.

Eakins's decision to include a representation of Mary's Assumption—her corporeal assumption into heaven—in the left-hand corner of the image was tied to its theological meaning. According to Roman Catholic tradition, Mary died in the presence of Christ's apostles. When they returned to the tomb and found it empty, they determined her body had been assumed into heaven. Her corporeal ascension, then, stressed her humanity and her divinity. Just as God assumed Mary's body and soul into heaven, so Eakins assumed Turner into his gallery of modern exemplars. Indeed, Eakins relied on the Assumption to posit the inexorable relationship between immanence and transcendence. His manipulation of interior space allowed Mary to engage the material and spiritual realms. Her left hand reaches for Turner's head, anointing him and blessing his earthly work. At the same time, her arms open to invite him to heaven and eternal salvation. Turner also straddles the two spheres: the realm of Old World ecclesiastical hierarchy, represented by the elaborate railing and the traditional painting of Mary, and the realm of the rationally observed and scientifically rendered, shown in the strict geometric grid of the tile floor. Eakins placed Turner in the phenomenal world, the world in which the prelate labored, *and* provided him with the means to eternal life.

Eakins conceived of art and portraiture as a way to maintain human influence in the lives of beholders. In this way, he qualified Peirce's understanding of the sign. The philosopher wrote that "every thought-sign is translated or interpreted in a subsequent one, unless it be that all thought comes to an abrupt and final end in death." Eakins asserted, however, that art enabled the sign to continue signifying after death. The beholder made the historical figure present through the act of viewing. Portraits of individual excellence instilled in viewers the characteristics and values Eakins deemed necessary for contemporary life.

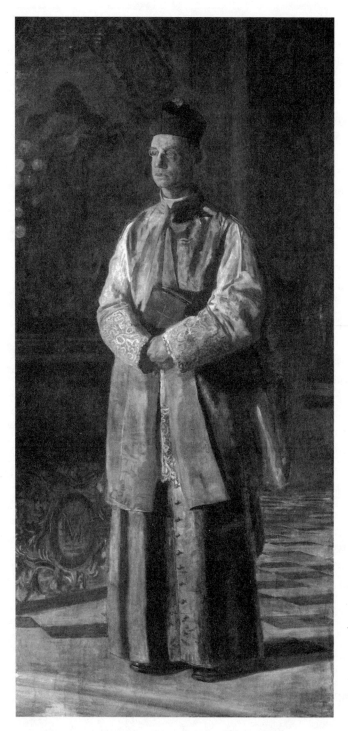

Figure 9. Thomas Eakins, *Monsignor James P. Turner*, ca. 1906. Oil on canvas, 88 1/8 × 41 7/8 in. (223.84 × 106.36 cm). Nelson–Atkins Museum of Art, Kansas City, Missouri. Gift of the Enid and Crosby Kemper Foundation, F83–41. Photograph by Jamison Miller.

Eakins's conception of painting as Logos proved enduring. Just as *The Crucifixion* resurrected the historical Christ through the art-historical tradition and the beholder's engagement with it, so *The Translator* incarnated Henry and presented the universal values he embodied to generations of viewers. The artist was not alone in his reliance on Logos and its formulation by John the Evangelist to make sense of translation. Peirce, too, turned to the Incarnation to explicate his "science of representation." He used the Trinity to elucidate the tripartite nature of the sign: God stood in for the object, the Holy Spirit, the sign, and Logos, the interpretant.[105] Logos united the sign and its object and gave it meaning. Eakins undoubtedly agreed with Peirce. His portrait of Henry as Logos stressed the translator's, and by extension the artist's, responsibility to integrate the sign (the pope's "melodious voice," Henry's character) with its object (the pope's written words, Henry's physiognomy) in his artistic production (*Poems, Charades, Inscriptions, The Translator*).

Eakins's particular understanding of Logos—specifically his emphasis on the real and the beholder's interpretive role—emerges clearly when compared with a later philosopher's far more mystical formulation of it. In 1923, Walter Benjamin wrote that a good translation is more than the equation of two languages or the literal rendering of syntax. It "consists in finding that intended effect upon the language into which he is translating which produces in it the echo of the original." He illustrates his point by applying the opening words of the Gospel according to John—"In the beginning was the Word"—to all translations, since all should seek pure language, or the living, creative Word. Benjamin ends his essay by claiming that the "interlinear version of the Scriptures" is the "prototype or ideal of all translation," since in it language and revelation are one without the mediation of meaning.[106]

In contrast to Benjamin's religious conception of translation, Eakins stressed the realism of Logos over its idealism. First, he created his paintings in relation to a viewer's physical placement in front of the image. Although Benjamin believed that art posited human's "physical and spiritual existence," he was not concerned with the beholder's response. Second, the artist stressed art's social and educational functions, while the literary critic and philosopher insisted that a work "'tells' very little. . . . Its essential quality is not statement or the imparting of information."[107] Finally, Eakins had less faith in the purity of language than in the intrusion of historical and personal realities into its meanings. He posited the translator's physical intervention in translation and the sign's historicity as its essence and meaning. Art did not subsume the immanent in favor of the transcendent, but emphasized their inexorable relationship to one another.

"A school-master to lead men to Christ"

Henry Ossawa Tanner's Biblical Paintings and Religious Practice

Mr. Tanner's religious pictures start out on a true Southern foundation of heartily expressed emotion. This accounts, however, for but half of their appeal to us. The other half is due to the fact that the emotion is expressed with a Northern exactness.
—ELBERT FRANCIS BALDWIN in the *Outlook* (1900)

Two years after Henry Ossawa Tanner's career as an internationally renowned painter of religious imagery commenced with the success of *The Resurrection of Lazarus* at the Paris Salon, *Outlook* critic Elbert Francis Baldwin expressed a sentiment that appeared throughout Tanner's contemporary reception: his paintings embodied emotion and exactness, attention to detail and a sense of suggestion, and an "all-embracing sense of the realistic, yet apparently ever in the service of the idea."[1] One way to understand Baldwin's distinction between "Northern exactness" and "Southern emotionalism" is through the lens of turn-of-the-century race prejudice, which assumed a homogenous African American mass and distilled its essence from popular conceptions of planta- tion slave life. Nineteenth-century genre paintings, song sheets, lithographs, minstrel shows, and trade cards propagated an essentialized image of black religious experience as emotional, frenzied, and superstitious, as opposed to the intellectual and sedate be- havior that presumably characterized European American churches. Many scholars of Tanner's life and work persuasively argue that the artist's African American heritage prompted his intervention into black stereotypes, both through his thoughtful repre- sentation of African American subjects in such early works as *The Thankful Poor* and his success in the international art world.[2]

Another way to read Baldwin's binary opposition, however, is through Tanner's privileged status in the African American community. Tanner was raised in the African Methodist Episcopal (AME) Church, a highly organized and formal institution established in the North whose hierarchical structure, ritual practice, and theological tenets were adopted from white churches. Considered an elite church by Southern

blacks, the Northern and Southern churches were fused together after Emancipation through the efforts of AME Church missionaries who worked to convert former slaves to Christianity, or more specifically, to their interpretation of Christian faith and practices. Along with their European American counterparts, they deemed Christianity the primary means to individual respectability, a civilized society, and the propagation of American democracy on an international scale. Perhaps inadvertently, then, Baldwin's careful characterization of Tanner's work referenced a diverse African American community, one differentiated by region, class, and conception of culture. Moreover, by citing Tanner's Northern exactness, the critic correctly linked the artist to the African American aristocracy that distinguished itself from the larger black community through its ancestry, complexion, gentility, education, and class.[3] In other words, to fully understand Tanner's religious paintings, we cannot isolate his racial identity from his class status, regional affinity, and denominational affiliation. To do so reinforces the notion of an African American essence and ignores the more multifaceted understanding of personal identity that Tanner and other black leaders struggled to assert at the turn of the century.

In this chapter, I argue that Tanner's association with the AME Church and its elite status among African Americans shaped his "visual exegesis," or the way in which he represented his interpretation of the biblical text.[4] Tanner's biblical paintings posited a relationship between seeing and believing, a theological formulation consistent with Methodism's emphasis on experience as a means to the divine. More specifically, they modeled a form of disciplined piety that Tanner and other African American intellectuals deemed crucial to "civilize" the newly freed slaves and attain racial equality in the United States. Tanner's conviction that art had the potential to inculcate middle-class values and standards of comportment underscores his affiliation with European American Protestant intellectuals and church leaders who turned to religious imagery to nurture the development of personality. Indeed, his stress on an interior religious life, and art's role in cultivating it, coalesced with the broader Protestant emphasis on consumption and modernization.

Henry Ossawa Tanner: A Pittsburgher of Four Generations

The Tanner home was a center of black intellectual life in Philadelphia in the final decades of the nineteenth century.[5] A "Pittsburgher of three generations,"[6] Tanner's father, Benjamin Tucker (B. T.) Tanner, was described in 1887 as "without doubt, one of the brightest, grandest, noblest, men in the ranks of Negro Methodism."[7] He began his career as a minister in Washington, D.C., but exchanged the pulpit for the editorship of the *Christian Recorder*, the church's religious journal and the most influential black newspaper in the United States.[8] After sixteen years of service to the *Recorder*, B. T. Tanner was named editor of the *A.M.E. Church Review*, a new quarterly church magazine later

described by one supporter as "the most successful literary achievement of the race."[9] After the elder Tanner was elected to the bishopric in 1888, he performed his leadership duties while focusing his attention on educating the clergy and producing biblical scholarship that emphasized the African presence in the bible.

Tanner's mother, Sarah, was the daughter of Elizabeth, a slave who bore six children to a freedman who wanted to marry her and five to the slave master who owned the plantation. When the slave master repeatedly increased the price of her freedom, Elizabeth contacted the Underground Railroad and sent her children north to Pennsylvania. On their arrival, the Pennsylvania Abolitionist Society dispersed the children and Sarah was sent to Pittsburgh. Benjamin and Sarah probably met at Avery College—a school founded for African Americans by a white abolitionist—and married soon afterward.

The Tanners' seven children attained high levels of success in their chosen professions. For example, Halle attended medical school, became the first black physician to pass the Alabama medical boards, and served as resident physician of Tuskegee Institute. Sadie became the second black woman in America to earn her doctorate in economics and the first to graduate from the University of Pennsylvania Law School, pass the bar, and practice in the state. Carlton, following in his father's footsteps, attended theological school, accepted a mission assignment in South Africa, and worked as managing editor of the *South African Christian Recorder*. Marrying into the Tanner family were other pioneers at the University of Pennsylvania, including the first African American to receive a doctorate from the institution and the first to graduate from the law school.

Tanner pursued his art studies at the Pennsylvania Academy of Fine Arts under Eakins. However, the art-world prominence that accompanied training in European ateliers, the need for reliable patronage, and race prejudice in the United States impelled Tanner to move to Paris in 1891. There he experienced a more open and supportive working environment. He remained in Paris for the rest of his life—even during the world wars—with extended stays in the United States for family visits and art exhibitions.

The pride of Tanner's father in his free ancestry, his mother's light complexion, and their joint emphasis on education and cultural refinement are just a few of the indicators that point to Tanner's place among the African American elite, identified in contemporary literature as the "colored aristocracy" or the "Talented Tenth." This community of upper-class blacks believed that once white Americans recognized their character, gentility, intellect, and self-restraint blacks would be integrated into American society as full and equal citizens.[10] This assumption was predicated on the fact they shared European American values and conceptions of the United States as a Christian nation. As one AME Church leader asserted, "it is a universally recognized fact that Christian lands are the most progressive on earth, holding highest the torch of civilization and doing most for the uplift of mankind."[11] So, while the AME Church took an active role in changing American attitudes toward blacks, it shared a vision of culture with whites and sought to assimilate lower-class blacks and former slaves into

that vision. It shaped, too, Tanner's conception of Christian belief and practice, his cultural presumptions, and his artistic program.

Tanner's Theology of Experience

Even a cursory glance through the biblical subjects Tanner chose to represent calls attention to a central theme: the presence of the divine in human life. Daniel sits unharmed in a den of lions; angels appear before the shepherds; Gabriel approaches Mary; the disciples watch Christ walk on the water and miraculously catch a boatful of fish; Lazarus rises from the dead; the disciples and the three Marys stare into an empty tomb; and Christ breaks bread with his disciples at Emmaus after his resurrection. Indeed, Tanner's religious paintings continually picture biblical figures who witness and encounter the divine. An examination of three of Tanner's most acclaimed and reproduced paintings in the United States—*The Annunciation* (1898), *Two Disciples at the Tomb* (1905–06), and *Behold, The Bridegroom Cometh* (1906–07)—highlights the centrality of sight and personal experience in Tanner's sacramental vision.[12]

Tanner's *Annunciation* (1898) depicts the angel Gabriel appearing to Mary:

> And in the sixth month the Angel Gabriel was sent from God into a
> City of Galilee named Nazareth; To a Virgin ... And the Virgin's name
> was Mary. Accordingly going into her, he filled the chamber where
> she was with a prodigious light. And when she saw him she was troubled.
> And the Angel said unto her, Fear not, Mary: behold, thou shalt bring
> forth a son, and shall call his name Jesus. (Luke 1:26–35)[13]

In his rendition of the event, Tanner used the conventional iconography of the Annunciation (plate 3). The figure of Mary, veiled beneath layers of cloth, responds to Gabriel within a foreshortened interior space. She sits on the edge of a narrow bed, compressed into a corner constructed by a tapestry and an interior arcade, and lacking noticeable signs of her divinity. Her hands lie clasped on her lap, with her body concealed underneath her striped cotton robe and crumpled bedsheets. Mary responds humbly, silently, and anxiously to the angel. However, unlike other images of the Annunciation, Gabriel appears to Mary not as a bodied angel but as a vertical beam of light, which forms a cross when the beam intersects with a shelf on the back wall. It is the disembodied representation of God (the only source of light in the image), Mary (who appears transfixed by the sight), and the relationship between the two that distinguishes Tanner's image from previous renditions of the same story, from Fra Angelico to Dante Gabriel Rossetti.

Tanner's *Annunciation* focused on the relationship between God's call and the individual's response. Commentators noted that Tanner depicted the moment when the angel "awakens the startled girl," or when Mary is "roused from sleep to meet

the mysterious announcement." Although the beholder probably knew Mary's response—"Here I am, the servant of the Lord; let it be with me according to your word"—Tanner represented what he assumed Mary felt upon the angel's arrival: astonishment and fear. Moreover, Tanner depicted Mary as an ordinary woman, or as what one writer described as a "young Jewish peasant sitting on the edge of a couch, wearing the common striped cotton of the Eastern women of the poorer classes."[14] In *The Annunciation*, Tanner highlighted God's unexpected intervention in the lives of even the most humble of believers.

Tanner's *Two Disciples at the Tomb* reiterated the theme of divine presence while underscoring the realization of Christ's promises (fig. 10). According to the scriptural account, Simon Peter and John rushed to the tomb after learning that Jesus's body was removed from the sepulcher: "The two were running together, but the other disciple outran Peter and reached the tomb first. He bent down to look in and saw the linen wrappings lying there, but he did not go in. [After Simon Peter arrived and entered the tomb] the other disciple, the one who reached the tomb first, also went in, and he saw and believed" (John 20:4–8). In his visual interpretation Tanner stripped the story to the bare essentials: two disciples staring into the empty tomb. While one puts his hand on his heart in subdued shock, the other looks straight ahead. Both are illuminated by the bright light emerging from the tomb. As in the *Annunciation*, light served as the mediator between the earthly and heavenly realms, or, as one critic put it, as the "messenger of the Lord."[15]

Most commentators agreed that the tone of *Two Disciples at the Tomb* was "expectancy" and the message was the "fulfillment of the promise made to them." Another critic provided an allegorical account of the picture, asserting the two disciples represented "faith and love," both of which were necessary for Christian belief: "Faith and love stand in eager and trustful expectancy to see the fulfillment of divine promise." The ability to witness the existence of God in the material world was central to the painting's message. The disciples rushed to the scene to see for themselves, or, as one critic noted, to "verify the incredulous talk of the resurrection."[16] In *Two Disciples at the Tomb*, Tanner linked seeing and believing. He stressed that faith enables the believer to expect, recognize, and interpret Christ's presence (or, in this case, absence) in everyday life.

Tanner summarized his visual theology in *Behold, the Bridegroom Cometh*, also known as *The Wise and Foolish Virgins* (fig. 11). In the parable concerning the Second Coming, ten bridesmaids took their lamps to meet the bridegroom. Only five of the virgins brought additional oil for their lamps. The bridegroom arrived late, after all the virgins had fallen asleep. Although all the lamps had gone out, those who remembered to bring extra oil were able to enter the wedding banquet. The five unprepared and foolish virgins had to buy additional oil, and by the time they returned they were unable to join the banquet. "Keep awake, therefore, for you know neither the day nor the hour" (Matthew 25:5–13).

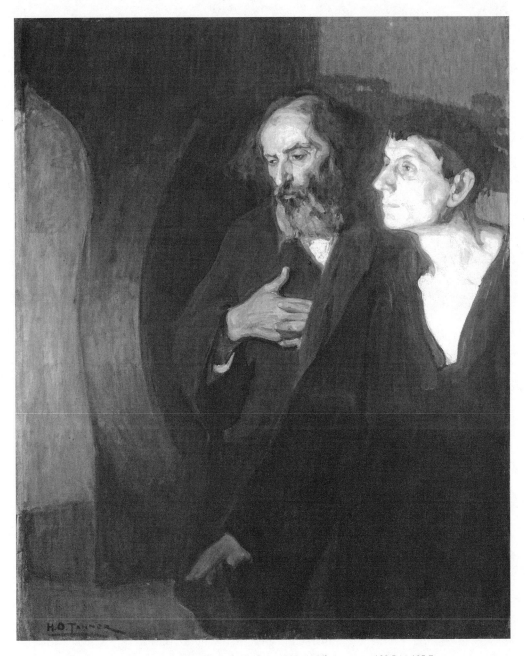

Figure 10. Henry Ossawa Tanner, *Two Disciples at the Tomb*, ca. 1905–6. Oil on canvas, 129.5 × 105.7 cm. Robert A. Waller Fund, 1906.300. Reproduction, Art Institute of Chicago.

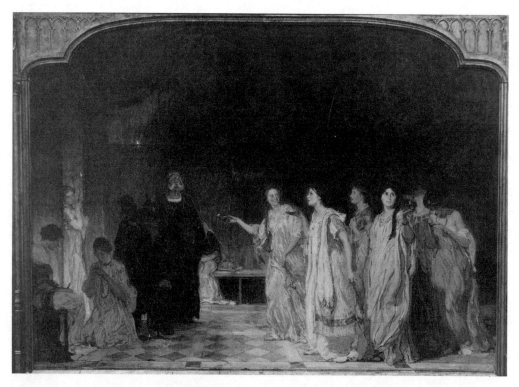

Figure 11. Henry Ossawa Tanner, *The Wise and Foolish Virgins (Behold! The Bridegroom Cometh),* ca. 1906–7. Oil on canvas. Location unknown. Photograph courtesy of the Pennsylvania Academy of the Fine Arts, Philadelphia, Archives.

As in the *Annunciation* and *Two Disciples at the Tomb,* Tanner used light to represent the divine and stressed the moment of summons and the theme of expectancy. One critic described the narrative moment as that in which "the master of ceremonies is in the act of giving his summons and the maidens are forming themselves into a procession which is to go forth and meet the Lord." The virgins, who are "made to typify the expectancy of the peoples awaiting a heavenly bridegroom," go to meet the bridegroom, "whose presence is made known by the light in the distance."[17] Tanner added a moral lesson on the treatment of those who are less fortunate:

> In "Behold! the Bridegroom Cometh" I hoped to take off the hard edge too often given to that parable; how generally the wise virgins are made good but unlovable; how I attempted to show that they were sympathetic for their sisters in distress, and that this sympathy was one of their beauties, in a marked degree, by the figure on the left on her knees—with her own lamp "bright burning" at her side—trying to bring to life the smoking lamp of her friend—in fact interpreting the whole parable in keeping with our knowledge of the goodness of God and what he considers goodness in us.[18]

Tanner's religious paintings continually highlighted the themes of God's call and intervention in human history, as well as the believer's response to that call through individual preparation and generosity to others. Light served as a compositional device that mediated the heavenly and earthly realms, representing the manifestation of the divine.

Tanner's emphasis on religious experience and personal knowledge of Christ was consistent with that of the Methodist Church at its founding and the AME Church at the turn of the century. The religious studies scholar Ann Taves illustrates how evangelical Protestants throughout the transatlantic awakening and far into the nineteenth century sought to determine the proper expression of religious experience by referencing the extreme poles of "formalism" and "enthusiasm." Formalists were accused of promoting the form of religion at the expense of emotion, while enthusiasts were assumed to be excessively or falsely inspired. John Wesley, the founder of the Methodist Church, sought to cultivate a "theology of experience" that mediated between the two traditions. His conception of "true religion" was heart religion, defined by the "witness of the spirit." People could not know God unless they experienced him: "No man can be a true Christian without such an inspiration of the Holy Ghost as fills his heart with peace and joy and love; which he who perceived not, has it not."[19] According to Wesley, inspiration was manifested in conversion and the continuing process of sanctification, and signs of experience were tested in practice and authenticated through the fruits of one's labors.

African Americans turned to Methodism in increasing numbers during the eighteenth and nineteenth centuries. As early as 1833, Richard Allen, founder and first bishop of the AME Church, asserted that Methodism was best suited to African Americans since its "plain and simple gospel" spoke clearly to the learned and uneducated. W. E. B. DuBois later added that the Methodist focus on "religious feeling and fervor" improved its adaptability to the beliefs of black slaves. Its emphasis on personal religious experience rather than mediated church doctrine coincided with varied remnants of their African religious traditions. More recently, the historian Albert Raboteau summarized this intellectual tradition by concluding that Methodism's theology and organizational structure harmonized with black religious practices in three primary ways: its emphasis on religious experience, conception of a just God, and antislavery message.[20] The gospel message preached by Methodists accommodated and made sense of slave life; it proposed a God who rewarded righteousness and assured redemption through suffering.

Tanner's visual theology was consistent with Methodism's emphasis on religious experience. His biblical figures witness the presence of God in human life; they display the expectancy of believers whose faith assures them of the coming of God's kingdom in human history; and they enact Christian charity, signifying their belief through action in the world. However, the AME Church had its roots in more than Methodism; it also emerged from race prejudice in the United States. As African Americans joined

the Methodist Church in escalating numbers, they became increasingly frustrated with racial segregation in worship spaces and the lack of ordained black preachers. In the late eighteenth century, three black Methodists were physically removed—while on their knees in prayer—from pews designated for white parishioners. The men did not return to the church, and three decades later founded an independent denomination in Phil-adelphia. The resulting church maintained Methodist discipline, structure, and theology but accommodated them to the African American experience.[21] Writing in the *A.M.E. Church Review*, E. H. Coit summarized the church's dual foundation in Methodist tradition and racial prejudice: "As it is known to all, the African Methodist Church had its origin, not in questions of doctrine or polity, but in the assertion of oneness and equality of all Christians, regardless of racial or social considerations. It was and is to-day a protest against the color line as found and favored in this country."[22]

Tanner's most obvious protest against American race prejudice appeared in the painting that established his status in the international art world, *The Resurrection of Lazarus* (1897) (plate 4). Tanner premised *The Resurrection* on a biblical passage in which Christ raised Lazarus from the dead. According to the Gospel account, Mary and Martha sent word to Jesus that his friend and their brother, Lazarus, was ill. When Christ arrived a few days later, Lazarus had been dead for four days. Nonetheless, Christ demanded that the stone in front of the burial cave be removed. He then raised his voice, cried "Lazarus, Come Out," and Lazarus returned to life (John 11: 1–44).

Tanner set his depiction of Lazarus's resurrection in a small, dark enclosure, its sole entrance in the back indicated by a band of white light. Three trees further truncate the space by establishing a frame unable to contain the mass of mourners present to grieve Lazarus's death. The painting's central drama takes place in the foreground. Christ looks down at Lazarus, composed and confident, and opens his arms in a gesture of invitation. Lazarus slowly rises from a deep pit in the earth, his left arm just beginning to support his body weight. His head is cradled by an elderly man whose muscular arms bulge under the strain.

Tanner included a single black man among the mourners. While the other witnesses wear dark clothing, the black figure is dressed in a white robe. Its light tone is repeated in the clothing of Lazarus, the burial cloth, and the light emanating from the cave's opening, linking the black man to notions of resurrection, liberation from death, and enlightenment. Moreover, rather than focusing on Christ's command—a far more common practice among artists—Tanner represented Lazarus's response.[23] A number of critics noted Tanner's original rendition of the biblical story. One commented that "Lazarus [was] just awakening to life with the glaze of death still in his eyes," while another wrote that the viewer is "certain that [Lazarus's] struggle back to life begins only when the Savior stretches out His hands above him."[24] In an environment that worked against African American equality in the legislature and judiciary, as well as in a variety of cultural, religious, and scientific communities, Tanner's visual link between the black man and the resurrection showed that black Americans, like

Lazarus, would be emancipated from their present position under the guidance and with the grace of God.

"There was race in it": Orientalism as Biblical Interpretation

Tanner's *The Resurrection of Lazarus* displays the artist's affiliation with the AME Church, emphasizing its foundation in Methodist experience and racial prejudice. However, the majority of Tanner's paintings, including *The Annunciation, Two Disciplines at the Tomb,* and *Behold! The Bridegroom Cometh,* do not reference African Americans so directly, nor did most contemporary critics suggest any explicit political import to the artist's works. However, W. S. Scarborough, vice president of Wilberforce University (the AME Church's theological seminary and the first African American university), indicated that Tanner displayed his race consciousness by painting in an "Orientalist" style:

> Of [Lazarus] there could be said what was said of the 'Daniel'—'there was race in it,' a quality that one critic avers to be new to biblical painting. Be that as it may, Mr. Tanner studied to put 'race in it'. . . . [He] went straight to the real—to the lowly people of Palestine—for his types, and he has succeeded admirably in his masculine subjects in showing us the Jew as he must have lived and looked nearly twenty centuries ago.[25]

Scarborough asserted that Tanner added race to his images by picturing contemporary Jews living in the Holy Land. By participating in the vogue for "ethnographically" accurate religious imagery, the artist integrated the Christian past and the American present; pictured the bible's protagonists within his own physiognomic, biblical, and religious heritage; and visualized the AME Church's way of reading the biblical text. Tanner's selection of an Orientalist aesthetic, in other words, functioned as his mode of visual exegesis.

 "Orientalism" was defined by one mid-nineteenth-century writer as "not merely associated with one country, race, or era. It is a complex idea made up of history and scenery, suffused with imagination and irradiate with revelation."[26] For the French artists who served as teachers and mentors to American students like Tanner, Orientalism coincided with France's colonial project in North Africa. By feminizing and exoticizing the "other," French artists "reduced the Orient to colony, concubine, and indolent heathen."[27] The art historian Holly Edwards shows that while American artists drew on the style, technique, and esteemed artistic tradition of their French instructors, American Orientalism had its roots in Manifest Destiny, Protestant piety, and America's self-appointed status as the "New Israel." By the end of the century, it acted, too, as a means to advance America's cultural superiority. Tanner shared many of the cultural hierarchies and prejudices that undergirded Orientalism and consistently differentiated

himself from the inhabitants of the Holy Land.[28] More important, here, he employed these contemporary ways of looking at the Holy Land to integrate the past, present, and future into a single image.

Contemporary art critics continually situated Tanner within Orientalism's visual and discursive field because of the artist's close attention to ethnographic detail, use of authentic props, and trips to Palestine. They discussed his purchase of Oriental costumes from the estate of the popular religious painter Mihály Munkácsy and the tiles he brought back from Jerusalem bearing "Arabic characters."[29] Tanner's close attention to the specifics of the Holy Land—its landscape, culture, and inhabitants—situated his work within the broad and diverse visual culture of "Holy Land consciousness" that permeated American life in the second half of the nineteenth century.[30] Since many Americans assumed the Holy Land had not changed since the life of Christ, and close study of its inhabitants, topography, architecture, and dress provided accurate knowledge of his physical, social, and moral environments, Tanner's attention to archaeological detail verified the Christian past and its enduring reality. Faith was fortified through the beholder's personal observation and experience of that reality.

Tanner's Orientalist idiom fused the biblical past, immediate present, and America's future in his religious paintings. There was ample precedent—and perhaps even a direct precursor—for such an assumption in the most commercially successful representations of the modern Christ. The French painter James Joseph Jacques Tissot produced over five hundred illustrations of the New Testament that toured the United States in 1898 and were published in two folio volumes accompanied by the Latin text of the Vulgate, its English translation, and the artist's archaeological notes on Oriental life and customs. The artist represented Mary and Christ as "Jewish types" in settings purportedly derived from Palestinian life and predicated on first-hand observation of Oriental life and customs (fig. 12).[31] As a result, Tissot's illustrations were seen to authenticate the biblical narrative by providing physical evidence for Christ's historical reality. In addition, they brought the biblical past into the present. One critic noted: "it is not merely a life of Jesus, but a living Jesus who passes from birth to death in the eyes of the spectator."[32] The reception of Tissot's illustrations paralleled that of Tanner's paintings and underscored the ability of Orientalism to integrate the historical past and immediate present in the minds of viewers.

Orientalism also allowed Tanner to "put race" in his paintings because of the relationship between blacks and Jews in physiognomic theory, biblical history, and contemporary life.[33] The North Carolina minister and professor, Arthur T. Abernethy, produced the most detailed attempt to trace the racial similarities of the two groups in his book, *The Jew a Negro* (1910). He claimed that the ancient Jews mixed with their African neighbors, leaving little difference between the two types. The Jews' migration to more temperate climates explained the lightness of their skin. Otherwise, "thousands of years of effort to throw off their nigrescence have failed to eradicate those race characteristics, and the Jew of to-day is essentially Negro in habits, physical peculiarities and tendencies."

Figure 12. J. James Tissot,
Eloi, Eloi, Lama Sabachthani,
ca. 1895. Reproduced from
J. James Tissot, *The Life of
Our Savior Jesus Christ*, vol. 4
(New York: McClure-Tissot
Company, 1899), 195.

While Abernethy's views were somewhat idiosyncratic, his conclusions were similar to those of other prominent race theorists of the day such as William Z. Ripley. Ripley traced Jewish origins to Africa and characterized the Jews in terms usually ascribed to African Americans; he highlighted full and sensual lips, swarthy complexion, and dark hair and eyes.[34] By depicting his biblical subjects as Jews, Tanner represented them within his own racial genealogy.[35]

Although ethnographic accuracy was a crucial element of contemporary religious painting, depicting Christ as a Jew was by no means a universal trend. For example, in 1906 three Cleveland businessmen commissioned ten American artists to paint their personal conception of Christ. The resulting paintings formed a traveling exhibition that generated extensive press coverage. Reviewers inevitably commented on Christ's racial type. One writer noted: "Standing before this [collection of paintings], one faces a Savior in Art whose physiognomy certainly suggests little or nothing of the Hebraic type. Gallic, Celtic, Teutonic or Slavic these types may be, but, curiously enough, one scarcely detects the Hebraic characteristic in them at all." Only Frank Vincent DuMond's *Christ and the*

Figure 13. Frank Vincent DuMond, *Christ and the Woman Taken in Adultery*, 1906. Reproduced in Homer Saint-Gaudens, "Ten American Paintings of Christ," *Putnam's Monthly and the Critic* 1, no. 3 (December 1906): 262.

Adulteress was exempted from the author's critique for his representation of Christ as a "distinctively Jewish type both in face and attitude" (fig. 13). For European American artists, to paint Christ as a Jew was to paint him as an "other." One rabbi commented, "To be true, [an image of Christ] must of necessity be the portrait of a Jew with his racial characteristics deeply sunk into his face; and would not this be a shock to Christian sensibilities?"[36]

African American Christians found their historical origins in the biblical past. Their association with the Jewish people began soon after they arrived in the New World and learned the tenets of Christianity from European American slave owners. The Africans identified themselves as God's chosen people by relating the Exodus story to their own experience in slavery. The religious studies scholar Yvonne Chireau writes: "Looking ahead to their ultimate day of deliverance, [antebellum] African Americans participated in a reenactment of the Jewish past, claiming Jewish history as *their* sacred history, a history in which the biblical world was inextricably bound with the present, in which the future carried the promise of freedom."[37] Slave religious practices, sermons, and spirituals heralded deliverance from oppression and the fulfillment of the Old and New

Testament ideals of freedom. This general use of Jewish history to construct an African American past was employed, too, by the AME Church. Bishop Daniel Payne, a friend, supporter, and sculpture subject for Tanner, preached:

> In history we also have manifestations of God . . . in which we see exhi-
> bitions of the retributive justice and providence of God as the Almighty
> Ruler of races and nations, of kingdoms and empires . . . breaking the
> arm of the brazen-hearted and blasphemous enslaver, as he did that of
> the Pharaoh; and out of an enslaved race to produce a great people, as
> illustrated by the history of the Israelites.[38]

By invoking a God who acted in history and worked on behalf of the oppressed and downtrodden, Payne found meaning in the past and confidence that his Christian faith would lead to spiritual and political freedom.

The allegorical relationship between blacks and Jews maintained its centrality in African American cultural life into the twentieth century. For example, the leading black poet at the end of the century, Paul Laurence Dunbar, ended his 1895 "An Ante-Bellum Sermon" based on the Exodus story with the stanza: "When Moses wif his powah /Comes an' sets us chillum free, / We will praise de gracious Mastah / Dat has gin us liberty; / An' we'll shout ouah hallyluyahs, / On dat mighty reck'nin' day, / When we'se rec'nised ez citiz'— / huh uh! Chillun, let us pray!"[39] Dunbar's poem-sermon integrates the biblical past and political present by proclaiming that Moses will free African Americans and insist on their recognition as citizens. His rendition of Exodus retained the theological message of equality and inserted contemporary realities into the narrative.[40]

In the second half of the nineteenth century, AME Church biblical scholars argued for more than an allegorical relationship to the Jewish past; they drew on contemporary trends in biblical criticism and existing scholarship in history, archaeology, geology, and linguistics to proffer an interpretation of the Bible that situated African Americans within Christian history. Writing in the *A.M.E. Church Review*, George Wilson Brent argued that the bible illustrated the many contributions blacks made to the history and development of Christian civilizations, and showed that the "white race" emerged after the other four races—the red (Indian), black (Negro), brown (Malay), and yellow (Mongolian)—and initially embodied undesirable characteristics. In addition, the bible served as a primary source for proving African Americans' parity with their Anglo-American counterparts. Brent stressed that Africa was the continent God favored most, as evidenced by the fact that "all notable events in the lives of Joseph, Moses, Jacob, Abraham, Solomon, and Our Savior Jesus Christ" occurred there.[41]

Finally, African American writers highlighted the shared sociopolitical realities of blacks and Jews in the nineteenth and early twentieth centuries. A leading black weekly commented: "There is a similarity between the Jew and the Negro. One is despised almost as much as the other." The black press excluded Jews in their

critiques of white immigrants and condemned the French government during the Dreyfus affair in the late 1890s, comparing the unfair persecution of Dreyfus to that experienced by African Americans. It even called on blacks to emulate the Jewish people. In 1892, the *A.M.E. Church Review* exclaimed: "Where everything else had been denied him—political rights, social standing, even the privilege of owning real estate—the Jew yet conquered. . . . Two things he could and did get—money and education. . . . [As a result, Jews are] among the foremost in every department of human industry and brain achievement."[42] Although the relationship between African and Jewish Americans became strained at the end of the nineteenth century and in the early decades of the twentieth century, it nonetheless remained inherent to African American religious and cultural identity.[43]

Tanner's reliance on Orientalism's ability to fuse the Jewish past and the African American present, biblical history and contemporary realities, coincided with the AME Church's interpretive traditions more broadly. Indeed, it enabled him to visualize how its members interpreted the biblical text, as manifested in sermons and scholarship alike. Scholars and preachers began with a biblical passage, placed it in its scriptural and historical contexts, and related it to current realities.[44] For example, in the sermon Bishop Payne delivered at B. T. Tanner's ordination to the bishopric, he equated the prophesy of Isaiah to the Second Coming:

> And the cow and the bear shall feed; the young ones should lie down together; and the lion shall eat straw like the ox. The lion shall not become an ox, nor the ox a lion, but they shall live in peace and harmony, in perfect harmony with the other. . . . What beautiful pictures! And what is meant? Why this: that all races shall become harmonized, and live in peace . . . the different nationalities of Europe shall not continue to wage war against each other. . . . The time is coming, it is fast approaching, when all the nations of the earth shall harmonize and live in peace to make way for the second coming of the Son of man.[45]

Bishop Payne interpreted Isaiah through the lens of contemporary race prejudice and international warfare to illustrate the divine injunction for peace.

Tanner's reliance on this pattern of interpretation emerges in the descriptions he wrote to accompany the illustrations he made for the "Women of the Bible" series, published in the *Ladies' Home Journal* (1902–3) (fig. 14). For example, Tanner's picture of Hagar was accompanied by the following text:

> And Abraham rose up early in the morning, and took bread, and a bottle of water, and gave it unto Hagar . . . and sent her away: and she departed, and wandered into the wilderness of Beer-sheba.—Genesis XXI, 14.
>
> Sad must have been the night before and the days following the events recorded—sad for Abraham, for we are told "the thing was very

Figure 14. Henry Ossawa
Tanner, *The Mothers of the
Bible—Hagar.* Published in the
Ladies' Home Journal 14, no. 11
(October 1902): 13.

grievous in Abraham's sight because of his son"; and sad for Hagar
because of the untold suffering she was called upon to endure.

I have tried to depict the scene where Abraham is in the act of giv-
ing the word that made Hagar a wanderer. Hard as it is to understand
why Abraham should have sent Hagar away with so little, yet we cannot
doubt the painful character of the parting. He turns his head—he can-
not bear the sight. To Ishmael, who had only received kindness from his
father, this change is incomprehensible. After Hagar has accepted her
fate Ishmael hopes for that which will not happen, for as the morning
sun begins to gild the hills the boy and his mother start on their weari-
some journey—a journey that their descendants to this day have not
finished.[46]

Tanner began with a scriptural quotation, placed it within its narrative context, and
explained its contemporary relevance. In content, structure, and theology, Tanner
painted his religious pictures within the traditions of the AME Church and its inter-
pretive practices.

More specifically, Tanner's paintings integrated all three elements of the sermon into a
single image. He depicted a particular moment of a biblical story, set the scene by calling

attention to the figure's psychological and spiritual struggles, and linked past and present through an Orientalist idiom. He did so, too, by encouraging the beholder's personal engagement with the biblical figures. The homiletic nature of Tanner's paintings was not lost on critics. In 1909, an art critic for *The Literary Digest* expressed the opinions of many when he pronounced, *Behold the Bridegroom Cometh*, a "strong sermon."[47]

Proper Religious Practice

Although Tanner's Orientalism enabled him to visualize the two founding tenets of the AME Church—religious experience and social equality—he consistently presented a particular kind of piety. Certainly, his biblical figures express emotion in response to divine presence: Mary shrinks back in trepidation; Simon Peter and John look with amazement and apprehension at the empty tomb; the wise virgins work to console their foolish counterparts; and the crowd gazes with astonishment as Lazarus rises from the dead. However, they remain subdued and restrained. They do not jump for joy or fall to the ground, but rather display bodily discipline and Victorian gentility. In his biblical paintings, then, Tanner achieves two distinct but related agendas: he seeks to elevate the race by undermining traditional stereotypes of African Americans while, at the same time, advocating a controlled religious practice more in keeping with European American ideals of comportment.

AME Church leaders highlighted the discrepancy between the gospel message and its interpretation by white "Christians": "This much ought to be conceded, that the American people, in dealing with their 'brother in black,' have clearly shown the existence of and their attachment to a caste Christianity that rarely measures up to the code formulated by the Divine Master."[48] Frederick Douglass plainly distinguished between "slaveholding religion" and "Christianity proper":

> Between the Christianity of [white America], and the Christianity of Christ, I recognize the widest possible difference—so wide, that to receive the one as good, pure, and holy, is of necessity to reject the other one as bad, corrupt, and wicked. . . . I love the pure, peaceable, and impartial Christianity of Christ: I therefore hate the corrupt, slaveholding, women-whipping, cradle-plundering, partial and hypocritical Christianity of this land. Indeed, I can see no reason, but the most deceitful one, for calling the religion of this land Christianity.[49]

African American thinkers argued that the New Testament preached a gospel of inclusion and racial harmony, and once white scholars read the Bible through a nonracist lens they would grasp Christ's true vision. Indeed, Bishop Tanner wrote forcefully that the "ambition" of white scholars was "so remorseless that [they have] not hesitated to lay unholy hands upon the Scripture of God." He argued that racial prejudice caused

them to ignore African contributions to the development of civilization as well as to the origins of Judaism and Christianity.[50]

African American religious leaders endeavored to enact the "best expression of Christianity and the truest embodiment of ethical perfection on the western hemisphere."[51] Because the Christianity of white America did not coincide with American ideals, it was the role of the black Church to remain true to democratic principles.[52] Benjamin Tucker Tanner's biographer suggests that Tanner believed that African Americans "were God's instrument . . . [to] make America live up to her declared principles of 'liberty and justice for all.' He believed that God gave the black man the responsibility to represent truth in America, 'and it is for him to realize the high honor, to be true through fire and blood.' " U.S. Senator Blanche K. Bruce, an African American, agreed with Tanner and urged African Americans to remain true to their "American" identity.[53]

Although AME leaders critiqued white America for its racist and distorted interpretation of Christianity, they agreed with European Americans that the espousal of Christianity was a prerequisite for progress and civilization. One scholar described Christianity as "constructive evolution."[54] Another writer asserted: "It is a universally recognized fact that Christian lands are the most progressive on earth, holding highest the torch of civilization and doing most for the uplift of mankind."[55] By putting the "intemperate, superstitious, and immoral" slave past behind them, AME Church leaders endeavored to instill the values of discipline, restraint, and self-reliance. Northern missionaries were "dedicated to teaching the freedman practical lessons in how to be intelligent, responsible citizens in a free society and productive wage laborers in a competitive market . . . [and] were also committed to instilling in them the ideals of northern, white, middle class virtue."[56] Thus, while the AME Church took an active role in changing American attitudes toward blacks through its interpretation of the Bible, it shared a vision of "culture" with whites and sought to assimilate black slaves into that vision.

For example, the paradigmatic expression of black religious experience in popular culture was the "ring shout." In accordance with Wesley's emphasis on continued sanctification, Methodists developed a series of interactive religious practices that brought the presence of God into the community through preaching, singing, and dancing. One early nineteenth-century observer described the performance:

> In the lowest part of the consecrated enclosure, we saw about fifty persons in various stages of prostration. Some were lying on their backs, some on their faces, some on their sides, some on their knees and elbows, some with half the body elevated from the ground, at an angle of about thirty degrees; while others were on their bended knees; and about the whole of this convicted group, a file of new converts was marching, in a circle, hand in hand. . . . The persons wheeling about in Indian file, were singing several different airs, to different words, and shouting and praying all at once. . . .[57]

Converts falling to the ground by the weight of their sinfulness, believers surrounding them in a circle, singing, dancing, shouting out: scenes like this one characterized the Southern religious experience in the Northern press, both white and black.

Such religious fervor caused consternation for the black intellectual elite, who condemned the emotional frenzy that characterized Southern religious practices since it violated Victorian standards of deportment. The decline of the ring shout in the late nineteenth and early twentieth centuries was due, in part, to the efforts of AME Church leaders.[58] Educated ministers and members sought to undermine the "primitive" element of Methodist services and remove excess emotionalism from worship services. In 1879, for example, Bishop Payne attended a camp meeting, witnessed a shout, and asked the pastor to end it. Although the congregants stopped their dancing, singing, and clapping, they remained in the circle, moving their bodies. Payne then told their leader "it was a heathenish way to worship and disgraceful to themselves, the race, and the Christian name." He went further, suggesting that excommunication should be used if necessary to terminate the emotive displays: "The time is at hand when the ministry of the A.M.E. Church must drive out this heathenish mode of worship or drive out all the intelligence, refinement, and practical Christians who may be in her bosom."[59] In this way, the language employed by black intellectuals paralleled that of white scholars throughout the period; both sought to control religious experience through its proper expression.

Tanner's entire oeuvre presented the ideal of religious restraint. Before his international success with biblical paintings, the artist produced a number of genre paintings including *The Thankful Poor* (1894) (fig. 15). Tanner situated his scene of piety and devotion in the domestic sphere. An old man and a boy sit across from one another, at a table covered by a cloth and set with simple dishware. The figures bow quietly in prayer, their heads resting on clasped hands. Set in the private space of the home and devoid of zealous religious expression, Tanner's *The Thankful Poor* illustrated the conception of "true religion" that shaped his later biblical pictures: ardent but formal, inwardly felt but emotionally subdued.

Tanner's painting differs from popular representations of black religious expression, exemplified by Watson Heston's *Prototype of Methodist Revivals* (1890) (fig. 16). The diptych compares "the Howling Methodist" to "the Howling Monkey," emphasizing the similarities in gesture and physiognomy between the two. Private versus public, personal devotion versus communal exuberance, quiet and controlled versus loud and spirited: Tanner's rendition of religious experience countered, as art historian Judith Wilson argues, the "contemporary perception of black religiosity as overwhelmingly emotional—and thus, presumably inferior to an allegedly more tranquil, stable, and introspective white brand of piety."[60] At the same time, however, Tanner presented the standards of his own religious experience as a formula for others to emulate. He promoted the AME Church's goal of undermining religious enthusiasm for the sake of African American uplift.

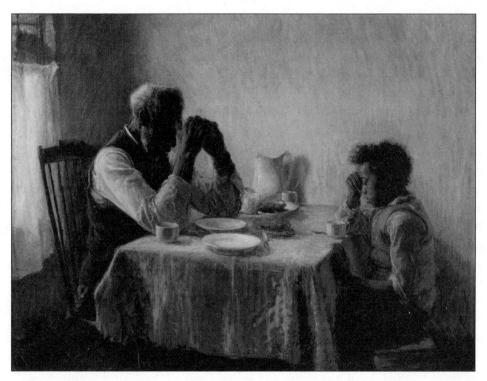

Figure 15. Henry Ossawa Tanner, *The Thankful Poor*, 1894. Oil on canvas. Private collection. Photo credit: Art Resource, New York.

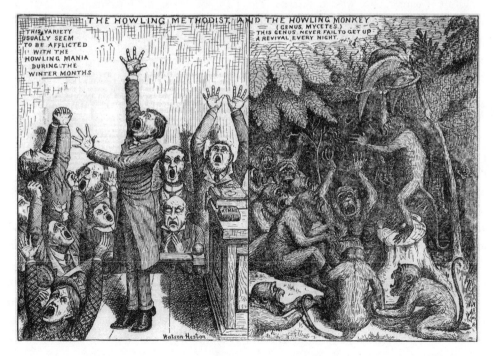

Figure 16. Watson Heston, "Prototype of Methodist Revivals." Published in *The Freethinkers' Pictorial Text-Book* (New York, 1890). Wisconsin Historical Society WHi-44791.

The apparent tension inherent in Tanner's identification with European Ameri-
can, middle-class values and the larger African American community was common
among African American artists and intellectuals of the period such as Dunbar and
the Jubilee Singers (to name two examples from the literary and performing arts). At
least three tensions formed the contours of African American art production and re-
ception during this period. First, although black artists' conceptions of fine art were
shaped by their educational and cultural heritage that celebrated standard English,
classical music, and fine art paintings, they also aspired to celebrate the distinctive
cultural legacy of African Americans through the use of dialect, the performance of
spirituals, and the representation of black subject matter in genre paintings. Second,
although black artists shared their white counterpart's desire for artistic freedom
and individual expression, they linked their success to that of the African American
community as a whole. Consequently, they were committed to augmenting the
prestige—and proving the equality—of African Americans by displaying the race's
ability to attain the highest levels of achievement. Third, although black artists relied
on European American patrons and their aesthetic sensibilities for their livelihood,
they still wanted to celebrate and contribute to the black community. These inter-
nal conflicts and external pressures manifested themselves in myriad ways. Dunbar
wrote in black dialect despite feeling constrained by it, and the Jubilee Singers
performed plantation spirituals rather than classical music, but in standard English
rather than dialect.[61]

Tanner's career, too, was shaped by these expectations and pressures. His decision
to cease painting representations of African American life like *The Thankful Poor* dis-
appointed many AME Church leaders who had hoped that "the treatment of race
subjects by him would serve to counterbalance so much that has made the race only
a laughing-stock subject for those artists who see nothing but the most extravagantly
absurd and grotesque."[62] The artist and his paintings were used to showcase African
American cultural achievement by European American and African American elites.
In 1907, the Toledo Museum of Fine Arts hosted a reception that reportedly brought
"over six hundred of [its] colored citizens" to the museum during a show of Tanner's
work, while in 1908 the *Boston Herald* noted that the local bishop of the AME Church
gave a reception for Tanner.[63] Tanner himself acknowledged his desire to disrupt African
American stereotypes. In the mid-1880s, the artist wrote: "To his mind, many of the
artists who have represented Negro life have only seen the comic, the ludicrous side of
it, and have lacked sympathy with and appreciation for the warm big heart that dwells
within such rough exterior."[64] However, Tanner's use of the third person and rather
patronizing description of Negro life suggests his lack of familiarity with the "serious,
and pathetic side of life among them" and his desire to distance his free, Northern
upbringing from that of Southern freedmen. Moreover, he continually resisted efforts
by patrons who believed he could sell more paintings if he marketed himself as a black
artist, rather than simply as an artist.[65]

Christian Nationalism

While Tanner's African American genre paintings underscored his relation to, and distinction from, the larger black community, his religious works differentiated him from the Jewish poor he represented in his paintings. The artist shared Western conceptions of the Palestinian people as uncorrupted and unchanged since the time of Christ. Reflecting on his visit to Lazarus's tomb ten years after he produced his rendition of the figure's resurrection, Tanner opened his description with typical Orientalist rhetoric:

> In Jerusalem—on foot, or riding a thin, wirey Arab horse—through narrow streets, in and out among a jostling, motley, turbaned burnoosed crowd—passed crowded cafes filled with wild men from beyond the Jordan playing checkers, or a kind of backgammon, each group surrounded by stately Arabs lazily smoking their chibouk—through the Bazaars where others more actively engaged are buying, selling, or disputing with money changers—past shops with their picturesque occupants, both Jew and Arab—past a ragged and, perchance, sore-footed sentinel at St. Stephan's Gate, and you are now outside Jerusalem.[66]

Tanner's "casual, epistolary" tone, emphasis on "space rather than time," exhibition of physical freedom to roam and see, and stress on the "uncivilized" nature of the picturesque figures in contrast to his own unspoken yet assumed civility locate the artist within the genre of travel writing and the context of colonial imperialism.[67] Moreover, they manifest Tanner's belief that Christian belief determined personal and national identity.

Tanner's differentiation of himself from the inhabitants of the Holy Land was common throughout his writings. He also situated them in the religious past. In 1903 he noted: "It was my chance in Jerusalem to run across a little Yemenite boy. Where could a better type be found than this swarthy child of Arabia, of purest Jewish blood—nurtured in the same land, under the same sun, and never, he nor his ancestors, having quitted its (at times) inhospitable shores?"[68] After his second trip to the Holy Land, Tanner remarked that "the people of Morocco . . . are still uncorrupted," and reiterated his interest in biblical types: "I still remember with pleasure the fine head of the old Yemenite Jew who posed for Nicodemus. . . . Never shall I forget the magnificence of two Persian Jews whom I once saw at Rachel's Tomb; what a magnificent 'Abraham' either one of them would have made."[69] Tanner's Orientalism was consistent with the writings of other African American intellectuals. For example, when Scarborough argued that Tanner's ethnographic accuracy enabled him to racialize his religious paintings, he noted that Tanner went to the "lowly people of Palestine" for his types and showed the spectator "the Jew as he must have lived and worked nearly twenty centuries ago."[70]

The tension that runs through Tanner's paintings and Scarborough's criticism between identifying with the Jewish inhabitants of the Holy Land and distancing themselves from them is consistent with the AME Church's position on American imperialism. While critiquing European America's racist understanding of the biblical text, AME Church leaders also believed Christianity was a prerequisite to civilization and American–style democracy. The historian Lawrence Little summarizes the theological and ideological paradox facing AME Church leaders:

> Influenced by politics, racism, and religion, leaders within the A.M.E. hierarchy developed an intellectual activism that sought to expose and counter many of the prevalent racial assumptions that characterized people of color as inferior and incapable of self-determination. Yet their arguments often displayed a cultural chauvinism that accepted and reinforced notions of racial hierarchy. . . . It was difficult, if not impossible, for them to reconcile the promise of American ideals and culture with the realities of American racism.[71]

AME Church theology and American ideology forged a philosophical system that led African American leaders to undermine Social Darwinism on the domestic front while employing it to denigrate "primitive" peoples abroad.

The AME Church's focus on Christian belief as the primary means to individual respectability, a civilized society, and the export of American-style democracy around the world underscored its confidence in the indivisibility of Protestant belief and American identity. In his *An Apology for African Methodism* (1867), B. T. Tanner located the origins of the AME Church in liberty, exemplified in scripture, American history, Methodist practice, and democratic ideals. By following scripture's assertion that God granted all people reason, he used the parable of the talents to argue that African Americans—like all Christians—had to work and spread the Christian message to "enter the joy of the master" (Matthew 25:25). He noted, too, that Richard Allen and the other founding members "heard the stories which make up the religious history of the country," including those of the Puritans who journeyed to America so "that they might not be ecclesiastically oppressed"; Roger Williams, who built a city "for all those who might be distressed on account of conscience;" and William Penn, who "forsook inherited honors and riches, with all their concomitant train of earthly delights, that he might be free, religiously free." America's foundation in the desire for religious liberty coincided with Methodism's reformist origins in the mid–eighteenth century. According to B. T. Tanner, Wesley sought religious experience outside the bounds of the Anglican Church, and later encouraged Francis Ashbury and Thomas Coke to break with the British institution and serve as superintendents of a new Methodist Episcopal Church in America. Finally, B. T. Tanner argued that the AME Church had its foundations in the ideals of American democracy. It was "the very genius of Columbia, the genius that speaks only of freedom" that told Allen

and other African Americans to "stand up with the crowd": "They learned it from the school boy, as he threw up his cap and shouted, Liberty! They learned it from the broken accent of the fresh foreigner, as he muttered out Liberty! They learned it from the stereo-typed prayer, uttered every Sabbath from ten thousand altars—the prayer of thankfulness for the privilege of worshiping God under our own vine and fig tree, none daring to molest or make us afraid." According to B. T. Tanner, the "strictest Democracy" was "the most approved Protestantism," and the AME Church embodied American ideals.[72]

B. T. Tanner asserted, in essence, that Christian belief was the critical determinant of personal and national identity. He argued that all people, regardless of color, sought religious truth and that the means to that truth—Christianity—was universal. In fact, he distinguished among people through their Christian faith rather than their racial heritage. B. T. Tanner's biographer, William Seraile, asserts that he "advocated the com-mingling of all races, particularly because he believed that all races, all colors, all lan-guages had the potential to become Christians. Although he believed in the solidarity of the American black man as a way for racial advancement, he was quick to chastise people of his own race whenever they practiced racial chauvinism."[73] The elder Tanner believed that environmental factors such as geography would create a national race distinguished from Africans, Asians, and Europeans. Racial mingling and intermarriage would create an "American race" that would appear bronze: one-eighth black and seven-eighths white with a "motley of yellow."[74]

Within this intellectual context, it is not surprising that contemporary critics stressed the ecumenical nature of Tanner's biblical paintings. A writer for the *Outlook* noted that although Tanner depicted "strictly Oriental and Jewish scenes," he provided "not merely Hebrew types, but world-types."[75] Although it also could be argued that the critic attempted to distance Tanner's biblical figures from a specific racial tradition in order to avoid Christ's Jewish, rather than European American, identity, African American writers shared this interpretation of Tanner's work. A critic for the *Voice of the Negro* noted "the real value of his work" was "a merit which puts it beyond the limitations of race and country."[76]

Although Tanner's relationship to organized religion changed after he moved to France—his regular attendance at the American Protestant Church in Paris waned, his faith became more mystical, and his conception of Christ became less "materialistic"—he sustained a disciplined prayer life and a markedly Christian vision.[77] Two years before the artist's death in 1937, an American clergyman wrote to him and asked permission to use his painting *Two Disciples at the Tomb* for a religious service aimed at improving race relations. Tanner replied favorably:

> We [Americans] are supposed to be a very practical people, and if race prejudice and race hate are vices why not treat them as we would oth-er evils that are generally recognized as needing the grace of God to cure. That you will finally win the day, there will be little doubt. For

> you cannot have a Christian religion without it winning the day. . . .
> I only think myself fortunate if the picture will in a however small
> degree bring the thoughts and actions of my fellow man closer to the
> teachings of our Lord and Master.[78]

Throughout his life, Tanner remained convinced that, even more than race, Christian faith determined a person's place in the world and proffered hope for social equality. This is important, since it demands a consideration of Tanner's paintings within the context of American Protestantism more generally.

Visual Experience as Religious Practice

Tanner's religious paintings depict biblical figures engaging with the divine. From *The Resurrection of Lazarus*, *The Annunciation*, *The Disciples at the Tomb*, and *Behold! The Bridegroom Cometh!* it becomes clear that Tanner's religious paintings posit a relationship between physical and spiritual vision. The artist's attempts to encourage the beholder's active encounters with his paintings indicates he wanted his paintings to facilitate a similar experience. He assumed the viewer would bring his or her biblical knowledge and Holy Land visual literacy to his paintings, and, in turn, become part of the Christian story. Tanner was safe in his presuppositions, since they intersected with contemporary trends in religious education.

Writers continually stressed how Tanner encouraged the viewer's personal engagement with his works. For example, one writer asserted: "He has sensed events removed by the lapse of nineteen centuries and has depicted them with such sincerity and feeling that the personages seem to live and breathe."[79] Another referenced *Christ and Nicodemus*, asserting that Tanner enabled the viewer to experience what the figures felt: "it transports us to the spiritual atmosphere of the East. . . . so subtle is the painter's power as not only to make one feel that which the characters of the picture, Christ and Nicodemus, are exchanging—one may even dare to think their thoughts after them."[80] And the critic most attuned to Tanner's intention noted: "Every picture is instinct with religious emotion. And this is of such a nature that it thrills also the spectator, and rouses within him the faith, hope, and love which were first kindled in the heart of the artist." He concluded that Tanner's works set "forth incidents in the gospel story" that "come home to the spectator."[81]

The theoretical framework Tanner employed in the creation of his religious paintings was predicated on the notion that art served an experiential means to religious knowledge. Object-centered education obtained widespread currency among cultural and religious leaders in this period, including Tanner's father, who cited the importance of sensory experience to obtaining knowledge of God in a series of theological lectures delivered and published in 1894. Bishop Tanner defined symbolism (through the words of another scholar) as "that system which represents moral or intellectual qualities by

external signs and symbols." He argued that God introduced the concept of "object-centered" learning in response to humans' sinful nature: "In the present condition of the human intellect, beclouded by the fall, darkened by sin, and weakened by evil, it is universally conceded that the subtler or more spiritual truths can best be learned by reference to or comparison with truths more superficial—truths that at once attract the attention of the senses, that may be seen, or felt, or heard, or tasted, or smelled." Bishop Tanner believed that God provided visible symbols of his invisible power and glory through his creation of the world. Humans were able to understand and know God through the visual because of the "association of ideas" that allowed them to ascertain the unknown through the known: "The law in its visibilities must be a school-master to lead men to Christ, or to the invisibilities of the Gospel."[82]

Bishop Tanner noted the universality of human's search for God through the visible world. Describing racial divisions in the United States as "miserable and utterly senseless," he argued that, as "there is no royal road to knowledge secular, even so there is none to knowledge spiritual. Whether the object of pursuit be the worm that crawls or the God that reigns, the methods are one and the same; and to all. To this important fact we call attention—important because it stamps the Race severely as one; none of its varieties scarcely having a more ready conception of God than the other." At the same time, he emphasized that knowledge of God emerged through personal experience, and by extension through the historical experiences of specific people living at certain times and in particular places: "In representation man does not, like the great Originator, create by his own fiat, his world of mental object. What he reproduces or constructs anew, is in some way dependent upon what he has personally experienced."[83] Although Bishop Tanner asserted humankind's equality in the eyes of God, he affirmed that personal experience shaped an individual's faith.

Tanner's biblical paintings, Bishop Tanner's *Theological Lectures*, and contemporary art criticism all assumed that the visual world could imprint its truths on the viewer's soul. As such, they shared the faith turn-of-the-century liberal Protestants had in art's capacity to mediate between the material and immaterial worlds. More important in this case, they assumed the viewer's familiarity with ways of seeing that enabled them to sympathize with and otherwise engage works of art. In doing so, the Tanners relied on new trends in religious education, philosophy, and psychology. For example, B. T. Tanner's discussion was shaped by John Veitch, a philosopher of logic whose book *Knowing and Believing* ended with the assertion: "The only philosophy and the only religion worthy of the name is that which looks beyond pure formulae of the mere intelligence or thought, and finds God in the breadth of experience, history, human life, yet, in Himself, utterly transcendent of all that in these we can know, feel, or name."[84] Veitch's emphasis on finding God in human history and experience intersected with contemporary psychological formulations of faith. In his *Rudimentary Psychology for Schools and Colleges*, G. T. Steele (another source for B. T. Tanner) defined faith as "largely emotional, though having in it something of the element of both the intellectual and the volitional."[85]

B. T. Tanner, Veitch, and Steele shared an emphasis on personal experience as the means to know God; a stress on faith as a combination of emotion, intellect, and action; and an equation of seeing and believing. Importantly, these same trends shaped Tanner's artistic training and the critical reception of Tanner's religious paintings. Eakins associated "seeing correctly and thinking profoundly," and insisted that students learn through close study of the visible world.[86] His lessons would have been reinforced in Tanner's Parisian studies, since Eakins patterned his program of study on the École de Beaux-Arts. The artist's extended trips to the Holy Land, purchase of Oriental props, and concern with finding appropriate models further solidified his belief in sight as a means to verify truth.

Tanner's participation in the wider Protestant movement to encourage devotional engagement with works of art in order to form personality and maintain social stability is indicated further by the way he constructed his artistic identity and his patronage.[87] Some of Tanner's earliest works revolutionized fine art representations of African Americans. However, not only did Tanner stop producing genre paintings but he ceased submitting those paintings to exhibitions and omitted them in discussions of his artistic career after the international success of his religious works. Although a few of the early paintings were visible to African Americans at the Wilberforce University Library and Hampton Institute Library, only *The Ox-Cart* appears to have been exhibited after 1897 and only Scarborough seems to have discussed them.[88] Moreover, Tanner's interactions with Robert C. Ogden, one of his most ardent supporters and a partner in the Wanamaker dry-goods business, indicate that Tanner resisted attempts by his patrons to market him as a black artist and that he self-consciously worked to fashion himself as a religious painter. For example, in a letter to Harrison Morris, managing director of the Pennsylvania Academy of the Fine Arts, Ogden mentioned that Tanner's race could be used to create a market for his pictures, but the artist resisted these efforts.[89] Later Ogden responded positively to Tanner's idea for a large, perhaps traveling exhibition of his religious pictures, modeled on Tissot's successful show in 1898.[90] The artist's first solo show in the United States in 1908 matched this description. Thus, although Tanner emphasized his frustration with the lack of black patronage throughout his career, he sought to establish an artistic identity independent of his race and one based on religious painting in particular.[91]

Consuming Art and Culture

B. T. Tanner argued that the AME Church embodied the highest ideals of Christianity and American democracy. He shared his belief that Christianity subsumed nationhood with turn-of-the-century merchants who saw no distinction between religious belief and commercial culture. A brief look at Tanner's patrons references the ways in which

Tanner's conception of an interior religious life helped prepare Americans for their new roles as modern consumers.

Ogden, for example, belonged to a new category of merchant who knew the selling power of images and advocated the use of illustrations.[92] His patronage of artists was consistent with his belief in the educational power of visual culture. In an article for *The Dry Goods Economist*, he wrote that advertisers had a responsibility to bring art to the ordinary people: "I have no doubt whatever that the high priests of art would sneer at the statement that art in advertising is art for humanity's sake; but, nevertheless, such is the case."[93] As president of the board of trustees of Hampton Institute in Virginia, he put his ideas into practice by donating one of Tanner's early genre paintings, *The Banjo Lesson*, to Hampton in 1894. Art and advertising were part and parcel of the same consumer culture, used to promote Christian values and sell novelty items.

Odgen's belief in the power of the visual played a significant role in John Wanamaker's successful department store enterprise. Before transforming the abandoned Pennsylvania Freight Station into one of the first modern department stores in 1876, Wanamaker invited the famed evangelist Dwight L. Moody to conduct a revival on the property. Properly anointed, his department stores grew alongside philanthropic efforts that centered on the practice and progress of Christianity around the world.[94] His son, Rodman, who took over the stores when his father died and upheld his business philosophy, was one of Tanner's most significant patrons. He funded the artist's first trip to the Holy Land after seeing *The Resurrection of Lazarus* in his Parisian studio, and another a few years later. Both father and son relied on more than impressive window displays and Parisian fashion to bring consumers into the store; they produced multisensory spectacles that included transforming the Grand Court into a church during the holidays and providing free concerts and performances. The elder Wanamaker even sought to transform museum spaces, which he deemed far too cluttered, by creating a "studio" in his store that highlighted pieces from his personal art collection on a rotating basis.[95] The two Wanamakers deemed art and mass-produced objects important instruments for promoting the gospels of Christianity and commerce.

In sum, Tanner's European American patrons like Ogden and Wanamaker believed their Christian faith shaped their social convictions and business enterprises. Moreover, they believed Tanner's artwork enhanced their mission. His paintings communicated their belief in Christianity as the means to progress and civilization and in the visual as a means to the hearts and minds of faithful consumers. The consumption of art was part and parcel of the consumption of mass-produced objects; to see is to appreciate beauty, to imprint values upon the soul, and to participate in American consumer culture.

Here, it is useful to return to one of the most provocative sentences in Bishop Tanner's lectures. Quoting an unnamed authority, he asserted that "by the presentation of visible objects to the eyes, divine truths may be most vividly photographed on the soul."[96] Relying on Methodism's emphasis on heart religion and his belief in object-centered

learning as a means to God, B. T. Tanner stressed the importance of vision as a mediating force between the material and divine worlds. His son's artwork sought to "present visible objects" to the eyes of the beholder in order to imprint "divine truths" upon his or her soul. Like symbols, Tanner's paintings served as means to religious knowledge. He created paintings that summoned the interaction of the spectator. The viewer was called to commune with the picture in order to experience God and know God for himself or herself. Tanner's son, Jesse, summarized the artist's endeavor: "The public . . . wanted to see every button on the coat. My father wanted the public to commune with the picture and the subject, and everybody was expected to bring something out of themselves."[97]

The success of Tanner's religious art rested on the individual beholder's engagement with the painting. Importantly, the religious experience represented and encouraged was not communal in nature, nor was it expected to teach a lesson. It was intended to make the viewer "feel" what the biblical figures felt, to transport the beholder into another time and place. Tanner's attention to the individual believer, as opposed to a religious community, is embedded in his paintings. The majority of his images include only a few figures, and those that depict large groups contain figures that are easily distinguished from one another. As one critic put it, "They are living and breathing persons, and each one acts according to his character."[98] So, Tanner's paintings call on the theology of the AME church and its attention to object-centered learning to encourage the viewer's personal engagement with the divine. Importantly, this form of personal engagement is more in keeping with Victorian values and the process of modernization than with the vernacular traditions of the Southern freedmen.

Tanner's paintings forged a mode of aesthetic engagement predicated on religious experience, and incited religious emotion through individual encounters with works of art. First, he noted that art, like religion, required the active cooperation of the viewer and believer. Second, he believed that art and religion mediated the material and spiritual realms, enabling the beholder to encounter the divine and know the unseen through close attention to the visible world. Third, Tanner asserted that aesthetic experience, like religious belief, was individual in nature. Both enabled a personal relationship with the divine that brought meaning to the inexplicable. At the same time, however, Tanner's paintings induced a visual encounter that carried political resonances. By assuming that Christianity was the means to racial equality and unity at home and abroad, the paintings (to use Tanner's own words) "give the human touch 'which makes the whole world kin' and which ever remains the same."[99]

Art for Religion's Sake

F. Holland Day and The Seven Last Words of Christ

In the summer of 1898, photographer F. Holland Day and a coterie of friends and professional models ascended a hill outside Boston to perform Christ's life, death, and Resurrection for the camera. Selected for their presumed resemblance to the biblical figures, dressed in costumes with designs "furnished by archeological investigation," and fastened to crosses "in the same manner as the Christ was supported in the Oberammergau Passion Play," the participants helped Day produce over 250 studies—with the artist himself playing the role of Jesus Christ (plate 5). The photo series drew an intense and varied response from artists, critics, and journalists at home and abroad. The American critic Charles Caffin derided it, contending that "surely claptrap and misappreciation of the province and mission of art could go no further." But Edward Steichen, Day's friend and student, countered that "few paintings contain as much that is spiritual and sacred in them as do the 'Seven [Last] Words' of Mr. Day."[1]

The extensive debate prompted by Day's sacred series at the turn of the century tends to obscure the fact that his selection of religious subjects was not unprecedented, either in the United States or in Europe. His photographs followed Oscar Gustav Rejlander's *Head of St. John the Baptist on a Charger* (ca. 1858) and Julia Margaret Cameron's images of the Madonna and Child (1860s), as well as Charles I. Berg's *Madonna* (1898), Louis Bonnard's *Déploration du Christ* (1880s), L. Bovier's *Christ au tombeau* (1896), John E. Dumont's *Weeping Magdalen* (1897), and others exhibited in salons or published in journals. Nor was Day the only photographer of his era to use religious language to express the photograph's ability to transcend the material world. Cameron described the photographic portrait as "the embodiment of a prayer," and

Alfred Stieglitz claimed photography "represented . . . a religion" and that his cloud prints, the *Equivalents*, were "direct revelations of a man's world in the sky."[2] In his work and writings, Day endorsed more than a metaphorical relationship between religion and photography; he underscored the shared philosophical presuppositions of religious devotion and aesthetic experience.

In this chapter, I explore the vague but tenacious relationship between photography and religion at the end of the nineteenth century and, more specifically, religion's influence on the rise of an art-for-art's-sake viewing posture. Like many turn-of-the-century American artists, Day called on a shared visual vocabulary of mass-produced religious imagery, tableaux vivants, Passion plays, travel lectures, and early films to translate Christian beliefs and devotional practices into works of art that impelled new relationships between the viewer and the object. These established customs and innovative technologies overlapped with new spiritual traditions that found broad support among the cultural elite and reinforced the increasing attention to personal religious and aesthetic encounters. In short, Day's sacred series helped to establish protocols of active spectatorship that underscored the formation of modern aesthetic theory in the first decades of the twentieth century.

The Aesthetic and the Spiritual

F. Holland Day was the only child of affluent parents, who financially supported his forays into book collecting, publishing, and photography. Boston's aesthetic scene provided a supportive milieu for his interests. In the 1890s his group of friends was a virtual who's who of the up-and-coming Boston intellectual elite, including art critic Bernard Berenson; painter Thomas Meteyard; poets Bliss Carman and Richard Hovey; designers and printers Bertram Grosvenor Goodhue, Bruce Rogers, and Francis Watts Lee; architect Ralph Adams Cram; and publisher Herbert Small.[3]

Day's myriad literary and artistic activities challenged Boston's cultural mainstream. After he and his friend Herbert Copeland began a publishing firm modeled on William Morris's Kelmscott Press in England in the early 1890s, their names became synonymous with excellence in bookmaking and arts and crafts design. But they also earned a reputation for challenging Victorian sensibilities through their selection of avant-garde texts. The firm published Cram's *The Decadent: Being the Gospel of Inaction*, Carman and Hovey's *Songs from Vagabondia*, Stephen Crane's *The Black Riders and Other Lines*, Oscar Wilde's *Salome*, and ten issues of John Lane's *The Yellow Book* with illustrations by Aubrey Beardsley.[4] Day's association with a "decadent" brand of aestheticism was further solidified by the business relationships and friendships he developed during his travels to England in the late 1880s and early 1890s, when he became personally acquainted with Wilde, Lane, and Beardsley as well as the bookseller and photographer Frederick Evans and the Irish poet and playwright William Butler Yeats.

Day's aesthetic interests were accompanied by devotional pursuits. He and his friends searched for religious experience in unconventional as well as traditional sources. His New England Unitarianism, for example, was supplemented by attendance at High Anglican services and the Roman Catholic mass. His publishing firm also printed a large number of Roman Catholic writers and one of the first translations of Yiddish poetry.[5] Along with other Boston intellectuals such as William James, Day investigated alternative spiritual traditions, frequenting séances and lectures by noted mediums. He corresponded with the American Society of Psychical Research and consulted the famed Spiritualist Leonora Piper. He also explored cabalism, Mormonism, mysticism, the occult, Rosicrucianism, Theosophy, and a variety of Eastern religions.

Day's literary and spiritual interests coalesced around the priority he placed on artwork as a means to transcendence. As a publisher and collector, he treated texts as material objects, carefully selecting the appropriate paper, ink, typography, and design. Many of the nine hundred volumes in the personal library he had accumulated by age twenty-one were first editions. Day's admiration for particular writers extended beyond their literary works to encompass the traces they left behind. His captivation with poet John Keats, for example, led him to be "always in poor John Keats's track," visiting and photographing every place the poet lived, visited, or referenced. He even acquired the poet's death mask, making a friend's somewhat tongue-in-cheek reference to Day's extensive collection of Keats's items as "relics" quite pertinent.[6]

Day also collected Roman Catholic art and ritual objects. These included a wooden Madonna, processional cross, and censer—which he lent to exhibitions organized to raise money for philanthropic causes in 1892 and 1895—as well as an assortment of occult objects known to prompt religious experience, including a Japanese lacquer box and a crystal ball (fig. 17).[7] The objects in his collections are important because they serve as models for how the artist intended the beholder to attend to his photographs. Traditionally, icons portrayed a recognizable likeness of the sacred subject and made that figure present for believers. Occult objects, too, functioned as a means to transcendence. For example, it was thought that rubbing a Japanese lacquer box activated emanations that would enable communication with the spirit world. Both sets of objects required an active viewer or willing participant to generate meaning. In effect, they needed believers, people who shared a common set of tenets and practices that structured how they interacted with objects and understood their functions. Day's most elaborate attempt to theorize the relationship between the viewer and his photographs and to prompt the beholder's engagement with them appeared in the production of his sacred series.

A "Modern Sacred Art Affair"

Substantial time and preparation went into Day's "Modern Sacred Art Affair," so titled in a letter to the photographer from his close friend Louise Imogen Guiney. Day first

Figure 17. F. Holland Day, *Beauty Is Truth, Truth Beauty*, ca. 1896. Sepia-toned platinum. Prints and Photographs Division, Library of Congress, Washington, D.C.

Figure 18. F. Holland Day, *The Entombment*, ca. 1896. Photographic print. Prints and Photographs Division, Library of Congress, Washington, D.C.

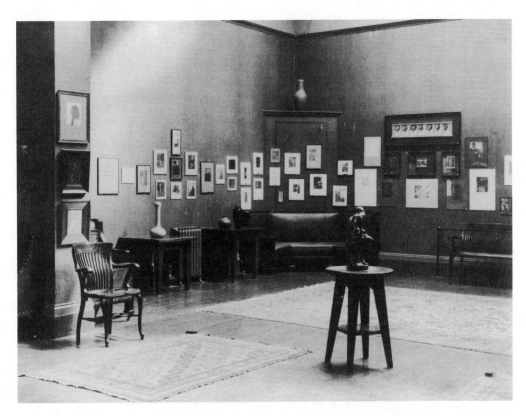

Figure 19. National Arts Club exhibit, 1902. Photograph from the Yale Collection of American Literature, Beinecke Rare Book Room and Manuscript Library, Yale University.

experimented with religious subject matter by depicting Guiney, a Roman Catholic poet, as Saint Barbara (1893) and himself as Christ in the *Entombment* (fig. 18). Two years later, from July to September 1898, Day created his major body of work in this realm—more than two hundred and fifty photographs that captured a range of subjects including Christ's baptism, Crucifixion, entombment, and Resurrection. He chose a spot twenty miles outside Boston, where "no stone fences or New England barns might be seen in the distance." He sought advice from friends and selected his models carefully. Day also claimed that "much of the drapery used upon these figures were real costumes of antique pattern, such as were used at the time of the actual crucifixion, and procured from Assyria and Arabia; others were manufactured here from designs furnished by archeological investigation."[8] Soon after their completion, the photographs were exhibited extensively in a variety of frames and groupings, as illustrated in the display of Day's works at the 1902 exhibition on American pictorial photography at the National Arts Club in New York (fig. 19).

A brief analysis of Day's *The Seven Last Words of Christ*—one of the more successful and most often exhibited pieces from the series—reveals the iconographic traditions

and protocols of spectatorship Day relied on in his photographic production (plate 6). The work is made up of a sequence of seven photographs that narrate Christ's Passion. Theatrical lighting distinguishes the sacred figure's darkened and detailed face from the empty background, which renders the emaciated body first nebulous, then invisible. Day titled each photograph on the frame's frieze—set on a series of pilasters with Corinthian capitals—where he inscribed phrases spoken by Jesus in the four Gospel accounts. He then positioned Christ's head and directed his eyes in a manner that illustrated the martyr's facial response to the Crucifixion.

To viewers well versed in the Passion and liturgical traditions, the narrative of Day's *Seven Last Words* may have read something like this: in the first photograph, Christ's eyes look to heaven as he pleads with God to save those who condemn and crucify him, "Father, forgive them. They know not what they do" (Luke 23:24). The soldiers, however, continue to taunt him, as does one of the criminals crucified next to him. The second criminal rebukes the first, repents, and asks Christ to remember him in the kingdom of heaven. Christ looks over to the penitent criminal and proclaims, "Today, thou shalt be with me in paradise" (Luke 23:43). Later his mother, Mary, finds her way through the crowd and sits at the foot of the cross with one of the disciples. Christ looks down to comfort the pair and reminds them that all people are members of God's family: "Woman, behold thy son. Son, thy mother" (John 19:26–27). Time passes, and he looks up to God again and cries out in a loud voice, "My God, my God, why hast thou forsaken me?" (Matthew 27:46; Mark 15:34) (fig. 20). When he senses death's final approach, he looks down at those who remain at the site, declares "I thirst," and receives a sponge soaked in sour wine from one of the few remaining bystanders (John 19:28). Then, as the temple curtain tears in two and the earth shakes, Christ looks to God, closes his eyes in resignation, and says, "Into thy hands I commend my spirit" (Luke 23:46). He bows his head and dies: "It is finished" (John 19:30).

A Shared Vocabulary

Far from unique in its visual environment, Day's sacred series echoed well-known representations of the Passion in both fine art and popular culture. The *Seven Last Words* can be seen as a series of quotations from old master paintings, particularly renditions of *The Crucifixion* by Diego Velázquez (a print of which Day purchased for his own collection) and Guido Reni (fig. 21). More to the point here, the iconography established by the old masters and appropriated by Day saturated the visual culture of American Christianity, composed of popular prints, stereo photographs representing Christ's life, illustrated Bibles and Life of Christ books, tableaux vivants, and theatrical and cinematic productions of the Passion.

The shared visual vocabulary is clear in photographs like *Crucifixion with Mary, Mary Magdalen, Joseph, and Saint John* (plate 5). Compare Day's image to a contemporary

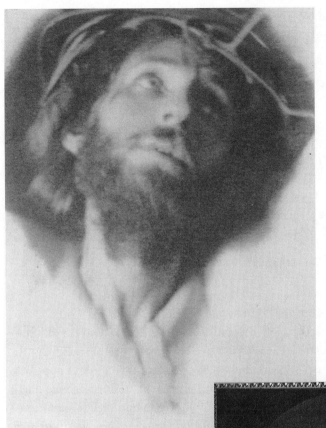

Figure 20. F. Holland Day [Christ with crown of thorns, looking up], 1898. Photographic print on large French mat: platinum. Prints and Photographs Division, Library of Congress, Washington, D.C.

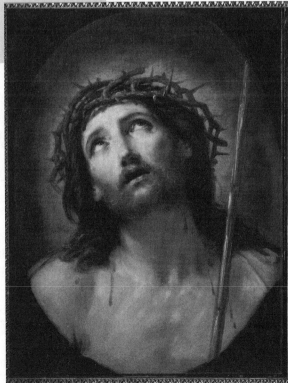

Figure 21. Guido Reni, *Ecce Homo*. Louvre, Paris. Photo Credit: Erich Lessing/Art Resource, New York.

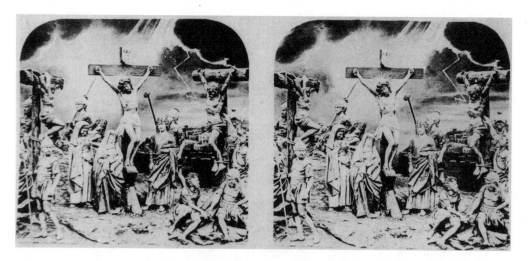

Figure 22. *The Crucifixion*, n.d. Stereo photograph. Ingersoll View Company, St. Paul, Minnesota.

reproduction of Velásquez's painting; a stereo photograph of Christ's death on the cross; a Crucifixion tableau from the 1890 Oberammergau Passion Play; and a still from an early cinematic portrayal of the Passion, also at Oberammergau (figs. 22–24). In almost every representation, the actors are dressed in layers of flowing robes popularly associated with the time of Christ. They are static, frozen in position. Exaggerated gestures communicate their emotional states to the viewer, while their conventional poses, costumes, and props heighten the theatricality of the scene. For the most part, Christ has light skin, long dark wavy hair, and a beard. His head hangs down and toward his right; his naked body is draped with a white loincloth. If other figures are present, they appear at the foot of the cross, women embracing the base and men gazing upward at Christ's body.

Day mined the visual culture of American Christianity for more than religious iconography; he relied on the protocols of viewing that animated popular forms to induce particular ways of seeing. He assumed that if his photographs mirrored standard depictions of the sacred subject, spectators would respond to them as they would to other turn-of-the-century representational forms. In the process of viewing, they would access the universal through the particular and eclipse the two thousand years separating Christ and his representation.

Day relied on tableaux vivants because they offered a model of spectatorship that one contemporary writer declared could "assimilate the real with the ideal."[9] Staged in upper- and middle-class parlors, at charity fund-raisers, civic and religious pageants, and additional social settings of domestic and mass entertainment, tableaux vivants were also essential to productions of the Passion play, like that held once a decade in Oberammergau, Germany. Day attended and photographed the daylong, multimedia event in 1890, which featured dramatic tableaux of every aspect of

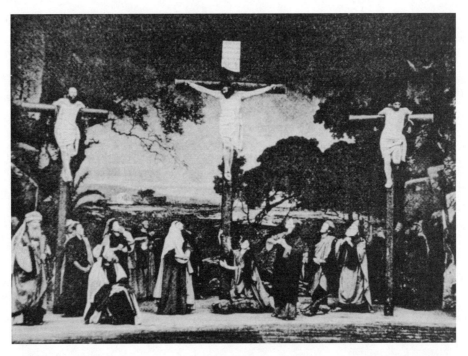

Figure 23. Carl Stockmann, *On Calvary*. From William T. Stead, *The Story That Transformed the World: or the Passion Play at Ober Ammergau in 1890* (London: Review of Reviews, 1890), 139.

Figure 24. Richard G. Hollaman, *Passion Play of Oberammergau*, 1898. Film frame. Image courtesy of Motion Picture Department, George Eastman House, Rochester, New York.

Christ's Passion based on fine-art paintings and which almost certainly inspired his later foray into religious representation.

In tableaux, the heroic and historic were translated into the prosaic world of everyday life in the present and made accessible through a visual language shared by the wider community. This language was premised on facial expression, gesture, and pose—on signs that represented interior sentiments. Such theories of human expression, supported by Charles Darwin's *Expression of Emotions* (1872) and long employed in academic art practices, explicitly linked human expression and internal emotional states. The resulting visual vocabulary standardized the meaning of external signs. Importantly, nineteenth-century liberal Protestants advocated art's edifying and devotional functions on the basis of this relationship between material signs and internal emotional states, which enabled the artwork to transmit and communicate feeling.[10]

Day's decision to photograph rather than paint New Testament scenes accentuated the assumptions implicit in tableaux regarding the relationship between an external sign and its commonly held meaning. Indeed, documenting the relationship between physical appearance and inner character was one of the foremost social uses of photography in the second half of the nineteenth century. The medium's popular reputation for scientific accuracy, attention to detail, and "objective" reproductive ability made it the perfect vehicle to standardize and champion the "legibility of appearances." Francis Galton's promotion of composite portraiture and Alphonse Bertillon's deployment of the "mug shot" are two examples of the multiple ways photography was applied to grant visible proof of criminality, mental illness, racial difference, and disease in newspapers, academic studies, and police stations by the 1890s (fig 25).[11]

The *Seven Last Words* can be linked to such diagnostic photographic practices, visually and conceptually, in several ways. The formal composition of the work consists of a series of isolated head shots set against a nondescript background that is similar but not identical to Galton's and Bertillon's scientific systems of representation. Day's series of photographic stills also denotes specific moments in the biblical narrative, much as Eadweard Muybridge's photographic studies of animal locomotion delineate each stage of a subject's physical movement. Day selected models based on their physical characteristics and inner character, indicating his reliance on physiognomic modes of interpretation. And the success of Day's work rests on the assumption that a model can represent Christ. All of these link Day to what historian Miles Orvell has called the "typography of nineteenth-century photography," in which a photograph both represented the pictured subject and stood in for a more general class of subjects.[12] While tableaux were seen to assimilate the corporeal body with the ideal figure, photography coupled the specific and the type. It enabled the subject of representation to be himself or herself as well as the general subject depicted.

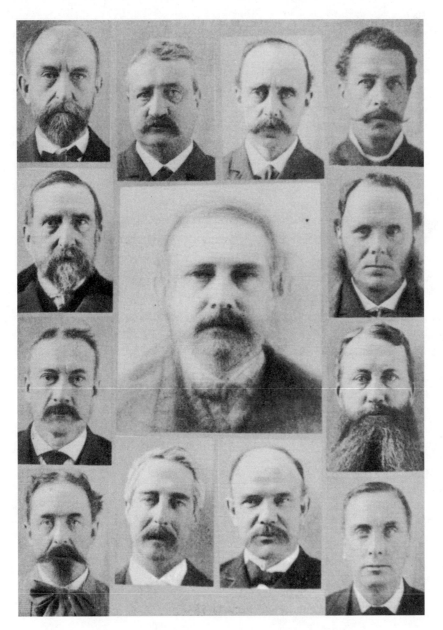

Figure 25. *Twelve Boston Physicians and Their Composite Portrait*, ca. 1894. From H. P. Bowditch, "Are Composite Photographs Typical Pictures?" *McClure's Magazine* 3 (September 1894): 333.

Vicarious Experience

Day's use of the camera to capture subject matter associated with the life of Christ was consistent with additional applications of photography, including its use by Christian apologists to uphold the authority of religion in a period marked by challenges to faith. It was presumed that the Holy Land had not changed since Christ's lifetime, and that close study of its inhabitants, landscape, and material culture would provide accurate knowledge of that historical reality. Late nineteenth-century photo books such as the N. D. Thompson Company's *Earthly Footsteps of the Man of Galilee* (1894) attempted to document every place the Savior visited, each road he walked along, and each view he beheld. Art historian John Davis writes that the photographs were seen to testify to the Bible's authenticity and reaffirm the centrality of scripture to Protestant belief by providing visual access to the landscape. The Holy Land functioned as tangible evidence of Christ's material reality; faith was fortified through personal observation and experience.[13]

Day's reliance on archaeological accuracy in the sacred series situated his photographs within the wider visual culture of "Holy Land consciousness" that included (in addition to the photographs already mentioned) panoramas, stereo photographs, and material re-creations of the Holy Land such as Palestine Park in Chautauqua, New York. There, visitors were encouraged to dress in oriental garb and traverse a scale model of Palestine made of stumps, sawdust, and sod. Perhaps the most elaborate illustration of America's appropriation of the biblical story as its own national history and destiny was the "Jerusalem" section of the Louisiana Purchase Exposition in 1904, an eleven-acre re-creation of Palestine that included the Church of the Holy Sepulcher, the Wailing Wall, and over a thousand actual inhabitants of the Holy Land who were "imported" for ethnographic authenticity.[14] These multisensory, embodied experiences were understood to present history and progress as well as the essential nature of religious truth.

From the outset, contemporary viewers inserted Day's sacred photographs into the larger discourse aimed at authenticating Christ's historical and eternal realities. On January 17, 1899, the *Boston Herald* announced:

> Sacred Art Modernized:
> Photograph of the Crucifixion from Living Figures. . . . The Models
> for His Group Clothed with Historical Accuracy. Scene Selected in
> Norwood [Massachusetts] Represented as Nearly as Possible Natural
> Features of Calvary.[15]

By paying careful attention to historic details of the figures' clothing, selecting a landscape thought to be similar to Palestine, and erasing all signs of contemporary New England life, Day created a "Photograph of the Crucifixion." His use of scientific

evidence collapsed temporal disjunctions. "Living figures" represented an event that occurred almost two millennia earlier and attested to eternal truth.

Importantly, Day's use of conventional iconography heightened the look of historical accuracy in the eyes of many contemporary viewers. Commenting on the sacred series, the French photographer and critic Robert Demachy noted: "I could say that had the sacred scenes been composed and photographed in the Holy Land, on the actual spot itself, people would have refused to recognize the genuineness of the surroundings, for our conception of local accuracy is taken from the false and conventional teachings of the necessarily conventional rendering of the painter."[16] In this way, Day's religious photographs conformed to another pattern of spectatorship familiar to turn-of-the-century audiences. Americans accepted replications of all sorts and believed mechanical reproduction could generate faithful simulacra of the "real." Viewers were aware of the photograph's staging, enjoyed the visual conundrum it posed, and judged it according to whether or not it was convincing—not on its "truthfulness."[17] Like contemporary history paintings of the Old West and colonial America that relied more on the popular imagination than geographic or historical accuracy, and trompe l'oeil pictures that encouraged viewers to participate in their own deception, Day's photographs took part in this culture of vicarious experience. He supposed spectators would relate his photographs to other religious reproductions, marvel at the similarities, and attend to the works as they would the sacred subject.

Resurrecting Christ

Day's reliance on the iconography and conceptual underpinnings of tableaux, Passion plays, and photographs of the Holy Land indicates that he could presume spectators would integrate the historic and represented Christ while looking at his religious photographs. Day's *Seven Last Words* demands additional investigation because it chronicles the Passion, in contrast to other works in the sacred series that render a single episode from a biblical story (fig. 26). Moving from left to right and following the dictates of English grammar and sentence construction, the series invites an extended mode of looking that does not end with the final image. Christ's eyes both respond to the Gospel narrative and serve as a guide for the act of beholding it. They lead the viewer to the text, back to previous photographs, down to the base of the frame, and back again. The photographs work in pairs, often doubling back on each other. The result is a sequence of photographs that create circular spaces of viewing, as the first and final photographs direct the viewer up and to the right, and down and to the left. The beholder is required to complete two interrelated narrative functions: to fill in the Passion narrative between Christ's seven utterances and to connect Christ's physical and facial movements from scene to scene. In this way, the *Seven Last Words* bears striking parallels to additional forms of middle- and upper-class entertainment: travel lectures and early cinema.

Figure 26. F. Holland Day. *Touch Me Not . . .* , ca. 1898. Photoprint. Prints and Photographs Division, Library of Congress, Washington, D.C.

All three required viewers to supply an overarching narrative thread to discontinuous still or moving images.

Day's sequence employed close-up and dissolving-view effects similar to those employed by John L. Stoddard, one of the most popular speakers on the travel-lecture circuit. Showmen like Stoddard used stereopticon slides and colorful narratives to guide their audiences to far-off destinations they could not afford the money or time to visit firsthand, evoking for them the history and culture of places ranging from Constantinople and India to Mexico and Norway. Stoddard also delivered a series on the Oberammergau Passion Play in 1880 and again in 1890, which included details of the play's production, historical information, and contemporary commentary. In his performance, Stoddard presented slides of fine art representations alongside photographs of the event. He also attempted to represent movement by dissolving between two lantern slides of still images, the first depicting Christ's head raised toward heaven, and the second Christ's head bent forward in death. Not only did Stoddard prefigure the movement represented by the final two photographs of Day's *Seven Last Words* but he also spoke some of the same biblical passages Day etched on the frame: "Finally it is evident that the end draws near. / With a loud voice he cries at last: / 'Father, into thy hands I commend my spirit.' / His head droops wearily upon his breast. / It is finished!"[18]

Spectators' responses to Stoddard's lectures indicate a close relationship between the terminology employed to describe the beholders' experience and popular rhetoric characterizing religious enthusiasm: "The drama and realism of [Stoddard's evocation of Christ's last moments] was reputed to have affected audiences tremendously, causing weeping and (if the reports can be believed) fainting."[19] This description of swooning participants suggests the degree to which modes of reception popularized by camp meetings, religious revivals, and new spiritual movements pervaded all forms of religious experience. Such "involuntary" expressions became part of larger religious and cultural practices. Viewers of the travel lectures or Day's photographs would have been taught how to respond to such imagery, both intellectually and bodily, according to their denominational affiliation, intellectual training, gender, and race, among other factors.[20] Day's *Seven Last Words* participated in a model of religious experience predicated on certain forms of bodily knowledge and learned responses.

Such culturally conditioned modes of religious experience helped American audiences merge the historical person of Christ with popular conceptions of him. The process of reconciliation, however, was not as seamless as the recorded reactions to Stoddard's lecture indicate. Contemporary responses to cinematic representations of the Passion clarify the series of conceptual shifts viewers had to make to effect religious experience.

Christ's life, particularly the Passion story, was a central subject in the development of narrative cinema. Early film, best described as a "cinema of attractions," followed a format similar to that of vaudeville and variety shows and drew on traditions of

popular entertainment like lantern slide shows, magical theater, and stereographs.[21] Viewers acknowledged the visual tricks produced by the director or performed by the demonstrator and marveled at their technological innovation. Early film versions of the Passion play were no different; the individual showman choreographed a presentation of more than twenty separate films (purchased individually or in sets), lantern slides, lectures, and music. For example, *The Passion Play*, filmed in Horitz, Austria, was a ninety-minute multimedia presentation, accompanied by a lecture, slides, organ music, and hymns.

Day's *Seven Last Words* presumed the active spectatorship demanded of early cinema as well as the beholder's willingness to overlook obvious representational signs and consider the subject "real," much as the visitors did at Palestine Park and the Jerusalem section at the Louisiana Purchase Exposition. Perhaps not coincidentally, Day began his sacred series just a few months after *The Passion Play* was shown at the Boston Museum and reviewed positively in the *Boston Herald*. The newspaper's review of the film is central to understanding how at least one spectator made sense of the representation—and, perhaps, how Day assumed beholders would commune with his photographic series.

The newspaper critic claimed the film was successful because it enabled the beholder to forget, in succession, the technological achievements of the film, its documentary nature, and its theatrical form. The writer claimed that "at first the spectator thinks of the pictures only as a representation of a representation—regards them in the light of an effort to show how the peasants at Horitz acted their 'Passion Play.'" The spectator's fascination with the film's technological novelty was soon replaced by his documentary interest in Austrian peasant life and the staging of the play: "The thought that one is gazing at a mere pictorial representation seems to pass away, and in its place comes, somehow or other, the notion that the people seen are real people, and that on the screen there are moving the very men and women who acted the 'Passion Play' last summer in the Bohemian forest to the delight of thousands of foreigners." Once the viewer's interest in the introductory scenes of the Old Testament builds, and the New Testament narrative begins, a "new change of the mental attitude" takes place. "So absorbing becomes the interest of the pictures that the onlooker, from merely regarding the figures as the figures of the real, live people who acted the play in Bohemia, begins to forget all about what was done in Bohemia and henceforth is lost in the thought that the faces and forms before him are the real people who lived in Palestine 2,000 years ago, and with their own eyes witnessed the crucifixion of Christ."[22]

According to the *Boston Herald* critic, after the spectator extricated the performance from its representational form and deemed it real, she or he witnessed Christ's life and death. In the case of Day's *Seven Last Words*, viewers called on their knowledge of religious iconography and devotional experiences to construct a coherent story and participate in the drama. By creating photographs that looked similar to popular representations of Christ and invoking communally shared forms of knowledge and experience, Day sought to evoke the appearance and presence of the divine in everyday life.[23]

Divine Imprints

Because Day expected viewers to play an active role in resurrecting the historic Christ, his religious photographs were quite different from attempts in the same era to provide tangible evidence through photography for the veracity of Christian teachings and certainty of an afterlife. The growth of Spiritualism, which advocated communication with spirits through human mediums, for example, and psychic research, which encouraged serious scientific investigation into the paranormal, coincided with the development of photography. Supporters believed that just as photography could capture the "invisible," including sound waves, the flight of bullets from firearms, and, later, X-rays, it could also capture spirits materialized during séances conducted by mediums.[24] So-called spirit photographs provided visual evidence for the reality of spirits and a rational basis for religious belief.

Visual technologies were also seen as having the power to effect religious experience in other ways. In the same year that Day created his sacred series, twelve films of Pope Leo were photographed and shown on a Mutoscope, an early motion picture device based on the principle of the flip-book, enabling audiences in the United States to see the Roman Catholic leader and his movements for the first time (fig. 27). The pope allowed a photographer to enter the Vatican gardens to record a number of religious events, including his blessing the American people. This led to a debate in Catholic circles about whether the benediction was bestowed every time the film was shown. Although the apostolic delegate to the United States renounced that possibility immediately, stating that the ability of a moving picture to bestow "a blessing is certainly an absurdity," the debate highlighted film's capacity to evoke a real religious presence, not simply the representation of one.[25]

More significantly, the *Photogram*, a British photographic journal that had reproduced a number of Day's religious photographs, linked them to Signor Secondo Pia's photograph of the Shroud of Turin in its 1899 year in review (fig. 28). "A curiously interesting and somewhat kindred piece of work [to Day's photographs] was the alleged miraculous impression of the body of Jesus, recorded on the Holy Shroud of Turin, and revealed in the photogram made by Signor Pia," it reported. Pia photographed the shroud that Joseph of Arimathea allegedly wrapped around the Christian savior after his death on the cross. Although the shroud contained the impression of the divine body, it did not become "visible" until Pia photographed it, revealing a "beautiful and perfect likeness" of Christ. Authenticated by the Vatican's Committee of Sacred Art, Pia's works provided "permanent testimony" of Jesus's sacrifice.[26] In fact, the testimony of the photograph was clearer than that of the shroud itself, privileging the photograph as the site of Christ's historic and miraculous presence.

Like spirit photography, the Mutoscope's representation of Vatican life, and the Shroud of Turin, Day's *Seven Last Words* was meant to represent the spiritual in material form

Figure 27. American Mutoscope Co., *Pope Leo XIII*, ca. 1898. Prints and Photographs Division, Library of Congress, Washington, D.C.

and employed the photograph as a medium between the two realms. The distinction between them lies in the relationship they posited between reality and the supernatural. Whereas the other photographs aimed to substantiate the divine in visual form through the subject of the image, Day aimed to do so through the viewer's encounter with the work—through human experience rather than scientific verification.

Ritual Engagement

Day's reliance on mainline American Protestant belief and practice in the production of the *Seven Last Words* overlapped with the influences of Roman Catholicism, symbolist aesthetic theory, and Theosophical writings. Day's fusion of practices generally considered at odds with one another—including entertainment and devotion, commercial success and religious truth, popular culture and high art—speaks to his varied and eclectic interests. More generally, it speaks to the fluidity of the cultural field and the remarkable parallels of the prosaic and avant-garde at the turn-of-the-century.

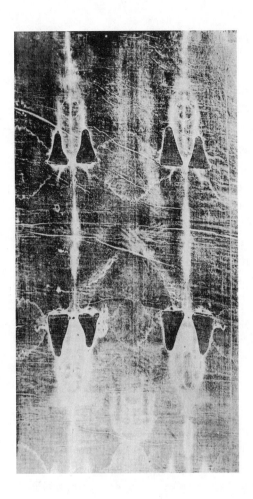

Figure 28. Secondo Pia, *The Shroud of Turin*, 1898.
From *Photogram* 5, no. 60 (December 1898): 365.

Day's composition of the *Seven Last Words* echoed a Roman Catholic ritual per-
formed during Holy Week and an orchestral composition by Joseph Haydn, commis-
sioned specifically for that service in the 1780s. Day's interaction with Boston's Ro-
man Catholic community was considerable. He published a Roman Catholic list with
Copeland and Day; developed close ties to Roman Catholic charities and organizations
in Boston; and often participated in the Church's rituals. He attended Holy Week ser-
vices with Guiney and did so the Easter before producing his sacred series. Moreover,
Day, in all likelihood, attended a performance of Haydn's the *Seven Last Words* in Boston
in 1899 and was certainly aware of its devotional character, ritual presentation, and
evocative power.[27]

The Seven Last Words was a devotional rite performed in Roman Catholic churches
during Holy Week.[28] On Good Friday, the celebrant would pronounce one of the Seven
Words from the pulpit, discuss it, and kneel before the altar while the congregation
listened to the chorus, sang hymns, said prayers and, most importantly, contemplated
Christ's pain and suffering. Haydn composed the *Seven Last Words* for the yearly event

held at the cathedral of Cadiz, and it followed, in both form and function, the ritual's ceremonial structure and theological intent.[29] The piece comprised seven sonatas, an introduction, and a conclusion, each titled after one of Christ's Seven Last Words (just like Day's photographs). The words served as inspiration for the sonatas, which, in turn, represented and evoked the text. Deep cries accompanied by rests, outbursts contrasted with sighs, intense call and response between soloists and the chorus: all served to dramatize the narrative and draw the listener into Christ's pain and suffering.

Day's *Seven Last Words* referenced Haydn's composition and the Catholic Church's Lenten ritual in its title and its sequential arrangement of seven photographs. Each photograph provided a place to focus one's attention on the word of Christ. Moments of respite or meditation were encouraged by the columns that interrupted the visual narrative, allowing the viewer time to contemplate the previous picture and adjust to the next photograph's message.[30] By calling attention to the work's relationship to formal ecclesiastical practices, Day encouraged a devotional engagement with the *Seven Last Words* that encouraged the beholder-listener to overcome the historical moment and achieve atonement with God. More specifically (and perhaps a bit ironically), Day promoted an extended mode of looking that corresponded with the mystical notion of "silence" described by the symbolist writer Maurice Maeterlinck and the Theosophist Madame Blavatsky.

Maeterlinck was one of Day's favorite authors, and *The Treasure of the Humble* his favorite text.[31] The book began with a chapter on "silence," which Maeterlinck described as "the element in which great things fashion themselves together, that at length they may emerge, full-formed and majestic, into the daylight of Life, which they are henceforth to rule." Whereas speech was temporal, silence was eternal and the essence of humanity. Because silence transcended words and signs, it served as the medium for true communication between souls that were absorbed and given life through the encounter. Maeterlinck wrote:

> Words can never express the real, special relationship that exists between two beings. Were I to speak to you at this moment of the gravest things of all—of love, death, or destiny—it is not love, death or destiny that I should touch; and, my efforts notwithstanding, there would always remain between us a truth which had not been spoken, which we had not even thought of speaking; and yet it is this truth only, voiceless though it has been, which will have lived with us for an instant, and by which we shall have been wholly absorbed.

Maeterlinck believed that presence was formed through the relationship between souls and that presence revealed Truth: "In mystic circles it is the mere *presence* that decides almost all."[32]

The close relationship Maeterlinck posited among communication between souls, mysticism, and silence was expressed in occult terminology as well. Combining

elements of Spiritualism, New England transcendentalism, Western conceptions of Hinduism and Buddhism, and occult traditions, Madame Blavatsky wrote a devotional tract entitled *The Voice of the Silence* in 1889, which suggested that wisdom emerged through the self's union with the divine. She wrote that the individual passed through three halls: the hall of ignorance, in which the self is unaware of its need for contact with the divine; the hall of learning, in which the individual is aware of a higher calling but distracted by psychic phenomenon; and the hall of wisdom, in which the individual comes into contact with the divine and hears the "voice of the silence." The material and spiritual elements of the self unite, eliminating personality in favor of a higher, impersonal ideal.[33]

Day sought to effect presence, a relationship between souls that transcends historical time, in the *Seven Last Words*. Day integrated sensibility and presence—the physical and spiritual worlds—through his symbolic portrayal as Christ. By inducing an extended period of contemplation, he provided the beholder with the means to transcend material reality.

Day attempted to integrate his hybrid spiritual interests formally in *Beauty Is Truth* (1896), shown here exhibited at the 1899 Philadelphia Photographic Salon (fig. 29). *Beauty Is Truth* is composed of two independent photographs, *Genius of Greek Art* (fig. 17) and *Entombment* (fig. 18), combined to recall Masaccio's *Trinity* (fig. 30). However, Day makes two critical iconographic changes. In Masaccio's fresco, the Virgin Mary, Saint John, and two donors flank the crucified Christ. God stands behind his son, holding the arms of the cross with his hands. The upper portion of the fresco sits atop a tomb, which contains a skeleton lying on a sarcophagus and the inscription: "What you are, I once was; what I am, you will become." In Day's *Beauty Is Truth*, God's dominant presence is replaced with a close-up of a partially draped young man, who holds a crystal ball in one hand and a bouquet of poppies in the other. Christ's attendants disappear, and the dead Christ, mourned by Magdalen, replaces the skeleton that serves as the foundation for Masaccio's *Trinity*. Day stressed Christ's humanity through his almost direct quotation of Hans Holbein's *The Dead Christ*. He included an inscription from Keats: "Beauty is truth, truth beauty: that is all ye know on earth and all ye need to know."

The *Trinity* posits a traditional notion of Christian redemption: through Christ's crucifixion, the believer attains eternal life with God. Day's *Beauty Is Truth* suggests an alternative narrative (albeit ambiguous at best), indicating that salvation occurs through the crystal ball and a bouquet of poppies. Both were well-known occult objects at the turn of the century; looking into the former produced visions after prolonged viewing, while smoking the refined opium of the latter induced hypnosis or hallucinations and, in turn, inner awareness and spiritual awakening.[34] According to Day, then, liberation from the physical world—represented by the historical Christ, who suffered and died for Truth and Beauty—occurred through the extended contemplation of material objects and works of art.

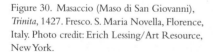

Figure 29. F. Holland Day, *Beauty Is Truth* and *The Entombment* exhibited at the 1899 Philadelphia Photographic Salon. *Interior View (works by F. Holland Day) Philadelphia Photographic Salon, 1899.* George Eastman House, Rochester, New York.

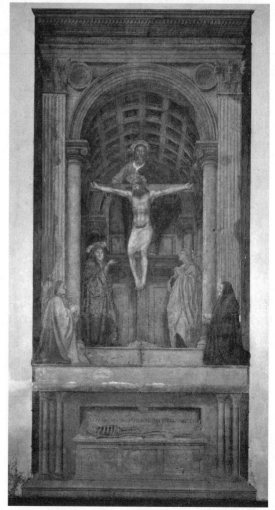

Figure 30. Masaccio (Maso di San Giovanni), *Trinita*, 1427. Fresco. S. Maria Novella, Florence, Italy. Photo credit: Erich Lessing/Art Resource, New York.

Beholding the *Seven Last Words*

Although Day deployed conventional iconography, relied on well-known models of spectatorship, and drew on a variety of mystical writers who enjoyed a relatively wide readership, the sacred series in general and *Seven Last Words* in particular produced considerable commentary from a variety of audiences. Nationally, the photographs were discussed and reproduced in newspapers like the *Boston Herald*, popular periodicals like *Godey's Magazine* and *Harper's Weekly*, and photographic journals like *Photo Era* and *Camera Notes*. They were displayed in one-man shows at Day's Boston studio and the New York Camera Club as well as juried exhibitions such as the 1898 and 1899 Philadelphia Photographic Salons. Day's prominence stretched across the Atlantic to include Britain and France in particular. He was elected to the prestigious British Linked Ring Brotherhood in 1896 and organized and hung the *New School of American Pictorial Photography* exhibition in London and Paris in 1900. In addition, his work was reproduced and reviewed frequently in British photographic journals. The fight for photography as a fine art was an international endeavor, and most publications committed to the medium reprinted articles from other periodicals and commented on shows at home and abroad. Consequently, when a British journalist described the breadth of the controversy over Day's sacred photographs as the "fiercest fight of the year," he was referencing a diverse and international viewing public. "The strong chorus of disapproval which met these pictures, not only in a series of letters to the journal in which they originally appeared but also in extensive newspaper comment and in lectures and speeches by some of the leaders in artistic photography, was perhaps the most vigorous expression of opinion on any purely artistic subject" in a decade on the nature of photography.[35]

The response to Day's religious photographs indicates that many of the assumptions he made in his production of the sacred series were not universally shared. In the following pages, I trace the theme that dominated the controversy: Who or what determined the meaning of a work of art? Discordant critics postulated that significance rested in the artist's intention, or the subject depicted, or the viewer's response. In the final analysis, it is clear that spectators conceptualized their encounters with Day's photographs in myriad ways at a historical moment in which different models of aesthetic engagement struggled for primacy.

First, the importance of the artist's intention in creating religious art pervaded the criticism surrounding the *Seven Last Words*. Although it is unclear how many of his contemporaries knew that Day himself posed as Christ or when they discovered it, it is apparent that critics' perceptions of Day clouded their interpretations of his sacred series. Even Sadakichi Hartmann, an American critic sympathetic to the photographer, suggested this when he wrote that Day's "peculiar *tournure d'esprit*, recognizable in his whole behavior, is decidedly against him; He has always lived the life of an aesthete, who appears to all at the first glance, as an extraordinary extravagant personality,

one that excites immediate curiosity."[36] The close relationship between the journalists' attitudes toward Day and his sacred photographs suggests that they did not separate the object's meaning from the artist's persona.

The critical backlash prompted by Day's sacred series was most strident in London, where his religious photographs appeared in the aftermath of Oscar Wilde's conviction for "gross indecency" in 1895.[37] The link contemporary critics made between the photographer's imagery and aestheticism was not unfounded; Wilde, Walter Pater, John Addington Symonds, and Edward Carpenter formed one of the primary intellectual frameworks for Day's photography. These writers celebrated male beauty and Greek love and sought to furnish cultural legitimacy for same-sex relationships through an amalgamation of paganism, Neoplatonism, and Christianity. Christ served as a typological model for asserting individuality against institutional authority, theological dogma, and social convention, and his life functioned as an autobiographical vehicle to represent the suffering and discrimination faced by homosexuals at the turn of the century. In an era in which the term "decadent" became a burdened euphemism for multiple infractions against public taste and served as a surrogate for the homosexual, Day's self-representation as Jesus presented Christ as a model of manhood considered perverse by a large portion of the population. Day's decision to alter the frame of the *Seven Last Words*—from the black lacquered exhibition frame it had in the 1898 Philadelphia Photographic Salon to a gilded architectural frame replete with classical and sacramental references for the 1900 exhibition in London and Paris—reifies the relationship Day's colleagues perceived between the artist's aesthetic and literary interests and his photographic work.[38]

Other critics faulted Day less, pointing to a general sense of religious doubt pervading the period. "The great painters of the 15th and 16th centuries certainly obtained marvelous results, but then they had at their disposition, beyond the resources of their creative brushes, the strong faith of their times: that faith which moves mountains," one noted.[39] The Passion play at Oberammergau was considered sincere, in contrast, because it was produced by villagers not burdened by modernity. As another writer put it:

> Only a people whose lives were thoroughly in touch with the religious scenes and feelings they portrayed could have commanded the unwearying attention of the multitude of visitors. . . . The Oberammergauers stand as a happy example of Christian culture apart from ordinary worldly influences. It is to be hoped that they shall long remain unspoiled by too close contact with what is worst in the civilization outside their village.[40]

By imagining the rural villagers of Oberammergau in a distant time and place and attributing divine attributes to human actors, beholders granted the Oberammergauers a simplicity and authenticity they deemed incompatible with modern life.

The critics' emphases on the artist's biography and historical moment as key indicators of meaning were not new methodological strategies. Art historians since Giorgio Vasari had situated painters and sculptors within their artistic milieu to determine their worth and historical position. However, turn-of-the-century American art criticism placed a particularly "insistent emphasis on the personal, and on the personality" of the artist.[41] This stress on the artist's personality as the primary marker of meaning helped shape public response. Moreover, since the second half of the nineteenth century was marked by challenges to Christianity, critics concluded that Day's religious photographs could not have the religious "purity" of earlier periods and that his motivations were more "earthly" than divine.

Second, critics debated whether the mere presence of Christ as a photographic subject guaranteed the work's sacredness. Throughout the later decades of the nineteenth century, American audiences distrusted theatrical performances of the Passion, attending to arguments that no actor could adequately represent Christ.[42] Applying a similar logic to Day's sacred series, many contended that no model could represent the sacred figure in a photograph because of the photograph's physical relationship to the object or person it represented. Critics like Caffin, who praised the photograph's ability to record nature, argued that the use of a model disrupted dispassionate viewing since the model had to correspond to his or her role perfectly, in both physical appearance and inner character. When pictorial effects overwhelmed the "personal record," and when "metaphysical issues and religious motives" superseded "abstract artistic impression," the photograph called attention to itself and its overt theatricality. A correspondent to the *British Journal of Photography* asserted:

> The very finest skill of the foremost British photographer, we are convinced, would break down at any attempt to divest a sacred subject, taken by means of the camera, of those insistent and cartographic details which impart an element of repulsiveness, in our eyes, to Mr. Holland Day's photographs—repulsive because we are conscious that the individuality of the originals has not been, cannot be, so completely masked or subdued as to destroy the mental persuasion that we are looking at the image of a man made up to be photographed as the Christian Redeemer, and not an artist's reverent and mental conception of a suffering Christ.[43]

Critics who treated the photograph as a symbol, a sign that attained meaning through the beholder's interpretation of it, assumed the photograph could express an idea that transgressed temporal and physical particularity. One writer said:

> As per the propriety of using models for such a purpose, well, we know what sort of model an Italian master, whose works of genius are not questioned, has used in his time for the representation of the

Virgin Mary; and as nobody is shocked at this particular liberty, I think
the subject might be dropped as regards photography.

Others noted that Christ was successfully represented in the Passion play, despite the
opinions of some contemporaries to the contrary. Keiley inquired in *Camera Notes*:
"Have Mr. Day's critics forgotten the efforts of the actors of the Passion Play, whose
earnest and pious efforts to present the passion and death of Christ has stirred an
irreligious and indifferent world to piety and tears?" Evans was even more specific,
rhetorically asking those who opposed Day's religious photographs if they would have
rejected them if Joseph Mayer, the actor famed for his performances at Oberammergau,
had posed as Christ.[44] The status of the photographic model was not an issue for critics
who viewed photographs as symbols and assumed models could overcome their own
individuality and embody that of another.

 Theological, ideological, and practical dilemmas were inherent in depicting Christ.
He was supposed to be both human and divine; a historic agent and contemporary
presence; a Jewish man and composite "Son of God"; and strong and just, patient and
consoling, traits associated with masculinity and femininity, respectively. The question
of Christ's appearance involved more than artistic genealogy; it challenged the very
nature of biblical interpretation. German biblical criticism, an interpretative strategy
that located the biblical text within human, rather than divine, history, was central to
one major strain of American religious thought by the second half of the nineteenth
century.[45] Promoted by liberal Protestants who sought an alternative to a religion
based on creeds and dogma, the "new criticism" situated Christ in his temporal and
physical environments. They understood the Bible as a record of religious history
written and compiled by men, rather than the literal word of God. Its human rather
than divine origins meant that scripture should be read, not for its literal meaning,
but for its symbolic message. Just as conservative clerics fumed over a literary reading
of the Bible, so viewers questioned the legitimacy of photographing a figure who
had been dead for almost two thousand years. Recognizing the culturally constructed
nature of its language required relinquishing the notion that the biblical text was di-
vinely inspired, and thereby transcendent and freed from historical contingency. Simi-
larly, identifying the hand of the artist in a photograph's conception and presentation
undermined photography's objective perspective and its claim to universal, scientific
"truth."

 Finally, critics questioned whether the sacred content of Day's *Seven Last Words* rest-
ed in the object itself or in the viewer's encounter with it. This controversy hinged
on the nature of the medium. If the photograph served a documentary function, its
meaning rested principally on the image's subject matter; if its purpose was aesthetic, its
significance hinged (at least in part) on the beholder's interpretation of it. The debate
centered on conflicting claims about the capacity of human perception and ways of
knowing.

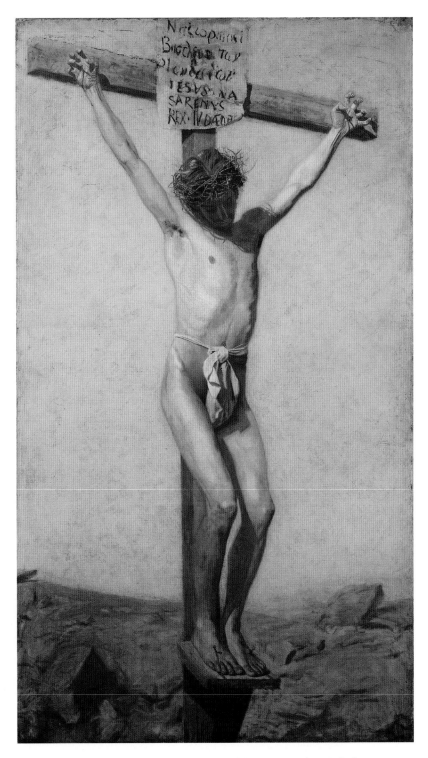

Plate 1. Thomas Eakins, *The Crucifixion*, 1880. Philadelphia Museum of Art: Gift of Mrs. Thomas Eakins and Miss Mary Adeline Williams.

Plate 2. Thomas Eakins, *The Translator* (Rt. Reverend
Hugh T. Henry), 1902. St. Charles Borromeo Seminary,
Overbrook, Pennsylvania. Photograph by P. Joseph
Mattera.

Plate 3. Henry Ossawa Tanner, *The Annunciation,* 1898. Philadelphia Museum of Art: Purchased with the W. P. Wilstach
Collection, 1899.

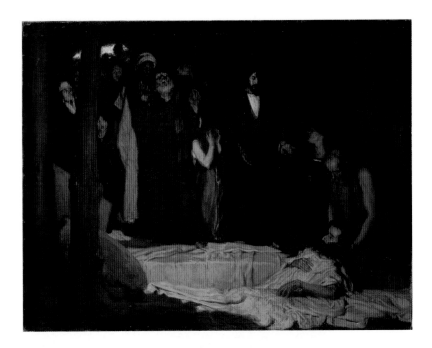

Plate 4. Henry Ossawa Tanner, *The Resurrection of Lazarus,* 1896. Oil on canvas. Photo: Herve Lewandowski. Louvre, Paris. Photo credit: Réunion des Musées Nationaux/Art Resource, New York.

Plate 5. F. Holland Day, *Crucifixion with Mary, Mary Magdalen, Joseph, and St. John,* 1898. Platinum print. Prints and Photographs Division, Library of Congress, Washington, D.C.

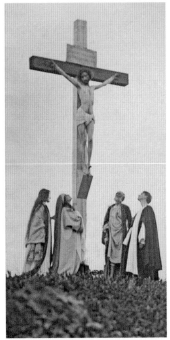

Plate 6. F. Holland Day, *The Seven Last Words of Christ,* 1898. Seven photographic prints in gilded frame, 3¼ x 13⅞ in. Prints and Photographs Division, Library of Congress, Washington, D.C.

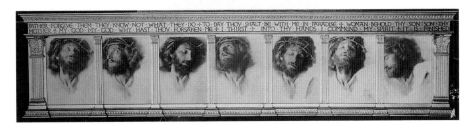

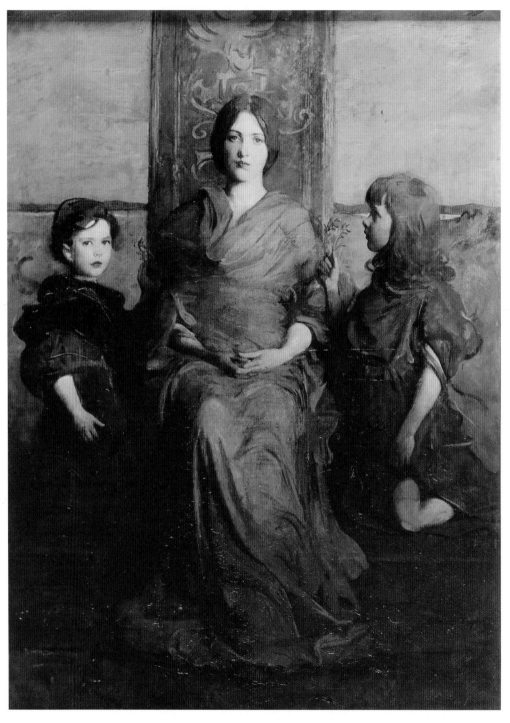

Plate 7. Abbott Handerson Thayer, *Virgin Enthroned*, 1891. Smithsonian American Art Museum, Washington, D.C. Photo credit: Smithsonian American Art Museum, Washington, D.C./Art Resource, New York.

Caffin defined photography's essential quality as "its accuracy of vision": through its "all-seeing eye and [its] accurate methods of registering impressions," the photograph expressed a "direct relation to human life." In contrast, Day assumed that photography had both documentary and aesthetic functions. He heeded the photographer's reliance on nature, writing, "Unable to count upon their imagination as much as painters do, [photographers] seek beauty in Nature herself. Unable to hope for its attainment solely by interpretation, they must find it in the object of interpretation." But while the truth of science lay in the detail, the truth of art lay in the ensemble. A strict reliance on detail could undermine the reality or "truth" of how things work and look. By way of example, Day noted that as a static image, the photograph could not capture movement, thus allowing the eye only partial perception and knowledge. It was the artist's role to select proper lighting, models, and composition to represent movement, to fill in perception, to correct distortion. Ultimately, the photographer's focus on nature and human life—on the material world—became "Truth" when filtered through Humanity and Art.[46]

Day, in other words, believed that the photograph's evocative potential was predicated on the photograph's material relationship to its subject and its ability to transcend that subject's particularity. He affiliated himself with like-minded photographers (including Evans, Steichen, and Alvin Langdon Coburn, among others) who sought "no longer detail, but ensemble, not an accumulation of facts, but simplification of the idea. They have chosen, not the sun-bright hours wherein all is to be seen, but hours neighboring to twilight wherein something is to be guessed." Significantly, Day's understanding of the modernist photograph postulated a discerning observer in front of the work who could fill in details, make sense of apparent disjunctions, and give the image meaning. By placing interpretative power in the beholder's hands, Day privileged "imagination" over "sight," and the photograph's ability to "suggest" over its ability to "record." He asserted that spectators learned the "indefinite is the road to the infinite" through thoughtful attention to the composition.[47]

Day's conception of the beholder as a perceptive observer rather than a mechanical eye led one critic to compare his photographs to religious mediums:

> Most of [Day's images] are elusive and indefinite in character; the mere suggestion of forms and features leave a great deal for imagination, yet the delicacy of treatment, the selection, the composition, in most cases denote intense feeling; but if the spectator lacks imagination and power of feeling, their effect upon him must be nil; or if he resists their influence, he is like an unwilling subject in the mesmerist's hands.[48]

This critic supported Day's indeterminate aesthetic and its evocative potential. However, his analogy between the photographic viewer and the hypnotized subject points to the danger of placing photographic meaning in the eyes, hearts, and minds

of viewers: experience took precedence over reason, emotion over intellect. Like re-
ligious authorities who sought to curb religious revivals and camp meetings over fear
of enthusiasm, advocates of photography's scientific status aimed to situate meaning
away from the individual spectator. Critics who wanted to see—rather than imagine—
rejected the photograph's ability to evoke an idea not contingent on temporal or geo-
graphic specificity and, therefore, the validity of Day's sacred photographs.

Art and Religion for Their Own Sakes

The debate over the beholder's interpretative role in photography was part of a larger
discussion about the roles of art and religion in human life: Did they underscore com-
munal values and codes of conduct, or did they sponsor individual experience? In
Washington Gladden's essay "Christianity and Aestheticism," the Social Gospel propo-
nent wrote there were two realms of human life: the ethical, the "domain of duty," and
the aesthetic, "the domain of refined and rational pleasure." Although both were essen-
tial, art needed to remain secondary to morality and patriotism in order to maintain the
national life. Gladden believed that the "increase of wealth," "enlargement of leisure,"
and "inventions of luxury" eroded the guiding principles of Christianity—righteousness
and service. Instead, those of the "luxurious classes" selected the "aesthetical law," whose
standards, he argued, were "purely selfish. What is the beautiful? That which gratifies
my taste. What is good art? That which pleases me. There is no other rule; the criterion
of all art judgment is the individual's own pleasure." The result of such a philosophy
was "no great art, no high character, no grand civilization; it can give birth to nothing
but a pretty, petty, puny dilettantism, weak in the sinews, light in the head, rotten at the
heart." At the core of Gladden's cultural critique was a particular interpretation of the
gospel message that advocated the supremacy of the ethical over the aesthetic life. He
argued that "Christ is the end of the law for righteousness to everyone that believeth,
but only when He has made them righteous in thought and word and deed." The New
Testament, in turn, "finds its crown and completion in right conduct."[49] Religion, in
other words, was not practiced for its own sake—for an individual relationship with the
divine—but for the common good.

 In contrast, Gladden's spokesman for the gospel of aestheticism, Oscar Wilde, in-
terpreted Christ's life according to another doctrine, that of suffering as a means to
Beauty and Truth. A year before Day began his sacred series, Wilde wrote the auto-
biographical *De Profundis*, in which he identified himself with Christ, suffering with
Beauty, and life with Art. Literary historian Guy Willoughby writes that for Wilde's
Christ, sorrow and suffering realized the Beautiful: Wilde's "genius was to make his
own life a reflection of this insight: 'And feeling. . . . that an idea is of no value till
it becomes incarnate and is made an image, he makes of himself the image of the
Man of Sorrows, and as such has fascinated and dominated Art as no Greek god ever

succeeded in doing.'"[50] According to Wilde, Christ's death resulted in human salvation only if people walked in his footsteps—suffered, attained self-perfection, and saved one another through imagined sympathy—and, like Christ, made their lives a work of art. In Wilde's formulation, Christ modeled individual actualization more than social responsibility.

The tension between conventional and aesthetic interpretations of Christ's life paralleled debates over the nature of perception and art's role in human life. Aesthetic philosophers and art critics sought to differentiate between turn-of-the-century viewing practices and looking at a work of art.[51] Intellectuals, philosophers, and psychologists like James and Peirce underscored the subjective nature of human vision. Within this theoretical framework, the meaning of an art object rested in the viewer's interpretation, which was mediated by his or her social milieu and personal beliefs and experiences. In contrast, art critics like Clive Bell and Roger Fry proposed a "modernist" viewing posture that divorced perception from the body and its location in time and space. In their view, the beholder's engagement with the object was not circumscribed by the individual's material conditions or autobiography; it took place in a realm apart from the world. To put it more concisely, at the same moment that some philosophers and psychologists indicated that the viewer's interaction with a work of art was shaped by environmental factors, modernist art critics asserted that the beholder's absorption rested in a higher realm of emotion unhindered by the prosaic details of everyday life.

By asserting art's detachment from the material realm and the beholder's individual engagement with the object, modernists uprooted art and religion from their social roots. In his own "Essay on Aesthetics" (1909), Fry echoed Gladden's division of the world while disputing his conclusions. Fry distinguished between "actual" life—the world of responsive action and moral responsibility—and "imaginative" life—a higher realm of human emotion and disinterested contemplation. He located art within the imaginary life, since it "appreciates emotion in and of itself." Fry went on to liken art to religion, since he presumed a believer "would probably say that the religious experience was one which corresponded to certain spiritual capacities of human nature, the exercise of which is in itself good and desirable apart from their effect upon actual life."[52] Fry's definitions of art and religion undermine their roles in promoting social change and insist instead on individual meditation that transcends historical specificity.

Day's life and art bridged—or attempted to integrate—these seemingly opposed philosophical positions. His social work with poor immigrant children in Boston was coupled with aestheticism; his participation in the Progressive movement coexisted with an admiration for the British decadents; and his generosity toward others merged with an insatiable desire to collect.[53] Like so many other turn-of-the-century figures, the photographer encouraged individual religious and aesthetic experience while, at the same time, concerning himself with larger cultural problems.

Figure 31. F. Holland Day,
Vita Mystica, ca. 1900.
Platinum print, 9 ? × 6 ?
in. National Museum of
Photography, Film, and
Television/Royal Photo-
graphic Society/Science
and Society Picture Library,
Bath, England.

Day's sacred series raised important issues central to the turn-of-the-century art scene. Where is meaning located—in artistic intention, the artist's historical moment, the object itself, or the beholder's response? What is the role of the art object in culture? Does it display truth or evoke emotion? Similar issues framed contemporary religious debates. Where does religious truth reside—in scripture, institutional churches, or personal experience? What role does Christianity play in the modern world? Does it structure human action or provide refuge? By representing Christ's body, Day entered contested terrain that shifted the topics of debate from artistic and religious meaning to what constitutes legitimate interpretative strategies, devotional practices, ethical behaviors, and assurances of life's meaning.

The reception of Day's *Seven Last Words* indicates that the photographic series embodied contradictory models of seeing and knowing in at least two ways. Day relied on the photograph's material relationship to its subject to resurrect Christ for contemporary

Figure 32. F. Holland Day,
*Frederick H. Evans Viewing
One of the Seven Last Words*,
1900. Platinum print, 8 3/4
× 6 ? in. National Museum
of Photography, Film, and
Television/Royal Photo-
graphic Society/Science
and Society Picture Library,
Bath, England.

viewers; at the same time, he asked the beholder to separate the subject's spiritual meaning from its physical referent, since a vast chasm of time separated the historic Christ from Day's photographic representation of him. In addition, Day appropriated an iconographic way of seeing, since he relied on a variety of commonly shared visual images and religious practices to communicate with the beholder. Concurrently, he sought to inspire a modernist art-for-art's-sake viewing posture by encouraging the spectator to emotionally respond to—rather than to read—the photographs. In essence, Day's sacred series embodied a tension between a social, intertextual model of engagement and a personal mode of aesthetic experience that disavowed the cultural conditions of the viewing subject.

 To better understand how Day's *Seven Last Words* could incorporate academic and modernist ways of seeing, I end with a pair of his photographs: *Vita Mystica* and *Frederick H. Evans Viewing One of the Seven Last Words* (figs. 31–32).[54] In Day's *Vita Mystica*, a monk stares away from the viewer at an image set in the corner of a small, darkened cell. He wears a long dark cassock secured by a cincture. Decoration is

sparse. A crucifix hangs above and behind him, bathed in light from a single window located outside the picture space. Removed from the material comforts of modern life, the young monk centers his attention on a picture, through which he transcends the material world and communes, in silence, with the eternal. In Day's picture of the photographer Frederick Evans, a man stands in front of a single image in a dark room, stripped of all ornament and interruption. His hands are clasped behind his back, and he wears a coat with a cape. His face is obscured, looking away from the viewer and toward the picture. The beholder of the photograph echoes Evans; just as Evans views one print from the *Seven Last Words*, so the beholder views Day's photograph of Evans. Just as Evans retreated to a private space to contemplate a single image in isolation, so, too, should the viewer.

Both photographs propose similar ways of seeing: a spectator concentrates on an object in a darkened space, alone and uninterrupted, with monastic austerity and discipline. While *Vita Mystica* depicts a devotional encounter, *Frederick H. Evans* translates that model of personal piety into modern aesthetic experience by locating the exchange in a gallery or exhibition space. In other words, nine years before Fry's "Essay in Aesthetics," Day, Steichen, and Evans linked religious devotion and aesthetic engagement.

The complex interaction of academic and modernist ways of seeing at the turn of the twentieth century is further supported by audience reactions to Day's sacred series in specific contexts. The majority of respondents discussed in this chapter viewed the photographs in a formal exhibition space where artworks were presented as objects of visual contemplation. In this environment, many proved unwilling or unable to separate the historic Christ from Day's photographic representation of him. They did not, in other words, view the *Seven Last Words* through a modernist lens, one that prompted the beholder to see the work as a suggestive means to disinterested contemplation about eternal truths rather than as a literal record of a historic subject or event.

When Day's photographs were seen in religious contexts, however, they were viewed with a more modernist sensibility. For example, when Guiney expressed concern about the potentially hostile reception of the sacred series soon after its completion, Day exhibited the photographs privately in his studio and solicited advice regarding a public presentation of the prints. Recalling this event three years later, Day noted that he invited "people of all shades of religious belief—Quakers, Jews, Anglican and Roman Catholics, Nonconformists, Swedenborgians, priests and clergymen" to attend the showing: "Among them, many were known to hold adverse opinions before seeing the prints, but with the exception of a single individual, these prejudices entirely disappeared." In one instance, "the son of a prominent Anglican bishop, himself a clergyman, expressed surprise at finding the literal quality that is usually considered an essential part of photography so far eliminated, and pronounced one of the Crucifixions as fine a rendering of its subject as he knew in any medium." A few years later, after Guiney moved to England, she lent her copy of the *Seven Last Words* to her local church at the request of the priest, who

wanted to display it during Holy Week. Viewers there deemed it a "devotional" work, and one local painter attributed its success to the "wonderfully fine model."[55] These anecdotes suggest that in a religious, rather than gallery, setting, spectators looked with a truer modernist sensibility; they separated the subject of the photograph from its sacred, historical referent and treated the work as a means to contemplation. This represents an interesting twist, for spectators in a modern art exhibition space deployed ways of seeing more consistent with academic theories of art, while Christian believers looked at Day's photographs through more modern lenses.

Day understood the photograph as both a physical trace of the real and an ideal evocation of it. By emphasizing Christ's likeness and presence and by requiring viewers to engage academic and modernist ways of seeing, Day created the *Seven Last Words* in the tradition of Christian icons. He likened aesthetic and religious visual practice, raising the photograph to the status of sacred art and providing the occasion for communion with the divine.

The Protestant Icons of Abbott Handerson Thayer

In 1875, Henry James observed that viewers of Raphael's *Madonna of the Chair* in the Uffizi Gallery treated the painting "as a kind of semi-sacred, an almost miraculous manifestation. People stand in worshipful silence before it, as they would before a taper-studded shrine."[1] The novelist's description of a painting as an icon, the gallery as a shrine, and the beholders as worshippers might sound strange given American Protestantism's historical antipathy for Roman Catholic "Mariolotry." However, James's reflection on the iconicity of Marian imagery was repeated by a variety of American artists and critics in the final decades of the nineteenth century. Abbott Handerson Thayer repeatedly asserted that "art is worship," for example, while critic Sadakichi Hartmann noted that Thayer's more than life-sized paintings of women and children "take the place of the old religious symbols, in which he himself very likely no longer believes, and yet they are imbued with so devout a spirit that they could be used as shrines for worship in modern homesteads."[2] The piety with which viewers engaged images of ideal womanhood in general, and Thayer's works in particular, illustrates how models of individual religious devotion structured aesthetic experience in turn-of-the-century America.

Americans were surrounded by idealized representations of Anglo-American womanhood. Dressed in antique or loose-flowing drapery, placed within a non-descript landscape or domestic interior, and depicted at rest or leisure, these representations adorned the walls of state capitals and commodities, art museums and advertisements, world's fairs and parlors.[3] Cultural leaders bestowed cultic significance on Ideal Woman because the fate of American civilization rested on her

domesticity, piety, and purity. She served as the primary medium for the salvation of men and children, the redemption of the nation, and the progress of civilization. The Madonna best incarnated contemporary conceptions of womanhood because she referenced the historical mother of Christ, epitomized chaste maternity, and mediated the earthly and heavenly realms. Not surprisingly, then, virtually all turn-of-the-century popular and fine art images of motherhood were granted sacred status; they presented Anglo-American middle-class women as Madonnas and helped viewers access the transcendent.

In this chapter, I explore the production and reception of Thayer's paintings to illustrate how fine art representations of ideal womanhood became icons that deserved and impelled the beholder's devotion. Thayer relied on woman's sacred role in turn-of-the-century American life to elevate his sitters into universal types, worthy of veneration and contemplation. Viewers, in turn, considered his paintings mediums of imagination, attention, and spiritual experience. No longer instructed by narrative or iconography, they surrendered themselves to the image. Together, Thayer and other artists, critics, and spectators translated a communal ritual practice into a personal spiritual experience characterized by the union of the actual and ideal. They formulated ways of seeing modeled on devotional practices that invested the work of art with moral force and the power to save souls.

The Protestant Madonna

Late nineteenth-century American Protestant artists drained Mary of her Roman Catholic heritage and charged her with signifying a set of potent but contested ideals about contemporary womanhood. The English art critic Anna Jameson made the Madonna safe for Protestant consumption in her *Legends of the Madonna as Represented in the Fine Art* (1852), the first extensive study of Marian iconography. Jameson contended the cult of Mary stemmed from two separate but related trends: it was the amalgamation of all "types of a divine maternity," represented by Eve of the Old Testament, Astarte of the Assyrians, Isis of the Egyptians, and Demeter and Aphrodite of the Greeks, among others; and it developed in tandem with new ideas of the "moral and religious responsibility of women" in civilized societies, namely the separation of male and female spheres.[4] Jameson articulated the associations among her history of art, model of ideal womanhood, and theory of social progress in the opening paragraph, when she asserted that representations of the Madonna served as the "visual form" of female character, characterized her "beneficence, purity, and power," and illustrated her mediating role between the Deity and humanity.[5]

While Jameson's conception of the Protestant Madonna shared a number of similarities with her Roman Catholic counterparts, their social roles were considerably different. For Roman Catholics, Mary remained tied to centuries-old theological debates and ritual

traditions under the purview of the organized church.[6] The rise in Marian apparitions, papal decrees, and clerical emphasis on private devotion throughout the nineteenth century ensured that Catholics, from the Pope to the Italian-American immigrant, appealed to Mary for divine aid. Marian devotion was a primarily paraliturgical activity, occurring outside the sacrament of the Mass. While the liturgy was public, enacted by the priest, and mandated by the Church, devotions were linked to specific events and rituals, accompanied by artifacts like rosaries and scapulars, and performed by individuals in confraternities and sodalities within the parish system. Lay devotions, in other words, took place outside the church building but remained under the control of the institutional hierarchy.[7]

Jameson's conception of the Madonna as the quintessence of Protestant womanhood created a language and usable past that enabled writers and artists to divorce Mary from her Roman Catholic doctrinal, liturgical, and ritual contexts. Her success was revealed forty-five years later, when Estelle Hurll, the editor of Jameson's works in the 1890s and fine art critic in her own right, produced her own analysis, *The Madonna in Art* (1897). Hurll avoided the theological underpinnings of Marian imagery almost entirely in order to focus on her conceptualization of Mary as the universal mother. She described her book as "a study of Madonna art as a revelation of motherhood" and isolated love, adoration, and witness as motherhood's most prominent aspects because of their centrality in old master pictures of the Virgin Mother.[8] By relying on the sacred nature of the Madonna to consecrate women's role in American culture and art's long history to universalize those attributes, Hurll contributed to a larger Protestant discourse that sacralized conceptions of ideal womanhood through their implicit associations with the transcendent.

American Protestants deployed the Madonna as the incarnation of universal womanhood because her status as emissary between earth and heaven dovetailed with contemporary conceptions of women's cultural role. Socially perceived as inherently emotional and religious, Anglo-American women were expected to cultivate a domestic environment that socialized children into the practices and values of middle-class life. Their beauty and faith consecrated the home and saved their husbands from falling into the moral decay many believed constituted the modern industrial world. Methodist bishop John Heyl Vincent, the founder of the Chautauqua Institution—a national organization that combined Protestantism and reform for a predominantly Anglo-American middle-class audience—added his voice to a chorus of others when he contended that women should pattern themselves on the Virgin Mother, just as men modeled themselves on Christ.[9] Predicating his remarks on Mary's status as human and divine, he wrote:

> Men expect, and rightly expect, women to be better than themselves. . . . The vice [men] have to rub against and perhaps be defiled with everyday, must not come into her presence; or, should they take

some of its clinging defilement there, they trust that, as the good Angel
of the Home, she will stand aloof from it, frown it into shame, and so
guard herself and them from the curse of their sacrilege.[10]

Because women were perceived to live outside the realm of industrialization and ur-
banization and to retain their innocence and purity, they held responsibility for the
redemption of their families and the nation.

Anglo-American womanhood's salvific work was not limited to family and nation; it
extended to Western civilization more generally. At the end of the nineteenth century,
"civilization" was a concept that embodied a set of assumptions and beliefs about
the world, supported by religion, science, and social practice, which justified Anglo-
American dominance.[11] According to most cultural producers, Western industrial-
ized nations were further along in human evolutionary development than "primitive"
peoples because they boasted sexual difference. Women were spiritual, domestic, and
delicate, while men were powerful and self-controlled defenders of women and chil-
dren. Since human history was perceived as progressive, and only the most advanced
cultures would survive the test of time and attain perfect human evolution, it was criti-
cal that Anglo-American women retain their purity and separateness.[12] As art historian
Kathleen Pyne puts it, Anglo-American woman served as the pinnacle of civilization
because she represented sexual differentiation, control over physical desire, and the
cultivation of spiritual sensibilities, as well as the maintenance of tradition and the
foundation of social stability.[13]

Importantly, men and women alike sponsored woman's sacred—and separate—
status. While the virtues of piety, purity, submissiveness, and domesticity, espoused by
the mid-century "cult of true womanhood," were deployed to undermine the wom-
an's movement in the middle decades of the nineteenth century, they had a decid-
edly different cast by century's end.[14] Evangelical Protestants assumed the leadership
of the turn-of-the-century woman's movement by using their presumed natural piety
and proximity to the divine to advocate for suffrage. Frances Willard, president of the
Women's Christian Temperance Union (WCTU) from 1879 to her death in 1898,
exemplifies how women extended their moral superiority from the home to the na-
tion and the world at large. Her leadership of the WCTU centered on the idea that
"since woman is the born conservator of home, and the nearest natural protector of her
children, she should have a voice in the decision by which the dram-shop is opened
or is closed against her home."[15] The popularity of Willard's message was strong.
The WCTU boasted a membership of over two hundred thousand in the 1880s, which
was twenty times that of the two groups more commonly associated with suffrage and
formed around the same time: the National Woman's Suffrage Association (NWSA)
and American Woman's Suffrage Association (AWSA).[16]

Turn-of-the-century Americans sought to protect the Protestant Madonna—and
by extension, themselves, their families, the country, and the progress of Western

civilization—by transforming her into an object of worship. In his meditations on Mary as a paradigm of Protestant womanhood, Bishop Vincent emphasized that woman must serve as a locus of piety for the sake of man's salvation and social stability. If men lose faith in women, they lose faith in humankind; as "men become skeptical of woman's sanctity, does society lose its moral no less than its sentimental tone." Because of women's centrality to social stability and moral order, Bishop Vincent distanced devotion to womanhood from Roman Catholic "idol worship": "[Woman's] beauty, since beauty is in the form of love, becomes to him the very mien of love divine, which he may worship without idolatry."[17] As modern Madonnas, contemporary women not only represented the sacred but presented it, allowing the transcendent to permeate the material realm.

A number of tensions characterize Protestant dedication to the Madonna. American Protestants presented a standard of womanhood no mortal could possibly fulfill by imaging her as both virgin and mother. They depended on Mary's historicity to underscore the eternal and sacred nature of women's intercessory status and, at the same time, considered the Madonna an abstract concept that could and should be embodied by contemporary women. Finally, they mined the Roman Catholic tradition of icons by treating women as material means to the transcendent while erasing the iconography and institutional apparatus that facilitated that practice. Marian imagery, in other words, represented the real and ideal simultaneously and fostered individual devotion to a communal symbol. Abbott Handerson Thayer, the period's preeminent painter of ideal womanhood, relied on these intimate unions in his paintings of family members and close friends as angels, Madonnas, and winged figures.

Enshrining Domesticity

The relationship between the material and transcendent, or what art historian Ross Anderson calls the literal and incorporeal, characterized Thayer's artistic production.[18] He drew on the academic tradition to enshrine women and nature and preserve them from the forces of "decadence," "egotism," and "unrelieved agnosticism" that he believed characterized contemporary life.[19] He sought to make Truth, embedded in the world, visible.

Thayer was born in Boston to a family of educators with broad-minded religious views in 1849 and was raised in a home that "reflected the intellectual life of Boston in that day when Emerson and his contemporaries were at the peak of their literary activities."[20] The artist's father, William Henry Thayer, was a Boston Unitarian who grew up attending William E. Channing's Federal Street Church. Channing was a major influence on the Transcendentalists and proclaimed the divinity of the soul, humans "likeness to God," and "self-culture" in his discourses, sermons, and writings. Thayer's mother, Hannah Mead, was the daughter of a prominent Congregationalist minister who challenged Calvinist doctrines and was tried before the church council for his liberal ideas. After they married, William and Hannah became regular and active participants in the Unitarian Church.

Thayer's liberal Protestant upbringing set the stage for a humanist conception of religion that stressed moral behavior more than church doctrine.

Trained in the academic tradition at the Brooklyn Art School, the National Academy of Design, and the École de Beaux-Arts in Paris, Thayer in his early works created intimate studies of the natural world, did commissioned portraits of women and young girls, and produced allegorical murals. As he reached the apex of his career, the self-proclaimed "worshipper" of nature and women focused on the places and people around him, subjects he knew familiarly and intimately. He developed theories of camouflage with his son, Gerald, while traipsing through the New England countryside, Florida, Sardinia, and the West Indies (among other locations). He painted landscapes of his beloved Mount Monadnock in Dublin, New Hampshire, where he began summering in 1888 and living year-round in 1901. And he represented his first wife, daughters, and close friends as angels, Madonnas, and winged figures, endowing them with divine attributes. These three subjects remained central to Thayer's artistic production until his death in 1921, when he was heralded by art critics as an American master.

Thayer incorporated his admiration for women, nature, and the Italian Renaissance and solidified his reputation as one of America's preeminent artists in *Virgin Enthroned* (1891) (plate 7). His contemporaries compared it to Raphael's *Sistine Madonna*—perhaps the most well-known and beloved painting at the end of the nineteenth century—and described it as "beyond a doubt Mr. Thayer's masterpiece, and one of the most remarkable works of art ever produced in the United States" (fig. 33).[21] In the painting, the Virgin sits at the center of the composition, pushed toward the viewer by the decorative drapery behind her. She is framed by two young children, one looking out to the viewer and the other gazing up at her and offering a small bouquet of flowers. All three figures are draped in fabric with little structure. While the drapery of the Virgin reveals the shape and position of her body, that of the two children is loose and oversized, making their ill-defined bodies appear even smaller underneath the layers of fabric. The relative lack of intimacy among the figures, each of which inhabits their own space, heightens the formality of the scene. Only the young child to the left of the Virgin seeks any sort of physical contact, his right forearm barely brushing hers.

Thayer excluded obvious signs pointing to the female figure's divinity: she has no halo above her head or sun radiating upon her; she does not hold a lily, rose, apple, or closed prayer book in her hand; she is not stepping on a serpent or standing on a globe or moon; and she is not covered in blue drapery or wearing a veil embroidered with a star. Despite the absence of Marian iconography, reviewers considered the female figure to be Mary, and the two children Christ and St. John the Baptist. American visual culture was so sated with Marian imagery that turn-of-the-century beholders would have been hard-pressed *not* to associate Thayer's figures with their biblical precursors. In addition to the extensive number of mass-produced items decorated with the Madonna in the middle-class marketplace, contemporary artists flooded art galleries, exhibition spaces, museum and private collections, and popular periodicals with their own

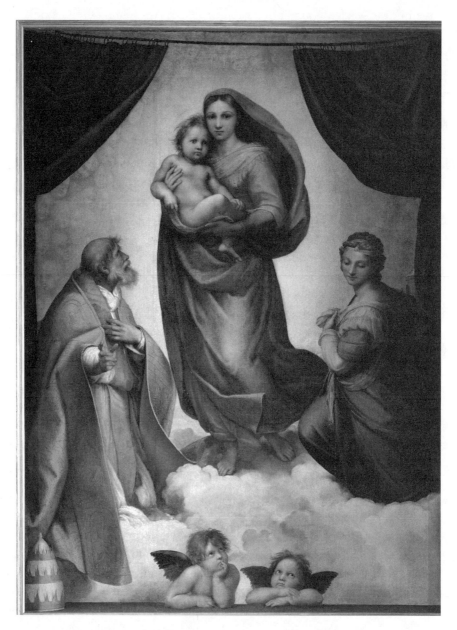

Figure 33. Raphael (Raffaello Sanzio), *Sistine Madonna,* 1512–13. Oil on canvas, 269.5 × 201 cm. Gemaeldegalerie, Staatliche Kuntsammlungen, Dresden, Germany. Photo credit: Erich Lessing/Art Resource, New York.

representations of the Virgin Mother. Indeed, a brief survey of those who relied on Marian associations at some point in their careers is a virtual who's who of American art at the turn of the century: George de Forest Brush, Mary Cassatt, Alvin Langdon Coburn, Frank Vincent DuMond, Sarah Jane Eddy, Lewis Hine, George Hitchcock, Gertrude Kasebier, Mary Macomber, Gari Melchers, Elizabeth Norse, Charles Sprague Pearce, John Singer Sargent, Jessie Wilcox Smith, Henry Ossawa Tanner, John Henry Twachtman, and Amelia Van Buren (figs 34–35). The sheer popularity of Marian imagery meant that Protestant artists could remove the traditional iconography associated with her while still sacralizing the presumed natural and eternal character of women's domestic role.

Like his contemporaries in art, literature, and society generally, Thayer venerated the women that surrounded him and ideal womanhood more generally in the *Virgin Enthroned*.[22] This painting continued a series of works that featured family and friends as divine personages, begun when Thayer's first wife, Kate, descended into mental illness. Later described by a close family as "in all ways [Thayer's] ideal of womanhood, innocent, poetic, graceful, maternal," Thayer depicted her in *Mother and Child* (1886) (fig. 36).[23] Two years later, when Kate was hospitalized for melancholia, the artist featured their eldest daughter in *Angel* (1888), initiating his life-long interest in the theme. *Virgin Enthroned*, completed the year Kate died, spotlighted all three of their living children; Mary posed as the Madonna, while son Gerald and youngest daughter Gladys stood in for Christ and St. John. Thayer continued to depict close family friends in his paintings of winged figures. Elise Pumpelly, a neighborhood friend of Mary's, posed for *Caritas* (1893). Bessie Price, the youngest of three sisters who worked for the Thayers and married a woodcarver who made frames for the artist, served as the model for both *Seated Angel* (1899) and *Stevenson Memorial* (1903). And Alma Waller, who sat for some of his later winged figures, married Thayer's son, Gerald, in 1911.[24] By representing loved ones as divine figures, Thayer elevated portraits of family and friends to religious objects and underscored his declaration: "I want the image of one I worship to become visible, for all time, to this world."[25]

The *Virgin Enthroned* emphasized Thayer's equation of women, nature, and divinity. He seated the Madonna and children in a landscape that boasted the same strong horizon line and color scheme found in his later representations of the local New Hampshire landscape, like *Cornish Headlands* (1898) and *View of Dublin Pond* (1900). In doing so, Thayer linked his desire to enshrine women's pure, crystalline, and "God-like" nature to his drive to preserve Mount Monadnock in particular and the environment in general from the encroachment of modernization. He worked as a community activist to prevent Dublin from losing its "Presence, those trees" to the introduction of electric lighting along the lake road, and later, to real estate development.[26] Thayer's belief in the shared divinity of women and nature led him to consecrate his female figures with natural elements in other paintings. In *The Angel* (1888), for example, a young girl, not yet developed into a womanly shape, stands at the center of the canvas. Her divinity is marked by two realistic-looking large wings that extend beyond the

Figure 34. Gertrude Käsebier, *Blessed Art Thou among Women*, 1899.
Photomechanical print: photogravure; 23.6 × 14.1 cm. mounted on gray mat,
28.5 × 20 cm., with ivory intermediate mount. Prints and Photographs Division,
Library of Congress, Washington, D.C.

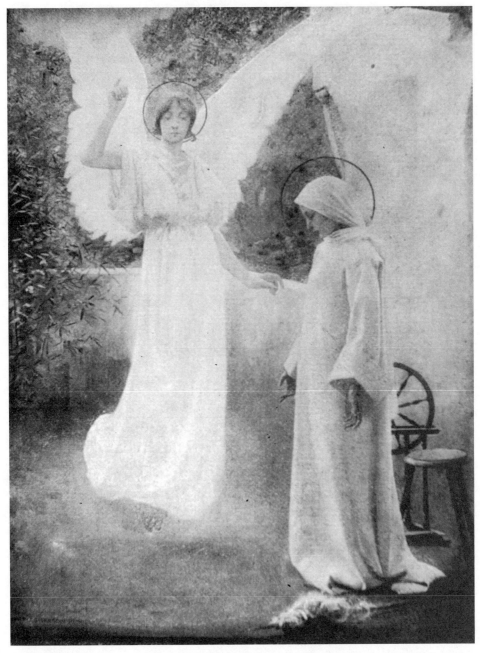

Figure 35. Charles Sprague Pearce, *The Annunciation*, ca. 1893. From *Official Illustrations from the Art Gallery of the World's Columbia Exposition*, ed. Charles M. Kurtz (Philadelphia: George Barrie, 1893), 204.

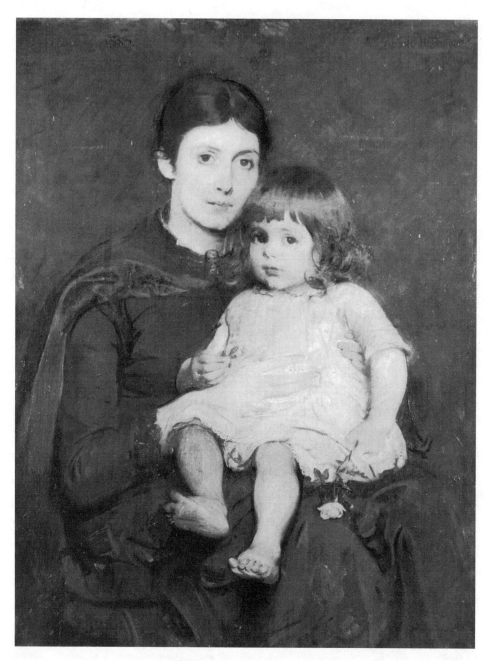

Figure 36. Abbott Handerson Thayer, *Mother and Child*, 1886. Oil on canvas, 36 × 28 in. Museum of Art, Rhode Island School of Design. Jesse Metcalf Fund and Special Gift Fund.

picture plane and appear to be attached to her upper back (fig. 37).[27] In *The Virgin* (1893), three figures walk intently toward the viewer (fig. 38). Two children, loosely draped in fabric, hold the hands of a young woman whose maturing body is revealed beneath the folds of her gown. While the background recedes and pushes the virgin and children to the foreground, it creates, too, a verticality emphasized by the clouds that appear like wings behind the young woman.

The intimacy of the natural world and universal virtue in Thayer's art was accentuated by his use of Renaissance precedents. Thayer embraced the art historical tradition. A series of photographs of Raphael's Madonnas and Michelangelo's Sistine sibyls and prophets graced the stairway of his home, while a plaster reproduction of Donatello's Madonna decorated the mantelpiece in his studio.[28] The influence of the old masters pervaded Thayer's homage to the Queen of Heaven as well. Indeed, *Virgin Enthroned* fit into well-established categories of old master representations of the Madonna. Jameson, for example, divided all Marian imagery into two primary categories: devotional subjects and historical subjects. When Hurll edited Jameson's book in the 1890s, she included Thayer's *Virgin Enthroned* as an example of the "Madonna Enthroned without her son," a subcategory of devotional subjects that appealed to the "faith and piety of the observer."[29]

Thayer's reliance on Renaissance art was not limited to composition; it encompassed, too, the social values of order and tradition it espoused. At the end of the nineteenth century, America's wealthiest citizens enacted their personal and nationalist ambitions by collecting works of old masters and bringing them to the United States. Believing America would never create a culture to match that of Europe without original masterpieces in its borders, they schemed to purchase Raphael's Madonnas in particular, since they were considered the paradigm of cultural refinement and the highlight of any collection.[30] Collectors focused on the old masters rather than contemporary art because the former reaffirmed values of stability and harmony and served as a source of aesthetic and moral values.[31] Thayer's angels, virgins, and winged figures drew on this cultural heritage and reinforced the correlation of the Madonna with Anglo-American middle-class domesticity.[32] They embodied familiar ideals and future prospects in an environment that posed strong challenges to traditional forms of family life and religious belief as a result of rapid industrialization, urbanization, immigration, as well as their attendant threats—both real and imagined—to Anglo-American Protestant authority.

Finally, Thayer's combination of portraiture and landscape in *Virgin Enthroned* and other images of women reflected the "naturalism" and "sympathetic sentiment" that contemporary writers claimed characterized the best of Renaissance art and religion.[33] Nicely summarizing this interpretive tradition in 1909, Edwina Spencer argued that the Madonna subject completely changed in "form and meaning" with the "marvelous artistic awakening in the Renaissance": "Its purely religious emphasis gave way to the naturalistic viewpoint; to its theological import was added the powerful appeal of

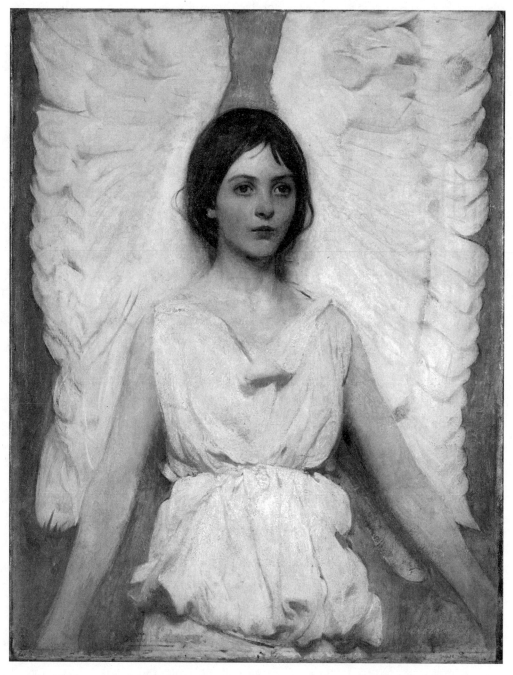

Figure 37. Abbott Handerson Thayer, *Angel*, ca. 1889. Smithsonian American Art Museum, Washington, D.C. Photo credit: Smithsonian American Art Museum, Washington, D.C./Art Resource, New York.

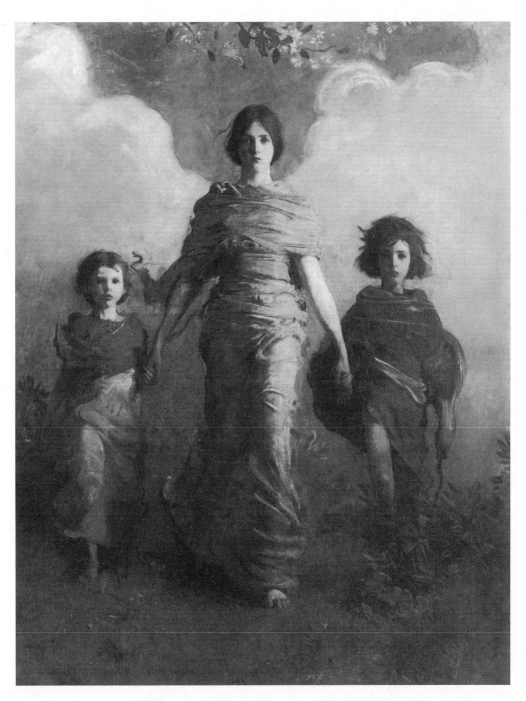

Figure 38. Abbott Handerson Thayer, *A Virgin*, 1892–93. Oil on canvas, 229.7 × 182.5 cm (90 7/16 × 71 7/8 in.). Freer Gallery of Art and Arthur M. Sackler Gallery, Smithsonian Institution, Washington, D.C. Gift of Charles Lang Freer, F1893.11a.

human motherhood."[34] Since Thayer worshipped women and nature and believed in their abilities to embody the real and ideal, his reliance on Renaissance composition and themes stressed his belief that transcendence was not divorced from the material world but emerged within it.

Real Idealism

Thayer's aesthetic philosophy rested on the belief that the body was regulated by the soul. In the early 1890s he emphasized the intimate relationship between the two: "The body is only at its real beauty when controlled by the soul, not when arranged by the painter, and it is still the body that I want to paint."[35] Thayer's assumption that realism and idealism were not antithetical to one another was embedded in the sculptural works of his friend, Augustus Saint-Gaudens (among other artists), and in art criticism generally. Writer Katie Cowper, for example, asserted that while the "real" and "ideal" seemed antagonistic on first glace, they were "so closely bound up with one another that they cannot be divorced in art without each suffering severely."[36] Thayer's belief in women's mediating role in American life, in Emerson's notion of the incarnate soul, and in Neoplatonism's conception of the world as a vertical continuum of the material and transcendent converged in his aesthetic philosophy of Idealization.

Thayer presented women as conduits of transcendence through their embodiment in the material world. In *Virgin Enthroned*, for example, the Madonna inhabits all three horizontal planes that compose the painting: the dirt of the earth, the location of the children between the wood bench and the horizon line, and the blue sky. While Mary's skin tone mirrors the brightness of the sky, her drapery becomes darker near the bottom, taking on a deeper green hue of the earth and blending into the dark character of the earth and ground. To cite another example, the large wings of the young woman in *The Stevenson Memorial* reach upward, while her body sits upon a rock firmly located in the material world (fig. 39). The wings connote the woman's ability to move between earth and heaven, or as Thayer put it later in his career, to "symbolize an exalted atmosphere (above the realm of genre painting) where one need not explain the action of his figures."[37] However, Thayer's almost sculptural emphasis on the winged figure emphasizes her physicality, and in one of the few direct references to Stevenson, he inscribed the rock with "VAEA," the name of the Samoan mountain on which Stevenson was buried. Real and ideal, presence and absence, intermingle in Thayer's painting, neither one taking priority over the other.

Thayer's focus on the natural world and women as sites of the divine stemmed from his life-long devotion to Ralph Waldo Emerson. Emerson's essay "Spiritual Laws" enjoyed a favored place throughout Thayer's life because it privileged sight as a means to access the transcendent.[38] In it, Emerson claimed that God exists as a "soul at the center of nature." Nature, in turn, "testifies" to eternal truths. Since people reason from the

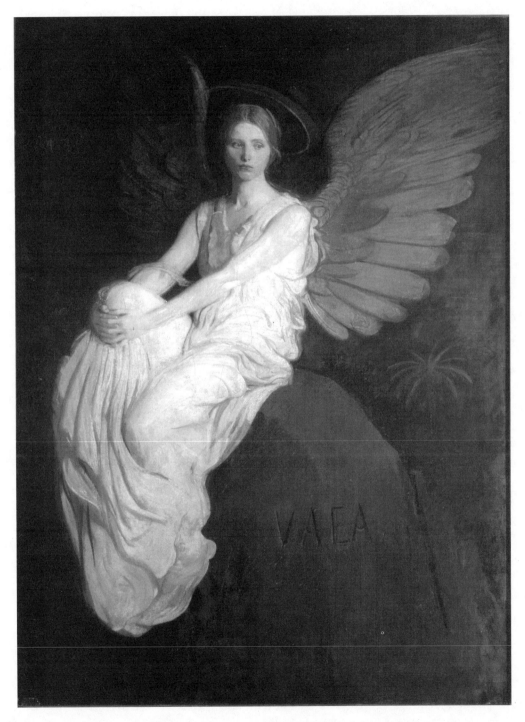

Figure 39. Abbott Handerson Thayer, *Stevenson Memorial*, 1903. Gift of John Gellatly. Smithsonian American Art Museum, Washington, D.C. Photo credit: Smithsonian American Art Museum, Washington, D.C./Art Resource, New York.

"seen to the unseen," vision is the means through which people apprehend the soul. Emerson used the example of women to illustrate the process of faith in "Spiritual Laws." In the second to last paragraph he calls on painters to use the conventional stories of the "Virgin Mary, of Paul, of Peter," but to present the essence of those figures rather than represent the historical figure:

> Let a man believe in God, and not in names and places and persons. Let the great soul incarnated in some woman's form, poor and sad and single, in some Dolly or Joan, go out to service, and sweep chambers and scour floors, and its effulgent daybeams cannot be muffled or hid, but to sweep and scour will instantly appear supreme and beautiful actions, the top and radiance of human life, and all people will get mops and brooms; until lo! Suddenly the great soul has enshrined itself in some other form, and done some other good deed, and that is now the flower and head of all living nature.[39]

Emerson relied on a number of verbs to emphasize the presence of God in nature: the soul was embosomed, infused, incarnated, enshrined, and expressed in the visual world. In this philosophical system, nature and humankind embodied the divine and served as the means through which it was apprehended.

Thayer's approach to making art was deeply influenced by Emerson's exposition of the incarnate soul and moral nature, and his consistent representation of women literalized the philosopher's use of the female form to illustrate his philosophy. His embrace of Transcendentalism existed alongside a Neoplatonic conception of the world as an upright axis that located darkness, dirt, sickness, and mortality on the earth and equated lightness, purity, health, and truth with the divine.[40] The artist believed that men and women, particularly worshippers like himself, reached toward the heavens to escape the confines of the civilized world. In 1880 he cited proof of immortality by asking: "Is it not true that this eternal reaching after beauty and less and less attachment to physical things is a proof beyond dispute that such climbing is not subject to accidental interpretations?" Thirty-four years later he made a similar point, asserting "every real worshipper inevitably climbs to higher and higher summits in an effort to approach God."[41]

Thayer's perception of human life as a process of moving closer and closer to the divine through the aid of women, nature, and other prophetic intercessors is best expressed in one of his most telling letters to the editor, written in 1902. In it, he used the metaphor of great birds and winged people to describe the prophets who soared above humanity's "ephemeral hordes":

> But let us not lose heart for humanity when we learn that its moral specific gravity is not yet improved enough to float it. It is slowly but surely gaining. One might liken the prophetic souls who strive against a national decadence to great birds, the winged part of a people,

spreading their pinion above the sea of circumstances, and with strong wing-beats, holding up the water-logged raft to the last moment, then soaring aloft together. Let us find our peace in perceiving that this species of winged being does exist. Indeed, it is the healthiest of all, though of limited numbers, and probably the only one that steadily increases amidst the ephemeral hordes that so often darken out sight.[42]

According to Thayer, winged beings acted as emissaries between the herds that populated the earth and the God who created and ordered it. While Thayer metaphorically described prophets as winged figures, his depiction contained a literal dimension. Since winged figures could behold nature's details on the ground and their relationship to others from a distance, they could see the beauty and truth of those particularities.

Thayer considered the artist a winged figure who sought to look as God looked and to produce art that enabled the beholder to see "from all points and from all moments as God does."[43] To do so, Thayer worked to eradicate everything else in his mind: "I am still keeping away from studio but getting full of confidence and clear visions and feel so out of all memory of how my things look, in fact utterly cool that after a day or two on Mary's head I shall be omnipotent." At other times, he claimed his works came to him as visions: "All of a sudden *I saw my* picture."[44] In a letter to one of his students, William James Jr., Thayer used the word "daimon" to explain the artist's need to be both supreme being and humble servant, all-seeing god and recipient of divine intervention.[45] The artist's conception of daimon was informed by Plato's dialogue, *The Symposium*, in which Socrates learns that it is a great spirit and mediator who "spans the chasm which divides them, and therefore in him all is bound together, and through him the arts of the prophet and the priest, their sacrifices and mysteries and charms, and all, prophecy and incantation, find their way."[46] Thayer's daimon served as an active inner voice that interceded between humanity and genius and, just as importantly, bound the two together.

Thayer described his approach to making art as a process of Idealization. He believed that artists had to see their subjects as human types, "representative beings, both animal and poetic, making them, or rather seeing them to be, the central figure of each complete world picture." In doing so, he continued, they followed "God's law given to them with their exceptional beauty when they remove to the necessary distance for seeing people."[47] For Thayer, the artist inversed the telescopic process, moving from the particular details to the general type.[48] Not surprisingly, he applied his aesthetic theory to his personal life. Soon after Kate's death, Thayer wrote to Emma Beach, a woman he and Kate befriended in the early 1880s and relied on for financial and managerial assistance. Thayer proposed marriage to Emma (she later accepted and became his second wife), in part because he wanted his children to have a "representative woman, mother" as well as a representative man in the house.[49] For Thayer, individual people were both "real" and "representative," historical figures and eternal souls.

Figure 40. Joseph Gray Kitchell, *Composite Madonna*, ca. 1899. From "The First Composite Madonna in the World," *Ladies' Home Journal* 22, no. 6 (May 1905): 7.

Thayer's interest in the representative type can be clarified by comparing his focus on the ideal to the underlying assumptions of composite photography. He argued that while the artist began with "materialistic accuracy" and waited for the model's "beauty and grandeur" to "reveal their *climax*," the composite photograph was "condemned to record, i.e. the average looks."[50] One can only imagine his distaste for the *Composite Madonna*, displayed in the Tissot Gallery of Wanamaker's New York department store in 1899 and sold as a framed reproduction in three sizes at the cost of five, ten, and sixty-five dollars six years later (fig. 40).[51] The *Composite Madonna* was produced by Joseph Gray Kitchell, who combined two hundred and seventy-one pictures of the Madonna to create a composite image. Since there were so many blurred lines in the resulting photograph, the artist Elliott Daingerfield, "an American painter of Madonnas," produced a final version on canvas that he claimed consisted of a "little surer placing of line and subtlety of modeling."[52] While the *Composite Madonna* received critical acclaim from such esteemed and varied figures as Secretary of State John Hay, Chief Justice Melville Weston Fuller, educator Booker T. Washington, and inventor Thomas Edison, at least one person sent a letter to the editor of the *New York Times* expressing disdain for it: "[When] Madonnas are blended as teas are blended, as coffee is blended, and as cocktails are blended, we are, indeed, at the end of an epoch."[53] Asserting a

conception of art shared by Thayer, the writer argued that art cannot be reduced to scientific reproduction of the real but, rather, must be an individually inspired ideal.

The relationship between the actual and the transcendent was a delicate one, and Thayer expressed deep remorse when he was unable to harmonize them. For example, Thayer's best known work in the period, *Caritas* (1893–97), pictured a young woman, clothed in white, holding out her hands in benediction over two small children (fig. 41). Branches and leaves set against the sky create a wing-like effect behind her. The woman's pose, airy attire, and closed eyes would suggest an ethereal nature if her limbs were not so clearly drawn and her foot, peaking out from under her drapery, did not bear so much weight. The children's nudity, moreover, points to their sexuality, a reality that is remarkably absent from Thayer's other images. While *Caritas* followed the pattern established by Thayer in *Virgin Enthroned* and *Virgin*, the artist expressed his mixed feelings about the work in a letter to the director of the Museum of Fine Arts in Boston, the purchaser of the painting: "You are quite right about the so-called Caritas—It is almost the only thing I have ever done without having some honest pride as to having sounded a pure note, as it were, no matter how dim."[54] Thayer felt the painting's emphasis on the body rendered it "display" rather than "true expression." Since display, like fashion, was fleeting rather than eternal, the painting did not belong in a museum of art. Thayer required his sacred figures to be part of the world and able to transcend it, not so mired in materiality that they could not fly. In turn, he wanted viewers to contemplate the divinity of his female figures, not become distracted by particularities and remain within the material world.

The Spiritual in Art

Thayer's approach to art was distinct from any organized religious tradition and theological formulation; it was "spiritual": inward looking, human centered, and eternally present. Like so many others of his generation, Thayer distinguished between individual faith and theological dogma. In 1902, he clearly contrasted "what is called Christianity" to the figure of Christ, highlighting the distinction between the human institution and the individual figure.[55] His youngest daughter, Gladys, reiterated this point, indicating that her father did not believe reverence should be labeled since it would inevitably limit its potency and expansiveness. Nor could religious belief be delimited to a single set of rites or rituals: "Again the church in his opinion was far too often a cheap whitewash condoning moral delinquency during the six free days, not conceded to God. It amused him, too, that the creator should be allotted only one day out of seven. Christ was a vital force in his life but to be worshipped only as a man."[56] Like James, whom he admired greatly, Thayer defined religion in relationship to individual experience rather than a community of believers brought together by shared histories and traditions.

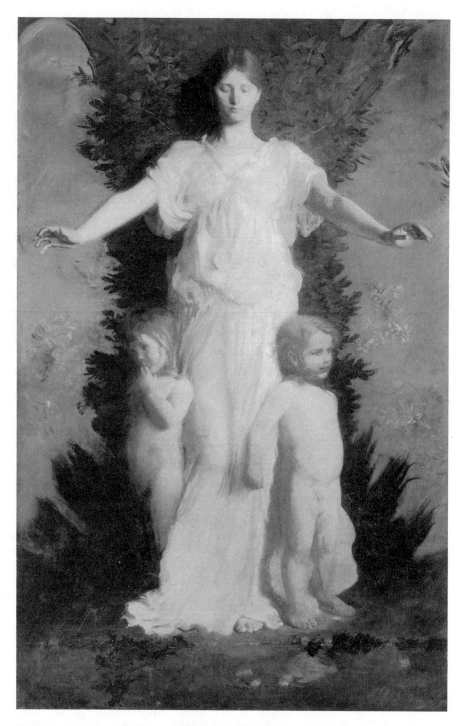

Figure 41. Abbott Handerson Thayer, *Caritas*, 1894–95. Oil on canvas, 216.53 × 140.33 cm (85 1/4 × 55 1/4 in.). Museum of Fine Arts, Boston. Warren Collection—William Wilkins Warren Fund and contributions, 97.199.

Thayer's attention to the experience of religion as opposed to its linguistic and ritualistic codification emerged further in his definition of himself as a worshipper. In a letter to Edward B. Poulton, professor of entomology at Oxford University, Thayer described worship as the "the capacity to feel rapturous over every step into nature."[57] He further clarified what he meant in an undated draft of a letter to writer Owen Wister after the 1913 Armory Show, when he contrasted the worshipper and self-asserter: "While every real worshipper inevitably climbs to higher and higher summits in an effort to approach God, far down below the *self-asserter* lacks all such upward drawing and vaunts himself on his ability to *perform*, be the performance no matter what."[58] Thayer linked the act of worship to the attempt to overcome material particularity and see Truth. Art, in turn, was to record, visualize, and immortalize that worship: "It goes far to describe art to say it is a record of worship, alias love."[59]

The ways of seeing sponsored by Thayer in his paintings paralleled James's focus on the interior and subjective experience. Thayer deemed the female body and art object as mediums for spiritual experience and vehicles of redemption for sick souls. By excluding iconography that required the beholder's knowledge of the emblematic tradition to deduce meaning, narrative elements that encouraged the viewer to read the painting, and familiar objects that caused the spectator to identify or sympathize with the subject, Thayer encouraged an individual encounter with the divine. The fact the paintings were more than life-sized, engulfing the viewers who stood before them only heightened their iconic presence. As Thayer wrote: "Art rescues man from his state of being limited to a point and to a moment." While the intellect functions as a camera, capturing the "smallest accident of the moment's and the place's particularity," contemplating a work of art frees the beholder to look as God looks, to exist in an eternal present of complete perception.[60]

Divine Intercession

Contemporary reception indicates that Thayer achieved his goal; beholders encountered his paintings of angels, Madonnas, and winged figures as devotional objects. They engaged the artwork and surrendered themselves to it. Critics characterized this way of seeing as "spiritual," concerned with personal experience and transformation rather than communal instruction and ritual.

Thayer relied on the Madonna and her associations with ideal womanhood to induce the viewer's communion with the object. Women's sacred status in American culture ensured that reviewers would contemplate and absorb themselves in Thayer's paintings. As Samuel Isham noted in *History of American Painting* (1905), images of ideal womanhood encouraged—and even demanded—that kind of interaction:

> [Americans] have no goddesses or saints, they have forgotten their legends, they do not read the poets, but something of what goddess, saint, or heroine represented to other races they find in the idealization of their

womankind. . . . The American girl is placed upon a pedestal and each offers worship according to his abilities, the artist among the rest.[61]

Contemporary response of Thayer's paintings indicates that viewers situated the artist's work in the genre of ideal womanhood. One critic encapsulated popular adoration for *Virgin Enthroned*, for example, by observing, "The lovely figure of Motherhood sits enthroned there, worshipped by her sweet and innocent offspring."[62] Caffin went further, indicating that women's divinity was a self-fulfilling prophesy in Thayer's work: "The girl-figure that haunts his canvases, nobly formed, but free of any cloy of flesh, front the world with starlike eyes, serenely fixed beyond the range of common things. She is a vestal virgin, that has in her keeping the spiritual ideal of which she herself is the creation."[63] Thayer's paintings of ideal womanhood presented the object that Anglo-Americans venerated.

It was not only the subject matter of Thayer's paintings that mediated the material and spiritual realms; it was the art object itself. One critic described a scene reminiscent of Henry James's description of popular response to Raphael's *Madonna of the Chair*; when the reviewer visited the museum to see (in all likelihood) *Virgin Enthroned*, "the room was full of people standing in a sort of reverent silence before it."[64] This writer was not alone in focusing less on the painting's subject matter than on its influence over the viewer. Most commentators mentioned one or all of the following characteristics. First, Thayer's paintings reflected or inspired the imagination: "Immediately on entering the first gallery one sees [the *Stevenson Memorial*] through the long vista of galleries shining and resplendent like the angel of our imagination."[65] Second, the works demanded attention: "Without attempting to startle by jarring conceits, Thayer's inspiration envelops our willing imaginations in the reserved mystery of his direct conceptions. His pictures always demand attention."[66] Third, they haunted the memory or mind's eye: "His pictures appeal to every one with a charm difficult to analyze, but which haunts the memory of those who know them."[67] Another wrote: "The face of the young mother is one of those faces which wistfully, sadly, sweetly and serenely seem to follow the visitor with that indescribable glance far beyond the confines of the gallery and to haunt the mind's eye."[68] Whether the picture enveloped the imagination, demanded attention, or haunted the mind's eye, Thayer's image invited, and even pressed, the spectator's considered engagement.

Most critics relied on the word "spiritual" to characterize the influence of Thayer's art on the viewer. For example, Mrs. Arthur Bell asserted that "the most striking characteristic of the subjects [is] their deep spiritual significance."[69] Caffin wrote that Thayer's "pictures move and hold one by the force of their spirituality." Later, he reiterated that they were a "notable embodiment" of spirituality and imagination, two values absent in contemporary culture.[70] Still another claimed that "the artist has so interpenetrated his work with his idea that spirituality encompasses it, breathes out from it, and between Raphael and him we do not know of a finer instance of the sort."[71] All these critics

attributed a religious dimension to Thayer's work since it pictured eternal, transcendent truths. Rather than representing a theological concept or scriptural interpretation, the artist presented ideals that required viewers to draw on their own experience. Thayer did not assume his beholders shared a visual language or set of correspondences but, rather, a common array of feelings and concerns about themselves and the world around them that they accessed in front of his pictures.

Viewers' attempts to locate the spiritual in Thayer's art underscore its foundation in the individual's engagement with the world. One writer asserted that "Mr. Thayer's painting has been spoken of as not designed to portray the legendary 'Madonna,' the Mary, mother of Jesus, written of by the evangelists. But no one can look at it without feeling that whatever the intention the work is divine, and that nothing will suit what has been done save the old story of the scriptures."[72] While this critic sought to distinguish between the transcendence of the legendary Madonna and Thayer's women, she or he failed to find another appropriate model and resorted to tradition. Sadakichi Hartmann was a bit more successful. While assuming the correlation between art and religion, he distinguished between institutional and private religious practices.[73] Another humanized Thayer's religious imagination further, comparing "churchly" and "earthly" religion: "It is probable that Mr. Thayer had no definitely religious intention in painting the beautiful picture. . . . Certainly it is no churchly religion here typified, but rather the religion of love 'twixt a father and his children, an early religion."[74] The spiritual in art rested on the beholder's personal experience with the work, shaped by private devotion rather than church doctrine, domestic relationships rather than communal rituals.

The Perception of Beauty and Its Moral Import

While Thayer's primary concern rested with the individual's emotional encounter with the work, he nevertheless believed art had a social purpose. Writing to Dwight Tyron in 1914, Thayer argued against calling art a form of expression: "Beethoven was not trying to express something, was building trustfully the structures God (we will call it that for want of a name) reveals to him, and which he told him to build for his fellow men."[75] For Thayer, art remained a revelation of the "Infinite Source Inscrutable," and the artist retained the responsibility to reveal that vision for viewers. Art was not for its own sake but played a critical social role in the elevation of taste and maintenance of social stability.

Thayer's belief in art's salvific role was a natural outgrowth of the German idealist tradition in which he was well-versed. His first wife, Kate Bloede, immigrated with her family to the United States in 1850 after her father was released from prison and allowed to leave Germany after serving as one of the revolutionists of 1848. In her parents' household, Thayer's Unitarian and Transcendentalist upbringing was conjoined with the idealist philosophy and romantic literature of Kate's native country.[76] Thayer

boasted a particular interest in the German poet Friedrich Schiller, who believed that aesthetic education was a condition for citizenship in a modern democratic state. Beauty united the sensual and rational elements of human nature and reconciled individuals with themselves and the physical world. It elevated and liberated the individual soul, a necessary prerequisite for human freedom on a national scale. As art historian David Morgan contends, the resulting conception of art as a receptacle of individual genius and distillation of a nation's soul could lead (and often did) "toward a very private self-communion, where artistic experience was akin to a kind of mysticism, a transcendentalism that sacralized art."[77]

Thayer joined educators, tastemakers, and Progressive Era reformers influenced by John Ruskin's moral aesthetics and William Morris's craftsman ideal in deeming art a primary means to cultivate taste and socialize children and immigrants into American life. They believed the home—its architecture and material culture—had the power to shape the character of its inhabitants.[78] Reproductions of fine art were critical to the reformation process, and authors instructed women how to select pictures for the home. Working in the tradition of women's advice literature and homemaking guides, for example, Hurll (author of *The Madonna in Art*) argued that pictures are a "perpetual source of education and delight" that not only furnish and beautify the home but "elevate the taste to the highest standards." She asserted that Raphael's *Sistine Madonna* was an excellent choice for the parlor, since "it is a picture whose elevating influence will make itself felt upon all the sweet, strong spirituality of this ideal of womanhood, hastening down the centuries to present Christ to the world."[79]

The use of Marian imagery among reformers to assimilate working girls, immigrants, and former slaves into middle-class Protestant American life—or more specifically, into the model of civilization and progress embodied by Anglo-Americans—was considerable, and anecdotes about its effectiveness appeared consistently in periodicals and newspapers. For example, a Boston woman gave working girls a "Madonna party" on Christmas Eve in 1893. She asked each invitee to bring at least one picture of the Madonna, and the group spent the afternoon examining and discussing them, "proving a deployment into the field of art such as the girls had never known before."[80] The Hull House settlement in Chicago operated a circulating picture gallery, where framed prints of fine art paintings by artists like Thayer, Millet, and Fra Angelico could be checked out for two-week periods and displayed in the "bare, ugly" rooms of working-class Chicagoans. The writer Lucy Monroe believed that they needed "to have art brought close to the people, to make them see it and feel it and live with it. It should be part of themselves, as necessary and inevitable as food and shelter."[81] Lillie B. Chace Wyman agreed and believed fine art could help "Southern colored women." She used the observation that "the general presence of copies of the Sistine Madonna in New England homes has not only created there an ideal of womanhood, but has caused its embodiment in many a sweet and serious life," to assert that colored women need "similar ideals of beauty and goodness."

Because their furtive imaginations and emotional natures were tended by the "crude religious exhortations" of their illiterate and undisciplined preachers, they required the "finer influence of civilization" for their "purification."[82] Deploying the common argument that art could foster taste, Wyman called particularly for images of the Madonna to imprint the "ideal of womanhood" on Southern women and to "purify" them.

While fine art socialized children and immigrants into American life, it accomplished a far more important mission: it cultivated the soul. In the June 1898 edition of *Brush and Pencil*, Peter W. Dykema, a prominent educator, described an "experiment" at West Aurora High School in Illinois that aspired to determine whether including the study of art would help develop "the feeling, the higher qualities of the imagination—we might almost say the soul—[that] has been woefully neglected" in America's educational system. He explained that during the 1896–97 school year, two to four weeks of English instruction were replaced with the study of "The Madonna in Art." In addition to a "number of large framed pictures ... obtained from the homes in the city," students were asked to find images in "magazines, illustrated books, art portfolios, in fact, everything containing pictures." The students collected "three hundred or four hundred pictures of all sizes and qualities."[83] Even if some of prints depicted the same image, the sheer number of objects the students collected points to the Madonna's pervasiveness and popularity in turn-of-the-century American life.

Based on this experiment, Dykema reached three conclusions about art's potential role in education. He argued that art-historical examination stimulated close observation. Students no longer looked at a painting, they contemplated it, and used these thoughts to better appreciate the world around them. Second, the close observation of paintings imparted knowledge about the history of art and encouraged students to seek out opportunities to see art and to purchase it. It encouraged them to be open to beauty and liberate their souls. Third, the ability to look at art and understanding its place in history developed a "certain tone or spirit." It came as a "stimulating, inspiring force" and created a "sense of the unattainable, of the infinite."[84] Marian imagery did not inculcate moral values, elucidate scripture, or endorse community standards; it promoted contemplation, liberated souls, and stimulated a sense of the transcendent.

Perhaps the clearest explanation of beauty's social influence was articulated in 1898 by the president of the Chicago Woman's Club. In her article, "The Relation of Art to Morality," Marie Remick wrote: "Art has a vital relation to morality, but we must seek it not in its didactic teaching, but in beauty, which always exerts a refining influence, tending to soften manners and elevate character." Art does not teach through didacticism, but through influence. It exerts, tends to, elevates, and anoints. It serves as a respite from the materiality of the world, as an adornment that brings pleasure, and a means of "spiritual refreshment." Instead of bringing knowledge to the work of art, according to Remick, the viewer must "surrender" himself or herself to it. It is not how much a person knows that makes a work meaningful but the amount of "sensibility and

warmth of the imagination" the viewer brings to it.[85] Beauty has a force that viewers must receive willingly, and if they accept it, their tastes are elevated and souls refreshed. The art critic Hartmann put it more bluntly: while "art should exercise a distinct moral and educational influence," it should emerge "not merely by the choice of subject, but rather unconsciously, by force of its beauty."[86]

Art's relationship to spirituality and beauty shared an emphasis on the beholder's individual encounter with the work of art, its role in self-knowledge, and its transcendence of the everyday. It imparted values critical for social stability, created environments that cultivated the behavior necessary for its maintenance, and saved the souls that learned to appreciate it.

Gendering Modernism

In his autobiography, *The Education of Henry Adams*, and history of the Middle Ages, *Mont-Saint-Michel and Chartres*, the historian Henry Adams wondered why Americans never felt the force of the Virgin Mary like medieval Christians or contemporary French believers who flocked to Lourdes to visit the site where peasants claimed to have seen her. While Adams's assertion that Americans did not experience the power of the Madonna appears strange based on her pervasiveness in the nation's fine and popular arts, his concern with Mary's potency distinguished his interpretation of her. He described her as a "goddess because of her force; she was the animated dynamo; she was reproduction—the greatest and most mysterious of all energies; all she needed was to be fecund."[87] While Adams considered the Virgin at Chartres a "channel of force" that contained the power to inspire, propagate, and create, he deemed the Madonna of Protestant leaders and art collectors a "channel of taste," charged to measure cultural standards, to control the sexual impulse, and attain control over anarchy.[88]

Thayer's winged figures were more similar to Adams's American Madonna than to his description of the Virgin of Chartres, working to reinforce European American middle-class standards of morality and the order of things. Nevertheless, they hinted at the latter's generative and destructive power. Indeed, the painter's almost obsessive repetition of the Marian theme underscored its instability. For example, Thayer's language of ideality was often laced with an undercurrent of sexuality. In a description of his progress on *The Angel*, Thayer slipped between a discussion of Mary the person and Mary the subject of the painting: "In this way I dream of having every touch on (?) Mary seen so potent and effective that I shall paint her better."[89] Thayer was not alone in his use of sensual language to describe female purity. Saint-Gaudens noted, for example, that Thayer had "mastered the charm in the suggestiveness of repose."[90] While the language of beauty employed by turn-of-the-century artists, critics, and tastemakers may have aimed for the Platonic ideal, it was mired more often in human longing and physical desire.

Moreover, although Thayer celebrated the union of the real and ideal in his correspondence and work, he realized it rarely in his daily life. In a letter presumably written to one or more of his children in 1905, Thayer opened with his customary idealizing language about his first wife, Kate. As the letter continued, Thayer wrote that when Kate entered the hospital, he turned to a female friend for support: "And when [Kate] ceased to be herself and I by confiding my grief to my dear friend Miss [Carrie] Hecker found myself getting in love with her, I always knew and I kept Miss Hecker perfectly enlightened about it and impressed with it, that were your mother ever to be again I should instantly be again *all hers* if only by simple virtue of her being more God-like than every body else—no matter why!" Thayer used the Parable of the Sower (Matthew 13:3–9) to compare his relationships with Kate and Miss Hecker: "And my infatuation with Miss H. like a seed sprouting on rocks, withered away soon by the limiting power of your mother's existence in my heart."[91] Abstract conceptions of the ideal that Thayer used to characterize his marriage to Kate were unable to compensate for the human realities of loneliness and sorrow he experienced with her illness and death.[92]

Thayer's lifelong struggle to marry the material and spiritual realms motivated his paintings of winged figures. As channels of sentiment that struggle to manage the tensions produced by modernization, his paintings underscore the social implications of ideal womanhood and the gendering of modernism more generally. Purportedly transcendent, the American Madonna inscribed the values of European American Protestantism on the bodies of all women, no matter what their denominational affiliations or ethnicities. Moreover, her eternal nature relegated women outside human history, unable to influence or actively engage the world in which they lived and worked. Finally, as artists, critics, and patrons treated women and art as objects of devotion, they fashioned aesthetic experience on heterosexual desire. This tangled association of women, art, and modernism, codified at the end of the century, was picked up and transformed by Alfred Stieglitz and his circle two decades later.[93] While they shifted the subject matter of modern art from the female body to abstract forms, and its theoretical formulation from Christianity to psychoanalysis, they maintained fine art's intimate relationship to religious belief and practice.

Art's spiritual function in American life emerged alongside historic shifts in religious belief and practice. Just as art demanded the beholder's emotional rather than conceptual engagement with it, religion stressed empirical encounters with the divine. Intellectuals of all kinds articulated this monumental transition. In 1905, for example, the American philosopher George Santayana announced that the "aspiring side of religion may be called Spirituality."[94] Critic and historian Charles Caffin went further, arguing that the future of modern American art rested on its ability to develop the spiritual.

In his 1907 book, *The Story of American Painting*, Caffin identified two dominant traditions in American art: the "material" and the "spiritual." While the dominant

characteristic of American art was its materialism, James McNeill Whistler, Thomas Dewing, and Thayer paved another path and "treated the actual appearance as a symbol of moods and apprehensions of the imagination and spirit."[95] For these men, truth was embedded in matter, and the actual evoked the spiritual. Caffin asserted further that the development of this strain of American artistic production was "necessary for the highest form of expression in modern art." He believed that artistic masterpieces grew out of "religious consciousness," when common people had a collective need to "have its faith and soul-experiences bodied forth by art in terms of religion." Artists, in turn, responded to that need. A work of art became a masterpiece when it embodied the sacred, defined by its expression of the community's consciousness rather than its representation of a scriptural event.

While Caffin noted that the contemporary "belief in humanity" was sufficient for "man's physical, material, and intellectual uplifting," it was not a motive for fine art, since its "influence [was] almost purely materialistic and sensuous."

> It is only when this new religion shall be impregnated with a corresponding practical belief in the facts of spirit, that the possibility of a great art in modern times will arise. Symptoms of this new movement, as I have said, can already be detected in American painting. Whether they shall multiple and replenish the earth depends in a final analysis upon the public.[96]

Caffin believed that modern American art should be predicated on a collective spiritual sense, just as the old masters were influenced by a shared religious tradition. He believed that Whistler, Thayer, and Dewing set the stage for such an art by evoking the transcendent in depictions of the visible world. However, unless the public pressed its artists to realize its spiritual consciousness, contemporary America would never produce artistic masterpieces.

For Caffin, and so many other American artists, critics, and viewers, modern art was not defined by contemporary subject matter or abstraction but its ability to express people's needs and values. The spiritual was located less in the art object and its subject matter than in the "spiritual energy" that flew between the beholder and the object. It fulfilled the very functions of James's religious experience: it compelled viewers to absorb themselves in the work and to find communion with the transcendent.

Notes

Introduction

1. "Art Gossip: Revival of Religious Art," *Art Age* 5 (February 1887): 19. I want to thank Sally Promey for bringing this article to my attention.

2. Sargent quoted in Sally M. Promey, *Painting Religion in Public: John Singer Sargent's Triumph of Religion at the Boston Public Library* (Princeton: Princeton University Press, 1999), 11.

3. E. A. Taylor quoted in Clara T. MacChesney, "A Poet-Painter of Palestine," *International Studio* 50, no. 197 (July 1913): xiv.

4. Promey, *Painting Religion in Public;* Violet Oakley, *The Holy Experiment: Our Heritage from William Penn* (Philadelphia: Cogslea Studio Publications, 1950). David Morgan discusses Mihály Munkácsy's painting in *Protestants and Pictures: Religion, Visual Culture, and the Age of American Mass Production* (New York: Oxford University Press, 1999), 319–21. Tissot's New Testament illustrations were shown in New York, Chicago, Boston, Pittsburgh, Philadelphia, Washington, and other principal cities. The itinerary for the exhibition is included in Clifton H. Levy, "The Life of Our Lord to the Life. M. Tissot's Wondrous Work," *Ave Maria* 48, no. 6 (11 February 1899): 163.

5. Thomas Lawton and Linda Merrill, *Freer: A Legacy of Art* (Washington, D.C.: Freer Gallery of Art, Smithsonian Institution; New York: Abrams, 1993); and Kathleen Pyne, *Art and the Higher Life: Painting and Evolutionary Thought in Late Nineteenth-Century America* (Austin: University of Texas Press, 1996). On religious art in the popular press, see, for example, Rufus Rockwell Wilson, "Religious Painting in America," *Outlook* 54 (12 December 1896): 1085–89; Clara Erskine Clement, "Early Religious Painting in America," *New England Magazine* 17, no. 4 (December 1894): 387–402, and "Later Religious Painting in America" *New England Magazine* 18, no. 2 (April 1895): 130–54.

6. *The Light of the World; or Our Savior in Art* (Chicago: Elder Company, 1896), frontispiece.

7. See particularly Neil Harris, *Cultural Excursions: Marketing Appetites and Cultural Tastes in Modern America* (Chicago: University of Chicago Press, 1990).

8. On the patronage of Munkácsy, see Charles M. Kurtz, *Christ before Pilate: The Paintings by Munkacsy* (New York: Published for the exhibition, 1887), 8. On the relationship between collectors and religious education, see Morgan, *Protestants and Pictures.*

9. The term "cultural capitalists" comes from Paul DiMaggio, "Cultural Entrepreneurship in Nineteenth-Century Boston: The Creation of an Organizational Base for High Culture in America," in *Rethinking Popular*

Culture: Contemporary Perspectives in Cultural Studies, edited by Chandra Mukerji and Michael Schudson (Berkeley: University of California Press, 1991), 374–97. On the favor shown Raphael by collectors, see David Alan Brown, *Raphael and America* (Washington, D.C.: National Gallery of Art, 1983). On the "sacralization of culture," see Lawrence Levine, *Highbrow/Lowbrow: The Emergence of Cultural Hierarchy in America* (Cambridge: Harvard University Press, 1988); and T. J. Jackson Lears, *No Place of Grace: Antimodernism and the Transformation of American Culture, 1880–1920* (Chicago: University of Chicago Press, 1994).

10. William Leach, *Land of Desire: Merchants, Power, and the Rise of a New American Culture* (New York: Pantheon, 1993), 191–224.

11. "The Wanamaker Store. A Careful, Bountiful, Economical New York Christmas Store," *New York Times,* 12 December 1899, 4; and "The Famous Kitchell Composite Madonna Exhibited in Our Art Gallery," *New York Times,* 20 April 1905, 4. Tissot's four-volume *Life of Christ* was the centerpiece of Wanamaker's Christmas advertising campaign in Philadelphia in 1899. Consumers could join the "Wanamaker Tissot Club" to purchase the $30 to $50 book for $1 down and $3 a month. See "Wanamaker Daily Store News: Tissot's Life of Christ," *North American* (Philadelphia), 26 October 1899, 8; and "Christmas Suggestions from Wanamaker's: Tissot's Life of Christ" *North American,* 18 December 1899, 9.

12. The literature on world's fairs is extensive. See, among others, Harris, *Cultural Excursions;* Robert W. Rydell, *All the World's a Fair: Visions of Empire at American International Exhibitions, 1876–1916* (Chicago: University of Chicago Press, 1984); and *Revisiting the White City: American Art at the 1893 World's Fair* (Washington, D.C.: National Museum of American Art and National Portrait Gallery, Smithsonian Institution, 1993).

13. JoAnne Mancini, *Pre-Modernism: Art-World Change and American Culture from the Civil War to the Armory Show* (Princeton: Princeton University Press, 2005), 9.

14. See Mancini, *Pre-Modernism;* Michele H. Bogart, *Advertising, Artists, and the Borders of Art* (Chicago: University of Chicago Press, 1995); Sarah Burns, *Inventing the Modern Artist: Art and Culture in Gilded Age America* (New Haven: Yale University Press, 1996); and Miles Orvell, *The Real Thing: Imitation and Authenticity in American Culture, 1880–1940* (Chapel Hill: University of North Carolina Press, 1989).

15. Henry Ossawa Tanner, "The Mothers of the Bible—By H. O. Tanner" *Ladies' Home Journal* (September 1902): 9; (October 1902): 13; (November 1902): 13; (January 1903): 13. On Edward Bok and the *Ladies' Home Journal,* see, Edward Bok, *The Americanization of Edward Bok: The Autobiography of a Dutch Boy Fifty Years After,* 28th ed. (New York: C. Scribner's Sons, 1923); and Jennifer Scanlon, *Inarticulate Longings: The Ladies' Home Journal, Gender, and the Promises of Consumer Culture* (New York: Routledge, 1995).

16. David Morgan and Sally Promey, eds., introduction to *The Visual Culture of American Religions* (Berkeley: University of California, 2001), 1–24. On American religion and consumer culture, see Paul C. Gutjahr, *An American Bible: A History of the Good Book in the United States, 1777–1880* (Stanford: Stanford University Press, 1999); Colleen McDannell, *Material Christianity: Religion and Popular Culture in America* (New Haven: Yale University Press, 1995); R. Laurence Moore, *Selling God: American Religion in the Marketplace of Culture* (New York: Oxford University Press, 1994); Morgan, *Protestants and Pictures;* and Leigh Eric Schmidt, *Consumer Rites: The Buying and Selling of American Holidays* (Princeton: Princeton University Press, 1995). For an examination of specifically Catholic devotional items, see Saul Zalesch, "The Religious Art of Benziger Brothers," *American Art* 13, no. 2 (Summer 1999): 56–79.

17. Max Weber, *The Protestant Ethic and the Spirit of Capitalism,* trans. Talcott Parsons (London: Routledge, 1992); and Max Weber, *The Sociology of Religion* (Boston: Beacon Press, 1963). The bibliography on Weber and processes of secularization is extensive. See, for example, Steve Bruce, ed., *Religion and Modernization: Sociologists and Historians Debate the Secularization Thesis* (Oxford: Clarendon Press, 1992); and Bryan Wilson, "Secularization: The Inherited Model," in *The Sacred in a Secular Age,* ed. Philip E. Hammond (Berkeley: University of California Press, 1985), 9–20. For a discussion on the relationship between Christianization and secularization in American religious history, see Leigh E. Schmidt, "Mixed Blessings: Christianization and Secularization," *Reviews in American History* 26, no. 4 (December 1998): 642; and James Gilbert, *Redeeming Culture: American Religion in an Age of Science* (Chicago: University of Chicago Press, 1997).

18. James Turner, *Without God, without Creed: The Origins of Unbelief in America* (Baltimore: Johns Hopkins University Press, 1985), 137. See also Paul A. Carter, *The Spiritual Crisis of the Gilded Age* (DeKalb: Northern Illinois University Press, 1971); and Martin Marty, *Modern American Religion: The Irony of It All, 1893–1919* (Chicago: University of Chicago Press, 1986).

19. Marty, *Modern American Religion,* 2.

20. Promey, *Painting Religion in Public,* 4–5; Marty, *Modern American Religion,* 7–24; Jon Butler, *Awash in a Sea of Faith: Christianizing of the American People* (Cambridge: Harvard University Press, 1990); and Nathan O. Hatch, *The Democratization of American Christianity* (New Haven: Yale University Press, 1989).

21. William James, *The Varieties of Religious Experience* (New York: Penguin Books, 1982), 31, 38, 485–519.

22. David A. Hollinger, "'Damned for God's Glory': William James and the Scientific Vindication of Protestant Culture," in *William James and a Science of Religions: Reexperiencing The Varieties of Religious Experience*, edited by Wayne Proudfoot (New York: Columbia University Press, 2004), 10. My understanding of religious experience is heavily influenced by Wayne Proudfoot, *Religious Experience* (Berkeley: University of California Press, 1985); and Ann Taves, *Fits, Trances, and Visions: Experiencing Religion and Explaining Experience from Wesley to James* (Princeton: Princeton University Press, 1999).

23. Catherine L. Albanese, *America: Religion and Religions*, 3rd ed. (Belmont, Calif.: Wadsworth, 1999), 8–10.

24. David D. Hall, ed., introduction to *Lived Religion in America: Toward a History of Practice* (Princeton: Princeton University Press, 1997), viii.

25. Morgan, *Protestants and Pictures*, 318. On art education in the United States more generally, see Eileen Boris, *Art and Labor: Ruskin, Morris, and the Craftsman Ideal in America* (Philadelphia: Temple University Press, 1986).

26. See, for example, Diane Apostolos-Cappadona, *The Spirit and the Vision: The Influence of Christian Romanticism on the Development of 19th-Century American Art* (Atlanta: Scholars Press, 1995); John Davis, *The Landscape of Belief: Encountering the Holy Land in Nineteenth-Century American Art and Culture* (Princeton: Princeton University Press, 1996); Wendy Greenhouse, "Daniel Huntington and the Ideal of Christian Art," *Winterthur Portfolio* 31, nos. 2–3 (Summer–Autumn 1996): 103–40; Gail E. Husch, *Something Coming: Apocalyptic Expectation and Mid-Nineteenth-Century American Painting* (Hanover, N.H.: University Press of New England, 2000); Angela Miller, *The Empire of the Eye: Landscape Representation and American Cultural Politics, 1825–1875* (Ithaca: Cornell University Press, 1993); Roger Stein, "Charles Willson Peale's Expressive Design: The Artist in His Museum," in *New Perspectives on Charles Willson Peale: A 250th Anniversary Celebration*, ed. Lillian B. Miller and David C. Ward (Pittsburgh: Published for the Smithsonian Institution by the University of Pittsburgh Press, 1991), 167–218, and "Thomas Smith's Self-Portrait: Image/Text as Artifact," *Art Journal* 44, no. 4 (Winter 1984): 316–27; Dickran Tashjian and Ann Tashjian, *Memorials for Children of Change: The Art of New England Stonecarving* (Middletown, Conn.: Wesleyan University Press, 1974); and Bryan Wolf, "All the World's a Code: Art and Ideology in Nineteenth-Century American Painting," *Art Journal* 44, no. 4 (Winter 1984): 328–37.

27. On the importance placed on the object at the turn of the century, see Bill Brown, *A Sense of Things: The Object Matter of American Literature* (Chicago: University of Chicago Press, 2003); Roger Stein, "Artifact as Ideology: The Aesthetic Movement in Its American Cultural Context," in *In Pursuit of Beauty: Americans and the Aesthetic Movement*, ed. Doreen Bolger (New York: Metropolitan Museum of Art, 1986), 23–51. See also Boris, *Art and Labor.*

28. *Crayon* 2 (28 November 1855), 335; and *Crayon* 2 (18 July 1855), 31. Stillman qtd. in Roger B. Stein, *John Ruskin and Aesthetic Thought in America, 1840–1900* (Cambridge: Harvard University Press, 1967), 108–10.

29. For a far more complete discussion of the relationship of the German philosophical tradition to the development of religious and aesthetic experience, see Proudfoot, *Religious Experience*, and David Morgan, "Toward a Modern Historiography of Art and Religion," in *Reluctant Partners: Art and Religion in Dialogue*, ed. Ena Giurescu Heller (New York: The Gallery at the American Bible Society, 2004), 16–47.

30. John Dewey, *Experience and Nature* (LaSalle, Ill.: Open Court, 1987), 10, quoted in Martin Jay, *Songs of Experience: Modern American and European Variations on a Universal Theme* (Berkeley: University of California Press, 2005), 288.

31. See Jonathan Crary, *Suspensions of Perception: Attention, Spectacle, and Modern Culture* (Cambridge: MIT Press, 2000); Leigh Eric Schmidt, *Hearing Things: Religion, Illusion, and the American Enlightenment* (Cambridge: Harvard University Press, 2000); and Taves, *Fits, Trances, and Visions.*

32. Lears, *No Place of Grace*; and Alan Trachtenberg, *The Incorporation of America: Culture and Society in the Gilded Age* (New York: Hill and Wang, 1982).

33. Clara Erskine Clement, "Later Religious Painting in America," *New England Magazine* 18, no. 2 (April 1895): 131. Variations on the theme appeared in the reviews of other authors as well, like the "Art Gossip" columnist for *Art Age* who wrote that a religious work should "typify by visible signs and tokens those things which are beyond the heavens and are more than life and death" ("Art Gossip: Revival of Religious Art," *Art Age* 5 [February 1887]: 19).

34. Margaret McHenry, *Thomas Eakins Who Painted* (Oreland, Pa.: Privately printed, 1946), 29; James L. Wood to Samuel Murray, 14 March 1925, Samuel Murray and Thomas Eakins Papers, Hirshhorn Museum and Sculpture Garden, Smithsonian Institution, Washington, D.C.

35. W. E. B. DuBois, *The Souls of Black Folk* (New York: Dover, 1994), 120.

36. Jay, *Songs of Experience*, 6–7.

37. Michael Baxandall, *Painting and Experience in Fifteenth Century Italy: A Primer in the Social History of Pictorial Style*, 2nd ed. (Oxford: Oxford University Press, 1988), 29–40.

38. The modernization of vision is a model formulated by art historian Jonathan Crary in his influential studies: *Techniques of the Observer: On Vision and Modernity in the Nineteenth Century* (Cambridge: MIT Press, 1992), and *Suspensions of Perception*. The subject has been explored, too, by intellectual historian Martin Jay; film studies scholars Tom Gunning and Miriam Hansen; and art historians David Morgan, Michael Leja, Rachael Ziady DeLue, and Martin A. Berger. See Jay, *Downcast Eyes: The Denigration of Vision in Twentieth-Century French Thought* (Berkeley: University of California Press, 1993); Tom Gunning, "The Cinema of Attractions: Early Film, Its Spectator and the Avant-Garde," in *Early Cinema: Space—Frame—Narrative*, ed. Thomas Elsaesser and Adam Barker (London: BFI Publishing, 1990), 56–62; Hansen, *Babel and Babylon: Spectatorship in American Silent Film* (Cambridge: Harvard University Press, 1991); Morgan, *Protestants and Pictures*; Leja, "Modernism's Subjects in the United States," *Art Journal* 55 (Summer 1996): 65–72, and Leja, *Looking Askance: Skepticism and American Art from Eakins to Duchamp* (Berkeley: University of California Press, 2004); DeLue, *George Inness and the Science of Landscape* (Chicago: University of Chicago Press, 2004); and Berger, *Sight Unseen: Whiteness and American Visual Culture* (Berkeley: University of California Press, 2005).

39. David Morgan, *The Sacred Gaze: Religious Visual Culture in Theory and Practice* (Berkeley: University of California Press, 2005), 3. For additional introductions and alternative approaches to the field of visual culture, see *Visual Culture: Images and Interpretations*, ed. Norman Bryson, Michael Ann Holly, and Keith Moxey (Hanover, N.H.: University Press of New England for Wesleyan University Press, 1994); James Elkins, *Visual Studies: A Skeptical Introduction* (New York: Routledge, 2003); Nicholas Mirzoeff, ed., *The Visual Culture Reader*, 2nd ed. (London: Routledge Press, 2002); and W. J. Thomas Mitchell, *Picture Theory: Essays on Verbal and Visual Representation* (Chicago: University of Chicago Press, 1994).

40. On the professionalization of the art critic, see Joanne Mancini, "'One Term Is as Fatuous as Another': Responses to the Armory Show Reconsidered," *American Quarterly* 51, no. 4 (December 1999): 838; and *Pre-Modernism*. See also Burns, *Inventing the Modern Artist*; H. Wayne Morgan, *Keepers of Culture: The Art-Thought of Kenyon Cox, Royal Cortissoz, and Frank Jewett Mather, Jr.* (Kent, Ohio: Kent State University Press, 1989), and *New Muses: Art in American Culture, 1865–1920* (Norman: University of Oklahoma Press, 1978).

41. Daniel Joseph Singal, "Towards a Definition of American Modernism," in *Modernist Culture in America*, ed. Singal (Belmont, Calif.: Wadsworth, 1991), 2. See also David A. Hollinger, "The Knower and the Artificer," *American Quarterly* 39, no. 1 (Spring 1987): 37–55; Lears, *No Place of Grace*; Tractenberg, *The Incorporation of America*; and Robert Wiebe, *The Search for Order, 1877–1920* (New York: Hill and Wang, 1967).

42. Miriam Bratu Hansen, "The Mass Production of the Senses: Classical Cinema as Vernacular Modernism," *Modernism/Modernity* 6, no. 2 (1999): 60.

Chapter 1. Thomas Eakins's Clerical Portraits and the Art of Translation

1. Jenny Franchot, *Roads to Rome: The Antebellum Protestant Encounter with Catholicism* (Berkeley: University of California Press, 1994), 44–45. I am deeply indebted to Franchot's work on the influence of "Romanist" discourse on antebellum American literature, and to John Davis for his discussion of its influence on American art. John Davis, "Catholic Envy: The Visual Culture of Protestant Desire," in *The Visual Culture of American Religions*, 105–28.

2. David Morgan's work on nineteenth-century Protestant visual culture shows that the distinctions between Protestants and Catholics was often more rhetorical than practical. See *Protestants and Pictures*. On the changing status of the Protestant clergy at the end of the century, see Ann Douglas, *The Feminization of American Culture* (New York: Anchor Books, 1977). On the general crisis of authority that pervaded the era, see Lears, *No Place of Grace*. On the rise of specialization and establishment of academic disciplines, see Burton J. Bledstein, *The Culture of Professionalism: The Middle Class and the Development of Higher Education in America* (New York: W. W. Norton, 1978).

3. On the relationship between Eakins's art and the growing "rift" between seeing and knowing, see Michael Leja, "Eakins and Icons," *Art Bulletin* 83, no. 3 (September 2001): 479–97. For a more general study of how skepticism influenced the visual arts in the American northeast at the turn of the century, see his book *Looking Askance*.

4. The literature on Eakins is voluminous. Some of the major books that encompass the artist's entire body of work include Lloyd Goodrich, *Thomas Eakins: His Life and Work* (New York: Whitney Museum of American Art, 1933); McHenry, *Thomas Eakins Who Painted*; Sylvan Schendler, *Eakins* (Boston: Little, Brown, 1967); Gordon Hendricks, *The Life and Work of Thomas Eakins* (New York: Grossman Publishers, 1974); Elizabeth Johns, *Thomas Eakins: The Heroism of Modern Life* (Princeton: Princeton University Press, 1983); William Innes Homer, *Thomas*

Eakins: His Life and Art (New York: Abbeville, 1992); Kathleen A. Foster, *Thomas Eakins Rediscovered: Charles Bregler's Thomas Eakins Collection at the Pennsylvania Academy of the Fine Arts* (New Haven: Yale University Press, 1997); Martin A. Berger, *Man Made: Thomas Eakins and the Construction of Gilded Age Manhood* (Berkeley: University of California Press, 2000); Darrell Sewell, ed. *Thomas Eakins* (Philadelphia: Philadelphia Museum of Art, 2001); Henry Adams, *Eakins Revealed: The Secret Life of an American Artist* (New York: Oxford University Press, 2005); and Sidney D. Kirkpatrick, *The Revenge of Thomas Eakins* (New Haven: Yale University Press, 2006).

5. There are a number of important exceptions, including (but not limited to) Evan H. Turner, "Thomas Eakins at Overbrook," *Records of the American Catholic Historical Society of Philadelphia* 81, no. 4 (1970): 195–98; William H. Gerdts, "Thomas Eakins and the Episcopal Portrait: Archbishop William Henry Elder," *Arts Magazine* 53, no. 9 (May 1979): 154–57; Foster, *Thomas Eakins Rediscovered*, 212–20; Elizabeth Milroy, "*Consummatum est* . . . : A Reassessment of Thomas Eakins' *Crucifixion* of 1880," *Art Bulletin* 71, no. 2 (June 1989): 269–84; Marjorie Alison Walter, "A Christian Agnostic: Thomas Eakins and His Crucifixion and Prelate Portraits" (master's thesis, University of California at Berkeley, 1989); and Kirkpatrick, *Revenge of Thomas Eakins*, 470–77.

6. According to one of Eakins's biographers, "Tom Eakins was always teasing Sallie Shaw about her going to church and to Sunday school." McHenry, *Thomas Eakins Who Painted*, 29. Friends and sitters remembered Eakins as an "agnostic" and as "[smiling] superciliously when anyone spoke about future life." James L. Wood to Samuel Murray, 14 March 1925, Samuel Murray and Thomas Eakins Papers, Hirshhorn Museum and Sculpture Garden, Smithsonian Institution, Washington, D.C. (hereafter Eakins-Murray Papers).

7. On the influence of the secularization theory in American art historiography, see: Sally Promey, "The 'Return' of Religion in the Scholarship of American Art," *Art Bulletin* 85, no. 3 (September 2003): 581–603.

8. Thomas Eakins to Fanny Eakins, 19 June 1867, Thomas Eakins Letters 1867–1869, Archives of American Art, Smithsonian Institution, Washington, D.C. See also Thomas Eakins (TE) to Fanny Eakins (FE), Good Friday, 1868, Thomas Eakins Letters 1867–1869, Archives of American Art, Smithsonian Institution, Washington, D.C. (hereafter Eakins Papers)

9. TE to FE, April Fool's Day, 1869, Eakins Papers.

10. Ibid.

11. Qtd. in McHenry, *Thomas Eakins Who Painted*, 18–19. See also TE to FE, 8 July 1869 and April Fool's Day, 1869, Eakins Papers. For a discussion of Eakins's engagement with the developing field of ethnography, see Alan C. Braddock, "Eakins, Race, and Ethnographic Ambivalence," *Winterthur Portfolio* 33, nos. 2–3 (Summer–Autumn 1998): 135–61.

12. Davis, "Catholic Envy," 105–28.

13. Davis suggests that Weir hid the crucified body of Christ to "[render] it discreetly 'safe' for Protestant consumption." Davis, "Catholic Envy," 117. See also John Dillenberger, *The Visual Arts and Christianity in America: The Colonial Period through the Nineteenth Century* (Chico, Calif.: Scholars Press, 1984), 143.

14. Franchot, *Roads to Rome*, 234.

15. Davis, "Catholic Envy."

16. TE to FE, April Fool's Day, 1869, Eakins Papers. See also McHenry, *Thomas Eakins Who Painted*, 13–14.

17. McHenry noted that "Murray remembered that though Eakins did very little reading, he often read the New Testament in the Latin version." McHenry, *Thomas Eakins Who Painted*, 129.

18. TE to Caroline Eakins, 1 October 1866, Charles Bregler's Thomas Eakins Collection, Pennsylvania Academy of the Fine Arts, Philadelphia (hereafter Bregler's Eakins Collection).

19. TE to Benjamin Eakins, 2 December 1869. Qtd. in Kathleen A. Foster and Cheryl Leibold, *Writing about Eakins: The Manuscripts in Charles Bregler's Thomas Eakins Collection* (Philadelphia: University of Pennsylvania Press, 1989), 211.

20. John LaFarge, *The Gospel Story in Art*, 2nd ed. (New York: Macmillan, 1926), 2. Generally organized chronologically from the Annunciation to the Ascension according to the synoptic narrative, "Life of Christ" books were illustrated by the work of Giotto, Fra Angelico, Raphael, Guido Reni, Albrecht Dürer, and Holman Hunt (among others). Spanish paintings were generally excluded from these illustrated books. For additional examples of the "Illustrated Life of Christ" genre, see Frederic Farrar, *The Life of Christ as Represented in Art* (Cincinnati: Jennings and Graham, 1894); *The Light of the World;* Joseph Lewis French, *Christ in Art* (Boston: L. C. Page and Company, 1899); and Estelle M. Hurll, *The Life of Our Lord in Art* (Boston: Houghton, Mifflin, 1898).

21. Kenyon Cox, *Painters and Sculptors: A Second Series of Old Masters and New* (New York: Duffield and Company, 1907), 50.

22. LaFarge, *Gospel Story in Art*, 315.

23. Marty, *Modern American Religion*, 32, 17, 13.

24. Turner, *Without God, without Creed*, 230–31.

25. On *The Crucifixion*, see Milroy,"*Consummatum est . . .*". On Eakins's approach to art making, see (among others) Foster, *Thomas Eakins Rediscovered;* Michael Fried, *Realism, Writing, Disfiguration: On Thomas Eakins and Stephen Crane* (Chicago: University of Chicago Press, 1987); Johns, *Thomas Eakins*, 82–114; and Leja, "Eakins and Icons."

26. Milroy,"*Consummatum est . . . ,*" 269.

27. Qtd. in Lois Dinnerstein,"Thomas Eakins' *Crucifixion* as Perceived by Mariana Griswold Van Rensselaer," *Arts Magazine* 53, no. 9 (May 1979): 140.

28. Ernest Renan, *The Life of Jesus*, trans. Charles Edwin Wilbour (New York: Carlton, 1867), 350. For a longer discussion of Eakins's reliance on Renan, see Milroy, "*Consummatum est . . . ,*" 279. On the historical Jesus, see (among others) Charlotte Allen, *The Human Christ: The Search for the Historical Jesus* (New York: Free Press, 1998).

29. For additional iconographic and visual references in both high art and popular culture, see Milroy, "*Consummatum est . . . ,*" 269–84.

30. For Wallace's account of events, see McHenry, *Thomas Eakins Who Painted*, 53–54. For another version, see "Memories of Thomas Eakins," *Harper's Bazaar* 81 (August 1947): 184.

31. For biographical information on Wood, see "A Busy Life: Our Late Archbishop as Priest and Prelate" in the *Philadelphia Standard and Times*, 30 June 1883, 1–2; and Francis L. Dennis,"Most Rev. James Frederick Wood, (1813–1883): The Fifth Bishop and First Archbishop of Philadelphia, an Essay" (master's thesis, Catholic University of America, 1932). For a history of the seminary, see Augustin J. Schulte, *Historical Sketch of the Philadelphia Theological Seminary of St. Charles Borromeo: 1832–1905* (Philadelphia: Geo. W. Gibbons and Sons, 1905); and James F. Connelly, *St. Charles Seminary, Philadelphia* (Philadelphia: St. Charles Seminary, 1979).

32. Phyllis D. Rosenzweig, *The Thomas Eakins Collection of the Hirshhorn Museum and Sculpture Garden* (Washington, D.C.: Smithsonian Institution Press, 1977): 58–59.

33. "The Fine Arts: Review of the Fifty-Third Annual Exhibition of the Pennsylvania Academy of the Fine Arts. (Second notice)," *Philadelphia Evening Bulletin*, 13 November 1882.

34. "Society of American Artists. The Anorexe Exhibition—Suggestive Pictures—Christ Crucified by Eakins—Venice after Palmer and Bunce—Two Excellent Marines by Martin and Thayer," *New York Times*, 4 May 1882. A number of scholars have begun to look at the "gothic" character of Eakins work and American art generally. See Sarah Burns, "Ordering the Artist's Body: Thomas Eakins and the Act of Self-Portrayal," *American Art* 19, no. 1 (Spring 2005): 83–107; Adams, *Eakins Revealed;* and Sarah Burns, *Painting the Dark Side: Art and the Gothic Imagination in Nineteenth-Century America* (Berkeley: University of California Press, 2004).

35. [Wm. C. Clark], "The Fine Arts," *Daily Evening Telegraph*, November 1, 1882.

36. "Art at the Exposition. This Year's Display of Pictures," *Chicago Tribune*, 6 September 1882, 7; *Art Amateur*, June 1882, 2. Quotations can be found in Milroy,"*Consummatum est*," 273–274.

37. Very Rev. D. I. McDermott, *The Use of Holy Pictures and Images* (Philadelphia: Catholic Truth Society, n.d.), 2, 11–12. According to seminary records, McDermott was the seminarian tutor from 1863 to 1864 at the prepatory seminary in Glen Riddle, Pennsylvania. Schulte, *Historical Sketch*, 77.

38. The author defended this proposition by referring to a lawyer's examination of a witness: "the witness testifies not only with his tongue, but also with his eye, his hand, his manner, his tone of voice; it is, in a word, because the whole man testifies that we must see as well as hear the witness in order to know what value to give his testimony." McDermott, *Use of Holy Pictures and Images*, 8.

39. Eakins qtd. in Foster, *Thomas Eakins Rediscovered*, 60. See chap. 7, "Drawing: Thinking Made Visible," for a complete discussion of Eakins's manual. For the manual itself, see Kathleen A. Foster, ed. *A Drawing Manual by Thomas Eakins* (Philadelphia: Philadelphia Museum of Art in association with Yale University Press, 2005).

40. Milroy, "*Consummatum est . . . ,*" 279.

41. James Stevenson Riggs, *The Messages of Jesus according to the Gospel of John: The Discourses of Jesus in the Fourth Gospel, Arranged, Analyzed and Freely Rendered in Paraphrase* (New York: Charles Scribner's Sons, 1907), 3; Charles Gore, *The Incarnation of the Son of God* (New York: Charles Scribner's Sons, 1905), ix; and George Barker Stevens, *The Johannine Theology: A Study of the Doctrinal Contents of the Gospel and Epistles of the Apostle John*, rev. ed. (New York: Charles Scribner's Sons, 1904), 11.

42. Thomas D. Hamm, *The Transformation of American Quakerism: Orthodox Friends, 1800–1907* (Bloomington: Indiana University Press, 1988).

43. TE to FE, June 10, 1867, Eakins Papers. Eakins was a master of languages, speaking French, Italian, Spanish, Greek, Latin, and a little German. McHenry wrote that "even in languages Thomas Eakins was an expert, speaking and writing them well and not as a 'near linguist.' Murray would tell Eakins a story and Eakins would read an earlier version of that joke from the Greek." McHenry, *Thomas Eakins Who Painted*, 103. Eakins's facility with languages was accented in another anecdote as well. When a group of Chinese priests visited Overbrook Seminary, Eakins spoke with them in Latin. Goodrich, *Thomas Eakins*, 106.

44. F. Max Müller, *Lectures on the Science of Language Delivered at the Royal Institution of Great Britain in April, May, and June, 1861* (Nai Sarak, Delhi-6, India: Munshi Ram Manohar Lal, 1965), 130.

45. Robert Needham Cust, *Language as Illustrated by Bible Translation* (London: Trübner and Co., 1886).

46. Müller, *Lectures on the Science of Language*, 396, 401.

47. Ibid., 12.

48. Turner, "Thomas Eakins at Overbrook," 196.

49. The Right Reverend Hugh T. Henry wrote to Goodrich: "You are doubtless aware that Mr. Eakins painted such portraits simply out of love for his art. . . . He asked me to sit for him, offered me the completed work as a gift, and only at my suggestion presented it to the American Catholic Historical Society, Philadelphia." Letter qtd. in Goodrich, *Thomas Eakins*, 194.

50. Raymond H. Schmandt, "Catholic Intellectual Life in the Archdiocese of Philadelphia: An Essay," in *The History of the Archdiocese of Philadelphia*, ed. James F. Connelly (Philadelphia: Archdiocese of Philadelphia, 1976), 601.

51. Statistics qtd. in J. L. J. Kirlin, *The Life of the Most Reverend Patrick John Ryan, D.D., LL.D.: Archbishop of Philadelphia and Record of his Golden Jubilee*, vol. 1 (Philadelphia: Gibbons Publishing, 1903), 87.

52. Mary Consuela, "The Church of Philadelphia (1884–1918)," in *History of the Archdiocese of Philadelphia*, 297.

53. Eakins painted most of his clerical portraits in the first decade of the twentieth century, a period in which he paid homage to members of the arts community, broadly defined to include artists, collectors, critics, curators, patrons, and teachers. Although he continued to celebrate surgeons and scientists and to honor his family, friends, and students, he paid particular attention to those who participated in the production, display, and dissemination of art. His sitters included Robert M. Lindsay, a Philadelphia art dealer and print collector (1900); Mrs. William D. Frishmuth, a collector of musical instruments who was involved in museum affairs (1900); Leslie W. Miller, a painter and teacher of art who was principal of the School of Industrial Art of the Pennsylvania Museum (1901); Charles F. Haseltine, a Philadelphia art dealer who handled Eakins's early work (1901); Walter Copeland Bryant, a collector of American art (1903); Edward Taylor Snow, a painter, collector, and prominent figure in the Philadelphia art world (1904); William H. Lippincott, painter and professor of painting at the National Academy of Design in New York (1905); Florence Einstein, a teacher of art and head of the department of design of the School of Design for Women in Philadelphia (1905); and Gilbert Sunderland Parker, curator of paintings at the Pennsylvania Academy of the Fine Arts (1910). For a more complete list, see Goodrich, *Thomas Eakins*, 161–209.

54. Herman Heuser to Samuel Murray, 22 January 1920, Eakins-Murray Collection. As early as 1897, Reverend Heuser wrote to Eakins with the text of a Latin inscription Eakins asked him to translate. Heuser continued to act in this advisory role long after Eakins completed most of the clerical portraits, since Eakins again requested his aid in 1908. See Herman Heuser to Thomas Eakins, n.d. [1897], Bregler's Eakins Collection; Heuser to TE, 28 June 1908, Herman Joseph Heuser, D. D. Papers, 1872–1933, Philadelphia Archdiocesan Historical Research Center, Overbrook, Pennsylvania (hereafter Heuser Papers); and Heuser to Murray, 22 January 1920, Eakins-Murray Collection.

55. Pope Leo XIII, *Poems, Charades, Inscriptions*, trans. Hugh T. Henry (New York: Dolphin Press, 1902), xiii, xiv.

56. Eakins was familiar with sign language. A former student and colleague at the Ecole des Beaux Arts, Harry Humphrey Moore, was deaf. The two men traveled to Spain together in 1869 and remained friends. A later newspaper article highlighted the friendships of Eakins, Moore, and Murray. See Hugh J. Harley, "True Romance Revealed in Unique Bonds of Three Gifted Artists," *Philadelphia Press Magazine*, 13 February 1916.

57. TE to FE, 19 June 1867, Eakins Papers.

58. TE to FE, 12 June 1867, Eakins Papers. Eakins included an advertisement for a book entitled *A Few Ideas on the Structure of the Old French Language*, which heralded how the "author has been a very acute observer and points out with unshrinking fidelity all the advantages of this language over all modern ones."

59. For information on the influence of Central High School's curriculum on Eakins's art, see Elizabeth Johns, "Drawing Instruction at Central High School and Its Impact on Thomas Eakins," *Winterthur Portfolio* 15, no. 2 (Summer 1980): 139–149; Fried, *Realism, Writing, Disfiguration;* Amy B. Werbel, " 'For Our Age and Country': Nineteenth Century Art Education at Central High School" in *Central High School Alumni Exhibition* (Philadelphia: Woodmere Art Museum, 2002), 6–12.

60. Qtd. in Johns, "Drawing Instruction at Central High School," 141.

61. TE to unknown recipient, undated, Eakins Papers.

62. TE to FE, April Fool's Day, 1869, Eakins Papers.

63. Eakins's description of good portraiture echoes his early apology for painting. See TE to BE, 6 March 1868; qtd. in Foster and Leibold, *Writing about Eakins*, 206–8.

64. Leja has pointed to the parallels between Eakins and Peirce as well. See "Eakins and Icons" and *Looking Askance*.

65. For information on Peirce's life and thought, see Joseph Brent's invaluable biography *Charles Sanders Peirce: A Life*, rev. ed. (Bloomington: Indiana University Press, 1998).

66. Charles Sanders Peirce, "On a New List of Categories," in *Peirce on Signs: Writings on Semiotic by Charles Sanders Peirce*, ed. James Hoopes (Chapel Hill: University of North Carolina Press, 1991), 23–33; "Sign," in *Peirce on Signs*, 239–240; and Brent, *Charles Sanders Peirce*, 349–362.

67. For further biographical information of Elder, see Rev. John H. Lamott, *History of the Archdiocese of Cincinnati: 1821–1921* (Cincinnati: Frederick Pustet Company, 1921); and *Character Glimpses of Most Reverend William Henry Elder, D.D., Second Archbishop of Cincinnati* (Cincinnati: Frederick Pustet and Co., 1911).

68. See Gerdts, "Thomas Eakins and the Episcopal Portrait," 154–57.

69. Charles H. Caffin, "American Studio Talk: Pennsylvania Academy Exhibition," *International Studio* 22, no. 85 (March 1904): ccxxxix. For a historiography of Eakins criticism, see Adams, *Eakins Revealed*.

70. Charles H. Caffin, *The Story of American Painting* (New York: Frederick A. Stokes Company, 1907), 232.

71. See particularly, Johns, *Thomas Eakins;* David M. Lubin, "Modern Psychological Selfhood in the Art of Thomas Eakins," in *Inventing the Psychological: Toward a Cultural History of Emotional Life in the United States*, ed. Joel Pfister and Nancy Schnog (New Haven: Yale University Press, 1997), 133–65; and Kathleen Spies, "Figuring the Neurasthenic: Thomas Eakins, Nervous Illness, and Gender in Victorian America," *Nineteenth Century Studies* 12 (1998): 84–109.

72. Johns, *Thomas Eakins*, 3–5.

73. Herbert Thurston, "Rings," in *The Catholic Encyclopedia*, vol. 13 (New York: Robert Appleton Company, 1912), http://www.knight.org/advent.

74. Herbert Thurston, "The Cross and Crucifix in Liturgy," in *The Catholic Encyclopedia*, vol. 4 (New York: Robert Appleton Company, 1908), http://www.knight.org/advent. Also, Rev. William Wood Seymour, *The Cross: In Tradition, History, and Art* (New York and London: G.P. Putnam's Sons, 1898), 251.

75. Lamott, *History of the Archdiocese of Cincinnati*, 90.

76. Herbert Thurston, "Biretta," in *The Catholic Encyclopedia*, vol. 2 (New York: Robert Appleton Company, 1907), http://www.knight.org/advent. Work on *The Catholic Encyclopedia: An International Work of Reference on the Constitution, Doctrine, Discipline, and History of the Catholic Church* began in 1905, and the editors asked Catholic scholars from around the world to write entries in their areas of specialization. Many of the priests at St. Charles Borromeo Seminary in Philadelphia were intimately involved in the project; both Hugh T. Henry and James F. Loughlin, for example, contributed a number of articles.

77. Qtd. in *Character Glimpses of Most Reverend William Henry Elder*, 85.

78. Ibid., 175.

79. Hugh T. Henry, *Catholic Customs and Symbols: Varied Forms and Figures of Catholic Usage, Ceremony, and Practice Briefly Explained* (New York: Benziger Brothers, 1925), 10–15.

80. Hugh T. Henry, *Annual Address Delivered before the American Catholic Historical Society at the Annual Meeting in December, 1897* (n.p., 1897), 2.

81. Hugh T. Henry, "The 'Original Sources' of European History," *American Catholic Quarterly Review* 23, no. 91 (1898): 453.

82. Henry believed that Catholics should write to editors whenever an injustice to Catholics appeared in print and work under the assumption the writer committed the injury out of ignorance and not out of malice. If Catholics did not explicate their beliefs to the wider community, they were partly to blame for prejudices against them. For a discussion of Henry's public role as a Catholic apologist, see undated newspaper clipping, vol. 3, pg. 5, VARIA (of H. T. H.), Hugh T. Henry Papers, Mullen Library, Catholic University of America, Washington, D.C. (hereafter Henry Papers).

83. Many scholars have examined Eakins's homosociality, particularly in relationship to *The Swimming Hole* (1883–85) and his Arcadian photographs. See, for example, Berger, *Man Made;* Whitney Davis, "Erotic Revision in Thomas Eakins's Narratives of Male Nudity," *Art History* 17, no. 3 (September 1994): 301–41; Randall C. Griffin, "Thomas Eakins' Construction of the Male Body, or 'Men Get to Know Each Other across the Space of Time,'" *Oxford Art Journal* 18, no. 2 (1995): 70–80; and Elizabeth Johns, "An Avowal of Artistic Community: Nudity and Fantasy in Thomas Eakins's Photographs," in *Eakins and the Photograph: Works by Thomas Eakins and His Circle in the Collection of the Pennsylvania Academy of the Fine Arts* (Washington, D.C.: Smithsonian Institution Press, 1994), 65–93.

84. TE to FE, 12 June 1967, Eakins Papers. Emphasis added.

85. Goodrich, *Thomas Eakins*, 193.

86. Johns argued that a major factor in "Eakins's and his friends' pursuit of the nude in photography was that it created a sense of bohemian community and inspired fierce loyalty in his students." Johns, "Avowal of Artistic Community," 67, 84–89.

87. Although Murray is often mentioned in Eakins scholarship, he is rarely discussed as an artist, collaborator, or influence on the elder artist. Two notable exceptions are Michael W. Panhorst, *Samuel Murray: The Hirshhorn Museum and Sculpture Garden Collection, Smithsonian Institution* (Washington, D.C.: Smithsonian Institution Press, 1982); and Mariah Chamberlin-Hellman, "Samuel Murray, Thomas Eakins, and the Witherspoon Prophets," *Arts Magazine* 53, no. 9 (May 1979): 134–39.

88. Many of Murray's sculptures represented Irish and Catholic leaders. He sculpted Archbishops Patrick J. Ryan and Edmond Prendergast, Bishops Philip R. McDevitt and John W. Shanahan, Monsignors Kiernan and James P. Turner, and Reverend William Corby, C. S. C., among others. Murray's relationship with the Catholic community extended beyond Eakins's death. Murray and McDevitt continued to correspond, for example, and Murray later produced a Crucifixion for the Harrisburg Cathedral, the official seat of McDevitt's bishopric.

89. Contemporary art criticism concerning Eakins and Murray included a number of stylistic resonances, particularly the artists' attention to "likeness," "character," and "realism." See, for example, "Widow Smiles as Grandson Unveils Sculpture of Leidy," *Philadelphia Inquirer*, 31 October 1907. Even more striking, similar myths developed around the two artists' representations of Christ's crucifixion, despite the fact they were completed over thirty-five years apart. See Irving Bacon, "Murray's Crucifixion for Harrisburg Cathedral Born Out of Travail: Volunteer Hangs by Hands to Make Possible Rare New Work of Art," no source, Murray-Eakins Collection. Although the shared critical rhetoric and mythologies suggested a striking parallel in the lives and works of Eakins and Murray, Murray was, by all accounts, a very congenial man, extremely well-liked and respected in Philadelphia. He attained much critical success in his lifetime, and did not seem to share the same ostracism from the art community that Eakins received.

90. Harley, "True Romance Revealed in Unique Bonds of Three Gifted Artists."

91. On the Witherspoon prophets, see Chamberlin-Hellman, "Samuel Murray, Thomas Eakins, and the Witherspoon Prophets," 134–39.

92. Ibid., 135–36; McHenry, *Thomas Eakins Who Painted*, 128.

93. William Henry Green, *General Introduction to the Old Testament* (New York: Charles Scribner's Sons, 1898), 80–81.

94. Eakins and Murray, "Brotherhood," Murray-Eakins Collection.

95. On Eakins's teaching methods, see Elizabeth Johns, "Thomas Eakins and 'Pure Art' Education," *Archives of American Art Journal* 30, nos. 1–4 (1990): 71–76. For two different interpretations of Eakins's dismissal, see Foster and Leibold, *Writing about Eakins*, 69–122; and Adams, *Eakins Revealed*, 11–123.

96. Eakins assisted Fairman Rogers in organizing Muybridge's 1883 series of lectures at the Pennsylvania Academy of the Fine Arts, the Franklin Institute, and the Academy of Music. The two men further helped Muybridge secure financial support and studio space at the University of Pennsylvania to establish what became known as the "Muybridge commission." Eakins painted three fellow commission members—Rogers, William Marks, and George Barker. See Sarah Gordon, "Prestige, Professionalism, and the Paradox of Eadweard Muybridge's Animal Locomotion Nudes," *Pennsylvania Magazine of History and Biography* 130, no. 1 (January 2006): 79–104.

97. On the portrait, see also Mark Sullivan, "Thomas Eakins and His Portrait of Father Fedigan," *Records of the American Catholic Historical Society* 109, nos. 3–4 (Fall–Winter, 1998), 1–23. Sullivan and I wrote on Fedigan's portrait around the same time, unaware of one another's work. I learned of his essay after I completed my analysis.

98. For a discussion of Fedigan's rise in the Augustinian order, see Harry A. Cassel, "John Joseph Fedigan, O.S.A.: 1842–1908," in *Men of Heart: Pioneering Augustinians, Province of Saint Thomas of Villanova* (Villanova, Penn.: Augustinian Press, 1983), 170. For the history of Villanova College, see David R. Contosta, *Villanova University, 1842–1992: American—Catholic—Augustinian* (University Park: Pennsylvania State University Press, 1995).

99. Diane M. Bones, "Eakins: The Villanova Connection," *Villanova* 1, no. 3 (November 1985): 9.

100. Qtd. in Harry A. Cassel, "John Joseph Fedigan," 180.

101. Thomas Eakins to Edward Coates, n.d. (ca. 10 March 1886). Qtd. in Foster and Leibold, *Writing about Eakins*, 215–216.

102. Thomas Eakins to Harrison Morris, 23 April 1894, Charles Bregler's Thomas Eakins Collection, Pennsylvania Academy of the Fine Arts, Philadelphia.

103. In *Realism, Writing, Disfiguration*, Michael Fried suggests that people who hold writing implements in Eakins's work function as representations of the artist and, in turn, call attention to the painting's meditation on the nature of artistic production. Whereas Fried pays particular attention to *The Gross Clinic* as an "allegory of painting," Bryan J. Wolf shows that Eakins's portrait of *Professor Henry Rowland* (1897) similarly serves as a "painting about painting." Bryan J. Wolf, "Professor Henry A. Rowland" and "Sketch for Professor Henry A. Rowland," in *Thomas Eakins*, ed. John Wilmerding (Washington, DC: Smithsonian Institution Press, 1993), 128–33.

104. Additional biographical information on Turner can be found in: "Monsignor Turner Dies; Ill Only Two Days; Obsequies Held," *Catholic Standard and Times*, 8 June 1929; "Turner, James Patrick," *Who's Was Who in America, vol. 1 (1847–1942)* (Chicago: A. N. Marquis Co., 1942), 1259; and "Turner, Very Rev. James P., V. G.," *American Catholic's Who's Who*, ed. Georgina Pell Curtis (St. Louis: B. Herder, 1911), 659.

105. Brent, *Charles Sanders Peirce*, 65.

106. Walter Benjamin, "The Task of the Translator: An Introduction to the Translation of Baudelaire's *Tableaux parisiens*," in *Illuminations*, ed. Hannah Arendt (New York: Schocken Books, 1969), 76, 69–82.

107. Ibid., 69.

Chapter 2. "A school-master to lead men to Christ": Henry Ossawa Tanner's Biblical Paintings and Religious Pratice

The title of this chapter comes from Benjamin Tucker Tanner, *Theological Lectures* (Nashville, Tenn.: Publishing House A.M.E. Church Sunday School Union, 1894), 52–53.

1. Elbert Francis Baldwin, "A Negro Artist of Unique Power," *Outlook* 64 (January–April 1900): 793–96.

2. For discussions of Tanner's genre paintings, see: Albert Boime, "Henry Ossawa Tanner's Subversion of Genre," *Art Bulletin* 75, no. 3 (September 1993): 415–42; Amy Kurtz, " 'Look Well to the Ways of the Household, and Eat Not the Bread of Idleness': Individual, Family, and Community in Henry Ossawa Tanner's *Spinning by Firelight—The Boyhood of George Washington Gray*," *Yale University Art Gallery Bulletin* (1997–98): 53–67; and Judith Wilson, "Lifting the 'Veil': Henry O. Tanner's *The Banjo Lesson* and *The Thankful Poor*," in *Critical Issues in American Art: A Book of Readings*, ed. Mary Ann Calo (Boulder, Colo.: Westview Press, 1998), 199–219.

3. For an extended discussion of the black elite at the turn of the century, see Willard B. Gatewood, *Aristocrats of Color: The Black Elite, 1880–1920* (Fayetteville: University of Arkansas, 2000).

4. The conception of religious art as visual exegesis is theorized by Paolo Berdini in his book, *The Religious Art of Jacopo Bassano: Painting as Visual Exegesis* (Cambridge: Cambridge University Press, 1997). Although the book centers on the sixteenth-century artist Jacopo Bassano, Berdini's introduction develops an interpretive model for the study of religious art in general.

5. Dr. Carter G. Woodson to Arturo Alfonso Schomburg, 17 May 1936, Albert Smith Papers, Schomburg Center for Research in Black Culture, New York Public Library; and Lawrence S. Little, *Disciples of Liberty: The African Methodist Episcopal Church in the Age of Imperialism, 1884–1916* (Knoxville: University of Tennessee Press, 2000), 42. The biographical material presented here is indebted to Rae Alexander-Minter, "The Tanner Family: A Grandniece's Chronicle," in Dewey F. Mosby, Darrel Sewell, and Rae Alexander-Minter, *Henry Ossawa Tanner* (Philadelphia: Philadelphia Museum of Art, 1991), 23–33. Dewey F. Mosby's exhibition catalogs provide the most expansive and detailed presentation of Tanner's biography and artistic career. See Mosby, Sewell, and Alexander-Minter, *Henry Ossawa Tanner*; and Mosby, *Across Continents and Cultures: The Art and Life of Henry Ossawa Tanner* (Kansas City, Mo.: The Nelson-Atkins Museum of Art, 1995).

6. H. O. Tanner, "The Story of an Artist's Life, I," *World's Work* 18 (July 1909): 11662.

7. Rev. William J. Simmons, "Rev. Benjamin Tucker Tanner, A.M., D.D.," in *Men of Mark: Eminent, Progressive and Rising* (Cleveland: Geo. M. Rewell and Co., 1887), 984–88.

8. The historian of the *Christian Recorder* writes that "though not the first black newspaper, it was the longest-lived black owned, financed, and operated weekly in [Philadelphia], and published news and commentary that black Americans could not find anywhere else." Gilbert Anthony Williams, *The* Christian Recorder, *Newspaper of the African Methodist Episcopal Church: History of a Forum for Ideas, 1854–1902* (Jefferson, North Carolina: McFarland and Company, 1996), 20.

9. William Seraile, *Fire in His Heart: Bishop Benjamin Tucker Tanner and the A.M.E. Church* (Knoxville: University of Tennessee Press, 1998), 111.

10. Gatewood, *Aristocrats of Color*.

11. E. H. Coit, "Methodism and the Universal Church," *A.M.E. Church Review* 22 (April 1906): 306–16, quoted in Stephen W. Angell and Anthony B. Pinn, eds., *Social Protest Thought in the African Methodist Episcopal Church, 1862–1939* (Knoxville: University of Tennessee Press, 2000), 209–10.

12. I have selected these three paintings because of their critical and popular acclaim in the American press during Tanner's lifetime. *The Annunciation* toured the United States in 1898 and 1899 and was eventually purchased for the Wilstach Collection, the forerunner of the Philadelphia Museum of Art. *The Two Disciples at the Tomb* won the Harris Prize for best painting at the annual exhibition of American art at the Art Institute of Chicago. After its American tour, it was acquired for the Institute's collection. *Behold, the Bridegroom Cometh* was

perceived to be Tanner's masterpiece when it was exhibited at the 1908 "Old" French Salon and the solo exhibition of his work at the American Art Galleries in New York City. Despite its immense popularity and physical size, the ten-by-fifteen foot canvas is presumed to have been destroyed.

13. *Religious Paintings: Henry Ossawa Tanner*, exhibition catalog, Henry Ossawa Tanner Papers, Archives of American Art, Smithsonian Institution, Washington, D.C. (hereafter Tanner Papers).

14. Baldwin, "A Negro Artist of Unique Power," 795; W. S. Scarborough, "Henry Ossian [*sic*] Tanner," *Southern Workman* 31, no. 12 (December 1902): 668; Oscar L. Joseph, "Henry O. Tanner's Religious Paintings," *Epworth Herald* (6 March 1901): 1043; "The Academy's Annual Show," *Philadelphia Inquirer*, 15 January 1899; and Helen Cole, "Henry O. Tanner, Painter," *Brush and Pencil* 6, no. 3 (June 1900): 101; and "An Afro-American Painter Who Has Become Famous in Paris," *Current Literature* 45 (October 1908): 408.

15. "An Afro-American Painter Who Has Become Famous in Paris," 408.

16. Associated Press newspaper clipping [1906], Tanner Papers; Florence L. Bentley, "Henry O. Tanner," *Voice of the Negro* (November 1906): 480; and Joseph, "Henry O. Tanner's Religious Paintings," 1043.

17. "Mr. Tanner's Bible Paintings on View" [1908?], newspaper clipping, Tanner papers. Another critic reiterated the sentiment, saying "the herald is announcing the approach of the festal company." Joseph, "Henry O. Tanner's Religious Paintings," 1043; *New York Evening Mail*, 22 December 1904, newspaper clipping, Tanner papers; Oscar L. Joseph, *The Christian Herald*, quoted in *The Literary Digest* (1909), newspaper clipping, Tanner Papers.

18. Henry Ossawa Tanner, "The Story of an Artist's Life, II—Recognition," *World's Work* 18 (July 1909): 11744.

19. Wesley qtd. in Taves, *Fits, Trances, and Visions*, 51.

20. Richard Allen, *The Life Experience and Gospel Labors of the Rt. Rev. Richard Allen* (Philadelphia: Martin and Boston, 1833), quoted in Milton C. Sernett, ed., *African American Religious History: A Documentary Witness*, 2nd ed. (Durham: Duke University Press, 1999), 149; W. E. B. DuBois, "Of the Faith of the Fathers," in *The Souls of Black Folk* (New York: Dover, 1994), 119; and Albert Raboteau, *Slave Religion: The Invisible Institution in the Antebellum South* (New York: Oxford University Press, 1978).

21. Albert J. Raboteau, "Richard Allen and the African Church Movement," in *A Fire in the Bones: Reflections on African-American Religious History* (Boston: Beacon Press, 1995), 79–102. Allen adopted the white Methodists' *Articles of Religion and General Rules of the Methodist Episcopal Church* without changes. See William E. Montgomery, *Under Their Own Vine and Fig Tree: The African-American Church in the South, 1865–1900* (Baton Rouge: Louisiana State University Press, 1993), 9.

22. E. H. Coit, "Methodism and the Universal Church," *A.M.E. Church Review* 22 (April 1906): 306–16, qtd. in Angell and Pinn, *Social Protest Thought*, 211.

23. A number of contemporary art historians have commented on the relationship between the story of Lazarus and the African American experience, including Jennifer J. Harper, "The Early Religious Paintings of Henry Ossawa Tanner: A Study of the Influence of Church, Family, and Era," *American Art* 6, no. 4 (1992): 69–85. Harper in particular notes Tanner's decision to paint the moment of invitation.

24. Cole, "Henry O. Tanner, Painter," 99; and Scarborough, "Henry Ossian [*sic*] Tanner," 667.

25. Scarborough, "Henry Ossian [*sic*] Tanner," 666.

26. "Orientalism," *The Knickerbocker* 41, no. 6 (June 1853): 479–96, qtd. in Holly Edwards, "A Million and One Nights: Orientalism in America, 1870–1930," in *Noble Dreams, Wicked Pleasures: Orientalism in America, 1870–1930* (Princeton: Princeton University Press in association with Sterling and Francine Clark Art Institute, 2000), 18.

27. Edwards, "A Million and One Nights," 11.

28. See for example Henry Ossawa Tanner, "A Visit to the Tomb of Lazarus," *AME Church Review* 15 (January 1908): 359; and "The Story of An Artist's Life: II—Recognition," 11774.

29. Cole, "Henry O. Tanner, Painter," 102; and Scarborough, "Henry Ossian [*sic*] Tanner," 669.

30. My understanding of Holy Land visual culture and consciousness is based on John Davis's excellent book, *The Landscape of Belief*.

31. It is clear Tanner was aware of Tissot's successful traveling exhibition in 1898 and sought to mold his own career on that model. See Robert C. Odgen to Henry Ossawa Tanner, July 12, 1900, Tanner Papers. For contemporary accounts of Tissot, see: Edith Coues, "Tissot's 'Life of Christ'," *The Century Magazine* 51, no. 2 (December 1895): 289–302; Jean Jacques, "An Artist's Conception of the Life of Christ," *Bookman* 8 (December 1898): 282, 352–59; Clifton Harby Levy, "James Tissot and His Work," *Outlook* 60, no. 16 (December, 1898): 954–64; and Cleveland Moffett, "J. J. Tissot and His Paintings of the Life of Christ," *McClure's Magazine* 12, no. 5 (March 1899): 386–96.

32. Levy, "James Tissot and His Work," 959. Tissot described his intention in a similar way: "to make alive again before the eyes of the spectator the divine personality of Jesus, in his spirit, in his deeds, in all the sublimity of his surroundings." Tissot quoted in Jacques, "An Artist's Conception," 353.

33. Almost all contemporary reviews of Tanner's work by European and African American critics commented on his use of Jewish models and compared his work to that of Rembrandt, also known for his Orientalist aesthetic and use of Jewish models. For illustrative reviews see: Baldwin, "A Negro Artist of Unique Power," 793–796; Cole, "Henry O. Tanner, Painter," 97–107; and Scarborough, "Henry Ossian [sic] Tanner," 661–70. For contemporaneous biographical sketches of Rembrandt, see: Cox, *Painters and Sculptors*; and John LaFarge, *Great Masters* (Garden City, N.Y.: Doubleday, Page, 1915). The latter was copyrighted in 1903 and first appeared as essays in *McClure's*. Albert Boime makes a similar point in his article on Tanner's genre paintings: Boime, "Henry Ossawa Tanner's Subversion of Genre," 415–442.

34. Arthur T. Abernethy, *The Jew A Negro: Being a Study of the Jewish Ancestry from an Impartial Standpoint* (Moravian Falls, N.C., 1910), 105; and William Z. Ripley, "The Racial Geography of Europe: A Sociological Study. Supplement—The Jews," *Popular Science Monthly* 54 (1898–99): 339. Both cited in Eric L. Goldstein, "The Unstable Other: Locating the Jew in Progressive-Era Racial Discourse," *American Jewish History* 89, no. 4 (December 2001): 383–409.

35. On the image of the Jew in turn-of-the-century America, see Goldstein, "The Unstable Other." See also Sander L. Gilman, "The Jew's Body: Thoughts on Jewish Physical Difference," in *Too Jewish? Challenging Traditional Identities*, ed. Norman L. Kleeblatt (New York: The Jewish Museum, 1996), 60–73.

36. William Griffith, "Christ as Modern American Artists See Him—New Conceptions of the Nazarene by Nine Notable Painters," *Craftsman* 10 (June 1906): 291–92. Griffith was not alone in his observation. Another critic added that artists painted Christ as a "north Italian, a German, or a Lowlander—an odd license of the artist." Samuel Swift, "New Conceptions of the Christ," *Brush and Pencil* 17, no. 4 (April 1906): 151. Rabbi qtd. in Kate P. Hampton, "The Face of Christ in Art: Is the Portraiture of Jesus Strong or Weak?," *Outlook* 61, no. 13 (1 April 1899): 739.

37. Yvonne Chireau, "Black Culture and Black Zion: African American Religious Encounters with Judaism, 1790–1930, An Overview," in *Black Zion: African American Religious Encounters with Judaism*, ed. Yvonne Chireau and Nathaniel Deutsch (New York: Oxford University Press, 2000), 18.

38. Daniel A. Payne, "Semi-Centennial Sermon [Cincinnati 1874]," in *Sermons and Addresses, 1853–1891: Bishop Daniel A. Payne*, ed. Charles Killian (New York: Arno Press, 1972), 79. The relationship between Tanner and Payne, as well as Payne's support and patronage of Tanner's art, was described briefly in Scarborough, "Henry Ossian [sic] Tanner," 663. Tanner's bust of Payne is discussed in "A Bust of Bishop Payne," *Christian Recorder* 31 (14 December 1893): 2; and Mosby, *Across Continents and Cultures*, 32.

39. Paul Laurence Dunbar, "An Ante-Bellum Sermon," in Maurianne Adams and John Bracey, eds., *Strangers and Neighbors: Relations between Blacks and Jews in the United States* (Amherst: University of Massachusetts Press, 1999), 55–56. One critic linked Tanner, Dunbar, Booker T. Washington, and DuBois as "solutions" to the "race problem." *Kansas City Times*, 9 October 1908. Another described Tanner as "the mulatto who illustrated Paul Dunbar's books." I have been unable to locate evidence that proves this assertion. *Boston Advertiser*, 30 April 1908. Both newspaper clippings are located in the Tanner Papers.

40. For a discussion of the importance of Exodus to African American life after Emancipation, see Albert J. Raboteau, "African-Americans, Exodus, and the American Israel (excerpts)," in Adams and Bracey, *Strangers and Neighbors*, 61. See also Lawrence Levine, *Black Culture and Black Consciousness: Afro-American Folk Thought from Slavery to Freedom* (Oxford: Oxford University Press, 1977), 30–55. For a discussion of the importance of Moses in black folk life, see John Roberts, *From Trickster to Badman: The Black Folk Hero in Slavery and Freedom* (Philadelphia: University of Pennsylvania Press, 1989). For a more general study of the jeremiadic tradition, see Wilson Jeremiah Moses, *Black Messiahs and Uncle Toms: Social and Literary Manipulations of a Religious Myth*, rev. ed. (University Park: Pennsylvania State University Press, 1993).

41. George Wilson Brent, "The Ancient Glory of the Hamitic Race," *A.M.E. Church Review* 12 (October 1895): 272–75; and "Origin of the White Race," *A.M.E. Church Review* 10 (January 1893): 278–88. Both are quoted in Angell and Pinn, *Social Protest Thought*, 148–50, 150–54.

42. *New York Age*, 18 May 1889; and *A.M.E Church Review* 9 (1892–93), 8. Both are quoted in Philip S. Foner, "Black-Jewish Relations in the Opening Years of the Twentieth Century," in Adams and Bracey, *Strangers and Neighbors*, 238.

43. For a discussion of the events that strained black-Jewish relations, see Chireau, "Black Culture and Black Zion," 3–32; and Foner, "Black-Jewish Relations in the Opening Years of the Twentieth Century," 237–44.

44. Raboteau describes the general structure of the sermon in "The Chanted Sermon," *A Fire in the Bones*, 141–51. For examples of AME sermons that deployed this formula, see Payne, *Sermons and Addresses*.

45. Daniel A. Payne, "The Ordination Sermon [1888]," in *Sermons and Addresses*, 60–61.

46. Tanner, "Mothers of the Bible," 13.

47. *The Literary Digest* (1909), Tanner Papers.

48. William Hannibal Thomas, "Religious Characteristics of the Negro," *A.M.E. Church Review* 10 (April 1893): 338–402, quoted in Angell and Pinn, *Social Protest Thought*, 155.

49. Frederick Douglass, *Narrative of the Life of Frederick Douglass, An American Slave* (Boston: Anti-Slavery Office, 1845), quoted in Sernett, *African American Religious History*, 106.

50. Tanner, *Theological Lectures*, 59.

51. Thomas, "Religious Characteristics of the Negro," quoted in Angell and Pinn, *Social Protest Thought*, 162.

52. Raboteau, "'Ethiopia Shall Soon Stretch Forth Her Hands': Black Destiny in Nineteenth-Century America," in *A Fire in the Bones*, 52.

53. Seraile, *Fire in His Heart*, 35; and Williams, *The Christian Recorder*, 90.

54. Thomas, "Religious Characteristics of the Negro," 161.

55. Ibid.; and Coit, "Methodism and the Universal Church." Both quoted in Angell and Pinn, *Social Protest Thought*, 161 and 209–10.

56. Montgomery, *Under Their Own Vine and Fig Tree*, 85, 45. Montgomery further argues that Northern missionaries "bore with them values that stressed self-restraint, were based on European-American Protestant theology, and included a Puritan work ethic" (85). Another historian of the AME Church agrees and suggests that Methodism provided the rationale for the development of a black middle class. The discipline required by the church enabled African Americans to attain the characteristics of "industry, thrift, and self-reliance" and to become productive American citizens. See Clarence E. Walker, *A Rock in a Weary Land: The African Methodist Episcopal Church during the Civil War and Reconstruction* (Baton Rouge: Louisiana State University Press, 1982), 3, 7. For a contemporary articulation of these ideals, see Bishop Daniel A. Payne, "Welcome to the Ransomed; or Duties of the Colored Inhabitants of the District of Columbia (Baltimore 1862)," in *Sermons and Addresses*, 5–16.

57. Ezra Stiles Ely, "Review of *Methodist Error*," *Quarterly Theological Review* 2, no. 2 (April 1819): 229, qtd. in Taves, *Fits, Trances, and Visions*, 99.

58. See Levine, *Black Culture and Black Consciousness*, 164–66; and Montgomery, *Under Their Own Vine and Fig Tree*, 38–96.

59. Works Progress Administration, *Negro in Virginia*, 110 and 146, qtd. in Levine, *Black Culture and Black Consciousness*, 165–66. B. T. Tanner also decried religious enthusiasm. He "eschewed emotional displays" and did not allow "shouting" during his church services. Seraile, *Fire in His Heart*, 133.

60. Wilson, "Lifting the 'Veil,'" 199–219.

61. See, for example, Gatewood, *Aristocrats of Color*; Eleanor Alexander, *Lyrics of Sunshine and Shadow: The Tragic Courtship and Marriage of Paul Laurence Dunbar and Alice Ruth Moore* (New York: New York University Press, 2001); and J. B. T. Marsh, *The Story of the Jubilee Singers: With Their Songs*, rev. ed. (Boston: Houghton, Mifflin, [1880]).

62. Scarborough, "Henry Ossian [*sic*] Tanner," 665–66.

63. Newspaper clipping, *New York Herald*, 29 November 1908; and "Reception to Artist," *Boston Herald*, 30 December 1908. Both newspaper clippings are located in the Tanner Papers. Tanner married Jessie Macauley Olssen, a European American woman from San Francisco, in 1899. Although her racial heritage is rarely mentioned, it appeared on at least one other occasion. A contemporary critic noted that Tanner had "become more than ever associated with the whites by marrying a white woman." Baldwin, "A Negro Artist of Unique Power," 793. Tanner's decision to marry Olssen would have been supported by his father, who believed that intermarriage would eventually produce a distinctly "American" race. Benjamin Tucker Tanner, "The Coming American Race—What Is It to Be?" *Christian Recorder*, 15 May 1884, quoted in Seraile, *Fire in His Heart*, 89–90.

64. Quoted in Mosby, ed., *Henry Ossawa Tanner*, 116.

65. Robert C. Ogden to Harrison Morris, 28 September 1898, Tanner Papers.

66. Henry Ossawa Tanner, "A Visit to the Tomb of Lazarus," *A.M.E. Church Review* 15 (January 1908): 359.

67. For a discussion of American travel writing, see Terry Caesar, "'Counting the Cats in Zanzibar': American Travel Abroad in American Travel Writing to 1914," *Prospects: An Annual of American Cultural Studies* 13 (1988): 95–134. For a discussion of Western visual appropriations of the Holy Land, see Davis, "Landscape, Photography, Spectacle in the Late Nineteenth Century," in *Landscape of Belief*, 73–97.

68. Tanner, "Mothers of the Bible," 13. B. T. Tanner noted the purity of the Jewish race in a lecture on "Biblical Chronology," in *Theological Lectures*, 17–19.

69. William E. Barton, "An American Painter of the Resurrection: Henry Ossawa Tanner," *Advance* (20 March 1913): 2012; and Tanner, "Story of An Artist's Life: II—Recognition," 11774.

70. Scarborough, "Henry Ossian [*sic*] Tanner," 666. B. T. Tanner shared his son's bias. Bishop Tanner essentialized African culture and dismissed it as inferior to American Anglo-Saxon culture. Seraile, *Fire in His Heart*, 31, 107, 83.

71. Little, *Disciples of Liberty*, xii.

72. B. T. Tanner, *An Apology for African Methodism* (Baltimore, 1867), 13–26.

73. Seraile, *Fire in His Heart*, 49.

74. B. T. Tanner, "The Coming American Race—What Is It to Be?" quoted in Seraile, *Fire in His Heart*, 89–90.

75. The critic went on to exemplify his point: "The figure of Nicodemus, for instance, might be that of an old man in any country—a world craving for knowledge; the figure of Mary in 'The Annunciation' that of any young girl—the awakening of humanity by divinity." Baldwin, "A Negro Artist of Unique Power," 796.

76. Bentley, "Henry O. Tanner," 480.

77. *Literary Digest* (1909), newspaper clipping, Tanner Papers; and Marcia Mathews, *Henry Ossawa Tanner: American Artist* (Chicago: University of Chicago Press, 1969), 60–61. Among Tanner's personal papers is a sheet of paper that contains his daily meditations. Tanner Papers.

78. Qtd. in Mathews, *Henry Ossawa Tanner*, 238–39.

79. Newspaper clipping, 16 December 1908, Tanner Papers.

80. Baldwin, "A Negro Artist of Unique Power," 794–95.

81. Joseph, "Henry O. Tanner's Religious Paintings," 1043.

82. Tanner, *Theological Lectures*, 49–50, 51, 52–53.

83. Ibid., 54, 53.

84. John Veitch, *Knowing and Being* (Edinburgh: William Blackwood and Sons, 1889), 322.

85. G. M. Steele, *Rudimentary Psychology for Schools and Colleges* (Boston: Leach, Shewell, and Sanborn, 1890), vii, 1, 171, and 196.

86. Johns, "Drawing Instruction at Central High School," 147. See also Johns, "Thomas Eakins and 'Pure Art' Education," 71–76.

87. For illustrative reviews, see Scarborough, "Henry Ossian [*sic*] Tanner," 668; and Joseph, "Henry O. Tanner's Religious Paintings," 1043.

88. Scarborough noted that "three oil paintings are upon the walls of Wilberforce University library, the gift of Bishop Payne, who admired most heartily and encouraged steadfastly this budding genius, as indeed he did all genius in the race." He also mentioned that visitors to the Hampton Institute Library were able to view *The Banjo Lesson*, a gift to Hampton from Robert Ogden in 1894. Scarborough, "Henry Ossian [*sic*] Tanner," 663–65.

89. Robert C. Ogden to Harrison Morris, 28 September 1898, Tanner Papers.

90. Robert C. Odgen to Henry Ossawa Tanner, 12 July 1900, Tanner Papers.

91. In 1894, the AME Church in Philadelphia attempted to purchase Tanner's *The Banjo Lesson* and present it to the Pennsylvania Academy of the Fine Arts on behalf of "the colored people of Philadelphia." The plan fell through when only three hundred of the one thousand dollars necessary was collected. In 1895, Tanner hoped his submissions to the Atlanta Exposition would secure patronage. Again, he was disappointed. Although Tanner did secure a commission for a portrait of Booker T. Washington from the Iowa Federation of Colored Women's Clubs in 1915, he pursued a lawsuit against the Mother Bethel AME Church of Philadelphia when they refused payment for a commission in the 1920s. For discussions of Tanner's frustrations with black patronage, see W. E. B. DuBois, "Tanner," *Crisis* 28 (May 1924): 12; Mosby, *Across Continents and Cultures*, 33; Mosby, *Henry Ossawa Tanner*, 18; Boime, "Henry Ossawa Tanner's Subversion of Genre," 419–23, 429; and Jack Lufkin, "Henry Tanner and Booker T. Washington: The Iowa Story Behind the Portrait," *Palimpsest* 72, no. 1 (Spring 1991): 16–19.

92. Leach, *Land of Desire*, 51.

93. Robert Ogden, "Advertising Art," *Dry Goods Economist* (15 May 1898), quoted in Leach, *Land of Desire*, 52.

94. Leach, *Land of Desire*, 191–224.

95. Schmidt, *Consumer Rites*, 159–69; and Leach, *Land of Desire*, 134–39.

96. Tanner, *Theological Lectures*, 51.

97. Jesse Tanner quoted in Carroll Greene Jr., introduction to *The Art of Henry Ossawa Tanner (1859–1937)* (Washington, D.C.: Frederick Douglass Institute and National Collection of Fine Arts, 1969), 12.

98. Cole, "Henry O. Tanner, Painter," 102.

99. Qtd. in Regenia Perry, *Free within Ourselves: African-American Artists in the Collection of the National Museum of American Art* (Washington, D.C.: National Museum of American Art, 1992), 159.

Chapter 3. Art for Religion's Sake

1. "Sacred Art Modernized: Photographs of the Crucifixion from Living Figures," *Boston Herald*, 17 January 1899; Charles Caffin, "Philadelphia Photographic Salon," *Harper's Weekly* 42, no. 2185 (5 November 1898): 1087; and Edward J. Steichen, "The American School," *Camera Notes* 6, no. 1 (July 1902): 23.

2. Julia Margaret Cameron, "Annals of My Glass House," in *Photography in Print: Writings from 1816 to the Present*, ed. Vicki Goldberg (Albuquerque: University of New Mexico Press, 1981), 186; Stieglitz is quoted in John Szarkowski, *Alfred Stieglitz at Lake George* (New York: Museum of Modern Art, 1996), 26.

3. Estelle Jussim's monograph on the photographer helped establish Day scholarship; see *Slave to Beauty: The Eccentric Life and Controversial Career of F. Holland Day* (Boston: David R. Godine, 1981). See also James Crump, *F. Holland Day: Suffering the Ideal* (Santa Fe: Twin Palms, 1995); and Pam Roberts, "Fred Holland Day (1864–1933)," in *F. Holland Day*, ed. Roberts (Amsterdam: Van Gogh Museum, 2000), 11–28. For helpful discussions of Day's cultural milieu, see Anne E. Havinga, "Setting the Time of Day in Boston," in *F. Holland Day*, ed. Roberts, 29–38; and Douglass Shand-Tucci, *Boston Bohemia, 1881–1900: Ralph Adams Cram; My Life in Architecture* (Amherst: University of Massachusetts Press, 1995).

4. The firm of Copeland and Day has been discussed by Jussim, *Slave to Beauty*, 61–73, 83–87; Thomas G. Boss, "Copeland and Day and the Art of Bookmaking," in *New Perspectives on F. Holland Day: Selected Presentations from the Fred Holland Day in Context Symposium Held at Stonehill College North Easton, Massachusetts, April 19, 1997*, ed. Patricia J. Fanning (North Easton, Mass.: Stonehill College, 1998), 17–24; and Joe Walker Kraus, *Messrs. Copeland and Day* (Philadelphia: George S. MacManus Co., 1979).

5. For a discussion of how Day and his Boston associates formed literary clubs and became allies in broader spiritual quests, see Ralph Adams Cram, "My Life in Architecture," F. Holland Day Papers, Archives of American Art, Smithsonian Institution, Washington, D.C. (hereafter Day Papers). Day's religious exploration is well documented in his correspondence with Louise Imogen Guiney. See Louise Imogen Guiney Papers, Library of Congress, Washington D.C. (hereafter Guiney Papers).

6. Guiney to Mrs. Richard W. Gilder, 12 February 1890, Guiney Papers; and Guiney to Day, 15 November 1892, Guiney Papers.

7. Guiney to Day, 9 November 1892, and 26 October 1895, Guiney Papers.

8. "Mr. Day and His Work," *Boston Herald*, 17 January 1899.

9. Tony Denier, *Parlor Tableaux: or, Animated Pictures* (New York: Samuel French, 1869), v. Day's intimate knowledge of tableaux and their application to photography is clear from his correspondence with Guiney and his photographic writings. Guiney to Day, 19 December 1887 and 10 April 1893, Guiney Papers; and F. Holland Day, "Portraiture and the Camera," *American Annual of Photography and Photographic Times Almanac for 1899* (New York: Scovill and Adams [1898]), 19–25. For an investigation into tableaux vivants in nineteenth-century American culture, see Mary Megan Chapman, "'Living Pictures': Women and *Tableaux Vivants* in Nineteenth-Century American Fiction and Culture" (PhD diss., Cornell University, 1992), 2. For a discussion of the epistemology behind posing in the late nineteenth and early twentieth century, see Martha Banta, *Imaging American Women: Idea and Ideals in Cultural History* (New York: Columbia University Press, 1987), 632–41.

10. Morgan, *Protestants and Pictures*, 342–48.

11. Art historian Abigail Solomon-Godeau deploys the phrase "legibility of appearances" in her essay, "A Photographer in Jerusalem, 1855: Auguste Salzmann and His Times," *Photography at the Dock: Essays on Photographic History, Institutions, and Practices* (Minneapolis: University of Minnesota Press, 1991), 155. The relationship between external appearance and internal character was by no means stable. Concern over the photograph's "legibility" led criminologists to devise a larger archival system in which images were translated into text in order to provide multiple sources of evidentiary proof. See, for example, Allan Sekula, "The Body and the Archive," *October* 39 (Winter 1986): 3–64.

12. Day and Guiney discussed appropriate models for the sacred series, referencing both the appearance and character of potential participants. Guiney to Day, 22 September 1898 and 4 September 1898, Guiney Papers. Orvell uses Day and Galton to illustrate his argument in "Almost Nature: The Typology of Late Nineteenth-Century American Photography," in *Multiple Views: Logan Grant Essays on Photography, 1983–89*, ed. Daniel P. Younger (Albuquerque: University of New Mexico Press, 1991), 150.

13. On Holy Land visual culture and consciousness, see Davis, *Landscape of Belief*.

14. On Chautauqua in general, see Alan Trachtenberg, "'We Study the Word and Works of God': Chautauqua and the Sacralization of Culture in America," *Henry Ford Museum and Greenfield Village Herald* 13, no. 2 (1984): 3–11. On the role of stereoscopes in American imperialism, see Richard Masteller, "Western Views in Eastern Parlors: The Contribution of the Stereograph Photographer to the Conquest of the West," *Prospects* 6 (1981): 55–71. On Palestine Park, see John Davis, "Holy Land, Holy People? Photography, Semitic Wannabes, and Chautauqua's Palestine Park," *Prospects* 17 (1992): 241–71. On the Jerusalem section of the 1904 Louisiana Purchase Exposition, see Davis, *Landscape of Belief*, 94–96.

15. "Sacred Art Modernized: Photographs of the Crucifixion from Living Figures," *Boston Herald*, 17 January 1899.

16. Robert Demachy, "Exhibition of the New American School of Artistic Photography at the Paris Photo-Club," *Amateur Photographer* 33, no. 861 (5 April 1901): 275–77, quoted in Verna Posever Curtis and Jane Van Nimmen, eds., *F. Holland Day: Selected Texts and Bibliography* (New York: G. K. Hall and Co., 1995), 100.

17. Orvell, *Real Thing*.

18. John Stoddard, *Red Letter Days Abroad* (Boston: James R. Osgood and Company, 1884), 98. On Stoddard's lecture, see Charles Musser, "Passions and the Passion Play: Theater, Film, and Religion in America, 1880–1900," *Film History* 5, no. 4 (1993): 429.

19. X. Theodore Barber, "The Roots of Travel Cinema: John L. Stoddard, E. Burton Holmes, and the Nineteenth-Century Illustrated Travel Lecture," *Film History* 5, no. 1 (1993): 76.

20. Taves, *Fits, Trances, and Visions*, 10.

21. Tom Gunning, " 'Primitive' Cinema: A Frame-Up? Or the Trick's on Us," in *Early Cinema: Space—Frame—Narrative*, ed. Thomas Elsaesser and Adam Barker (London: BFI Publishing, 1990), 100.

22. "The 'Passion Play' Given Here in Boston. Splendid Reproduction of the Impressive Spectacle," *Boston Herald*, 4 January 1898, quoted in Charles Musser, *Edison Motion Pictures, 1890–1900: An Annotated Filmography* (Washington, D.C.: Smithsonian Institution Press, 1997), 370–71.

23. My dual emphasis on the appearance and presence of holy images is taken from Hans Belting's magisterial work on icons, *Likeness and Presence: A History of the Image before the Era of Art*, trans. Edmund Jephcott (Chicago: University of Chicago Press, 1994). For a variety of historical reasons, Belting argues that icons lost their essential religious meaning and social function with the transition from what he calls the Era of Images to the Era of Art. Although I do not disagree with his conclusions, I am interested in investigating how turn-of-the-century artists and beholders imbued modern imagery with similar meanings and functions in culturally specific ways.

24. Rolf H. Krauss, *Beyond Light and Shadow: The Role of Photography in Certain Paranormal Phenomena; An Historical Survey*, trans. Timothy Bill and John Gledhill (Munich: Nazraeli Press, 1995), 16. For a history of Spiritualism, see R. Laurence Moore, *In Search of White Crows: Spiritualism, Parapsychology, and American Culture* (New York: Oxford University Press, 1977). For a discussion of the relationship between photography and the supernatural, see Tom Gunning, "Phantom Images and Modern Manifestations: Spirit Photography, Magic Theater, Trick Films, and Photography's Uncanny," in *Furtive Images: From Photography to Video*, ed. Patrice Petro (Bloomington: Indiana University Press, 1995), 42–71.

25. "Moving Pictures of the Pope," *New York Tribune*, 15 December 1898, 7; "Mutoscope Pictures of Vatican Life," *Catholic Standard and Times* 3, no. 32 (9 July 1898): 1–2; "17,000 Pictures of Pope Leo," *Catholic Standard and Times* 4, no. 1 (3 December 1898): 1; "The Pope's Pictures: Managers of the Mutoscope Make an Absurd Claim, Which Will Injure Their Cause if Persisted In," *Catholic Standard and Times* 4, no. 4 (24 December 1898): 2. Musser notes that at the end of 1898, a program of Pope Leo films was shown in Boston at a preeminent vaudeville theater on Sundays and at one of its smaller houses during the week. Preceded by a stereopticon lecture on "Ancient and Modern Rome," the program ran for eight weeks. Charles Musser, *The Emergence of Cinema: The American Screen to 1907* (New York: Charles Scribner's Sons, 1990), 220.

26. "The Work of the Year. A Fragmentary Retrospect," *Photograms of the Year. 1899* (London: Dawbarn and Ward, 1899): 64; "The Work of the Year. A Fragmentary Retrospect," *Photograms of '98* (London: Dawbarn and Ward, 1898): 50; and "Photographic Miracles. The Holy Shroud of Turin," *Photogram* 5, no. 60 (December 1898): 368–70. Interestingly, in the same article that described Pia's miraculous photograph of the Shroud of Turin, it was announced that a number of French photographic societies voted to make Saint Veronica the patron saint of photography. According to tradition, Veronica handed Christ a cloth to wipe his face as he carried the cross to Golgotha. He returned it to her with his face impressed upon it. Its negative imprint was "the first of what may be called photographic miracles." "Photographic Miracles," 368–70.

27. Even if Day did not attend the performance of *The Seven Last Words* held in Boston in March 1899, he was certainly aware of the concert and intended to go. Guiney to Day, 14 March 1899 and 20 March 1899, Guiney Papers. For references to Day's participation in Catholic ritual, see Guiney to Day, 31 March and 4 April 1898, Guiney Papers.

28. The theatrical nature of the Passion was used often by Roman Catholic parish missions to inspire spiritual renewal. On the Catholic revival tradition, see Jay P. Dolan, *Catholic Revivalism: The American Experience, 1830–1900* (Notre Dame, Ind.: University of Notre Dame Press, 1978).

29. Haydn described the circumstances surrounding the commission in 1802, in the preface to the choral version. It is quoted in Jonathan Daniels Drury, "Haydn's *Seven Last Words*: An Historical and Critical Study" (PhD diss., University of Illinois at Urbana-Champaign, 1975), 4–5. For an essay on Haydn's reception in the nineteenth century, see Leon Botstein, "The Demise of Philosophical Listening: Haydn in the 19th Century," in *Haydn and His World*, ed. Elaine Sisman (Princeton: Princeton University Press, 1997), 255–85.

30. The *Seven Last Words* was, perhaps, Day's most literal synthesis of the arts. Nevertheless, music was a popular metaphor for describing the influence of Day's photographs on the beholder. See, for example, A. Horsley

Hinton, "Both Sides," *Camera Notes* 2, no. 3 (January 1899): 79. On Day and symbolism, see Edwin Becker, "F. Holland Day and Symbolism," in *F. Holland Day*, ed. Pam Roberts, 53–64. On the relationship between music and the symbolist movement, see Gerard Vaughan, "Maurice Denis and the Sense of Music," *Oxford Art Journal* 7, no. 1 (1984): 38–48; Günter Metken, "Music for the Eye: Richard Wagner and Symbolist Painting," in *Lost Paradise: Symbolist Europe* (Montreal: Montreal Museum of Fine Arts, 1995), 116–23; and Bruce F. Campbell, *Ancient Wisdom Revived: A History of the Theosophical Movement* (Berkeley: University of California Press, 1980), 165–71.

31. Day gave Guiney *The Treasure of the Humble* in 1897, soon after its publication. Guiney to Day, 23 September 1897 and 28 September 1897, Guiney Papers.

32. Maurice Maeterlinck, *The Treasure of the Humble*, trans. Alfred Sutro (New York: Dodd, Mead and Company, [1897]): 19, 20–28, 30–34, 50–51, and 56.

33. For a summary of Blavatsky's main points, see Campbell, *Ancient Wisdom Revived*, 48–51.

34. For a discussion on the relationship between pictorialism and the orb, see Colleen Denney, "The Role of Subject and Symbol in American Pictorialism," *History of Photography* 13, no. 2 (April–June 1989): 109–28.

35. "The Work of the Year," *Photograms of the Year. 1899*, 64

36. Sadakichi Hartmann, "A Decorative Photographer: F. H. Day," *Photographic Times* 32 (March 1900): 105.

37. Recognizing the contrasting personalities of Day and the British press corps, one journalist warned: "That [Day and Steichen's] ideas, sympathies, their very lives, are widely different to those of the public whom these pictures await was easy to see, and we fear they will feel keenly the isolation which such differences must create." See "Pictorial Photography from America," *Amateur Photographer* (12 October 1900), quoted in "The English Exhibitions and the 'American Invasion,'" *Camera Notes* 4, no. 3 (January 1901): 182.

38. Crump, *F. Holland Day: Suffering the Ideal*. The term "homosexuality" was not coined until the final decades of the nineteenth century, when medical writers employed it to describe sexual perversions. See Elaine Showalter, *Sexual Anarchy: Gender and Culture at the Fin de Siècle* (New York: Penguin Books, 1990); and John D'Emilio and Estelle B. Freedman, *Intimate Matters: A History of Sexuality in America*, 2nd ed. (Chicago: University of Chicago Press, 1998). For a discussion of Day's framing techniques, see Jeff Rosen, "Strategies of Containment: The Manipulation of the Frame in Contemporary Photography," *Afterimage* (December 1989): 14–15.

39. L. Bovier, "Correspondence," *Photogram* 6, no. 64 (April 1899): 127.

40. James J. Walsh, "The Passion Play," *Catholic World* 72, no. 428 (November 1900): 247, 253.

41. Burns, *Inventing the Modern Artist*, 4. Mary Warner Marien discusses this trend in relation to photographic criticism specifically in *Photography and Its Critics: A Cultural History, 1839–1900* (Cambridge: Cambridge University Press, 1997).

42. Musser, "Passions and the Passion Play," 449.

43. Charles Caffin, "Philadelphia Photographic Salon," *Harper's Weekly* 43 no. 2237 (4 November 1899): 1119–20; and "Correspondence," *Photogram* 6, no. 64 (April 1899): 127–28. See also Darwin Marable, "The Crucifixion in Photography," *History of Photography* 18, no. 3 (Autumn 1994): 256–63.

44. Demachy, "Exhibition of the New American School," 275–77, quoted in Curtis and Van Nimmen, *F. Holland Day*, 101; Joseph T. Keiley, "The Philadelphia Salon," *Camera Notes* 2, no. 3 (9 January 1899): 124; and Frederick H. Evans, "The Exhibition of American Photography at Russell Square," *British Journal of Photography* 47, no. 2113 (2 November 1900): 702, quoted in Curtis and Van Nimmen, *F. Holland Day*, 91.

45. Allen, *Human Christ*, 177. Debate over what Christ looked like—and should look like—preoccupied turn-of-the-century Americans. See, for example, Hampton, "Face of Christ in Art," 735–48; Griffith, "Christ as Modern American Artists See Him," 286–99; Swift, "New Conceptions of the Christ," 148–57; and Homer Saint-Gaudens, "Ten American Paintings of Christ" in *Putnam's Monthly and the Critic* 1, no. 3 (December 1906): 257–72.

46. Charles Caffin, "Philadelphia Photographic Salon," 1087; Harold Baker, "Correspondence," *Photogram* 6, no. 64 (April 1899): 127; F. Holland Day, "Is Photography an Art?" undated, typewritten manuscript, 18–19; Day Papers.

47. F. Holland Day, "Is Photography an Art?" 5.

48. "Pictorial Photography from America," *Amateur Photographer* (12 October 1900), quoted in "The English Exhibitions and the 'American Invasion,'" *Camera Notes* 4, no. 3 (January 1901): 182.

49. Washington Gladden, "Christianity and Aestheticism," *Andover Review* 1 (January 1884): 15, 17, 19, 23, 14.

50. Guy Willoughby, *Art and Christhood: The Aesthetics of Oscar Wilde* (London: Associated University Presses, 1993), 104.

51. Crary, *Suspensions of Perception*, 46.

52. Roger Fry's "An Essay in Aesthetics (1909)," in *Art in Theory 1900–1990: An Anthology of Changing Ideas*, ed. Charles Harrison and Paul Wood (Cambridge, Mass.: Blackwell, 1992), 81, 80.

53. A number of scholars have discussed Day's extensive social work in the Boston area. See Patricia Berman, "F. Holland Day and his 'Classical' Models: Summer Camp," *History of Photography* 18, no. 4 (Winter 1994): 348–67; and Verna Curtis, "F. Holland Day and the Staging of Orpheus," in *New Perspectives on F. Holland Day,* 51–60.

54. While the photograph owned by the Royal Photographic Society is attributed to Day, the one located at the Metropolitan Museum of Art is credited to Steichen. Either photographer could have taken the picture, and both may have been present for the sitting. Day and Steichen worked together closely during this period, hanging the New School of American Photography exhibitions in London and in Paris. Day served as Steichen's first teacher, and their mutual respect is suggested by their similar styles and artistic aims. Crump, *F. Holland Day*; and Dennis Longwell, *Steichen: The Master Prints, 1895–1914; The Symbolist Period* (New York: Museum of Modern Art, 1978). For a discussion of Day's influence on Steichen, see Penelope Niven, "Camping in the Latin Quarter: Fred Holland Day as Edward Steichen's First Teacher," in *New Perspectives on F. Holland Day*, 39–49 and 77–80.

55. A draft of the invitation is in the Guiney Papers. It appears she edited the invitation before Day sent it to select friends and acquaintances. Guiney to Day, 30 October 1898, Guiney Papers; "Sacred Art and the Camera: A Few Notes Taken in Conversation with F. Holland Day," *Photogram* 8, no. 88 (April 1901): 91–92; and Guiney to Day, 23 March 1904, Guiney Papers.

Chapter 4. The Protestant Icons of Abbott Henderson Thayer

1. Henry James, *Transatlantic Sketches* (Boston: James R. Osgood and Company, 1875), 293.

2. Sadakichi Hartmann, *A History of American Art*, vol. 1 (Boston: L. C. Page, 1902), 276.

3. Banta, *Imaging American Women*; Carolyn Kitch, *The Girl on the Magazine Cover: The Origins of Visual Stereotypes in American Mass Media* (Chapel Hill: University of North Carolina Press, 2001); and Bailey Van Hook, *Angels of Art: Women and Art in American Society, 1876–1914* (University Park: Pennsylvania State University Press, 1996), and *The Virgin and the Dynamo: Public Murals in American Architecture, 1893–1917* (Athens: Ohio University Press, 2003).

4. Anna Jameson, *Legends of the Madonna*, ed. Estelle M. Hurll, (Boston: Houghton, Mifflin, 1895), 3–4. It is difficult to underestimate the importance of Jameson's *Legends* to the study of Marian art among fine art critics and popular audiences; it was continually reprinted throughout the second half of nineteenth century and served as the primary source for the manifold books and articles on Marian art published thereafter. On Jameson and her work, see Adele M. Holcomb, "Anna Jameson (1794–1860): Sacred Art and Social Vision," in *Women as Interpreters of the Visual Arts, 1820–1979*, ed. Claire Richter Sherman with Adele M. Holcomb (Westport, Conn.: Greenwood Press, 1981), 93–121.

5. Jameson, *Legends of the Madonna*, 1.

6. For a description of the American Catholic Church in this period, see (among others), R. Laurence Moore, *Religious Outsiders and the Making of Americans* (New York: Oxford University Press, 1986); Marty, *Modern American Religion*; and John McGreevy, *Catholicism and American Freedom: A History* (New York: W. W. Norton, 2003).

7. Ann Taves, *The Household of Faith: Roman Catholic Devotions in Mid-Nineteenth-Century America* (Notre Dame, Ind.: University of Notre Dame, 1988); and Dolan, *Catholic Revivalism*. See also Colleen McDannell, *The Christian Home in Victorian America, 1840–1900* (Bloomington: Indiana University Press, 1986), and *Material Christianity*.

8. Estelle M. Hurll, *The Madonna in Art* (Boston: L. C. Page and Company, 1897), xi.

9. On Chautauqua, see Trachtenberg, "'We Study the Word and Works of God,'" 3–11.

10. Bishop Vincent, "Sunday Readings," in *Chautauquan; A Weekly Newsmagazine* 18, no. 1 (April 1893): 24.

11. Gail Bederman, *Manliness and Civilization: A Cultural History of Gender and Race in the United States, 1880–1917* (Chicago: University of Chicago Press, 1995), 25–31.

12. On issues of class and race in the woman's movement, see Bederman, *Manliness and Civilization*; Lori D. Ginzberg, *Women and the Work of Benevolence: Morality, Politics, and Class in the Nineteenth-Century United States* (New Haven: Yale University Press, 1990); Evelyn Brooks Higginbotham, *Righteous Discontent: The Women's Movement in the Black Baptist Church* (Cambridge: Harvard University Press, 1993); and Louise Michele Newman, *White Women's Rights: The Racial Origins of Feminism in the United States* (New York: Oxford University Press, 1999).

13. Pyne, *Art and the Higher Life*, 3.

14. On the mid-nineteenth-century formulations of womanhood, see (among others) Barbara Welter, "The Cult of True Womanhood: 1820–1960," in *American Quarterly* 18, no. 2, pt. 1 (Summer 1966): 151–74. For additional information on the role of religion in the woman's movement in the nineteenth century, see Ann Braude,

Radical Spirits: Spiritualism and Women's Rights in Nineteenth-Century America (Boston: Beacon Press, 1989); Frances B. Cogan, *All-American Girl: The Ideal of Real Womanhood in Mid-Nineteenth-Century America* (Athens: University of Georgia Press, 1989); and Kathryn Kish Sklar, *Catherine Beecher: A Study in American Domesticity* (New Haven: Yale University Press, 1973).

15. Frances E. Willard, *Do Everything: A Handbook for the World's White Ribboners* (Chicago: The Woman's Temperance Publishing Association, [1895?]), 20. For an earlier explication of her ideas on temperance and the WCTU's structure and organization, see *Home Protection Manual: Containing an Argument for the Temperance Ballot for Woman, and How to Obtain It, as a Means of Home Protection; Also Constitution and Plan of Work for State and Local W.C.T. Unions* (New York: "The Independent" Office, 1879). For studies on the WCTU, see Ruth Bordin, *Women and Temperance: The Quest for Power and Liberty, 1873–1900* (Philadelphia: Temple University Press, 1984); and Barbara Leslie Epstein, *The Politics of Domesticity: Women, Evangelism, and Temperance in Nineteenth-Century America* (Middletown, Conn.: Wesleyan University Press, 1981).

16. Kathi Kern, *Mrs. Stanton's Bible* (Ithaca: Cornell University Press, 2001), 121. On Christianity and the woman's movement at the end of the nineteenth century, see also Ginzberg, *Women and the Work of Benevolence*.

17. Bishop Vincent, "Sunday Readings," 24–26.

18. Ross Anderson, *Abbott Henderson Thayer* (Syracuse, N.Y.: Everson Museum of Art, 1982), 11. For a full biographical account of Thayer's life and work, see Nelson C. White, *Abbott H. Thayer: Painter and Naturalist* (Hartford: Connecticut Printers, 1951). See also James K. Kettlewell, *Transcendent Universe: The Paintings of Abbott Handerson Thayer* (Glens Falls, N.Y.: Hyde Collection, 1996). For more localized interpretations of Thayer's art, see Alexander Nemerov, "Vanishing Americans: Abbott Thayer, Theodore Roosevelt, and the Attraction of Camouflage," *American Art* 11, no. 2 (Summer 1997): 50–82; Richard Murray, "Abbott Thayer's Stevenson Memorial," *American Art* 13, no. 2 (Summer 1999): 2–25; and Elizabeth Lee, "Therapeutic Beauty: Abbott Thayer, Antimodernism, and the Fear of Disease," *American Art* 18, no. 3 (Fall 2004): 32–52.

19. Thayer to Tyron, 7 December 1914; Thayer to Mrs. Henry Holt, 23 February 1911[?]; Thayer to Edward B. Poulton, undated (circa 1904?), Nelson and Henry C. White Research Material, Archives of American Art, Smithsonian Institution, Washington D.C. (hereafter White Research Material). For a discussion of the northeast cultural elite at the end of the nineteenth century, see Lears, *No Place of Grace*.

20. White, *Abbott H. Thayer*, 12.

21. "Art by the Wayside," *Springfield Republican*, 29 May 1892, clipping in the White Research Material; and "Abbott Thayer's New Painting of the Madonna," White Research Material.

22. Thayer's father wrote that the idea for *Virgin Enthroned* stemmed from a tableau in which Mary (Thayer's oldest daughter) performed a year earlier. William Henry Thayer, "Family Record (1889–1896)," vol. 2, 7, Abbott Handerson Thayer and William Henry Thayer Papers, Archives of American Art, Smithsonian Institution, Washington, D.C. (hereafter, Thayer Papers). For a discussion of the types of entertainment enjoyed in Dublin, New Hampshire, during the summer months, see Barbara Ball Buff, "The Dublin Colony," in *A Circle of Friends: Art Colonies of Cornish and Dublin* (Durham, N.H.: University Art Galleries, University of New Hampshire, 1985), 9–29.

23. Maria Oakey Dewing, "Abbott Thayer—A Portrait and an Appreciation," *International Studio* 74, no. 293 (August 1921): xi–xii. See also Lee, "Therapeutic Beauty."

24. Anderson, *Abbott Henderson Thayer*, 63–73.

25. Abbott Handerson Thayer to Royal Cortissoz, 14 April 1915, White Research Material.

26. Thayer's correspondence is full of references to women's transparency and transcendence. See, for example, AHT to Emma Beach, undated [early 1880s?], White Research Material; and AHT to his child[ren], 7 June 1905, White Research Material. On Thayer's environmental concerns, see AHT to Mary, 18 December 1904, White Research Material; Abbott H. Thayer, "A Protest against lighting the Dublin roads with electricity," 25 May 1904, Thayer Papers; and AHT to Mrs. William Amory and Rev. George F. Weld, draft of undated letter, Thayer Papers.

27. Although Thayer originally intended to depict the female figure clasping a mandolin and stem of lilies, neither the instrument of the heavenly choir nor the symbol of purity appeared in the final version. AHT to Emma Beach, 21 July 1887, White Research Material.

28. White, *Abbott H. Thayer*, 95. On the American Renaissance, see Richard Guy Wilson, Dianne Pilgrim, and Richard Murray, *The American Renaissance* (New York: Pantheon Books, 1979).

29. Jameson, *Legends of the Madonna*, 42.

30. "Prices for Words of Art," *Scientific American* 78, no. 7 (February, 1898): 103; William Sharp, "The Art Treasures of America," *Living Age* (29 October 1898): 1; "The Colonna Madonna," *New York Times* (23 October 1901), 8; "Sheedy Madonna Condon's," *New York Times* (8 January 1905, 1); and "Art at Home and Abroad," *New York Times* (11 October 1908, X1).

31. Brown, *Raphael and America*, 31.

32. Anne Higonnet, *Pictures of Innocence: The History and Crisis of Ideal Childhood* (New York: Thames and Hudson, 1998), 60.

33. Jameson, *Legends of the Madonna*, 14, 19.

34. Edwina Spencer, "Early Madonnas," *Chautauquan* 57, 1 (December 1909): 126.

35. AHT to John W. Beatty, Director of Fine Arts, Carnegie Institute, [early 1890s?], White Research Material.

36. Katie Cowper, "Realism of to-Day," *Nineteenth Century: A Monthly Review* 35 (1894): 618.

37. AHT to director, Hillyer Gallery, Smith College, ca. 1916, Smith College Archives.

38. For an examination of the relationship between Emerson and Thayer's landscape painting, see Anderson, *Abbott Henderson Thayer*, 84–111. On Thayer's particular interest in "Spiritual Laws," see AHT to William James Jr., 9 September 1910, White Research Material.

39. Ralph Waldo Emerson, "Spiritual Laws," in *Essays: First Series* (1841), Ralph Waldo Emerson—Texts, http://www.emersoncentral.com/spirituallaws.htm.

40. Many scholars, including art historians Alexander Nemerov, Richard Murray, and Elizabeth Lee, demonstrate that Thayer's obsession with purity was informed by a deep desire to combat display, disease, sexuality, and filth, and that the tenacity with which he pursued it signifies its centrality to his conceptions of manliness, morality, and the state of Western civilization. See Nemerov, "Vanishing Americans"; Murray, "Abbott Thayer's Stevenson Memorial"; and Lee, "Therapeutic Beauty."

41. AHT to Thomas Millie Dow, 23 May 1880; and AHT to Owen Wister, undated, [1913?], White Research Material.

42. Abbott H. Thayer, "To the Editor of The Republican," *Springfield Republican*, 1902, White Research Material.

43. Fragment dated 1912, White Research Material.

44. AHT to Emma Beach, 8 May 1902 and June 1892, White Research Material.

45. AHT to William James Jr., 18 November 1904, White Research Material.

46. Plato, *The Symposium*, trans. Benjamin Jowett. Internet Classics Archive, http://classics.mit.edu//Plato/symposium.html.

47. AHT to Emma Beach, undated, [early 1880s?], White Research Material.

48. AHT to Royal Cortissoz, White Research Material.

49. AHT to Emma Beach, 27 July 1891, White Research Material.

50. AHT to Royal Cortissoz, 8 July 1911, White Research Material.

51. "The Wanamaker Store. A Careful, Bountiful, Economical New York Christmas Store," *New York Times*, 12 December 1899, 4; and "The Famous Kitchell Composite Madonna Exhibited in Our Art Gallery," *New York Times*, 20 April 1905, 4.

52. "The First Composite Madonna in the World," *Ladies' Home Journal* 22, no 6 (May 1905): 7.

53. "The First Composite Madonna in the World," 7.

54. AHT to General Loring, 13 December 1899, Curatorial Files, Museum of Fine Arts, Boston.

55. Abbott H. Thayer, "To the Editor of The Republican," *Springfield Republican*, 1902, clipping in the White Research Material.

56. Gladys Thayer quoted in White, *Abbott H. Thayer*, 177.

57. AHT to Edward B. Poulton, undated [ca. 1904?], White Research Material.

58. AHT to Owen Wister, undated [after 1913], White Research Material.

59. AHT to Royal Cortissoz, 8 July 1911, White Research Material.

60. AHT, fragment dated 1912, and AHT to Edward Martin Taber, no date [before Taber's death in 1896], White Research Material.

61. Samuel Isham, *The History of American Painting* (New York: Macmillan, 1905), 468–71.

62. "Abbott Thayer's New Painting of the Madonna," White Research Material.

63. Caffin, *Story of American Painting*, 182, 185.

64. *The Listener*, clipping in White Research Material.

65. "American Artists. Striking Features of the Exhibition of the Society," [1903?], clipping in the White Research Material.

66. Homer Saint-Gaudens, "Abbott H. Thayer," *Critic and Literary World* 46, no. 5 (1905): 423.

67. Mrs. Arthur Bell, "An American Painter: Abbott H. Thayer," *Studio* 15 (January 1899): 248.

68. "Abbott Thayer's New Painting of the Madonna," clipping in White Research Material.

69. Bell, "An American Painter: Abbott H. Thayer," 248.

70. Caffin, *Story of American Painting*, 182, 185.

71. "Art by the Wayside," *Springfield Republican*, 29 May 1892, clipping in White Research Material.

72. Ibid.

73. Hartmann, *History of American Art*, 276.

74. "Society of American Artists," *New York Evening Post*, 4 May 1892, clipping in the White Research Material.

75. AHT to Tyron, 7 December 1914, White Research Material.

76. For a discussion of the German influence in Thayer's art and thought, see Murray, "Abbott Thayer's Stevenson Memorial," 2–25.

77. Morgan, "Toward a Modern Historiography of Art and Religion," 32.

78. See Boris, *Art and Labor*, particularly chaps. 4 and 5.

79. Estelle M. Hurll, "Selecting Pictures for the Home," *Arthur's Home Magazine* (March 1894): 235–36.

80. "Her Point of View," *New York Times,* 14 January 1894, 18.

81. Lucy Monroe, "A Circulating Picture Gallery," *Current Literature* 19, no. 1 (January 1896): 46–47. On art at Hull House, see Mary Ann Stankiewicz, "Art at Hull House, 1889–1901: Jane Addams and Ellen Gates Starr," *Women's Art Journal* 10, no. 1 (Spring–Summer 1989): 35–39; and Helen L. Horowitz, "Varieties of Cultural Experience in James Addams' Chicago," *History of Education Quarterly* 14, no. 1 (Spring 1974): 69–86.

82. Lillie B. Chace Wyman, "Southern Colored Women. How Other Women Can Help Them," *Chautauquan* 11, no. 6 (September 1890): 752–53.

83. P. W. Dykema, "The Madonna in Art," *Brush and Pencil* 2, no. 3 (1898): 97–98.

84. Dykema, "The Madonna in Art," 102–4.

85. Marie C. Remick, "The Relation of Art to Morality," *Arena* 19, no. 101 (April 1898): 493, 487.

86. Hartmann, *History of American Art*, 281.

87. Henry Adams, "The Virgin and the Dynamo," in *The Education of Henry Adams* (Boston: Houghton, Mifflin Company, 1973 [1918]), 385.

88. On Adams's treatment of religion and the Virgin, see Alfred Kazin, "Religion as Culture: Henry Adams's *Mont-Saint-Michel*" in *Henry Adams and His World*, ed. David R. Contosta and Robert Muccigrosso (Philadelphia: American Philosophical Society, 1993), 48–56; and Richard F. Miller, "Henry Adams and the Influence of Woman," *American Literature* 18, no. 4 (January 1947): 291–98.

89. AHT to Emma Beach, 21 July 1887, Thayer Papers.

90. Saint-Gaudens, "Abbott H. Thayer," 423.

91. AHT to his child[ren], 7 June 1905, White Research Material.

92. Thayer expressed a similar sentiment to his friend Thomas Millie Dow: "I, in those nearly two years that hope itself about Kate had been dead, have felt almost with horror my feverish susceptibilities to women's charms, by no means alone of their bodies but of their souls too." AHT to Thomas Millie Dow, 2 May 1891, White Research Material.

93. On the gender of modernism, see Pyne, *Art and the Higher Life*; and Marcia Brennan, *Painting Gender, Constructing Theory: The Alfred Stieglitz Circle and American Formalist Aesthetics* (Cambridge: MIT Press, 2001).

94. George Santayana, *The Life of Reason* (New York: Dover, 1980), Project Gutenberg eBooks, http://www.gutenberg.org/etext/15000.

95. Caffin, *Story of American Painting*, 382.

96. Ibid., 382, 385–86.

Bibliography

Archival Resources

Abbott Henderson Thayer and William Henry Thayer Papers, Archives of American Art, Smithsonian Institution, Washington, D.C.

Charles Bregler's Thomas Eakins Collection, Pennsylvania Academy of the Fine Arts, Philadelphia.

F. Holland Day Papers, Archives of American Art, Smithsonian Institution, Washington, D.C.

Henry Ossawa Tanner Papers, Archives of American Art, Smithsonian Institution, Washington, D.C.

Herman Joseph Heuser, D. D. Papers, 1872–1933, Philadelphia Archdiocesan Historical Research Center, Overbrook, Pennsylvania.

Hugh T. Henry Papers, Mullen Library, Catholic University of America, Washington, D.C.

Louise Imogen Guiney Papers, Library of Congress, Washington, D.C.

Nelson and Henry C. White Research Material, Archives of American Art, Smithsonian Institution, Washington, D.C.

Samuel Murray and Thomas Eakins Papers, Hirshhorn Museum and Sculpture Garden, Smithsonian Institution, Washington, D.C.

Thomas Eakins Letters, 1867–1869, Archives of American Art, Smithsonian Institution, Washington, D.C.

Secondary Sources

Adams, Henry. *The Education of Henry Adams.* Boston: Houghton Mifflin, 1973 [1918].

Adams, Henry. *Eakins Revealed: The Secret Life of an American Artist.* New York: Oxford University Press, 2005.

Adams, Maurianne, and John Bracey, eds. *Strangers and Neighbors: Relations between Blacks and Jews in the United States.* Amherst: University of Massachusetts Press, 1999.

"An Afro-American Painter Who Has Become Famous in Paris." *Current Literature* 45 (October 1908): 404–8.

Ahlstrom, Sydney E. *A Religious History of the American People.* New Haven: Yale University Press, 1972.

Albanese, Catherine L. *America: Religion and Religions.* 3rd ed. Belmont, Calif.: Wadsworth, 1999.

Alexander, Eleanor. *Lyrics of Sunshine and Shadow: The Tragic Courtship and Marriage of Paul Laurence Dunbar and Alice Ruth Moore.* New York: New York University Press, 2001.

Allen, Charlotte. *The Human Christ: The Search for the Historical Jesus.* New York: Free Press, 1998.

Anderson, Ross. *Abbott Handerson Thayer.* Syracuse, N.Y.: Everson Museum of Art, 1982.

Angell, Stephen W., and Anthony B. Pinn, eds. *Social Protest Thought in the African Methodist Episcopal Church, 1862–1939*. Knoxville: University of Tennessee Press, 2000.

Apostolos-Cappadona, Diane. *The Spirit and the Vision: The Influence of Christian Romanticism on the Development of 19th-Century American Art*. Atlanta: Scholars Press, 1995.

"Art Gossip: Revival of Religious Art." *Art Age* 5 (February 1887): 19.

The Art of Henry Ossawa Tanner (1859–1937). Washington, D.C.: Frederick Douglass Institute and National Collection of Fine Arts, 1969.

Baldwin, Elbert Francis. "A Negro Artist of Unique Power." *Outlook* 64 (January–April 1900): 793–96.

Banta, Martha. *Imaging American Women: Idea and Ideals in Cultural History*. New York: Columbia University Press, 1987.

Barber, X. Theodore. "The Roots of Travel Cinema: John L. Stoddard, E. Burton Holmes, and the Nineteenth-Century Illustrated Travel Lecture." *Film History* 5, no. 1 (1993): 68–84.

Barton, William E. "An American Painter of the Resurrection: Henry Ossawa Tanner." *Advance* (20 March 1913): 2011–12.

Baxandall, Michael. *Painting and Experience in Fifteenth Century Italy: A Primer in the Social History of Pictorial Style*. 2nd ed. Oxford: Oxford University Press, 1988.

Becker, Edwin. "F. Holland Day and Symbolism." In *F. Holland Day*, edited by Pam Roberts, 53–64. Amsterdam: Van Gogh Museum, 2000.

Bederman, Gail. *Manliness and Civilization: A Cultural History of Gender and Race in the United States, 1880–1917*. Chicago: University of Chicago Press, 1995.

Belting, Hans. *Likeness and Presence: A History of the Image before the Era of Art*. Translated by Edmund Jephcott. Chicago: University of Chicago Press, 1994.

Benjamin, Walter. "The Task of the Translator: An Introduction to the Translation of Baudelaire's *Tableaux Parisiens*." In *Illuminations*, edited by Hannah Arendt, 69–82. New York: Schocken Books, 1969.

Bentley, Florence L. "Henry O. Tanner." *Voice of the Negro* (November 1906): 480–82.

Berdini, Paolo. *The Religious Art of Jacopo Bassano: Painting as Visual Exegesis*. Cambridge: Cambridge University Press, 1997.

Berger, Martin A. *Sight Unseen: Whiteness and American Visual Culture*. Berkeley: University of California Press, 2005.

———. *Man Made: Thomas Eakins and the Construction of Gilded Age Manhood*. Berkeley: University of California Press, 2000.

Berman, Patricia. "F. Holland Day and His 'Classical' Models: Summer Camp." *History of Photography* 18, no. 4 (Winter 1994): 348–67.

Blanchard, Mary Warner. *Oscar Wilde's America: Counterculture in the Gilded Age*. New Haven: Yale University Press, 1998.

Bledstein, Burton J. *The Culture of Professionalism: The Middle Class and the Development of Higher Education in America*. New York: W. W. Norton, 1978.

Bogart, Michele H. *Advertising, Artists, and the Borders of Art*. Chicago: University of Chicago Press, 1995.

Boime, Albert. "Henry Ossawa Tanner's Subversion of Genre." *Art Bulletin* 75, no. 3 (September 1993): 415–42.

Bok, Edward. *The Americanization of Edward Bok: The Autobiography of a Dutch Boy Fifty Years After*. 28th ed. New York: C. Scribner's Sons, 1923.

Bolger, Doreen, and Sarah Cash, ed. *Thomas Eakins and the Swimming Picture*. Fort Worth: Amon Carter Museum, 1996.

Bones, Diane M. "Eakins: The Villanova Connection." *Villanova* 1, no. 3 (November 1985): 9.

Bordin, Ruth. *Women and Temperance: The Quest for Power and Liberty, 1873–1900*. Philadelphia: Temple University Press, 1984.

Boris, Eileen. *Art and Labor: Ruskin, Morris, and the Craftsman Ideal in America*. Philadelphia: Temple University Press, 1986.

Botstein, Leon. "The Demise of Philosophical Listening: Haydn in the 19th Century." In *Haydn and His World*, edited by Elaine Sisman, 255–85. Princeton: Princeton University Press, 1997.

Braddock, Alan C. "Eakins, Race, and Ethnographic Ambivalence." *Winterthur Portfolio* 33, nos. 2–3 (Summer–Autumn 1998): 135–61.

Braude, Ann. *Radical Spirits: Spiritualism and Women's Rights in Nineteenth-Century America*. Boston: Beacon Press, 1989.

Brennan, Marcia. *Painting Gender, Constructing Theory: The Alfred Stieglitz Circle and American Formalist Aesthetics*. Cambridge: MIT Press, 2001.

Brent, Joseph. *Charles Sanders Peirce: A Life*. Rev. ed. Bloomington: Indiana University Press, 1998.

Brown, Bill. *A Sense of Things: The Object Matter of American Literature*. Chicago: University of Chicago Press, 2003.

Brown, David Alan. *Raphael and America*. Washington, D.C.: National Gallery of Art, 1983.

Bruce, Steve, ed. *Religion and Modernization: Sociologists and Historians Debate the Secularization Thesis*. Oxford: Clarendon Press, 1992.

Bryson, Norman, Michael Ann Holly, and Keith Moxey, eds. *Visual Culture: Images and Interpretations*. Hanover, N.H.: University Press of New England, for Wesleyan University Press, 1994.

Buff, Barbara Ball. "The Dublin Colony." In *A Circle of Friends: Art Colonies of Cornish and Dublin*, 9–29. Durham: University Art Galleries, University of New Hampshire, 1985.

Burns, Sarah. *Inventing the Modern Artist: Art and Culture in Gilded Age America*. New Haven: Yale University Press, 1996.

——. "Ordering the Artist's Body: Thomas Eakins and the Act of Self-Portrayal." *American Art* 19, no. 1 (Spring 2005): 83–107.

——. *Painting the Dark Side: Art and the Gothic Imagination in Nineteenth-Century America*. Berkeley: University of California Press, 2004.

Butler, Jon. *Awash in a Sea of Faith: The Christianizing of the American People*. Cambridge: Harvard University Press, 1990.

Caesar, Terry. "'Counting the Cats in Zanzibar': American Travel Abroad in American Travel Writing to 1914." *Prospects: An Annual of American Cultural Studies* 13 (1988): 95–134.

Caffin, Charles. "American Studio Talk: Pennsylvania Academy Exhibition." *International Studio* 22, no. 85 (March 1904): ccxxxix.

——. "Philadelphia Photographic Salon." *Harper's Weekly* 42, no. 2185 (5 November 1898): 1087.

——. "Philadelphia Photographic Salon." *Harper's Weekly* 43, no. 2237 (4 November 1899): 1119–20.

——. *The Story of American Painting*. New York: Frederick A. Stokes Company, 1907.

Campbell, Bruce F. *Ancient Wisdom Revived: A History of the Theosophical Movement*. Berkeley: University of California Press, 1980.

Campbell, F. J. "Henry O. Tanner's Biblical Pictures." *Fine Arts Journal* 25 (March 1911): 163–66.

Carter, Paul A. *The Spiritual Crisis of the Gilded Age*. DeKalb: Northern Illinois University Press, 1971.

Cassel, Harry A. "John Joseph Fedigan, O.S.A.: 1842–1908." In *Men of Heart: Pioneering Augustinians, Province of Saint Thomas of Villanova*, 169–85. Villanova, Penn.: Augustinian Press, 1983.

Chamberlin-Hellman, Mariah. "Samuel Murray, Thomas Eakins, and the Witherspoon Prophets." *Arts Magazine* 53, no. 9 (May 1979): 134–39.

Chapman, Mary Megan. "'Living Pictures': Women and *Tableaux Vivants* in Nineteenth-Century American Fiction and Culture." PhD diss., Cornell University, 1992.

Character Glimpses of Most Reverend William Henry Elder, D.D., Second Archbishop of Cincinnati. Cincinnati: Frederick Pustet and Co., 1911.

Chauncey, George. *Gay New York: Gender, Urban Culture, and the Making of the Gay Male World, 1890–1940*. New York: Basic Books, 1994.

Chireau, Yvonne. "Black Culture and Black Zion: African American Religious Encounters with Judaism, 1790–1930, an Overview." In *Black Zion: African American Religious Encounters with Judaism*, edited by Yvonne Chireau and Nathaniel Deutsch, 15–32. New York: Oxford University Press, 2000.

Clattenburg, Ellen Fritz. *The Photographic Work of F. Holland Day*. Wellesley, Mass.: Wellesley College Museum, 1975.

Clement, Clara Erskine. *Angels in Art*. Boston: L. C. Page and Company, 1898.

——. "Early Religious Painting in America." *New England Magazine* 11, no. 4 (December 1894): 387–402.

——. "Later Religious Painting in America." *New England Magazine* 12, no. 2 (April 1895): 130–54.

Coates, James. *Photographing the Invisible: Practical Studies in Spirit Photography, Spirit Portraiture, and Other Rare but Allied Phenomena*. Chicago: Advanced Thought Publishing, 1911.

Cogan, Frances B. *All-American Girl: The Ideal of Real Womanhood in Mid-Nineteenth-Century America*. Athens: University of Georgia Press, 1989.

Cole, Helen. "Henry O. Tanner, Painter." *Brush and Pencil* 6, no. 3 (June 1900): 97–107.

Connelly, James F. *Saint Charles Seminary, Philadelphia*. Philadelphia: Saint Charles Seminary, 1979.

Consuela, Mary. "The Church of Philadelphia (1884–1918)." In *The History of the Archdiocese of Philadelphia*, edited by James F. Connelly, 271–338. Philadelphia: Archdiocese of Philadelphia, 1976.

Contosta, David R. *Villanova University, 1842–1992: American—Catholic—Augustinian*. University Park: Pennsylvania State University Press, 1995.

Cooper, Emmanuel. *The Sexual Perspective: Sexuality and Art in the Last 100 Years in the West*. 2nd ed. New York: Routledge, 1994.

Corn, Wanda. *The Great American Thing: Modern Art and National Identity, 1915–1935*. Berkeley: University of California Press, 1999.

Coues, Edith. "Tissot's 'Life of Christ.'" *Century Magazine* 51, no. 2 (December 1895): 289–302.

Courson, Countess de. "A Modern Christian Painter, M. James Tissot." *Rosary Magazine* 16, no. 4 (April 1900): 324–34.

Cox, Kenyon. *Painters and Sculptors: A Second Series of Old Masters and New*. New York: Duffield and Company, 1907.

Crary, Jonathan. *Suspensions of Perception: Attention, Spectacle, and Modern Culture*. Cambridge: MIT Press, 2000.

———. *Techniques of the Observer: On Vision and Modernity in the Nineteenth Century*. Cambridge: MIT Press, 1992.

Crump, James. *F. Holland Day: Suffering the Ideal*. Santa Fe, N.M.: Twin Palms, 1995.

Curtis, Verna Posever. "F. Holland Day and the Staging of Orpheus." In *New Perspectives on F. Holland Day: Selected Presentations from the Fred Holland Day in Context Symposium Held at Stonehill College North Easton, Massachusetts, April 19, 1997*, 51–60. North Easton, Mass.: Stonehill College, 1998.

Curtis, Verna Posever, and Jane Van Nimmen, eds. *F. Holland Day: Selected Texts and Bibliography*. New York: G. K. Hall and Company, 1995.

Cust, Robert Needham. *Language as Illustrated by Bible Translation*. London: Trübner and Co., 1886.

Danly, Susan, and Cheryl Leibold, eds. *Eakins and the Photograph: Works by Thomas Eakins and His Circle in the Collection of the Pennsylvania Academy of the Fine Arts*. Washington, D.C.: Smithsonian Institution Press, 1994.

Davis, John. "Catholic Envy: The Visual Culture of Protestant Desire." In *The Visual Culture of American Religions*, edited by David Morgan and Sally Promey, 105–28. Berkeley: University of California Press, 2001.

———. "Holy Land, Holy People? Photography, Semitic Wannabes, and Chautauqua's Palestine Park." *Prospects* 17 (1992): 241–71.

———. *The Landscape of Belief: Encountering the Holy Land in Nineteenth-Century American Art and Culture*. Princeton: Princeton University Press, 1996.

Davis, Whitney. "Erotic Revision in Thomas Eakins's Narratives of Male Nudity." *Art History* 17, no. 3 (September 1994): 301–41.

Day, F. Holland. "Art and the Camera." *Camera Notes* 2, no. 1 (July 1898): 3–5.

———. "Portraiture and the Camera." In *American Annual of Photography and Photographic Times Almanac for 1899*, 19–25. New York: Scovill and Adams, [1898].

DeLue, Rachael Ziady. *George Inness and the Science of Landscape*. Chicago: University of Chicago Press, 2004.

Demachy, Robert. "The American School of Photography in Paris." *Camera Notes* 5, no. 1 (July 1901): 33–42.

———. "Exhibition of the New American School of Artistic Photography at the Paris Photo-Club." *Amateur Photographer* 33, no. 861 (5 April 1901): 275–77.

D'Emilio, John, and Estelle B. Freedman. *Intimate Matters: A History of Sexuality in America*. 2nd ed. Chicago: University of Chicago Press, 1998.

Denier, Tony. *Parlor Tableaux: or, Animated Pictures*. New York: Samuel French, 1869.

Denney, Colleen. "The Role of Subject and Symbol in American Pictorialism." *History of Photography* 13, no. 2 (April–June 1989): 109–28.

Dennis, Francis L. "Most Rev. James Frederick Wood (1813–1883): The Fifth Bishop and First Archbishop of Philadelphia, an Essay." MA Thesis, Catholic University of America, 1932.

Dewey, John. *Experience and Nature*. LaSalle, Ill.: Open Court, 1987.

Dillenberger, John. *The Visual Arts and Christianity in America: The Colonial Period through the Nineteenth Century*. Chico, Calif.: Scholars Press, 1984.

DiMaggio, Paul. "Cultural Entrepreneurship in Nineteenth-Century Boston: The Creation of an Organizational Base for High Culture in America." In *Rethinking Popular Culture: Contemporary Perspectives in Cultural Studies*, edited by Chandra Mukerji and Michael Schudson, 374–97. Berkeley: University of California Press, 1991.

Dinnerstein, Lois. "Thomas Eakins' 'Crucifixion' as Perceived by Mariana Griswold Van Rensselaer." *Arts Magazine* 53, no. 9 (May 1979): 140–45.

Dolan, Jay P. *Catholic Revivalism: The American Experience, 1830–1900*. Notre Dame, Ind.: University of Notre Dame Press, 1978.

Doss, Erika. "Robert Gober's 'Virgin' Installation: Issues of Spirituality in Contemporary American Art." In *The Visual Culture of American Religions*, edited by David Morgan and Sally Promey, 129–45. Berkeley: University of California Press, 2001.

Douglas, Ann. *The Feminization of American Culture*. New York: Anchor Books, 1977.

Drury, Jonathan Daniels. "Haydn's *Seven Last Words*: An Historical and Critical Study." PhD diss., University of Illinois at Urbana-Champaign, 1975.

DuBois, W. E. B. *The Souls of Black Folk*. New York: Dover, 1994.

——. "Tanner." *Crisis* 28 (May 1924): 12.

Dykema, P. W. "The Madonna in Art." *Brush and Pencil* 2, no. 3 (1898): 97–105.

Edwards, Holly. "A Million and One Nights: Orientalism in America, 1870–1930." In *Noble Dreams, Wicked Pleasures: Orientalism in America, 1870–1930*, 11–57. Princeton: Princeton University Press in association with the Sterling and Francine Clark Art Institute, 2000.

Elkins, James. *Visual Studies: A Skeptical Introduction*. New York: Routledge, 2003.

Ellenzweig, Allen. *The Homoerotic Photograph: Male Images from Durieu/Delacroix to Mapplethorpe*. New York: Columbia University Press, 1992.

Epstein, Barbara Leslie. *The Politics of Domesticity: Women, Evangelism, and Temperance in Nineteenth-Century America*. Middletown, Conn.: Wesleyan University Press, 1981.

Fanning, Patricia J., ed. "'The Frame We Have Invented': Culture, Biography, and the Friendship of Fred Holland Day and Louise Imogen Guiney." In *New Perspectives on F. Holland Day: Selected Presentations from the Fred Holland Day in Context Symposium Held at Stonehill College North Easton, Massachusetts, April 19, 1997*, 7–12. North Easton, Mass.: Stonehill College, 1998.

Farrar, Frederic. *The Life of Christ as Represented in Art*. Cincinnati: Jennings and Graham, 1894.

Fink, Lois Marie. *American Art at the Nineteenth-Century Paris Salons*. Cambridge: Cambridge University Press, 1990.

"The First Composite Madonna in the World." *Ladies' Home Journal* 22, no 6 (May 1905): 7.

Foster, Kathleen A. ed. *A Drawing Manual by Thomas Eakins*. Philadelphia: Philadelphia Museum of Art in association with Yale University Press, 2005.

——. *Thomas Eakins Rediscovered: Charles Bregler's Thomas Eakins Collection at the Pennsylvania Academy of the Fine Arts*. New Haven: Yale University Press, 1997.

Foster, Kathleen A., and Cheryl Leibold. *Writing about Eakins: The Manuscripts in Charles Bregler's Thomas Eakins Collection*. Philadelphia: University of Pennsylvania Press, 1989.

Franchot, Jenny. *Roads to Rome: The Antebellum Protestant Encounter with Catholicism*. Berkeley: University of California Press, 1994.

French, Joseph Lewis. *Christ in Art*. Boston: L. C. Page and Company, 1899.

Fried, Michael. *Realism, Writing, Disfiguration: On Thomas Eakins and Stephen Crane*. Chicago: University of Chicago Press, 1987.

Gatewood, Willard B. *Aristocrats of Color: The Black Elite, 1880–1920*. Fayetteville: University of Arkansas, 2000.

Gerdts, William H. "Thomas Eakins and the Episcopal Portrait: Archbishop William Henry Elder." *Arts Magazine* 53, no. 9 (May 1979): 154–57.

Gilbert, James. *Redeeming Culture: American Religion in an Age of Science*. Chicago: University of Chicago Press, 1997.

Gilman, Sander L. "The Jew's Body: Thoughts on Jewish Physical Difference." In *Too Jewish? Challenging Traditional Identities*, edited by Norman L. Kleeblatt, 60–73. New York: Jewish Museum, 1996.

Ginzberg, Lori D. *Women and the Work of Benevolence: Morality, Politics, and Class in the Nineteenth-Century United States*. New Haven: Yale University Press, 1990.

Gladden, Washington. "Christianity and Aestheticism." *Andover Review: A Religious and Theological Monthly* 1 (January 1884): 13–24.

Glassberg, David. *American Historical Pageantry: The Uses of Tradition in the Early Twentieth Century*. Chapel Hill: University of North Carolina Press, 1990.

Goldberg, Vicki, ed. *Photography in Print: Writings from 1816 to the Present*. Albuquerque: University of New Mexico Press, 1981.

Goldstein, Eric L. "The Unstable Other: Locating the Jew in Progressive-Era Racial Discourse." *American Jewish History* 89, no. 4 (December 2001): 383–409.

Goodrich, Lloyd. *Thomas Eakins: His Life and Work*. New York: Whitney Museum of American Art, 1933.

Gordon, Sarah. "Prestige, Professionalism, and the Paradox of Eadweard Muybridge's Animal Locomotion Nudes." *Pennsylvania Magazine of History and Biography* 130, no. 1 (January 2006): 79–104.

Gore, Charles. *The Incarnation of the Son of God: Being the Bampton Lectures for the Year 1891*. New York: Charles Scribner's Sons, 1905.

Green, William Henry. *General Introduction to the Old Testament*. New York: Charles Scribner's Sons, 1898.

Greenhouse, Wendy. "Daniel Huntington and the Ideal of Christian Art." *Winterthur Portfolio* 31, nos. 2–3 (Summer–Autumn 1996): 103–40.

Griffin, Randall C. "Thomas Eakins' Construction of the Male Body, Or 'Men Get to Know Each Other across the Space of Time.'" *Oxford Art Journal* 18, no. 2 (1995): 70–80.

Griffith, William. "Christ as Modern American Artists See Him: New Conceptions of the Nazarene by Nine Notable Painters." *Craftsman* 10 (June 1906): 286–99.

Gunning, Tom. "The Cinema of Attractions: Early Film, Its Spectator and the Avant-Garde." In *Early Cinema: Space—Frame—Narrative*, edited by Thomas Elsaesser and Adam Barker, 56–62. London: BFI Publishing, 1990.

——. "Phantom Images and Modern Manifestations: Spirit Photography, Magic Theater, Trick Films, and Photography's Uncanny." In *Furtive Images: From Photography to Video*, edited by Patrice Petro, 42–71. Bloomington: Indiana University Press, 1995.

——. "'Primitive Cinema': A Frame-Up? Or the Trick's on Us." In *Early Cinema: Space—Frame—Narrative*, edited by Thomas Elsaesser and Adam Barker, 95–103. London: BFI Publishing, 1990.

Gutjahr, Paul C. *An American Bible: A History of the Good Book in the United States, 1777–1880.* Stanford: Stanford University Press, 1999.

Hall, David D., ed. *Lived Religion in America: Toward a History of Practice.* Princeton: Princeton University Press, 1997.

——. "Review Essay: What Is the Place of 'Experience' in Religious History?" *Religion and American Culture* 13, no. 2 (2003): 241–50.

Hamm, Thomas D. *The Transformation of American Quakerism: Orthodox Friends, 1800–1907.* Bloomington: Indiana University Press, 1988.

Hampton, Kate P. "The Face of Christ in Art: Is the Portraiture of Jesus Strong or Weak?" *Outlook* 61, no. 13 (1 April 1899): 734–48.

Hansen, Miriam Bratu. *Babel and Babylon: Spectatorship in American Silent Film.* Cambridge: Harvard University Press, 1991.

——. "The Mass Production of the Senses: Classical Cinema as Vernacular Modernism." *Modernism/Modernity* 6, no. 2 (1999): 59–77.

Harper, Jennifer J. "The Early Religious Paintings of Henry Ossawa Tanner: A Study of the Influence of Church, Family, and Era." *American Art* 6, no. 4 (1992): 69–85.

Harris, Neil. *Cultural Excursions: Marketing Appetites and Cultural Tastes in Modern America.* Chicago: University of Chicago Press, 1990.

Harrison, Charles, and Paul Wood, eds. *Art in Theory 1900–1990: An Anthology of Changing Ideas.* Cambridge, Mass.: Blackwell, 1992.

Hartmann, Sadakichi. "A Decorative Photographer, F. Holland Day." *Photographic Times* 32 (March 1900): 102–6.

——. *A History of American Art.* 2 vols. Vol. 1. Boston: L. C. Page and Company, 1902.

——. "Portrait Painting and Portrait Photography." *Camera Notes* 3, no. 1 (July 1899): 13–15.

Hatch, Nathan O. *The Democratization of American Christianity.* New Haven: Yale University Press, 1989.

Havinga, Anne. "Setting the Time of Day in Boston." In *F. Holland Day*, edited by Pam Roberts, 29–38. Amsterdam: Van Gogh Museum, 2000.

Hendricks, Gordon. *The Life and Work of Thomas Eakins.* New York: Grossma Publishers, 1974.

Henry, Hugh T. *Annual Address Delivered before the American Catholic Historical Society at the Annual Meeting in December, 1897.* [Philadelphia?]: N.p., 1897.

——. *Catholic Customs and Symbols: Varied Forms and Figures of Catholic Usage, Ceremony, and Practice Briefly Explained.* New York: Benziger Brothers, 1925.

——. "The 'Original Sources' of European History." *American Catholic Quarterly Review* 23, no. 91 (1898): 449–86.

Higginbotham, Evelyn Brooks. *Righteous Discontent: The Women's Movement in the Black Baptist Church.* Cambridge: Harvard University Press, 1993.

Higonnet, Anne. *Pictures of Innocence: The History and Crisis of Ideal Childhood.* New York: Thames and Hudson, 1998.

Holcomb, Adele M. "Anna Jameson (1794–1860): Sacred Art and Social Vision." In *Women as Interpreters of the Visual Arts, 1820–1979*, edited by Claire Richter Sherman with Adele M. Holcomb, 93–121. Westport, Conn.: Greenwood Press, 1981.

Hollinger, David A. "'Damned for God's Glory': William James and the Scientific Vindication of Protestant Culture." In *William James and a Science of Religions: Reexperiencing The Varieties of Religious Experience*, edited by Wayne Proudfoot, 9–30. New York: Columbia University Press, 2004.

——. "The Knower and the Artificer." *American Quarterly* 39, no. 1 (Spring 1987): 37–55.

Homer, William Innes. *Thomas Eakins: His Life and Art.* New York: Abbeville, 1992.

Hoopes, James, ed. *Peirce on Signs: Writings on Semiotic by Charles Sanders Peirce.* Chapel Hill: University of North Carolina Press, 1991.

Horowitz, Helen L. "Varieties of Cultural Experience in James Addams' Chicago." *History of Education Quarterly* 14, no 1 (Spring 1974): 69–86.

Hurll, Estelle M. *The Life of Our Lord in Art*. Boston: Houghton, Mifflin, 1898.

———. *The Madonna in Art*. Boston: L. C. Page and Company, 1897.

———. "Selecting Pictures for the Home." *Arthur's Home Magazine* (March 1894): 235–36.

Husch, Gail E. *Something Coming: Apocalyptic Expectation and Mid-Nineteenth-Century American Painting*. Hanover, N.H.: University Press of New England, 2000.

Isham, Samuel. *The History of American Painting*. New York: Macmillan, 1905.

Jacques, Jean. "An Artist's Conception of the Life of Christ." *Bookman* 8 (December 1898): 282, 352–59.

James, Henry. *Transatlantic Sketches*. Boston: James R. Osgood and Company, 1875.

James, William. *The Varieties of Religious Experience*. New York: Penguin Books, 1982.

Jameson, Anna. *Legends of the Madonna*. Edited by Estelle M. Hurll. Boston: Houghton, Mifflin, 1895.

Jay, Martin. *Downcast Eyes: The Denigration of Vision in Twentieth-Century French Thought*. Berkeley: University of California Press, 1993.

———. *Songs of Experience: Modern American and European Variations on a Universal Theme*. Berkeley: University of California Press, 2005.

Johns, Elizabeth. "An Avowal of Artistic Community: Nudity and Fantasy in Thomas Eakins's Photographs." In *Eakins and the Photograph: Works by Thomas Eakins and His Circle in the Collection of the Pennsylvania Academy of the Fine Arts*, 65–93. Washington, D.C.: Smithsonian Institution Press, 1994.

———. "Drawing Instruction at Central High School and Its Impact on Thomas Eakins." *Winterthur Portfolio* 15, no. 2 (Summer 1980): 139–49.

———. "Thomas Eakins and 'Pure Art' Education." *Archives of American Art Journal* 30, nos. 1–4 (1990): 71–76.

———. *Thomas Eakins: The Heroism of Modern Life*. Princeton: Princeton University Press, 1983.

Joseph, Oscar L. "Henry O. Tanner's Religious Paintings." *Epworth Herald* (6 March 1901): 1042–43.

Jussim, Estelle. *Slave to Beauty: The Eccentric Life and Controversial Career of F. Holland Day*. Boston: David R. Godine, 1981.

Katz, Melissa R., ed. *Divine Mirrors: The Virgin Mary in the Visual Arts*. New York: Oxford University Press, 2001.

Kazin, Alfred. "Religion as Culture: Henry Adams's *Mont-Saint-Michel*." In *Henry Adams and His World*, edited by David R. Contosta and Robert Muccigrosso, 48–56. Philadelphia: American Philosophical Society, 1993.

Kern, Kathi. *Mrs. Stanton's Bible*. Ithaca: Cornell University Press, 2001.

Kettlewell, James K. *Transcendent Universe: The Paintings of Abbott Handerson Thayer*. Glens Falls, N.Y.: Hyde Collection, 1996.

Kimmel, Michael. *Manhood in America: A Cultural History*. New York: Free Press, 1996.

Kippenberg, Hans G. *Discovering Religious History in the Modern Age*. Translated by Barbara Harshav. Princeton: Princeton University Press, 2002.

Kirkpatrick, Sidney D. *The Revenge of Thomas Eakins*. New Haven: Yale University Press, 2006.

Kirlin, J. L. J. *The Life of the Most Reverend Patrick John Ryan, D.D., Ll.D.: Archbishop of Philadelphia and Record of His Golden Jubilee*. Vol. 1. Philadelphia: Gibbons Publishing, 1903.

Kitch, Carolyn. *The Girl on the Magazine Cover: The Origins of Visual Stereotypes in American Mass Media*. Chapel Hill: University of North Carolina Press, 2001.

Kraus, Joe Walker. *Messrs. Copeland and Day*. Philadelphia: George S. MacManus Co., 1979.

Krauss, Rolf H. *Beyond Light and Shadow: The Role of Photography in Certain Paranormal Phenomena; An Historical Survey*. Translated by Timothy Bill and John Gledhill. Munich: Nazraeli Press, 1995.

Kurtz, Amy. "'Look Well to the Ways of the Household, and Eat Not the Bread of Idleness': Individual, Family, and Community in Henry Ossawa Tanner's *Spinning by Firelight—The Boyhood of George Washington Gray*." *Yale University Art Gallery Bulletin* (1997–98): 53–67.

Kurtz, Charles M. *Christ before Pilate: The Paintings by Munkacsy*. New York: Published for the exhibition, 1887.

LaFarge, John. *The Gospel Story in Art*. New York: Macmillan, 1913.

———. *Great Masters*. Garden City, N.Y.: Doubleday, Page, 1915.

Lallou, William J. "Herman J. Heuser: Founder of the American Ecclesiastical Review." *American Ecclesiastical Review* 121, no. 4 (October 1949): 281–85.

Lamott, Rev. John H. *History of the Archdiocese of Cincinnati: 1821–1921*. New York: Frederick Pustet Company, 1921.

Lawton, Thomas, and Linda Merrill. *Freer: A Legacy of Art*. Washington, D.C.: Freer Gallery of Art, Smithsonian Institution; New York: Abrams, 1993.

Leach, William. *Land of Desire: Merchants, Power, and the Rise of a New American Culture*. New York: Pantheon, 1993.

Lears, T. J. Jackson. *No Place of Grace: Antimodernism and the Transformation of American Culture, 1880–1920.* Chicago: University of Chicago Press, 1994.

Lee, Elizabeth. "Therapeutic Beauty: Abbott Thayer, Antimodernism, and the Fear of Disease." *American Art* 18, no. 3 (Fall 2004): 32–52.

Leja, Michael. "Eakins and Icons." *Art Bulletin* 83, no. 3 (September 2001): 479–97.

——. *Looking Askance: Skepticism and American Art from Eakins to Duchamp.* Berkeley: University of California Press, 2004.

——. "Modernism's Subjects in the United States." *Art Journal* 55 (Summer 1996): 65–72.

Leo XIII, Pope. *Poems, Charades, Inscriptions.* Translated by Hugh T. Henry. New York: Dolphin Press, 1902.

Lester, William R. "Henry O. Tanner: Exile for Art's Sake." *Alexander's Magazine* 7 (15 December 1908): 69–73.

Levine, Lawrence. *Black Culture and Black Consciousness: Afro-American Folk Thought from Slavery to Freedom.* Oxford: Oxford University Press, 1977.

——. *Highbrow/Lowbrow: The Emergence of Cultural Hierarchy in America.* Cambridge: Harvard University Press, 1988.

Levy, Clifton Harby. "James Tissot and His Work." *Outlook* 60, no. 16 (17 December 1898): 954–64.

——. "The Life of Our Lord to the Life. M. Tissot's Wondrous Work." *Ave Maria: A Magazine Devoted to the Honor of the Blessed Virgin* 48, no. 6 (11 February 1899): 161–64.

The Light of the World; or Our Savior in Art. Chicago: Elder Company, 1896.

Little, Lawrence S. *Disciples of Liberty: The African Methodist Episcopal Church in the Age of Imperialism, 1884–1916.* Knoxville: University of Tennessee Press, 2000.

Longwell, Dennis. *Steichen: The Master Prints, 1895–1914; The Symbolist Period.* New York: Museum of Modern Art, 1978.

Lovell, Margaretta. *Art in a Season of Revolution: Painters, Artisans, and Patrons in Early America.* Philadelphia: University of Pennsylvania Press, 2005.

Low, Will H. "Madonna and Child in Art." *McClure's Magazine* 6 (1895–96): 33–47.

Lubin, David. *Act of Portrayal: Eakins, Sargent, James.* New Haven: Yale University Press, 1985.

——. "Modern Psychological Selfhood in the Art of Thomas Eakins." In *Inventing the Psychological: Toward a Cultural History of Emotional Life in the United States,* edited by Joel Pfister and Nancy Schnog, 133–65. New Haven: Yale University Press, 1997.

Lufkin, Jack. "Henry Tanner and Booker T. Washington: The Iowa Story behind the Portrait." *Palimpsest* 72, no. 1 (Spring 1991): 16–19.

MacChesney, Clara T. "A Poet-Painter of Palestine." *International Studio* 50, no. 197 (July 1913): xi–xiv.

Maeterlinck, Maurice. *The Treasure of the Humble.* Translated by Alfred Sutro. New York: Dodd, Mead and Company, [1897].

Mancini, JoAnne. "'One Term Is as Fatuous as Another': Responses to the Armory Show Reconsidered." *American Quarterly* 51, no. 4 (December 1999): 833–70.

——. *Pre-Modernism: Art-World Change and American Culture from the Civil War to the Armory Show.* Princeton: Princeton University Press, 2005.

Marable, Darwin. "The Crucifixion in Photography." *History of Photography* 18, no. 3 (Autumn 1994): 256–63.

Marien, Mary Warner. *Photography and Its Critics: A Cultural History, 1839–1900.* Cambridge: Cambridge University Press, 1997.

Marsh, J. B. T. *The Story of the Jubilee Singers: With Their Songs.* Rev. ed. Boston: Houghton, Mifflin, [1880].

Marty, Martin. *Modern American Religion: The Irony of It All, 1893–1919.* Chicago: University of Chicago Press, 1986.

Masteller, Richard. "Western Views in Eastern Parlors: The Contribution of the Stereograph Photographer to the Conquest of the West." *Prospects* 6 (1981): 55–71.

Mathews, Marcia M. *Henry Ossawa Tanner: American Artist.* Chicago: University of Chicago, 1969.

McDannell, Colleen. *The Christian Home in Victorian America, 1840–1900.* Bloomington: Indiana University Press, 1986.

——. *Material Christianity: Religion and Popular Culture in America.* New Haven: Yale University Press, 1995.

McDermott, Very Rev. D. I. *The Use of Holy Pictures and Images.* Philadelphia: Catholic Truth Society, n.d.

McGreevy, John. *Catholicism and American Freedom: A History.* New York: W. W. Norton, 2003.

McHenry, Margaret. *Thomas Eakins Who Painted.* Oreland, Pa.: Privately printed, 1946.

Miller, Angela. *The Empire of the Eye: Landscape Representation and American Cultural Politics, 1825–1875.* Ithaca: Cornell University Press, 1993.

Miller, Richard. "Henry Adams and the Influence of Woman." *American Literature* 18, no. 4 (January 1947): 291–98.

Milroy, Elizabeth"'Consummatum Est . . . ': A Reassessment of Thomas Eakins' *Crucifixion* of 1880." *Art Bulletin* 71, no. 2 (June 1989): 269–84.

Mirzoeff, Nicholas, ed.*The Visual Culture Reader.* 2nd ed. London: Routledge, 2002.

Mitchell, W. J. Thomas*Picture Theory: Essays on Verbal and Visual Representation.* Chicago: University of Chicago Press, 1994.

Moffett, Cleveland"J. J. Tissot and His Paintings of the Life of Christ." *McClure's Magazine* 12, no. 5 (March 1899): 386–96.

Monroe, Lucy"A Circulating Picture Gallery." *Current Literature* 19, no. 1 (January 1, 1896): 46–47.

Montgomery, William E.*Under Their Own Vine and Fig Tree: The African-American Church in the South, 1865–1900.* Baton Rouge: Louisiana State University Press, 1993.

Moore, R. Laurence*In Search of White Crows: Spiritualism, Parapsychology, and American Culture.* New York: Oxford University Press, 1977.

———. *Religious Outsiders and the Making of Americans.* New York: Oxford University Press, 1986.

———. *Selling God: American Religion in the Marketplace of Culture.* New York: Oxford University Press, 1994.

*Protestants and Pictures: Religion, Visual Culture, and the Age of American Mass Production.* New York: Oxford University Press, 1999.

———. *The Sacred Gaze: Religious Visual Culture in Theory and Practice.* Berkeley: University of California Press, 2005.

———. "Toward a Modern Historiography of Art and Religion." In *Reluctant Partners: Art and Religion in Dialogue,* edited by Ena Giurescu Heller, 16–47. New York: The Gallery at the American Bible Society, 2004.

———. *Visual Piety: A History and Theory of Popular Religious Images.* Berkeley: University of California Press, 1998.

Morgan, David, and Sally M. Promey, eds.*The Visual Culture of American Religions.* Berkeley: University of California, 2001.

Morgan, H. Wayne*Keepers of Culture: The Art-Thought of Kenyon Cox, Royal Cortissoz, and Frank Jewett Mather, Jr.* Kent, Ohio: Kent State University Press, 1989.

———. *New Muses: Art in American Culture, 1865–1920.* Norman: University of Oklahoma Press, 1978.

Mosby, Dewey F.*Across Continents and Cultures: The Art and Life of Henry Ossawa Tanner.* Kansas City, Mo.: Nelson-Atkins Museum of Art, 1995.

Mosby, Dewey F., Darrel Sewell, and Rae Alexander-Minter*Henry Ossawa Tanner.* Philadelphia: Philadelphia Museum of Art, 1991.

Moses, Wilson Jeremiah*Black Messiahs and Uncle Toms: Social and Literary Manipulations of a Religious Myth.* Rev. ed. University Park: Pennsylvania State University Press, 1993.

Müller, F. Max*Lectures on the Science of Language Delivered at the Royal Institution of Great Britain in April, May, and June, 1861.* Nai Sarak, Delhi-6, India: Munshi Ram Manohar Lal, 1965.

Murray, Richard"Abbott Thayer's *Stevenson Memorial.*" *American Art* 13, no. 2 (Summer 1999): 2–25.

Murray, William M."F. H. Day's Exhibition of Prints." *Camera Notes* 2, no. 1 (July 1898): 21–22.

Musser, Charles*Edison Motion Pictures, 1890–1900: An Annotated Filmography.* Washington, D.C.: Smithsonian Institution Press, 1997.

———. *The Emergence of Cinema: The American Screen to 1907.* New York: Charles Scribner's Sons, 1990.

———. "Passions and the Passion Play: Theater, Film, and Religion in America, 1880–1900." *Film History* 5, no. 4 (1993): 419–56.

Nemerov, Alexander"Vanishing Americans: Abbott Thayer, Theodore Roosevelt, and the Attraction of Camouflage." *American Art* 11, no. 2 (Summer 1997): 50–82.

Newman, Michele*White Women's Rights: The Racial Origins of Feminism in the United States.* New York: Oxford University Press, 1999.

"New Portrayals of Christ by American Painters." *Current Literature* 40 (May 1906): 537–40.

Niven, Penelope"Camping in the Latin Quarter: Fred Holland Day as Edward Steichen's First Teacher." In *New Perspectives on F. Holland Day: Selected Presentations from the Fred Holland Day in Context Symposium Held at Stonehill College, North Easton, Massachusetts, April 19, 1997,* 39–49. North Easton, Mass.: Stonehill College, 1998.

Oakley, Violet*The Holy Experiment: Our Heritage from William Penn.* Philadelphia: Cogslea Studio Publications, 1950.

Orvell, Miles"Almost Nature: The Typology of Late Nineteenth-Century American Photography." In *Multiple Views: Logan Grant Essays on Photography, 1983–89,* edited by Daniel P. Younger, 139–67. Albuquerque: University of New Mexico Press, 1991.

———. *The Real Thing: Imitation and Authenticity in American Culture, 1880–1940.* Chapel Hill: University of North Carolina Press, 1989.

BIBLIOGRAPHY 163

Panhorst, Michael W. *Samuel Murray: The Hirshhorn Museum and Sculpture Garden Collection, Smithsonian Institution.* Washington, D.C.: Smithsonian Institution Press, 1982.

Parrish, Stephen Maxfield. *Currents of the Nineties in Boston and London: Fred Holland Day, Louise Imogen Guiney, and Their Circle.* New York: Garland Publishing, 1987.

Parry, Ellwood C, III. "Thomas Eakins's 'Naked Series' Reconsidered: Another Look at the Standing Nude Photographs Made for the Use of Eakins's Students." *American Art Journal* 20, no. 2 (1988): 53–77.

Payne, Daniel A. *Sermons and Addresses, 1853–1891: Bishop Daniel A. Payne,* edited by Charles Killian. New York: Arno Press, 1972.

Perry, Regenia. *Free within Ourselves: African-American Artists in the Collection of the National Museum of American Art.* Washington, D.C.: National Museum of American Art, 1992.

"Photographic Miracles: The Holy Shroud of Turin." *Photogram* 5, no. 60 (December 1898): 368–70.

Promey, Sally. *Painting Religion in Public: John Singer Sargent's Triumph of Religion at the Boston Public Library.* Princeton: Princeton University Press, 1999.

———. "The 'Return' of Religion in the Scholarship of American Art." *Art Bulletin* 85, no. 3 (September 2003): 581–603.

———. "The Visual Culture of American Religions: An Historiographical Essay." In *Exhibiting the Visual Culture of American Religions,* edited by David Morgan and Sally M. Promey, 1–8. Valparaiso, Ind.: Brauer Museum of Art, Valparaiso University, 2000.

Prothero, Stephen. "Lived Religion and the Dead: The Cremation Movement in Gilded Age America." In *Lived Religion in America: Toward a History of Practice,* edited by David D. Hall, 92–115. Princeton: Princeton University Press, 1997.

Proudfoot, Wayne. *Religious Experience.* Berkeley: University of California, 1985.

Pyne, Kathleen. *Art and the Higher Life: Painting and Evolutionary Thought in Late Nineteenth-Century America.* Austin: University of Texas Press, 1996.

———. "Resisting Modernism: American Painting in the Culture of Conflict." In *American Icons: Transatlantic Perspectives on Eighteenth- and Nineteenth-Century American Art,* edited by Thomas W. Gaetgens and Heinz Ickstadt, 289–317. Chicago: University of Chicago Press, 1992.

Raboteau, Albert J. *A Fire in the Bones: Reflections on African-American Religious History.* Boston: Beacon Press, 1995.

———. *Slave Religion: The Invisible Institution in the Antebellum South.* New York: Oxford University Press, 1978.

Remick, Marie C. "The Relation of Art to Morality." *Arena* 19, no. 101 (April 1898): 483–95.

Renan, Ernest. *The Life of Jesus.* Translated by Charles Edwin Wilbour. New York: Carlton, 1867.

Revisiting the White City: American Art at the 1893 World's Fair. Washington, D.C.: National Museum of American Art and National Portrait Gallery, Smithsonian Institution, 1993.

Richardson, Harry V. *Dark Salvation: The Story of Methodism as It Developed among Blacks in America.* Garden City, N.Y.: Anchor Press/Doubleday, 1976.

Riggs, James Stevenson. *The Messages of Jesus according to the Gospel of John: The Discourses of Jesus in the Fourth Gospel, Arranged, Analyzed and Freely Rendered in Paraphrase.* Edited by Frank K. Sanders and Charles F. Kent. Vol. 10 of *The Messages of the Bible.* New York: Charles Scribner's Sons, 1907.

Roberts, John. *From Trickster to Badman: The Black Folk Hero in Slavery and Freedom.* Philadelphia: University of Pennsylvania Press, 1989.

Roberts, Pam, ed. *F. Holland Day.* Amsterdam: Van Gogh Museum, 2000.

Robinson, David. *From Peep Show to Palace: The Birth of American Film.* New York: Columbia University Press, 1996.

Rosen, Jeff. "Strategies of Containment: The Manipulation of the Frame in Contemporary Photography." *Afterimage* 17 (December 1989): 13–17.

Rosenzweig, Phyllis D. *The Thomas Eakins Collection of the Hirshhorn Museum and Sculpture Garden.* Washington, D.C.: Smithsonian Institution Press, 1977.

Rydell, Robert W. *All the World's a Fair: Visions of Empire at American International Exhibitions, 1876–1916.* Chicago: University of Chicago Press, 1984.

"Sacred Art and the Camera: A Few Notes Taken in Conversation with F. Holland Day." *Photogram* 8, no. 88 (April 1901): 91–92.

"Sacred Art Modernized: Photographs of the Crucifixion from Living Figures." *Boston Herald,* 17 January 1899, 1.

Saint-Gaudens, Homer. "Abbott H. Thayer." *Critic and Literary World* 46, no. 5 (1905): 422–23.

———. "Ten American Paintings of Christ." *Putnam's Monthly and the Critic* 1, no. 3 (December 1906): 257–72.

Scanlon, Jennifer. *Inarticulate Longings: The Ladies' Home Journal, Gender, and the Promises of Consumer Culture.* New York: Routledge, 1995.

Scarborough, W. S. "Henry Ossian [*sic*] Tanner." *Southern Workman* 31, no. 12 (December 1902): 661–70.

Schendler, Sylvan. *Eakins*. Boston: Little, Brown, 1967.

Schmandt, Raymond H. "Catholic Intellectual Life in the Archdiocese of Philadelphia: An Essay." In *The History of the Archdiocese of Philadelphia*, edited by James F. Connelly, 587–644. Philadelphia: Archdiocese of Philadelphia, 1976.

Schmidt, Leigh Eric. *Consumer Rites: The Buying and Selling of American Holidays*. Princeton: Princeton University Press, 1995.

———. *Hearing Things: Religion, Illusion, and the American Enlightenment*. Cambridge: Harvard University Press, 2000.

———. *Holy Fairs: Scotland and the Making of American Revivalism*. 2nd ed., with a new preface. Grand Rapids, Mich.: William B. Eerdmans, 2001.

———. "Mixed Blessings: Christianization and Secularization." *Reviews in American History* 26, no. 4 (December 1998): 637–43.

Schulte, Augustin J. *Historical Sketch of the Philadelphia Theological Seminary of Saint Charles Borromeo 1832–1905*. Philadelphia: Geo. W. Gibbons and Sons, 1905.

Sekula, Allan. "The Body and the Archive." *October* 39 (Winter 1986): 3–64.

Seraile, William. *Fire in His Heart: Bishop Benjamin Tucker Tanner and the A.M.E. Church*. Knoxville: University of Tennessee Press, 1998.

Sernett, Milton C., ed. *African American Religious History: A Documentary Witness*. 2nd ed. Durham: Duke University Press, 1999.

Sewell, Darrell, ed. *Thomas Eakins*. Philadelphia: Philadelphia Museum of Art, 2001.

Seymour, Rev. William Wood. *The Cross: In Tradition, History, and Art*. New York: G. P. Putnam's Sons, 1898.

Shand-Tucci, Douglass. *Boston Bohemia, 1881–1900: Ralph Adams Cram; My Life in Architecture*. Amherst: University of Massachusetts Press, 1995.

Shi, David E. *Facing Facts: Realism in American Thought and Culture, 1850—1920*. New York: Oxford University Press, 1995.

———. *The Simple Life: Plain Living and High Thinking in American Culture*. New York: Oxford University Press, 1985.

Showalter, Elaine. *Sexual Anarchy: Gender and Culture at the Fin de Siècle*. New York: Penguin Books, 1990.

Simmons, Rev. William J. "Rev. Benjamin Tucker Tanner, A.M., D.D." In *Men of Mark: Eminent, Progressive and Rising*, 984–88. Cleveland: Geo. M. Rewell and Co., 1887.

Singal, Daniel Joseph. "Towards a Definition of American Modernism." In *Modernist Culture in America*, edited by Daniel Joseph Singal, 1–27. Belmont, Calif.: Wadsworth, 1991.

Sklar, Kathryn Kish. *Catherine Beecher: A Study in American Domesticity*. New Haven: Yale University Press, 1973.

Smith-Rosenberg, Carroll. *Disorderly Conduct: Visions of Gender in Victorian America*. New York: Oxford University Press, 1985.

Solomon-Godeau, Abigail. *Photography at the Dock: Essays on Photographic History, Institutions, and Practices*. Minneapolis: University of Minnesota Press, 1991.

Spencer, Edwina. "Early Madonnas." *Chautauquan; A Weekly Newsmagazine* 51, no. 1 (December 1909): 114–27.

Spies, Kathleen. "Figuring the Neurasthenic: Thomas Eakins, Nervous Illness, and Gender in Victorian America." *Nineteenth Century Studies* 12 (1998): 84–109.

Stankiewicz, Mary Ann. "Art at Hull House, 1889–1901: Jane Addams and Ellen Gates Starr." *Women's Art Journal* 10, no. 1 (Spring–Summer 1989): 35–39.

Steele, G. M. *Rudimentary Psychology for Schools and Colleges*. Boston: Leach, Shewell, and Sanborn, 1890.

Stein, Roger B. "Artifact as Ideology: The Aesthetic Movement in Its American Cultural Context." In *In Pursuit of Beauty: Americans and the Aesthetic Movement*, edited by Doreen Bolger, 23–51. New York: Metropolitan Museum of Art, 1986.

———. "Charles Willson Peale's Expressive Design: The Artist in His Museum." In *New Perspectives on Charles Willson Peale: A 250th Anniversary Celebration*, edited by Lillian B. Miller and David C. Ward, 167–218. Pittsburgh: University of Pittsburgh Press, for the Smithsonian Institution, 1991.

———. *John Ruskin and Aesthetic Thought in America, 1840–1900*. Cambridge: Harvard University Press, 1967.

———. "Thomas Smith's Self-Portrait: Image/Text as Artifact." *Art Journal* 44, no. 4 (Winter 1984): 316–27.

Stevens, George Barker. *The Johannine Theology: A Study of the Doctrinal Contents of the Gospel and Epistles of the Apostle John*. Revised ed. New York: Charles Scribner's Sons, 1904.

Stoddard, John. *Red Letter Days Abroad*. Boston: James R. Osgood and Company, 1884.

Sullivan, Mark. "Thomas Eakins and His Portrait of Father Fedigan." *Records of the American Catholic Historical Society* 109, nos. 3–4 (Fall–Winter 1998): 1–23.

Swift, Samuel. "New Conceptions of the Christ." *Brush and Pencil* 17, no. 4 (April 1906): 148–57.

Szarkowski, John. *Alfred Stieglitz at Lake George*. New York: Museum of Modern Art, 1996.

Tanner, Benjamin Tucker. *An Apology for African Methodism*. Baltimore, 1867.

——. *Theological Lectures*. Nashville: Publishing House A.M.E. Church Sunday School Union, 1894.

Tanner, Henry Ossawa. "The Mothers of the Bible—By H. O. Tanner." *Ladies' Home Journal* (October 1902): 13.

——. "The Mothers of the Bible—By H. O. Tanner." *Ladies' Home Journal* (January 1903): 13.

——. "The Story of an Artist's Life, I." *World's Work* 18 (July 1909): 11662.

——. "The Story of an Artist's Life, II—Recognition." *World's Work* 18 (July 1909): 11769–75.

——. "A Visit to the Tomb of Lazarus." *A.M.E. Church Review* 15 (January 1908): 359.

Tashjian, Dickran, and Ann Tashjian. *Memorials for Children of Change: The Art of New England Stonecarving*. Middletown, Conn.: Wesleyan University Press, 1974.

Taves, Ann. *Fits, Trances, and Visions: Experiencing Religion and Explaining Experience from Wesley to James*. Princeton: Princeton University Press, 1999.

——. *The Household of Faith: Roman Catholic Devotions in Mid-Nineteenth-Century America*. Notre Dame, Ind.: University of Notre Dame, 1988.

Theberge, Pierre, and Jean Clair, eds. *Lost Paradise: Symbolist Europe*. Montreal: Montreal Museum of Fine Arts, 1995.

Trachtenberg, Alan. *The Incorporation of America: Culture and Society in the Gilded Age*. New York: Hill and Wang, 1982.

——. " 'We Study the Word and Works of God': Chautauqua and the Sacralization of Culture in America." *Henry Ford Museum and Greenfield Village Herald* 13, no. 2 (1984): 3–11.

Turner, Evan H., ed. *Object Lessons: Cleveland Creates an Art Museum*. Cleveland: Cleveland Museum of Art, 1991.

——. "Thomas Eakins at Overbrook." *Records of the American Catholic Historical Society of Philadelphia* 81, no. 4 (1970): 195–98.

Turner, James. *Without God, without Creed: The Origins of Unbelief in America*. Baltimore: Johns Hopkins University Press, 1985.

Van Hook, Bailey. *Angels of Art: Women and Art in American Society, 1876—1914*. University Park: Pennsylvania State University Press, 1996.

——. *The Virgin and the Dynamo: Public Murals in American Architecture, 1893–1917*. Athens: Ohio University Press, 2003.

Vaughan, Gerard. "Maurice Denis and the Sense of Music." *Oxford Art Journal* 7, no. 1 (1984): 38–48.

Veitch, John. *Knowing and Being*. Edinburgh: William Blackwood and Sons, 1889.

Vincent, John Heyl. "Sunday Readings." *Chautauquan; A Weekly Newsmagazine* 18, no. 1 (April 1893): 24–29.

Walker, Clarence E. *A Rock in a Weary Land: The African Methodist Episcopal Church during the Civil War and Reconstruction*. Baton Rouge: Louisiana State University Press, 1982.

Walsh, James J. "The Passion Play." *Catholic World* 72, no. 428 (November 1900): 241–53.

Walter, Marjorie Alison. "A Christ-Ian Agnostic: Thomas Eakins and His Crucifixion and Prelate Portraits." MA thesis, University of California at Berkeley, 1989.

Weber, Max. *The Protestant Ethic and the Spirit of Capitalism*. Translated by Talcott Parsons. London: Routledge, 1992.

——. *The Sociology of Religion*. Boston: Beacon Press, 1963.

Welter, Barbara. "The Cult of True Womanhood: 1820–1960." *American Quarterly* 18, no. 2, pt. 1 (Summer 1966): 151–74.

Wentworth, Michael. *James Tissot*. Oxford: Clarendon Press, 1984.

Werbel, Amy B. " 'For Our Age and Country': Nineteenth Century Art Education at Central High School." In *Central High School Alumni Exhibition*, 6–12. Philadelphia: Woodmere Art Museum, 2002.

White, Nelson C. *Abbott H. Thayer: Painter and Naturalist*. Hartford: Connecticut Printers, 1951.

Wiebe, Robert. *The Search for Order, 1877–1920*. New York: Hill and Wang, 1967.

Wiener, Philip P., ed. *Charles S. Peirce: Selected Writings (Values in a Universe of Change)*. New York: Dover, 1966.

Willard, Frances E. *Do Everything: A Handbook for the World's White Ribboners*. Chicago: Woman's Temperance Publishing Association, [1895?].

——. *Home Protection Manual: Containing an Argument for the Temperance Ballot for Woman, and How to Obtain It, as a Means of Home Protection; Also Constitution and Plan of Work for State and Local W.C.T. Unions*. New York: "The Independent" Office, 1879.

Williams, Gilbert Anthony. *The Christian Recorder, Newspaper of the African Methodist Episcopal Church: History of a Forum for Ideas, 1854–1902*. Jefferson, N.C.: McFarland and Company, 1996.

Willoughby, Guy. *Art and Christhood: The Aesthetics of Oscar Wilde*. London: Associated University Presses, 1993.

Wilmerding, John, ed. *Thomas Eakins*. Washington, D.C.: Smithsonian Institution Press, 1993.

Wilson, Bryan. "Secularization: The Inherited Model." In *The Sacred in a Secular Age*, edited by Philip E. Hammond, 9–20. Berkeley: University of California Press, 1985.

Wilson, Judith. "Lifting the 'Veil': Henry O. Tanner's *The Banjo Lesson* and *The Thankful Poor*." In *Critical Issues in American Art: A Book of Readings*, edited by Mary Ann Calo, 199–219. Boulder, Colo.: Westview Press, 1998.

Wilson, Richard Guy, Dianne Pilgrim, and Richard Murray. *The American Renaissance, 1876–1917*. New York: Pantheon Books, 1979.

Wilson, Rufus Rockwell. "Religious Painting in Amer
ica." *Outlook* 54 (12 December 1896): 1085–89.

Wolf, Bryan. "All the World's a Code: Art and Ideology in Nineteenth-Century American Painting." *Art Journal* 44, no. 4 (Winter 1984): 328–37.

Wyman, Lillie B. Chace. "Southern Colored Women. How Other Women Can Help Them." *Chautauquan; A Weekly Newsmagazine* 11, no. 6 (September 1890): 752–53.

Zalesch, Saul. "The Religious Art of Benziger Brothers." *American Art* 13, no. 2 (Summer 1999): 56–79.

Index

Abernethy, Arthur T., 52–53
Adams, Henry, 130
advertising, 11, 68–70
African Americans
 and biblical history, 44, 54–56
 and class, 42–45
 and Judaism, 52–56
 and Orientalism, 51–52, 58, 63–65
 and race prejudice, 44, 49–51, 59–60, 128–29
 representations of, 42–43, 52–53, 58–62, 68
African Methodist Episcopal Church, 9
 and African American elite, 42–45, 58–60
 and democracy, 43, 58–59, 64–65
 and imperialism, 63–65
 and biblical interpretation, 44, 56–59
 and Methodism, 43, 49–50, 59–60, 64
 and middle-class values, 42–45, 62, 145n56
 and missionary work, 42–43, 59–60
 and race prejudice, 49–50
 and religious experience, 43, 49–50, 58–62
 and sermon structure, 56–58
agnosticism, 9, 15, 19–20
art
 gendering of, 130–31
 spiritualization of, 7–8, 131–32
 social role of, 23, 26, 128–30
art collecting, 2–5, 115, 130, 139n53
art criticism, 7–8, 93–98, 118, 150n4
art museums, 3
art publishing, 2–5, 8, 93, 109–11
avant-garde, 11, 72, 88

Baldwin, Elbert Francis, 42–43
Benjamin, Walter, 41

Bertillon, Alphonse, 80
biblical criticism, 18, 20–21, 55–58, 96, 98–99
 and race prejudice, 58–59
Blavatsky, Helena Petrovna, 90–91

Caffin, Charles H., 30–31, 71, 95, 97, 126, 131–32
Cameron, Julia Margaret, 71–72
Christianity
 challenges to, 5, 15, 82, 94–95
 and consumer culture, 43, 68–70
 visual culture of, 1–5, 10, 76–80, 83–86, 109–11, 128–29, 137n20
civilization
 art's role in, 2–5, 7, 70, 128–30
 Christianity's role in, 2–5, 43, 44–45, 55, 59, 63–65, 107, 128–30
Coburn, Alvin Langdon, 97, 111
Copeland, Herbert, 72
Cox, Kenyon, 2, 19
Crucifixion, representations of, 71–72, 76–80
cultural hierarchies, 4, 11, 88, 104, 129

Day, F. Holland, art of
 and aestheticism, 72, 88, 93–94, 99
 and collecting, 72–73, 99
 and critical reception, 93–98
 and display, 75, 94
 and the occult, 10, 73, 91
 and philanthropy, 73, 89, 99
 and physiognomy, 71, 80
 and publishing, 72–73
 and religious exploration, 10, 73
 and Roman Catholicism, 73, 88–90
 and sacred series, 71, 73–75, 93

Day, F. Holland, art of (*continued*)
 and silence, 90–91
 and visual culture, 76–78, 83–86
 and writings on photography, 97–98
 Works:
 Beauty Is Truth, Truth Beauty, 75, 91–92, fig. 17, fig. 29
 Crucifixion with Mary, Mary Magdalen, Joseph, and Saint John, 76–80, plate 5
 The Entombment, 75, 91–92, fig. 18, fig. 29
 Frederick H. Evans Viewing One of the Seven Last Words, 101–2, fig. 32
 The Seven Last Words of Christ, 71, 75–76, 83–86, 88–90, 93–98, 100–103, plate 6
 Touch Me Not, 71, 75, 82–83, fig. 26
 Vita Mystica, 100–103, fig. 31
 See also Guiney, Louise Imogen; Theosophy
Demachy, Robert, 83
department stores, 3, 11. *See also* Ogden, Robert C.;
 John Wannamaker
Dewey, John, 8
Douglass, Frederick, 58
DuBois, W.E.B, 9, 49
DuMond, Frank Vincent, 2, 3–4, 53–54, 111, fig. 13
Dunbar, Paul Laurence, 55, 62

Eakins, Benjamin, 19, 29, 34
Eakins, Thomas, art of
 and anatomy, 9, 14, 20–21
 and brotherhood, 34–38, 39–40
 and iconography, 20–21, 31–33, 34
 and language, 9, 26, 138n43, 139n56
 and linear perspective, 9, 14, 24–25
 and Pennsylvania Academy of the Fine Arts, 34, 36–38, 44
 and Philadelphia's Roman Catholic community, 14, 20, 21, 27–28
 and portraiture, 21, 27, 28–33, 35, 39–40
 and Quakerism, 9, 14, 25–26
 and realism, 21–24, 33
 and religious commentary, 14–20, 21
 and Roman Catholicism, 9, 13–14, 15, 23–24
 and Romanism, 15–18
 and social hierarchies, 15–18, 33–34
 and theory of signs, 14, 26, 28–30, 39–41
 and translation, 29–30, 38–39, 41
 and visual perception, 24, 29
 Works:
 Archbishop William Henry Elder, 30–33, fig. 5
 Cathedral of Seville, 16–18, fig. 1
 The Chess Players, 34
 The Crucifixion, 9, 20–26, 30, 41, plate 1
 Father John J. Fedigan, O.S.A., 36–38, fig. 8
 George Morris, 34
 The Gross Clinic, 20, 23, 26, 30
 Law of Perspective, 23–25, fig. 4
 Monsignor James P. Turner, 39–40, fig. 9
 The Translator, 27–29, 34, 38–39, 41, plate 2
 William Rush, 20, 26
 See also logos; Murray, Samuel

early cinema, 4, 10, 11, 72, 76, 78–79, 85–86, 87, fig. 24, fig. 27
Eastern religions, 5, 10, 73, 91
Emerson, Ralph Waldo, 6, 118–20. *See also* Transcendentalism
Evans, Frederick, 72, 96, 97, 101–2
experience, theories of, 5–11

Fry, Roger, 8, 99, 102

Galton, Francis, 80
German idealism, 7–8, 10, 127–28
Gérôme, Jean-Léon, 29–30, 34
gift books, 4, 6, 19, 76, 105–6, 137n20
Gladden, Washington, 19, 98–99
Guiney, Louise Imogen, 73–75, 89, 102–3, 150n55

Hartmann, Sadakichi, 93, 104, 127, 130
Haydn, Joseph, 89–90
Henry, Right Reverend Hugh T., 27–28, 33–34, 38–39
Heston, Watson, 60–61, fig. 16
historical Christ, 6, 21
 Jewish origins of, 52–54
 representations of, 20–21, 52–54, 96, 149n45
Holy Land, visual culture of, 51–52, 63–65, 66, 75, 82–83
Hurll, Estelle, 106, 115, 128

icons, 73, 103, 104–5, 107–8, 125, 148n23
 ideal womanhood, 10
 and domesticity, 105–8, 115
 and the Madonna, 105
 representations of, 104–5, 125–26
 and the women's movement, 107–8
Isham, Samuel, 125–26

James, Henry, 105, 126
James, William, 5–6, 8, 73, 99, 123, 132
Jameson, Anna, 105–6, 115
John the Evangelist, Saint, 9, 24–26, 30, 41
Jubilee Singers, 62

Käsebier, Gertrude, 2, 111–12, fig. 34
Keats, John, 73, 91
Kitchell, Joseph Gray, 122–23, fig. 40

LaFarge, John, 4, 19
Leo XIII, Pope, 28–29, 34, 38, 87–88, 148n25
logos, 9, 14, 24–26, 30, 38, 41
Louisiana Purchase Exposition, 82, 86

Macomber, Mary L., 2, 4, 111
Madonna, 14, 104, 108, 120, 125, 127
 and the Annunciation, 45–46
 apparitions, 106, 130
 and the Assumption, 39
 of Henry Adams, 130
 and the Immaculate Conception, 15
 and Progressive era reform, 128–29

Protestant conceptions of, 104–8
Roman Catholic devotion to, 105–6
visual culture of, 109–11, 128–30
Maeterlinck, Maurice, 90–91
Masaccio, 91–92, fig. 30
Methodism
appeal to antebellum African Americans, 49–50
and religious experience, 9–10, 49, 59–60
See also Wesley, John
modernism
and aesthetic theory, 72, 99–103, 131–32
and consumption, 68–70
development of, 9
and gender, 130–31
within Protestantism, 19–20
and spirituality, 5–6, 131–32
visual practices of, 9–11, 72, 99, 100–103
modernization
processes of, 11, 70, 111
and religion, 2–8, 19–20, 43
and threats to tradition, 94, 106–7, 115
of vision, 4–5, 11, 136n38
Morris, William, 7, 72, 128
Müller, Friedrich Max, 26, 29
Munkácsy, Mihály, 1–3, 52
Murray, Samuel, 9, 27, 34–36, 141n88, 141n89
Muybridge, Eadweard, 36, 80

Oberammergau Passion Play, 71, 78–80, 85, 94, 96, fig. 23
object-centered education, 2–3, 7, 66–68, 70
Ogden, Robert C., 68–69
Orientalism, 51–52, 63–64

Palestine Park, 82, 86
Passion plays, 72, 86. See also Oberammergau Passion Play
Payne, Daniel, 55, 56, 60
Pearce, Charles Sprague, 111, 113, fig. 35
Peirce, Charles Sanders, 8, 30, 39–41, 99
Philadelphia Photographic Salons, 91–92, 94, fig. 29
photography
and composite portraiture, 80–81, 122–23, fig. 25, fig. 40
and criminal identification, 80
critical discussions of, 93–98
and the Holy Land, 82
religious language of, 71–72
and religious subject matter, 2, 71
and scientific developments, 87
and Spiritualism, 87
and typology, 80
physiognomy, 29–30, 41, 52–54, 60, 80
Pia, Secondo, 87, fig. 28
Presbyterian Board of Publication and Sabbath School Work, 14, 35
Progressive era reformers, 7, 128–30

Raphael, 3, 109–10, 115, 126, 128, fig. 33

religion
experience of, 5–8, 49–50, 59–61, 73, 82–83, 85–86, 98–99, 126–27
modern conceptions of, 2–8
and modernization, 5–8
pluralism, 5
Remick, Marie, 129–130
Renaissance art, 94, 115–18
Renan, Ernest, 21, 24–25
Reni, Guido, 76–77, fig. 21
Ripley, William Z., 53
Roman Catholicism, 73, 102
and aesthetic engagement, 23–24, 27
and early cinema, 87–88, 148n25
and Holy Week rituals, 89–90
Protestant perceptions of, 13, 15–19, 105–06
and symbolism, 33–34
Ruskin, John, 7, 128

Saint Charles Borromeo Seminary at Overbrook, 20, 21, 27–28
Saint-Gaudens, Augustus, 118
Santayana, George, 131
Sargent, John Singer, 1, 111
Scarborough, W. S., 51, 63, 68
secularization, theory of, 5, 14
Shroud of Turin, 87–89, 148n26. See also Pia, Secondo
Social Gospel, 98. See also Gladden, Washington; Progressive era reformers
Spencer, Edwina, 115, 118
Spiritualism, 5, 10, 73, 87, 91, 97
Steele, G. T., 67–68
Steichen, Edward, 71, 97, 102
stereo photographs, 4, 76–78, 85–86, fig. 22
Stieglitz, Alfred, 72, 131
Stoddard, John L., 85

tableaux vivants, 4, 10, 72, 76, 78–80, 147n9, 151n22
Tanner, Benjamin Tucker, 9, 43–44, 56, 58–59, 64–65, 66–70
Tanner, Henry Ossawa, art of:
and African American audiences, 62, 68, 146n91
and African American elite, 43–44, 62–64
and Christian nationalism, 63–66
and consumption, 43, 68–69
and disciplined piety, 43, 58–62
and ecumenical nature of, 65–66
and homiletics, 56–58
and Jewish models, 46, 51–52, 63
and Orientalism, 51–58, 63–64, 144n33
and patronage, 68–70
and race prejudice, 44, 50–51, 62
and religious experience, 45–51, 58, 60–61, 66, 70
and seeing and believing, 43, 46, 66–68
and Thomas Eakins, 44, 68
Works:
The Annunciation, 45–46, 66, 142n12, plate 3
The Banjo Lesson, 69, 146n91
Christ and Nicodemus, 66

Tanner, Henry Ossawa, art of (*continued*)
 The Mothers of the Bible-Hagar, 4, 56–58, fig. 14
 The Ox-Cart, 68
 The Resurrection of Lazarus, 42, 50–51, 66, 69, plate 4
 The Thankful Poor, 42, 60–61, fig. 15
 Two Disciplines at the Tomb, 45–47, 65–66, 142n12, fig. 10
 *The Wise and Foolish Virgins (Behold! The Bridegroom
 Cometh),* 46–49, 58, 66, 142n12, fig. 11
Thayer, Abbott Handerson, art of
 and conceptions of modern life, 108, 111, 120–21,
 152n40
 and German idealism, 127–28
 and Idealization, 118, 121–23, 130
 and Italian Renaissance, 109, 115, 118
 and natural world, 109, 111, 115, 118
 and Neoplatonism, 118, 120–21
 and real and ideal, 118, 123, 131
 reception of, 125–27
 and religious upbringing, 108–9, 127–28
 and role of fine art, 104, 108–9, 125, 127–28
 and spiritual experience, 123–25
 and typology, 10, 121
 and winged figures, 110–11, 115, 118, 120–21
 as worshipper, 104, 109, 111, 118, 120, 125
 Works:
 Angel, 111, 115–16, 130, fig. 37
 Caritas, 111, 123–24, fig. 41
 Cornish Headlands, 111
 Mother and Child, 111, 114, fig. 36
 Seated Angel, 111

 Stevenson Memorial, 111, 118–19, 126, fig. 39
 View of Dublin Pond, 111
 A Virgin, 2, 117, 123, fig. 38
 Virgin Enthroned, 4, 109, 115, 118, 123, 126, plate 7
Theosophy, 5, 10, 73, 88, 90–91
Tissot, James Joseph James, 2, 3, 52–53, 133n4, 134n11,
 143n31, fig. 12
Transcendentalism, 10, 91, 108–9, 118, 127. *See also*
 Emerson, Ralph Waldo
travel lectures, 10, 72, 83–85

Van Rensselaer, Mariana Griswold, 20–21
Veitch, John, 67–68
Velázquez, Diego Rodríguez, 19, 21–22, 30, 76, fig. 3,
 fig. 6
Vincent, John Heyl, 106–7, 108
visual culture, theories of, 11

Wanamaker, John, 3, 68
 and New York department store, 122
 and Philadelphia department store, 3, 69, 134n11
 and Tissot Gallery, 3, 122
Wanamaker, Rodman, 69
Weir, Robert Walter, 16–18, fig. 2
Wesley, John, 49, 59–60
Wilde, Oscar, 72, 94, 98–99
Willard, Francis, 107–8
Women's Christian Temperance Union, 107. *See also*
 Willard, Francis
Wood, Archbishop James Frederick, 21
World's Columbia Exposition, Chicago, 3–4, 5